Fundamentals of Photography

Joel Sartore

PUBLISHED BY:

THE GREAT COURSES
Corporate Headquarters
4840 Westfields Boulevard, Suite 500
Chantilly, Virginia 20151-2299
Phone: 1-800-832-2412
Fax: 703-378-3819
www.thegreatcourses.com

Joel Sartore
Photographer, National Geographic Fellow

Joel Sartore is a photographer and National Geographic Fellow, a speaker, an author, a teacher, and a regular contributor to *National Geographic* magazine. He holds a bachelor's degree in Journalism, and his work has been recognized by the National Press Photographers Association and the Pictures of the Year International competition. The hallmarks of his professional style are a sense of humor and a midwestern work ethic.

Mr. Sartore's assignments have taken him to some of the world's most beautiful and challenging environments, from the Arctic to the Antarctic. He has traveled to all 50 states and all seven continents, photographing everything from Alaskan salmon-fishing bears to Amazonian tree frogs.

His most recent focus is on documenting wildlife, endangered species, and landscapes, bringing public attention to what he calls "a world worth saving." His interest in nature started in childhood, when he learned about the very last passenger pigeon from one of his mother's TIME LIFE picture books.

Mr. Sartore has since published several books himself, including *RARE: Portraits of America's Endangered Species*, *Nebraska: Under a Big Red Sky*, and *Photographing Your Family: And All the Kids and Friends and Animals Who Wander through Too*. His most recent book is titled *Let's Be Reasonable*.

In addition to the work he has done for *National Geographic*, Mr. Sartore has contributed to *Audubon* magazine, *TIME*, *LIFE*, *Newsweek*, *Sports Illustrated*, and numerous book projects. He and his work have been the subjects of several national broadcasts, including National Geographic's *Explorer*, NBC's *Nightly News*, NPR's *Weekend Edition*, and an hour-long

PBS documentary titled *At Close Range with National Geographic*. He is also a regular contributor on the *CBS Sunday Morning* show.

Mr. Sartore is always happy to return to home base from his travels around the world. He lives in Lincoln, Nebraska, with his wife, Kathy, and their three children. ■

Table of Contents

Table of Contents

Table of Contents

Fundamentals of Photography

Scope:

Taught by a contributing photographer for *National Geographic* magazine, this course will show you how pictures work and how to make them work for you. You'll learn the basics of operating a camera and get dozens of practical tips to take your photography to the next level, illustrated with real-life examples. You'll also learn about all the elements that come together to make a good picture and how they relate. After each lecture, you can complete the suggested homework assignments to help you put the principles of this course into practice, making them second nature.

Anyone interested in photography with any level of experience can benefit from this course. For those just starting out or thinking about upgrading their equipment, there's an entire lecture devoted to researching and purchasing equipment. Instead of focusing on the bells and whistles of camera technology, you'll see how to find just the right tool for the job at hand. You'll learn the basic dials and buttons found on most cameras and how to use them to get the effects you want in your images. You'll also learn how to choose the right equipment for different photographic situations.

The course covers the nuts and bolts of exposure: aperture, shutter speed, and ISO. You'll see how these three elements affect the final image and when to vary what. Aperture and depth of field are critical concepts that are discussed in-depth. You'll also learn to read an exposure histogram and find out what kind of exposure gives you the most flexibility.

The course's twin centerpieces are in-depth, three-lecture discussions of composition and lighting. Both take you inside the thought processes of a professional photographer as he makes images. You will explore composition techniques, such as framing and the rule of thirds, that are easy to remember and apply and can be used with any kind of camera, from an advanced SLR to a simple point-and-shoot. You'll discover how to make backgrounds work for you—rather than against you—and how to harness the power of

perspective in your images. The ultimate compositional goal—a layered image—can be achieved by combining and applying these principles.

Entire books have been written on photographic lighting, and there is a great deal of nuance to the subject; the basics, though, are simple. The lectures on lighting cover finding and getting the most out of natural light, recognizing how color and intensity affect your pictures, and using and controlling artificial light sources. You'll also see how to use unconventional light sources to get great results.

This course features a number of on-location shoots to show you how a professional photographer thinks through a variety of real-life photographic situations. You'll see field demonstrations that showcase photography of rural and urban landscapes, wildlife, people, special occasions, and travel. In the process, you'll discover what makes an image look forced and posed and how to avoid those pitfalls to get a candid image that communicates something meaningful about your subject. You'll learn to recognize, think through, and solve a variety of visual problems, from cluttered backgrounds to bad light.

The later lectures cover advanced topics and share professional methods for research and preparation, low-light photography, and macro photography. Proven journalistic techniques for research and preparation are presented—critical aspects of any photo project. You'll also conquer macro photography and find out how to capture the tiny world that's so often overlooked in pictures. Although low light poses a challenge, it's also ripe with photographic opportunity, and you'll discover how to spot and capture great images in low-light conditions.

To round out the fundamentals of photography, you'll learn how to curate your own images. You'll see a demonstration of digital workflow, with each of the steps in the process explained. You'll also get practice in choosing the best image out of dozens or even hundreds of frames from one shoot. As a capstone, you'll learn how to put together photographic stories and essays, moving beyond the individual still image to photographic narrative. ∎

Making Great Pictures
Lecture 1

D o you already take good pictures but wish you could take better ones? Do you ever ask yourself why your photos aren't as good as others you've seen? Do you wonder why your photos don't always work and what you can do about it? In this course, you'll learn not only how to fix those problems but why the fix works. We'll go beyond the hardware—the cameras and lenses—to develop the skills you need to see well and think critically about your pictures. In this first lecture, we'll look at some iconic photographs to see if we can discover the elements that create lasting, meaningful art from even the most everyday situations.

Organization of the Course

- The first half of the course will be about the basics: cameras and lenses and how to use them. We'll learn essential terms, such as aperture, depth of field, and focal length, and we'll look at how a good photograph is constructed using the three building blocks of light, perspective, and composition.

- The second part of the course will focus on the subjects people are most interested in capturing: landscapes, wildlife, people, special occasions, and not-so-special occasions. Here, we'll focus on how to clean up and clarify the chaos of life.

- At the end of each lecture will be an assignment that's relevant to what you've just seen and heard. In some cases, I'll do the assignment along with you so that you can see the best ways to approach it.

- This course takes three approaches to learning about photography: through studio lectures; through analysis of photos, including both good and not-so-good examples; and through field shoots.

Special Photographs

- Pictures that are "iconic" are those in which everything comes together—light, composition, and subject—in a way that's new and interesting and memorable.

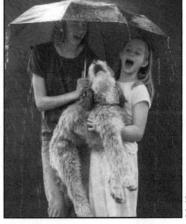

© Joel Sartore.

You don't have to travel to exotic locations to take great pictures; an iconic photo can be something as simple as a picture taken in your own driveway.

- Such photos may capture unique or dramatic moments, such as young cows watching a fire or a wolf snarling over a dead deer, or they may capture everyday moments, such as two girls singing under an umbrella. What makes a photo iconic is that it surpasses the original situation in which it was taken.

- Great pictures can be found anywhere. They don't have to come from an exotic location. You can take great pictures around your house or yard, at the local zoo, or in places you visit around your community. Iconic pictures are all around us; all we have to do is see them.

Seeing Well

- Photography is fairly simple; there are only a few basic controls on a camera. But seeing well is the tough part. It's the biggest challenge for anyone with a camera.

- "Seeing well" means pulling together the various elements that combine cleanly to make an image. It starts with the subject and includes the light on the subject, the background, and the space around the subject. Each element works both separately and in concert with the others to create good pictures.

- The primary tools for seeing well are your eyes and your brain. You'll need to master a few camera settings, but unless you can see well, the fanciest camera in the world won't give you the pictures you want.

- You train the eyes and the brain to look for three elements: great light, good composition, and an interesting subject. Two out of the three can create a good lyrical picture, and even just one of the three works sometimes, but a good photographer is always aware of all three.

- Keep your camera with you and look for soft light, compositional elements that give a sense of place, and a subject that goes beyond the obvious, such as a fierce dog or a toddler throwing a fit.

- Note that iconic photographs don't just happen. Before you shoot a picture, take a moment to evaluate the situation, see what's present, and think about the scene critically. Look for problems to solve.
 - Once you begin to think like a photographer, visual problems will become more apparent and so will the solutions.

 - This is the key to the whole course: Photographers are visual problem solvers.

 - If something is in your frame, it should be there because you want it to be in there, not because you couldn't figure out how to get rid of it.

Assignment
- First, pick out your favorite room in your home. Believe it or not, the rooms in your home can yield tremendous potential visually, but you have to be able to see it and identify it.
 - Look at the room at different times of the day and night. Try to see it in terms of what might cause problems with your picture and what might yield interesting results.

 - Get low and high to try to see the room from different angles.

- Next, you may need to declutter the room and adjust the lighting—the curtains, blinds, or table lamps.

- Now, take a picture of something happening in that room—maybe a person or a pet comes in, maybe you turn on the TV, or you open a window and the wind blows through. Take a picture of something happening.

- Don't just snap one or two pictures, and don't be afraid to change things around to make your photos better. Being a photographer is all about seeing, thinking, and making changes if necessary.

Behind the Lens

I got started at *Nat Geo* because I took pictures of the things that interested me—mainly the goofy, or the weird, or the surprising. The kinds of pictures I liked to take, *National Geographic* liked also. Seeing the surprising things drives what I do—the kinds of images that make people stop and stare, the kinds where they say, "Gee, that's really cool. How did they do that?" I love when people can't figure out how you got a picture. That's the best.

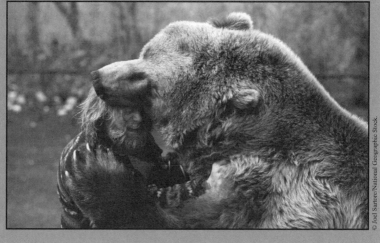

© Joel Sartore/National Geographic Stock.

- Pictures of your family, friends, and home should be some of the best photos you ever take because you have 24-hour access to your subjects. You can learn the best places and the best light to shoot in. At home, you have access to the most dramatic opportunities, from laughter to tears.

Pet the Whale
- The phrase "Sometimes, you've just got to pet the whale" is one way of saying that it's just not picture-taking time. Be selective. Some things are not meant to be shot.

- Before you shoot, ask yourself, "Is this worth it?" And if it's not, what can you do to make it worthwhile quickly? Sometimes, you may just take a shot or two and then put the camera down to appreciate the moment.

- Don't be so busy fiddling with your camera that you miss the experience of petting a whale or watching the birth of your child.

- Be discerning and discriminating about when you pick up your camera. Your pictures will be much better if you say no to most things. Through this course, you'll figure out when to say yes.

Suggested Reading

Abell and Gilka, *Stay This Moment*.

Morris, *Believing Is Seeing*.

Sartore (with Healey), *Photographing Your Family*, pp. 6–20.

Homework

Take a picture of your favorite room in your home.

Making Great Pictures
Lecture 1—Transcript

.I everyone. I am Joel Sartore, a contributing photographer for National Geographic Magazine and your professor for this course on Photography. For more than 20 years and 30 stories, I have traveled the world looking for good pictures. In fact, photography is about all I have done since I was 18 years old. Can you believe it? Judging by my wrinkles and gray hair, that is a long time.

I never dreamed that growing up in Nebraska I would be a National Geographic photographer, but here I am, and it's all thanks to a few little black boxes that I have hung around my neck for so many years. Indeed, a little box has been my passport to the entire planet. It has literally been a key that has allowed me to peek into the lives of nearly anyone, and nearly everywhere. It is an excuse to be a professional voyeur, and believe me, people love to show off all around the world.

It has also given me a legitimate reason to do things like climb to the top of a grain elevator or fly low over elephants on the African savannah, or even ride on a nuclear submarine. Isn't that something? It is amazing, isn't it?

Beyond all that though, photography seems to give me a reason for being here in the first place. I shoot all the time, whether I am at home, or on vacation or, on the job. After all these years, I still get very excited about great light and what there is in that. I love the fact that the quality of light is infinitely different each and every day, and that I will never, ever see the same things twice. I enjoy the process of visual problem solving as well, and that I will never truly master it. I also like making something out of nothing, especially of surprising my friends and family with lovely, intimate moments of themselves, looking healthy and passionate and fine.

Do you know the best part of all? Photographs can be used to make the world a better place. Nothing fixes a social or environmental ill like shedding a little light on a bad situation. That's really why I became a photojournalist in the first place. But most of all, I love still photography because I'm selfish. I get a huge kick out of it. Photography is endlessly surprising, to me and

those around me. It's a bit like acting I suppose. If you do it well enough, you never know where it will take you in terms of the end result.

I surprise myself every time I shoot, both pleasantly and unpleasantly, but I know that each situation I capture as a still image has the potential to become iconic, and to rise above the original situation from which it came. To be able to create lasting, meaningful art from even the smallest of situations, and to be continually amazed by it all, well, it doesn't get any better than that. Besides, now that I've done this for so long, I'd say it has pretty much ruined me for any other kind of work. So a photographer I'll stay until the day I die.

When I first picked up a camera, things were shot on film, and much simpler. But still that black Nikon camera with the heavy lens on it was so confusing to me, really it was. I wish I'd had this course way back then. It, would have saved me a lot of time and heartache.

This course will help you improve your photography in ways you may not have considered before. How? Well, we are going to talk about cameras and lenses, sure, but we are going to go way beyond that—beyond the hardware to the skills you need regardless of size, sophistication, and the price tag of your gear. Price tag does not matter, really, to make great pictures. Hard to believe, isn't it? Pure and simple, we are going to talk about seeing well, seeing well and thinking critically about your pictures. I mean being harsh on yourself. So first, what does it mean to "see well"?

Some more good questions: Do you already take good pictures but wish you could take better ones? Ever ask yourself why your photos aren't as good as others you've seen? Ever wonder why they don't always work and what you can do about it? You have come to the right place, my friends. You have. In this course you are going to learn not only how to fix problems but why the fix works, and it has everything to do with seeing well and thinking critically. It doesn't have anything to do with your gear, believe it or not.

Now, here's how this course is going to be organized. The first half is going to be about basics: cameras, lenses that you have, and how to use them, how to use what you have at home. You don't need to go out and buy a bunch of

.oduce you to essential terms like aperture, depth of field, focal
.i I'll talk with you about how photographers manipulate those, as
.i let you in on some of my own secrets and personal tricks of the trade.
.en we are going to look at how a good photograph is built, or constructed, using the building blocks of light, perspective, and composition. I'll say it again: light, perspective, and composition. Those are huge, and most people never think about them. They do not, but you're going to.

The second part of this course is going to focus on the kinds of pictures that people usually want to take. Things like landscapes of course, landscapes, wildlife, people—we all like to take good pictures of our family and friends, and special occasions, maybe even not-so-special occasions, just a snowstorm back in Nebraska.

We are going to focus on how to clean up and clarify the chaos of life so that your pictures really sing, no matter where you live, whether you are in a big city or out in the middle of nowhere. It's fun. It's relatively easy, and you can make better pictures right away. After this lecture, you will be able to make better pictures. I guarantee you.

At the end of each lecture I'm going to give you a little assignment that's relevant to what you've just seen and heard. In some cases, I'll do the assignment right along with you so you can see the best ways to approach it. I've made plenty of mistakes in all my years of shooting, and I can help you avoid the same pitfalls. The goal is to hit a home run with each picture, no matter what the situation. You may not always get there, but the goal is to try to hit a home run.

You are going to learn in three ways from this course. One way is through the studio lectures. Here we are in this lovely studio here at The Teaching Company, The Great Courses. The second is through plenty of photos I'll be showing as examples. These will be mostly good. I guess that is kind of good, but some not-so-good ones either. I shot that in a hotel room this morning, not so nice, right? I want you to get used to the idea that it usually takes more than one or two swings to hit a home run, for sure, especially when we are starting out. It's difficult. It is.

And third, you are going to come with me into the field sometimes, back to my home, Lincoln, Nebraska, to a little farm I own not too many miles down the road. Call this the Dunbar house. It is near Dunbar, Nebraska. We are also going to go to a fabulous place just on the edge of town called Raptor Recovery Nebraska in Elmwood, Nebraska, where injured birds of prey are nursed back to health and released back into the wild. It's a great place to shoot wildlife pictures. We are going to really have a lot of fun in this course, in other words. It is. It is going to be a lot of fun.

So to start off, I'd like to show a few pictures of here, the kind that got me my job at National Geographic. People always ask me that. How did you get your job at National Geographic? Well, this picture helped a lot, believe it or not. It's hard to believe, isn't it? It is of cattle watching a fire burn in Kansas. Just something I shot on the way to my grandmother's house to go fishing one evening.

What is it about this picture that attracted the Geographic? Well, it's at the right time of the day, when the orange glow of the fire kind of balances out with what's left of the light in the sky after the sunset. It's a nice composition with good lighting, and there are cattle in the middle of a fire. It's interesting. That helps. And the cattle add a little something, a little compositional element to complete the frame. These were young cows that were curious, that had never seen fire before. They were just standing. It was a nice calm evening. This is one of those pictures that got National Geographic's attention, and it was shot almost in my own backyard at the time. You do not need to go to Timbuktu to shoot something to get National Geographic's attention. Isn't that something? That is a lesson learned.

Let's take this one of a grizzly biting a guy's head. Well, that's something you do not see every day, do you? Not really. And to this day I meet folks who remember this picture years later after the original story came out in the magazine. This is a friend of mine named Doug Seus, and that is his movie star bear, Bart. Now Doug wasn't hurt. This was during a training session, but it's still epic. It's epic, and it's interesting. I am going to say that over and over again. It's interesting. That helps. It helps a lot of it's interesting.

Or how about this one? A wolf snarling over a dead deer. Now this was taken with a remote controlled film camera, right as this wolf is warning others in her pack to stay away until she has eaten her fill. So she's kind of growling at everybody else. I'd gotten the snarl on her face, but I couldn't be sure until I got my camera back and processed the film months later. That was really a tense time to see.

All these pictures go way beyond the original situation, right? They've lasted over time and have gone on to appear routinely in the 'best of' books by National Geographic. However, you guys don't have to have a picture of a bear biting a guy's head to make an iconic photograph, do you? No. You can make it right in your own backyard or in your driveway in this case. Two girls singing with a dog under an umbrella.

I use the word "iconic" for pictures where everything comes together—the light, composition, and subject—in a way that's interesting and new and memorable. Like that. It's just cute, and it was not a shot of a bear biting a guy's head or some elephants in Africa.

I'd like to talk for a minute about what makes a picture iconic. Do you know what I mean? I mean it's the kind of image where it's elevated to a degree where what you see is bigger than the original situation. Still photography does that so well. It's one reason I love it so to this very day. A great still image surpasses the original situation, and that, my friends, is impossible to do any other way.

The goal of this course is to get you to learn how to take iconic, great, and fun photos. And by that I mean images that capture a moment, convey an emotion, and mean something to you and those you love. Great pictures can be found anywhere. They do not have to come from an exotic location. It could be a picture on your sidewalk of your dog. It could be a monkey with a funny haircut at your local zoo. It could be my own feet or your own feet covered in mosquitoes. This is what a desperate photographer will do after not having shot a good picture in three days, by the way. My feet itched for hours.

It could be a guy dusting the stuffed sheep in the back of a sporting goods store. Iconic pictures are all around us. They surround us every day. All we have to do is look, and see them, and think. That is what this course is about: Just getting you to think. Simple as that. It is not about gear. It is not about how much money you spend on gear. It is about thinking. That's it. That's the course.

I got started at National Geographic because I took pictures of the things that interested me, mainly the goofy, or the weird, or the surprising. The kind of pictures I liked to take National Geographic liked also, so I am fortunate there. Seeing the surprising things drives what I do to this day—the kind of images that make people stop and stare; the kind where they say, "Gee, that's really cool. How did you do that?" I love it when people can't figure out how you get a picture. That's the best, just the best.

Photography is really very simple. There are only a few basic controls on your camera, but "seeing well," that's the tough part. That's the biggest challenge in anyone else with a camera.

By "seeing well" I mean pulling together the various elements that combine cleanly to make an image. And to some this can be a really tough concept; It scan be. It starts with your subject, truly, the light on your subject, the background, and the space around your subject. Through this course, you are going to learn to see each of those things individually. Each element works, both separately and in concert with the others, to create really good pictures.

Let's address our primary tools here, your eyes and your brain. That's right. The camera is just a box with buttons. That's all it is. It's just a tool, nothing to be scared of. I am going to bet that almost everything you've ever learned about that box is wrong. For example, you don't shoot portraits when the sun is real harsh over your shoulder. That's a very common mistake. Photographers end up torturing their subjects all the time by making them squint into the sun and sweat. Man, have I seen this a million times. No one wants to sit in the sun and squint and sweat, do they? I mean, please. Put the sun over your shoulder and blast right at it, right? Wrong. Look at this. My poor son, Spencer, just tortured once again. So how do you fix that? You shoot in softer light. And we'll talk about more graceful lighting in upcoming lectures.

Now notice that I did not say you need a fancy camera. A camera is just a box with bells and whistles, and boy, do they have a lot of bells and whistles these days. You don't need to master every aspect of it, even. I do not even know how all the features on my camera work! I mean the manual for the thing is 300 pages long! 300 pages! It's impossible! Unless you were the engineer that designed the camera or you wrote the book, forget it! Without using your eyes and your brain, the fanciest camera in the world won't give you good pictures. They won't give you the pictures you want. I guarantee it.

To start off, you need to master just a few of the camera settings, not all of them. You are going to learn what those settings are, nice and easy. When you get more comfortable with the basics, then pick up that manual and see if there's anything more complicated that you'd like to try, but don't try to know it all to start. Shoot, I'm still learning and I've been at this a long time.

This is not a technical course. Can you guess that by now? It's about simplifying the technical information, the basic stuff we need, to learn with whatever camera you have in making great pictures. Whatever camera you have I can guarantee you that you can make great pictures with it. Photography is not about the gear. Good photography isn't. It's about seeing and thinking. Besides, the gear we use changes all the time. It changes every day just about.

So, eyes and brain, and what is it we've got these things trained on? Three things. This is what we need: three things. A great picture consists of great light, good composition, and, oh, yeah, something interesting. Don't bore the viewer! Do not force boring pictures on people, please! We're all forced to look at boring pictures all our lives. Please don't do that. We're going to make sure you get off that nasty habit if you have been doing that. We're going to make sure of it.

Having said all that, know that two out of three things—great light, good composition, something interesting—two out of three can be enough. It can. Two out of three can create a good, lyrical picture. Heck, I've seen an excellent photograph with just one of the three. I've shot a few of those, but a good photographer is always aware of these three things: light, composition, and subject, even if one or two are iffy, and you need to be, too.

Here are some of the photographs that illustrate a couple of these components. I picked these that I thought were iconic and eventually yield the three features we're going for: great light, great composition, interesting subject.

The first nice shot came about, eventually, in the Salmon River Valley of Idaho. I was there to do a story on federal land use. I hadn't found anybody really using federal land, and I was just driving back to my hotel room. There was about an hour of light left. I figured I could go back and mope in my hotel room and get nothing, or wander around the field and run into something at least. Anything is better than nothing.

So, I'm driving down the highway minding my own business, a little mopey. The sky is kind of gray, hadn't shot anything all day, really. About an hour of light left, like I said, and there is a tractor and the guy is baling hay. I am thinking, at least the landscape is wide open. Let's work this a little bit. So then I get a little closer, go on down the gorge, get closer. I notice there's this kid in a striped shirt, and he is watching, turns out, grandpa on the tractor. I am thinking OK, all right, that's all right. This could be interesting.

The farmer's name was Phillip Goodell, and the grandson was hiding from him behind these bales. It was a very cute and idyllic scene. I made some frames. Made a few frames, and I liked them. It was just a pleasant little scene. I did not really expect anything to be published, and then when they got done I walked up to their truck. They invited me back to their home for dinner, something like that. I walked up to the truck and this happens. Wow! They have this blue heeler dog in the truck and he tries to come at me just so ferociously through the window. Grandpa is holding onto his back leg. Holding on to him so the dog can't kill me. The thing I am most proud of to this day is that I didn't run away shrieking. I didn't run away. I just stood there and I took a couple of pictures. And the grandson is meanwhile sitting in the backseat laughing. He thinks it's hilarious.

Let's talk about the mechanics of why this picture works so you can get an idea of my approach, believe it or not. I did have an approach in mind when I shot this. The sort of analysis I want you to learn to do with your pictures. Hopefully when there is not a dog trying to rip your face off, of course. First of all, the light is soft, nice, soft day. And the background is OK because

we get a sense of where we are. We are in a hay meadow, and we are in a rural setting, and there are mountains, and that is fine. We see a dark sky. We see the bales of hay, and we know we are somewhere in the country, in the Rockies maybe. Now you add the people and the dog into it, and wow. Is it interesting? Well, yeah! The dog is trying to rip my face off. Everything is sharp, and the fangs are bared, and it's right there.

Another layer on the onion is the kid laughing in the truck. The kid is laughing. He's looking at my reaction and I'm as scared as I can be. The dog was really trying to get out at me, and even clawing up the door, and the kid laughing adds another layer. So it becomes this iconic photograph that kind of lasts through the years, and it was total luck you guys, total luck. I had my camera with me so it worked out. If you carry your camera with you, you are going to see interesting things. And this is just in a hayfield in Idaho, and it started out as a nothing situation. I mean nothing, quiet, quiet, quiet.

Let's look at another one now. This is another picture I consider iconic as well. This is of my wife, Kathy, and our baby son, Cole. He is a toddler actually, and he is ruining a perfectly good evening for us at Dead Horse Point State Park in Utah. I was doing a story on Utah for National Geographic. It was sunset and we were at this beautiful scenic overlook. There were some other tourists scattered about, but it just needed something else. Anybody can take a nice picture of an epic scene like that. That's no trick at all. You just wait for the light to get good, right? But I wanted to show something else. And I am thinking well, Cole was in a foul mood that night, and I thought if Kathy held him up a little bit and held him still he would get in a much worse mood because kids hate holding still.

So I had her hold him up and in about 20 seconds he starts in again and he is in this funny little toddler outfit, this goofy little outfit, and you can see the background. The composition is good. The light is soft, and it's something interesting: The kid is screaming his head off. So all three elements in one frame! It doesn't happen very often. Even though he wrecked our day, this photo made up for it. It even ran in the National Geographic story on Utah. I knew when I shot it, it would probably run because we have good color, a good sense of place, and we have good composition. The background works well. It doesn't fight with the foreground, but it adds something to

the picture. And it's interesting. It's a kid throwing a fit in a funny outfit. So you very seldom see pictures with kids throwing fits, and that is remarkable because just about everybody has kids. I have three. Yet, how many times do we shoot them bawling? Never! So I think that's a great opportunity. You can go way beyond the obvious with that. Something that's a little bit different, something that makes people chuckle, right?

These things didn't just happen. I took a moment to evaluate the situation, to see what was there, and to really think about it, to think critically. I looked for problems to solve. Once you begin to think like a photographer, visual problems will become more and more apparent. So will the solutions. That's great! The more you do it, the easier the solutions. This is key. This is key to the whole course. We are visual problem solvers. The fact that you paid for this course and you want to learn how to solve visual problems, giddy-up. Let us do this. If we are serious about photography then we are serious about solving visual problems, and those problems are abundant. If it's in your frame, it's in there because you want it to be in there, not because you couldn't figure out how to get rid of it, OK?

So, to get you started, here is your first assignment: It has two parts. First, take a good picture of your favorite room in your own home. I want you to see that room in terms of what might cause problems with your picture.

Second, take a picture of something happening in that room—maybe a person comes in, maybe a pet walks through, maybe you turn the TV on, or you open a window and the wind blows through. Take a picture of something happening.

I will do that second part with you—the making something happen—so you can see what I have in mind. Let's go to my home now in Lincoln, Nebraska—to my favorite room. My living, actually. We'll talk about what we're seeing there, and how to think about it, and how to get you started making better pictures right at home.

OK, so, welcome to my house here in Lincoln, Nebraska. We are in my living room. This is my favorite room in the house. Why? Because it is big and it's hard to believe, but this is the least cluttered room in my house. We are real

pack rats around here. Anyway, this is about visual problem solving, isn't it? And this is your assignment. It's to find the best room in your house, your favorite. It's a nice thing because you can work right in your own home. And you're going to learn how to see well. That's the whole thing. Photography, good photography is about visual problem solving. So we really want you to learn how to see well here.

You are going to be looking differently at these rooms in your own home. Believe it or not, these rooms that you see over and over again, they can yield tremendous potential visually, but you have to be able to see it and identify it and look at it throughout different times of the day and night. Just see what room yields what at different times of the day with different things going on. So, we're going to do a few things in this room to basically unclutter it a bit more. I can shoot several different angles in here. I know that because I've done pictures in this room many times over the years.

I am going to do several different things. We are going to adjust the blinds. We are going to go over and work from different angles. We are going to get high angle, low angle. We're going to try different things in here. All of them will yield different pictures, but we are going to clean things up, tidy things up a little bit. And we're going to be thinking. This is about seeing well. That's all this is about at this point, seeing well in your own home. You can do it. If I can do it in a cluttered room like this, you can do it too. So, let's get started.

OK, so we have picked up the room. We've straightened it all up. We've put the pillows back on the couch. We've removed the light sabers sitting around on the floor and opened the blinds up a little bit to make the room a little bit more bright. Now, since I am a busy guy I don't have time to wait around for something to happen, so I am going to bring in my assistants, Grace and Rebecca and a couple of dogs, and we are just going to see what we can get here, try to make something really neat happen.

OK, so, we want to make something interesting happen in this room. I'm not a very patient guy. In fact, I would be terrible at sailing because you have to wait for the wind to push you. So, I've asked my assistants, Rebecca and Grace, to do something interesting, and this doesn't look too

interesting. They are standing there with their arms at their side, stiff as a board. We've talked about this ahead of time. You guys could do this too. Introduce something interesting into your living situation. For us, it's going to be our family dog. So, we've talked about this. Girls, do your thing, OK? Grab them up.

Now see? You got a dog as big as a horse. That is interesting. Now we're going to make a couple of pictures, just to see how this looks. The focus is going to be right there on Rebecca with Muldoon. Grace is in the background, and we are getting a few pictures. And you know what? This isn't working as well as it could. I'm seeing pictures and clutter in the background that I didn't see before. So, I think what we are going to do is remove that, clean it up, and see how that looks. Let's try that.

OK, so, we've removed the clutter above the mantel there. It's nice and clean. Rebecca, see if you can get Muldoon to go up. Now we are going to try it. Look at that. Let's see how this looks, a little bit more clean, a little bit better. Nice. Grace, just look at the dog. There we go, perfect. I know you are crazy about that dog. Let's see if Muldoon will give you a kiss. Almost. Rebecca, back up this way a little bit to the left. That gives us a little bit more separation between Muldoon and you and Grace. OK that's good, that's good.

There we go. There we go. OK, very nice, very nice. OK, now that looked perfect. Kind of fun, huh?

I want to point out to you that I didn't just snap one or two pictures there, did I? I took several. I changed up some stuff in the middle to make it better. It's all about seeing and thinking and changing up, if it's necessary.

Why would I ask you to do this? Because I want to start off easy. Photographs of your family, friends, and home should be the best photos you ever take. Why? Because you have 24-hour a day access to your subjects. The best places, the best things, the best light. You have access to the most dramatic opportunities from, let's see, laughter, of course. My daughter, Ellen, partying it up at one of her birthday parties, going over the top. To crying tears. Who doesn't want to photograph tears? I know I do. That's sick, isn't

it? But, you know, it's actually a good disciplinary tool. When you break out the camera, they all of a sudden get better. They hate having their picture taken when they are crying. It's really good for good behavior in kids. Try it some time.

What else can you shoot? All hours of the day, when the light is magic, when it pours into different rooms, in different ways and in different places, you are going to be with your family and friends at all times. Have a camera with you. Take advantage of that, for goodness' sakes.

I have a lot of sayings. Here is your first one: "Sometimes, you've just got to pet the whale."

This is my slang for the fact that, sometimes, it's just not picture taking time. Be selective, please. Some things are not really meant to be shot. Don't stand there fiddling with your camera. Look at it and think, Is this worth it? Is this worthy? Is this good enough to photograph? If not, can I make it good enough in short order without torturing those I know and love? Sometimes just take a shot or two, then appreciate the rest. I made some changes, I took a few more pictures and that was it, right? I didn't keep Rebecca, and Grace, and the dogs around for a couple of hours. It was just a few shots, something to record the moment. Don't torture your subjects.

So what about that whale? Why do I say "Sometimes you have to just pet the whale"? Well, because years ago, literally, I encountered whales on a piece I was doing for the Endangered Species Act story I was working on for National Geographic, and we went to this Laguna San Ignacio in Mexico on the Baja Peninsula.

You go out in these little boats called pangas and you are in this beautiful lagoon on a sunny day, and there are these grey whales there that have no memory of being hunted, and some of them come right up to the boat to be petted, believe it or not. Because they don't remember that people used to hunt them. Some of them roll on their backs and on their sides. They stick their tongues out. They want you to scratch their tongues! It is really incredible, just incredible.

So, there were people in the boat, believe it or not, and this is the saddest thing. They insisted on videotaping and shooting the entire thing, but they were supposed to be on vacation! They were supposed to be on vacation! They never stopped to pet the whales. They never stopped to pet the whales, can you believe it? If you can, you must pet a whale! And this means you have to put your camera down to do this.

Another example of when not to shoot, I photographed Cole's birth, my son's birth, but I did not experience it. Believe it or not, I did not experience it. How could that be? Well, it just is. I'd rigged up the camera so that I had remote cameras and foot switches and I could take pictures of Kathy in labor. Don't I look like I really care, like I am compassionate? No. I'm focusing in on Kathy because I know I have got to focus there and I am actually firing a camera with a foot switch under the bed, believe it or not.

I wanted to do this photo essay that showed Kathy as she goes to the hospital, gives birth. There are her doctors watching a James Bond movie on TV while they're waiting for contractions. There's the nurse teaching her how to breathe because I went to Lamaze with Kathy, but I wasn't helping her breathe. I was just shooting pictures. I wanted to do this little photo essay that I thought would be something lasting to give to Kathy, her mother, and my mom. There is Cole being born. Here I am presenting the baby. I look pretty happy, but I'm hitting a foot switch under the bed. That's how pathetic this is. I'm hitting a foot switch under the bed. So, I missed the whole experience. Look at this.

I look at these pictures and I'm actually kind of ashamed of them now because I was working. I was working the event. Yeah. Well, I got a nice set of pictures, and I shot my brother and my sister-in-law coming to see the baby, and there are my parents. My parents would stand back in case they have a cold. But you know, there is Kathy's family when we were at home. I got this nice set of photographs, surely, but I missed the birth. I missed it. I missed the whole thing because I was working it. I will not make that mistake again, I guarantee you. I worked the birth and I missed it.

Still bums me out to think about it. Well, when my second child, Ellen, was born, I took one picture of the baby on a table and then I cried like a baby. So, sometimes you just want to stop and enjoy life.

Look, 100 years from now, no one will know any of us even existed. So think about that, really. Some things you just don't want to shoot. Be very discerning and discriminating about when you pick up that camera. Your pictures will be a lot better if you just say no to most things. I want you to figure this out, though, through this course, when to say yes.

So now you are just itching to go out and buy a camera and get started. Not yet! In our next lecture we will talk about what equipment you do and do not need and how to make the most of what you have already in terms of gear. So please, stay with us.

Camera Equipment—What You Need
Lecture 2

I n this lecture, we'll talk about photography equipment. A professional photographer may have a lot of "stuff"—everything from camping equipment to ice-diving gear—but you can generally fit everything you need in a small backpack that you can carry on to an airplane. Into the backpack should go the following: a good camera, a lens or two, film or memory cards, extra batteries, a battery charger, and a lens cloth. If you have a more advanced camera, you'll need the external flash and batteries for it, as well. In this lecture, we'll learn some considerations for purchasing this equipment and some basic camera controls.

Equipment
- When you're purchasing a camera, think about what you'd like to do with it, how much time you want to devote to photography, and what your budget is.
 - If you're a point-and-shoot type of person, don't buy a camera that is overly complicated or too heavy. You can make great pictures with a small camera that fits into your purse or pocket.

 - At the same time, don't under-buy if your goal is to shoot art photographs.

- If you want interchangeable lenses, buy a single-lens reflex (SLR) camera instead of a point-and-shoot.
 - SLRs have the advantage of letting you build your lens collection gradually. You can start off with a normal focal-length lens (the kind most cameras come with), and later, you can build a repertoire of lenses, based on what you like to shoot.

 - You can buy a low-end camera, but buy the best lenses you can afford. Better lenses are both sharp and have the ability to open up for more light, allowing you to shoot in a broader range of situations.

- Any camera you buy should feel comfortable in your hands. Make sure you can reach all the controls and that it's not too heavy for you.

- For right-handed people, the left hand is both the camera platform and the lens control; the back of the camera rests on the back of the palm. Use the thumb and forefinger of the left hand to focus and zoom. Use the right hand for manipulating dials on the camera and pressing the shutter.

- Make sure the review screen on the back of the camera is big enough to allow you to really see the pictures you've taken. Looking at the review screen is called "chimping"; you'll learn to chimp constantly to check the exposure of your photo, the focus, the composition, and so on.

- You will also want to purchase a tripod. Using a tripod is one of the easiest and cheapest ways to improve your photography. A tripod eliminates camera shake because it basically bolts the camera to the ground. Be sure your tripod can easily hold the weight of your camera and your largest lens.

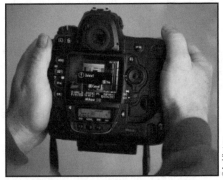

- You'll also want to have a cable release because pushing a shutter release will jiggle the camera, and that jiggle can ruin a picture with some camera settings.

Get in the habit of "chimping" constantly, that is, looking at the back of the camera to check the exposure, focus, composition, and so on.

© Joel Sartore.

- It's best to buy your equipment from a local dealer rather than online. Ask for the dealer's help and advice and try a variety of different cameras.

- Instead of a camera bag, you may want to buy a photo vest. These vests have deep pockets that zip to keep your equipment secure and allow you to keep your hands free to shoot photos.

Basic Camera Controls
- The hole in the lens of a camera is called the aperture. How big or how small that hole is determines how much light comes through the lens.
 - Lenses can be set to different apertures, which are also called f-stops or stops. An aperture setting of f/16 or f/11 is a tiny hole. An aperture of f/2.8 is a big hole.

 - The aperture setting determines how much of the image is in focus. With a setting of f/16, everything in the image will be in focus, but most of the time, you want the subject to be in focus and everything else to be a little soft.

- The shutter speed determines how long the shutter stays open to expose light to the sensor. The shutter is a curtain of blades that regulates the time that light is allowed in.
 - It's best to shoot in soft, graceful light, but this kind of light is weak and, therefore, requires a big hole in the lens to gather up the light while the shutter stays open.

 - Of course, you can't just leave your shutter open a long time because if you're holding a camera with a slow shutter speed, the image will be blurry. It's also true that the livelier the subject, the faster the shutter you'll need.

- The aperture and the shutter speed have the same two functions as your kitchen faucet. The faucet controls how much water you turn on and for how long. The aperture setting is how much you open up the hole, and the shutter speed is the amount of time it's open. The more open and the longer the duration, the more light comes through your lens.

- Most good cameras have shutter speeds that go from many seconds all the way to a thousandth of a second or even faster. You should use 1/60 of a second or 1/125 of a second, fairly fast shutter speeds.

- Aperture and shutter speed go hand in hand to create a proper exposure. If one is shifted, the other must be, too. They always change together.
 - ○ A faster shutter speed means you need a bigger hole in the lens to let in more light.

 - ○ A smaller hole in the lens means you want a slower shutter speed to allow the same amount of light in.

- The ISO is the sensor's or film's sensitivity to light. In low light situations, you want the sensitivity to be quite high, and you want it to be low in very bright situations. The setting of the ISO depends on the time of day you're shooting and the lighting conditions.

Choosing Your Settings
- Most modern cameras have automatic controls for aperture and shutter speed to give you a perfect exposure every time. But for this course,

Behind the Lens

[My] gear room ... is packed—jammed solid—full of the stuff that I take with me on assignment for *National Geographic*. ...

Everything you can think of [is here].... I had this [mamba box] made for containing arboreal venomous snakes, climbing venomous snakes, like mambas. Black mambas, for example, have been in here. You do not really want them to get loose while you are shooting them because that would be bad.

What else? ... The boots I wore at Volcanoes National Park in Hawaii. I thought I was walking in chewing gum, but I was walking on hot lava, and that sticky sensation was the bottoms of the boots melting off. It hurt a lot, but here I am.

This vest also. You see how it has got these oil stains all over it. This is from covering the Gulf oil spill, so I keep it as a keepsake. The thing about all of it, it's fun to look around and it's fun to think about where all of this stuff has been—to every continent on earth, literally, but you do not need any of it.

you will want a camera that gives you the option to shoot in aperture priority, shutter priority, and manual.

- o Aperture priority means you choose the aperture setting, and the camera will set the appropriate shutter speed to make the correct exposure.

- o Shutter priority means you choose the shutter speed, and the camera will set the appropriate aperture to make the correct exposure.

- o Full manual mode is when you pick both, but that's a lot to think about in addition to light, composition, and subject. It's probably best to use aperture priority and shutter priority.

- o In particular, aperture priority allows you to control the depth of field—essentially, the amount of the image that's in sharp focus as opposed to softer focus.

- The ISO must be set by the photographer unless you're shooting in full automatic mode. The ISO is your camera's level of sensitivity to light. With high, strong light, the ISO should be low. For low light, the ISO should be high.

Assignment
- Take a picture of one subject using many different settings on your camera, then look at how each setting changes the photograph.

- If you're ambitious, you can label each photograph to help you remember. You can even put a card in the picture to show you what the settings were. For example, the card might read: 1/1000 of a second at f/2.8.

Suggested Reading

Latimer, ed., *Ultimate Field Guide to Photography*, pp. 8–11.

Sartore (with Healey), *Photographing Your Family*, pp. 176–187.

Your camera's manual. Lost it? Most manufacturers offer a way to download manuals on their websites. Haven't bought a camera yet but have one in mind? Go online and read the in-depth review for it at www.dpreview.com.

Homework

Take a picture of one subject using every setting on your camera. Look at how each setting changes the way the image looks. If you need help remembering what you shot with which settings, put a card in the picture that notes the setting, for example: 1/1000 of a second at f/2.8. This is also a great first step to take with a new camera.

Camera Equipment—What You Need
Lecture 2—Transcript

So, welcome back. In this lecture, we are going to talk about photography equipment. Maybe you're wondering what equipment a professional photographer has to have. Well, you may be surprised. Let's go back to Lincoln and have a look.

Welcome to my underground lair. Not really a lair, it's underground, though. This is the basement of my home. I call this the gear room, and it is packed. I mean, packed, jammed, solid, full of the stuff that I take with me on assignment for National Geographic. What's down here? You name it. Everything from camping supplies for 40-below-zero nights to ice-diving gear, dry suits,—that kind of thing, things where you could literally go under ice water and stay warm or, at least, alive long enough to shoot your pictures.

What else? You name it. Everything you can think of. This little baby right here, this is what I call the mamba box. I had this made for containing our boreal venomous snakes, climbing venomous snakes like mambas. Black mambas, for example, have been in here. You don't really want them to get loose while you are shooting them because that would be bad.

What else? Oh, this was kind of bad. These are boots I wore at Volcanoes National Park in Hawaii. I thought I was walking in chewing gum, but I was walking on hot lava and that sticky sensation was the bottoms of the boots melting off. It hurt a lot. It hurt a lot, but here I am.

This vest also. You see how it has these oil stains all over it? This is from covering the Gulf oil spill, so I keep it as a keepsake. And you know, the thing about all of it, it's fun to look around, and it's fun to think about where all of this stuff has been, to every continent on earth, literally. But, you don't need any of it. To be honest with you, you do not need a thing. In fact, you can leave all this stuff right here. You don't need it. In fact, we are going to show you exactly what you need in the form of one backpack you can take with you on an airplane. That's it, one backpack full of gear. That's all you need.

So, let me ask you a question. I'm serious now. Be honest. Doesn't that vest make me look fat? I don't really want to know. Don't tell me. Don't be honest. So, a backpack? Yes, really, a backpack, like this. This is what I carry. You can carry everything you need in a backpack or a camera bag, just so it's small enough to fit in a seat in front of you, or an overhead bin, well kind of.

Take a look at the gear that I have to carry on assignment for National Geographic. Amazing, isn't it? Look at this. This entire plane is full of my junk in Brazil, and the problem is with this plane you had to be on the outside of the plane between the wings holding down a button to get the flaps to extend. There was something wrong with it and my assistant held onto my legs as the pilot flew. I got to be the guy that crawled up on the roof in-flight and held the button down. I won't forget that.

What else? This is the gear that I took with me, just for me, up the Amazon River, part of the Bolivian Amazon River system, a lot of stuff. Now this, though, this was in Iowa. Everything I needed was in that little backpack. We were working on an endangered snail species, believe it or not, on a real hot summer day.

So, even with all this stuff, though, I keep the real critical gear on me at all times, right? The stuff that I have to have, man, I keep that on me. I always try to carry on everything I need, obviously, to be able to shoot if my checked bags get lost. I don't really like to check any of my critical camera gear because I don't want it stolen, or damaged, or just vanishing. So as these planes get smaller, I fill two little camera bags or so. I do the best I can to take along what I need to get the job done. National Geographic can't publish excuses. I can't get off the airplane in Africa and say, oops, they lost my gear. I'm going to take along my critical gear with me, right on me.

So, get a good camera bag or backpack. It should be easy to open and close. It should offer enough padding to protect your equipment from the occasional bump and bruise. It should have a nice, soft shoulder strap so it doesn't chafe you or rub holes in your shoulders. You're going to be living with this thing.

In the camera bag go the following, and we have got it all laid out right here: A good camera, a lens or two, maybe more, and a few accessories to make life easier as well. What kind of accessories? Well, if you're shooting a film camera, obviously, film. For me, I shoot memory cards, so we have a memory card wallet, batteries, extra batteries, a battery charger—very important, and a lens cloth. In my case, I just use a chamois, like something you would use to dry your car with—nice and soft, inexpensive, you can clean it, lasts forever.

For those of you who buy a more advanced camera, don't forget the external flash, like this one. You can do some amazing things with this as well. You need batteries for that flash, and I always use a sync cord so I can get the flash off the camera. And a lot of these flashes you can do wireless as well, very easy now, very easy.

So, it all starts with that camera, doesn't it? You do not want to buy a camera that's too overly complicated or too heavy. Do not over-buy a camera system. I can't stress this enough. Don't try to keep up with the Joneses here. If you are a point-and-shoot person, you are going to want something about the size of a pack of playing cards that you can slip into your purse or your pocket.

I have this right here. Look at this, little Canon G-series camera. If this is the size of camera you want to carry, that's fine, and I envy you a little bit. You can make great pictures with this, actually. And for the record, I've had pictures run in National Geographic with something like this. You make lovely photos, in this course, with a point and shoot. We'll show you some of those coming up.

Conversely, do not under buy a camera if you have very lofty goals about being able to shoot lyrical, fine-art photographs, or dramatic long-lens shots of grizzly bears in beautiful light, or taking detailed flash pictures in which you have to get that flash off the camera to really make things sing. Just ask yourself this, what is it you would like to do, really? Only you can answer this question. How much time do you want to devote, and what is your budget?

Our next lecture is all about lenses, so we can go into greater detail about them then, but while we are weighing whether or not to buy a point-and-shoot camera or something higher end, we should talk about whether or not you want to buy interchangeable lenses. Huh, tough one.

If you want interchangeable lenses, you should go with an SLR instead of a point-and-shoot, in my opinion. SLR is short for single lens reflex. A camera that allows you to change lenses is called an SLR. SLRs have the advantage of letting you build your lens collection gradually so you don't have to shell out all your money at once. You can start off with a normal focal-length lens, the kind most cameras come with. Later you can build a repertoire of lenses, based on what you find yourself wanting to shoot.

Now this is all very handy, whereas with a point-and-shoot you are limited to whatever is built into it and whatever zoom range is on that little lens that comes with it. You'll understand these limitations better when we start talking about aperture, shutter speed, ISO, that kind of thing.

When choosing lenses for an SLR, remember you get what you pay for. In college, I had a very good professor named George Tuck, and he always said you can buy a low-end camera, no problem. It's just a box, but buy the best lenses you can because they are both sharp and they have the ability to open way up, big holes in the lenses—these are nice, nice lenses—to allow a lot of light in and allow you to shoot in a broader range of situations, especially low light when it is beautiful.

Hey, how about it. You want to talk about a great lens. Oh my goodness! Oh my goodness! It's a good thing this is just a coffee cup. Did I have you going there? That's kind of funny, isn't it? A friend gave me this. I didn't really drop that. It actually is a little bit tippy.

So, back to our show. It would cost a mint if I'd dropped this. This is my favorite lens, by the way, not the coffee cup, but this one right here. This is the 24–70mm, right here. This is my favorite thing. It's on this camera. It's a Nikon D3, a little bit old and by the way, my cameras are a little bit well worn. A lot of the paint is coming right off of them, but I find that endearing.

Here's the key: Make sure the camera feels comfortable in your hands. Can you reach all the controls? Here's a biggie you may not have thought of: Is it too heavy for you? You will not carry it if it's too heavy for you. If this thing was too heavy, I wouldn't want to carry it across this room right now. You may think it's OK in the camera store, but when you get it out in the field and you have to carry this thing all day, are you going to want to carry it for hours and hours? I bet you this weighs five pounds or so. Are you going to want to put it in the bag and put it in a closet and never take it out? That's where it's going to end up, in a closet, period. That's it.

So let's take a minute here, too, to talk about how to hold a camera properly. You are going to be much more comfortable and steady if you can hold this thing correctly, OK? I'm right-handed so my left hand becomes both a camera platform and my lens control. I'll show you. Here it is, camera platform and lens control. I put the camera right there on the back. It's resting on the back of my palm. I use my thumb and forefinger to focus and to zoom. My right hand is for manipulating the dials, the settings, and for pressing the shutter, OK?

So don't hold it from above. I see this a lot, especially in movies. It drives me crazy. I know they didn't have a good consultant to show the actors how to hold their cameras. You want to be able to be stable. A Geographic photographer taught me this a long time ago. You want to be able to be braced in soft, subtle light with slow shutter speeds. You want to be nice and steady and stable. There's more than one way to hold a camera, but in my opinion, this is the right way. You can really brace yourself well, and it's a comfortable way to shoot.

So next, let's look at the back of the camera here and try to determine what kinds of things we see. This is basically a typical way I hold a camera. I'm usually wearing something very comfortable, and usually it says National Geographic because I get a lot of those clothes for free, to be honest with you. The back of the camera, as you can see, look at all the bells and whistles. That's complicated, isn't it? There are a lot of bells and whistles on the back of the camera.

The thing is, that view screen is such a lifesaver. I love the ability to see the pictures I've just taken, and I'm constantly looking at that review screen on the back, constantly. It's called chimping. You know why It's called chimping? Because when digital cameras first came out—I find this very funny even to this day—you would get a picture on the back and people would look at this picture. When they'd shoot it they'd look immediately and they go, "Ooh ooh, ah ah, ooh, ooh, ah ah," like that, like a chimp, so, we still call it chimping. I'm constantly looking—or chimping—at the back of my camera to see how the exposure is, how the focus looks, how the composition is, you name it. That little screen on the back that shows me my pictures is so handy. I cannot tell you.

Also, you are going to want a tripod. A good tripod is one of the nicest, cheapest things to have. I cannot tell you. Look at this. A tripod is such a blessing, and it really improves photography. A tripod eliminates camera shake, because basically the tripod bolts the camera to the earth. It bolts it to the ground, doesn't it? Be sure your tripod can easily hold the weight of your camera and your largest lens. This tripod, I could sit on this thing and it'd be fine. If you have a giant, honking lens, then you do not want to get a flimsy little tripod, then do you? You want something heavy. This isn't even a very heavy tripod, and I am putting all my weight on it and it's just fine. You don't need a tripod that weighs 50 pounds like one that is used by a TV crew, but you do want a good tripod.

Let's take a look. This is just typical, typical tripod. This is what I use out in the field all the time. So you need one other thing with a tripod. There's one other thing. I know I brought one here. Here it is. It's not very expensive, but boy is it important. This is called a cable release. What's a cable release? This is just a little device. It's literally a cable. It releases the shutter remotely from only this far away. Why do you want to do that? Because when your finger presses down on the camera when you are doing a very slow exposure, very slow shutter, you'll jiggle that camera and it will ruin it. It will ruin it with camera shake. So we use cable releases a lot when we are doing very, very long exposures using a tripod.

So, do your homework, you guys. It's getting a little complicated, but not bad. I really suggest, really do, after this lecture, that you go to your local

camera dealer, local camera store, and ask for their help and advice. Try a wide variety of camera lenses right in the store. Do not buy stuff online without actually having tried the gear out for yourself, please. In fact, I would suggest you go to your local camera dealer, you take their time, you ask them the questions about the lenses and the cameras, you get a feel for it, you shoot with it a little bit, and then you pay a little extra, and actually buy it from your local dealer. They will stand behind the gear. A lot of times online companies will not, so that's really just the right thing to do, folks. If you chew up a local camera store's time, buy your gear from them. You'll be glad you did, OK?

Now, I know that I told you everything you really need to know that you need is in a backpack, but the truth is, I try not to even carry a bag if I'm going to be on my feet all day. I have a secret weapon. I use a photo vest. You've seen this a lot, haven't you, photo vest? This is a photo vest I wear all over the world. A little stinky, smells a little like Africa still. It's a little dirty, I have to tell you. I wear this photo vest, and this carries everything I need. Why do I do this? Because it distributes weight evenly and I do not want to wreck my shoulders. That feels good.

So watch this. In this vest will fit everything, everything, even this nice little big one that's here, 7200. Everything I have on this table will fit into this backpack, lenses, flashes. Look at this. I have so many pockets, I can even take my lens coffee cup with me if I wanted to, right? Most camera stores sell this like this, in all shapes and sizes so this is actually a very, very slick thing to have.

Note, I have very deep pockets here on the side. My pocket is that deep, that deep. That way I can put anything I can think of into this and look at that. They all zip up. You know why they zip up? It's to keep things more secure, that's why they zip up. Stuff can't fall out if it's zipped up. If I'm on a horse that runs away on me, or if I am in a big crowd and there are pickpockets, look at this, it's harder to get into something if it's zipped up. It's harder for me to spill stuff, right? Not only is this stuff more secure because it's in these deep pockets, but it distributes the weight more evenly yet. It doesn't feel like I'm carrying all this heavy gear. The heaviest thing I carry is the camera around my neck when I'm going after it like this.

Another thing about a photo vest is it frees your hands up. Look at this. I have all my gear on me, and yet my hands are still free, yeah. I always put my strap around my neck, by the way, always, always. One hand can hold the camera, adjust the zoom and focus, the other presses the buttons. You go in into here. If I am fighting with a camera bag as well, that's a lot more of a problem. It's a hassle, and if you sit it down it can get dirty or stolen. All the gear is off the ground. All the gear is with me. This is great.

So, really, this is the stuff you need. Whatever gear you have, the more familiar you are, by the way, with your equipment, the better your pictures will be. So, I'm going to show you the basic controls on a camera now, the fundamental foundation. This is information—it all starts here.

You can make great pictures, by the way, with any camera. I want to stress that. Any camera, can you believe that? But to take full advantage of the techniques we are going to tell you about in this course, you are going to want to have a camera that allows you to experiment with a wide range of these things: aperture, shutter speed, ISO. You are going to need to know all of it.

So let's start out with the setting for aperture on this camera. Aperture, what is it? It's the hole in the lens. How big or small that hole is determines how much light comes through the lens. The aperture function on your camera makes the hole bigger or smaller—put that strap around my neck again. You know why? Because I have dropped lots and lots cameras on the ground by not having that strap. Always do it. Always, OK?

So with apertures, these different hole sizes, we call them f-stops or just stops. An aperture setting of f/16 or f/11 is a fairly tiny hole. An aperture of f/2.8 is a big hole in the lens. Why should you care about the size of the hole in the lens? Well, the size of the hole, or aperture setting, determines how much of the image is in focus, and it also determines how much light gets through.

So why wouldn't you want to shoot everything on, let us say, f/16, tiny hole? Everything would be in focus. All your problems would be solved, right? Not so fast! Most of the time, contrary to what you have been led to believe,

you want very few things in focus, believe it or not. That's because the world is a chaotic place, and I want my subject to be in focus and the rest of the world can go a little soft, or out of focus, as far as I'm concerned. I want to give an impression of where we are in the background, but I don't need to see sharp detail in everything else in the background, really, most of the time. I want the focus to be on my subjects. Largely, my family members, or whatever or whoever I am shooting for National Geographic.

If you have everything in your focus, if you have everything in focus, how are you ever going to isolate your subject amid the chaos of life and make it stand out? We'll talk about this much more in later lectures.

Let's take a look here. Now let's look at this picture. In this case, there were so many tree limbs behind us that the right choice was a small aperture number to create a big hole in the lens to blur the background. That's the way to go. It's a really lovely, professional look, isn't it? Absolutely.

You know, another control on the camera is shutter speed. Shutter speed determines how long the shutter stays open to expose light to the sensor. The shutter is a curtain of blades that regulate the time the light gets in. That's all it is. Shutter speed is easier to understand in that way than aperture. It's the amount of time that the sensor is "seeing" what your lens has focused on.

I want you to be shooting in very soft, graceful light. I don't want you shooting into the blazing sun when your subject is squinting and sweating uncomfortably. We're going to work in beautiful, soft, graceful light, OK? But graceful light, that is weak light, and it requires a big hole in the lens to gather up whatever light is there, whatever light we can. That light is so weak sometimes, and so beautiful, and soft, and fragile, and delicate, it can barely get into your film or sensor, so you need a big hole to allow as much light as possible to come in while that shutter stays open.

Now you can't just leave your shutter open a long time, though, for two reasons: first, because we breathe and we are shaky—even when we are trying to hold still, we move a little bit. If you're holding a camera, handholding, with a slow shutter speed, things can get blurry, can't they? Because you are moving a little bit and your subject is probably going to be

moving too. If you have a lively subject, you'll probably need a faster shutter speed. A turtle sitting still does not need a fast shutter speed, while, let's say, a baseball player sliding into home, might.

Let me explain how these two things—aperture and shutter speed—work. This is one of my favorite little metaphors, the kitchen sink example. Imagine you're standing at your kitchen sink. Think of the water as light, and the sink is the camera's light-sensitive sensor, or film. How much water gets into that sink is determined by a faucet, right? OK. There are only two functions on a faucet: how much you open it up, and for how long—how wide open it goes and how long. In a nutshell, that's the same way the two basic camera controls work. Aperture is how much you open up the hole in the lens, and shutter speed is the amount of time it is open. It's that simple. The more open the whole in the lens and the longer time it is open, the more light comes through your lens and hits that sensor.

The shutter regulates the time the light gets in, and the hole in our lens, or the aperture, is how far open or closed our spigot is. I really want you to make sure you understand this because these two controls are the very foundation of still photography.

Most good cameras are going to have shutter speeds that go from many seconds all the way to a thousandth of a second, or even faster. Generally speaking, I like to say you want a shutter speed of $1/60^{th}$ or $1/125^{th}$ of a second, fairly fast shutter speeds. You'll need that fast a shutter speed to keep images sharp, because things are moving in front of your camera, and as we hold the camera we are moving too.

Aperture, the hole in the lens, and the shutter speed are tied hand-in-hand. They always walk together to create proper exposure. If one is shifted, the other must be also, and in different ways depending on the intensity or brightness of the light you are in. They always change together.

A higher shutter speed, a faster shutter speed, means you need a bigger hole in the lens to let in more light most of the time. A smaller hole in the lens, a tiny hole in the lens, means you want to have a slower shutter speed because a slower shutter speed will allow the same amount of light in through that

tiny hole. If you can understand that, you've got it. You have all the technical information you need for photography. To me, that's it. The end. It's not really a technical course. It's about good seeing and thinking, almost, almost.

There is a third control on a camera. There is. It's called ISO, which is the film's, or sensor's, sensitivity to light. In low light situations, you want that sensitivity to be very high, and you want that sensitivity to be low in really bright situations.

Now why do you care how much light gets to the sensor? If too much light gets to the sensor, it's absolute toast, that is why! Look at this, too much light on my assistant Grace. Wow! Look at that. Blinding light just blows it away, no detail at all. No good at all.

Now conversely, check this out. If you don't allow enough light on your sensor or film, it's like that. Way too dark. You can't see a thing. It's black! A happy medium is where you want to be. Set that ISO depending on the time of the day and the lighting conditions, OK?

ISO, together with shutter speed and aperture, are the basic controls of your camera. Most cameras now have automatic controls for aperture and shutter speed to give you a perfect exposure every time. When I was starting out in photography, 25, 30 years ago, whatever it was, it took some work to get a perfect exposure. Nowadays, you can do it all automatic. Do I want you to be thinking about how it works and learn how to do it yourself on manual? Yes, I do. But listen, you could get through this entire course just using automatic settings if you wanted to coast. You could, but what fun is that? Come on. I'm going to try to help you be in control of things. I want you to understand how these functions work and how they relate to each other. You are really going to feel empowered and feel good about it.

For this course, really, you are going to want a camera that gives you the option to shoot in aperture priority, shutter priority, and manual. Aperture priority means you choose the aperture and the camera will set the appropriate shutter speed to make the correct exposure. Shutter priority means you choose the shutter speed and the camera will set the appropriate aperture, the hole in the lens, to make the correct exposure. Wow. Either

way you go, shutter or aperture priority, you'll make a perfect exposure. Full manual mode is when you pick both, but that's a lot to think about in addition to light, composition—all the other stuff we are trying to get into. So for right now, I'm going to let you stick with aperture and shutter priority. Just baby steps right now.

I have to tell you, most of the time now, when I am on assignments for National Geographic magazine even, I shoot on aperture priority. This allows me to control the depth of field that I get—the amount of image that's in sharp focus and what's in softer focus.

Besides, most of the time I'm shooting in such soft light that I want the maximum sized hole in the lens that I can get, usually f/2.8, so I choose that, shoot in low light, and I let the camera choose the right shutter speed. It makes life a lot less complicated, allows me to get fast-happening situations, things that I don't really have time to think about, exposure, because they are going so quickly in front of me. And it allows me to really change up quickly.

The ISO, by the way, has to be set by you, the photographer, unless you are shooting in a full automatic mode. The ISO is your camera's sensitivity to light. High, strong light, you'll want to have a low ISO. Low light, high ISO. My high-end Nikon cameras allow me to go to 5000 ISO, 6400 ISO, and higher than that even. That means I can shoot, handheld, steady, with no tripod, almost at night now, in total darkness just about. If I can see it, I can get a picture of it, and that's remarkable.

When I started in photography, we had 50 ISO, 50 ISO color film. We could only shoot when the light was really strong. So we've gone from 50 to 5000 or higher in the expanse of my career! It's amazing. This is a great time to get into photography, you guys.

So hopefully you get this now and you have a real feeling for it. There's no substitute for an in-person demonstration when it comes to getting a feel for gear. And that's why I said go to your local camera store. Go to a friend's house who has the same gear as you want to buy. Then practice with it, hold

it in your hands, see how it feels, whether it's too heavy, understand the basics of what you are getting yourself into, OK?

So, your assignment: I want you to take a picture of one subject using many different settings on your camera. Take a look at how each setting changes the photograph of your object. If you are ambitious, you can label each one to help you remember. So I did this. I want to do things along with the course. I did this with my little boy, Spencer. He is, obviously, extremely excited to be helping his father, as are his other brother and sister, to be assisting me in this fine photo exhibition here. Anyway, he's holding up a little card right in front of me. For example, this one says 1/1000th of a second at f/2.8.

Now you notice no depth of field, big hole in the lens, no depth of field, just Spencer and that little piece of paper I shot, OK? You can check your settings quite easily on most digital SLR's, can't you? Usually with a little dial or button right on the back of the camera.

So what about this one? Look at this one. Oh! This is a little bit slower, isn't it? Much slower shutter speed. Now we are at f/16, a smaller hole. Look. Everybody is in focus. The kids still aren't very happy about having to pose for dad, but now there's lots more depth of field. Just in these two pictures we can see it. Look at this. Big hole in the lens, no depth of field. Small, tiny hole in the lens, f/16, lots of depth of field. Irritated kids in both.

In our next lecture, we'll talk about lenses and focal length. We just touched on these things here, but next we are going to be talking about choosing the right lenses and focal lengths for the kind of pictures you want to take. It's very important, but it's also fun. I love lenses. They feel good, you know? There are so many choices, and all could be potentially different tools in your toolbox. You wouldn't want to try driving a nail using a screwdriver, right? It's as simple as that.

So, go give that assignment a try and see what you can learn about that camera of yours, or what kind of camera you want to get, and after the next lecture, you're going to have even more interesting choices to make with your pictures. We will see you then.

Lenses and Focal Length
Lecture 3

M ost good pictures are good for one of two reasons: They are of something that nobody has ever seen before—Big Foot, Moby Dick—or they show the subject in a way that no one has seen before. That's what we're most likely to photograph—everyday scenes that are shot so well and unusually, they become interesting. Camera lenses are the tools we need to get this job done. In this lecture, we'll look at several lenses and learn what they can do.

Field Shoot: Raptor Recovery Nebraska

- Let's begin with a field shoot of a great horned owl. We'll start with a telephoto lens and work our way to a wide angle.

- A telephoto lens reduces the world to a pinpoint. It's what most wildlife and sports photographers use because they often can't walk right up to their subjects.
 - The disadvantage of a telephoto lens is that it doesn't allow you to see much of your surroundings.

 - The advantage is that the subject fills the frame and makes the background a nice blur of soft color.

 - Most people think they have to stay back from the subject with a telephoto lens, but you can actually move in close. You can even do portraits using a telephoto.

- A normal lens sees much as the eye sees. It's often difficult to get a good picture using a normal lens because everyone sees in basically the same way; with this lens, the subject must be extraordinary. You can also work the angles to see if you can get a good shot.
 - A point-and-shoot camera will work fine in a visually loaded situation, such as having a cooperative owl on a perch.

o The type of camera isn't always important; photography is about being close to something and seeing it well.

- With a wide-angle lens, you can also get close. With these lenses, the subject becomes very important, while the rest of the world fades away.

Camera Lenses
- Lenses are distinguished by focal length—the greater the number, the longer the lens. When your subject is far away and you want to bring it in closer in the frame, use a longer lens with a long focal length.

- With a long-focal-length lens, you're reaching out and grabbing a single point in the landscape; with a shorter focal length, you're showing much more of the world, a wider view.

- Camera lenses come in fixed and zoom focal lengths. The more expensive lenses—zoom lenses—are labeled by the range of focal lengths they can effectively photograph. Fixed-length lenses don't zoom; they're built to capture only one width.

- A 70-200mm lens can be used to "reach out and touch" something that's far away, or it can be used close up to something—to blur out a distracting background, fill the frame with the subject, or zoom in on an interesting detail.

- An 80-200mm lens is a manageable weight and a good compromise between big, expensive lenses and a normal lens.

- At the other end of the spectrum is a 14-24mm lens—a wide-angle lens. It's also a zoom lens, as opposed to a fixed one. What's called a rectilinear lens doesn't bend or stretch things terribly. This focal length is great for landscapes or tight scenes where you want to show everything and can't back up.
 o Wide lenses are good for use in interiors and exteriors of wide or big things. They are also good for giving context in pictures because they show a good bit of background.

o It's hard to show an entire mountain range with a telephoto lens, but you can show it with a wide lens if you are standing in the right spot.

o Wide-angle lenses generally have a focal length up to about 28mm. You can use these lenses to accentuate the distance between objects. They are also useful in tight quarters.

Behind the Lens

A normal lens is how we see, and I really prefer that. I use a normal lens most of the time any more when on assignment for *National Geographic*; can you imagine that? I'm traveling around the world and I'm shooting with a 50-mm lens. Good grief. If you can pull off a good picture with a normal lens, it means you've really done something. You're really seeing something well. If you can take a really interesting picture with a normal lens, it means you've either witnessed something amazing or you're taking something ordinary and making it amazing. It means you're not relying on those super-wide or telephoto lenses as a crutch to get you there to an interesting picture.

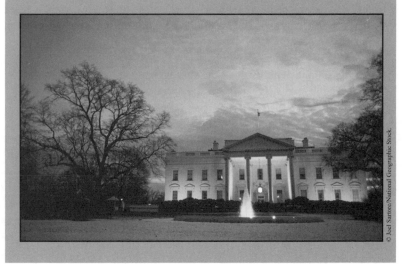

o Try to avoid putting people on one side or the other of a wide-angle picture, that is, along the edges. With a really wide-angle lens (say, 24mm or wider), it's generally best to center the subject, so the lens doesn't distort all or part of it. If you can't do that, you can back up.

o You can get by with a wide-angle lens and no normal lens, but that situation is not optimal. It's important, too, that you don't use a wide-angle lens as a substitute for good seeing.

- So-called normal lenses are 35-50mm. These lenses produce images that look natural to human observers because we see at about that focal length. They are often used for portraits because they don't cause the distortions that very wide lenses do.
 o Normal lenses allow you to shoot in a straightforward way, without gimmicks. With a wide-angle lens, the success of a shot may be attributed more to the lens than the photographer. But if you can pull off a good picture with a normal lens, you've seen something well.

 o Most of us see the world around us with a built-in 50mm lens in the brain. It's an accomplishment to be able to see differently when you have the same focal-length eyes as everyone else on the planet.

- A 24-70mm lens is a good workhorse lens. This lens sees as much as the human eye, plus a little more. It's the lens you'll likely use 99 percent of the time.

- Zoom lenses can take pictures in a certain range of focal length, which means, essentially, that there are many lenses packed inside one zoom. In contrast, prime lenses have fixed focal lengths.
 o The advantage of prime lenses is that they cost less and allow you to use a larger aperture. If you're using prime lenses, however, you'll need to buy more lenses to cover as much ground as a single zoom lens.

o The other advantage of prime lenses is that they force you to think through things more thoroughly and to be more creative. They make you get on your feet and back up.

o In fact, your feet are the best zoom you have. Walking up to a subject and backing away can help you find the best view.

Special-Purpose Lenses

- A macro lens acts as a telephoto lens for close-ups of tiny subjects. Most macros have a very limited depth of field, which means that very little in the image will be in focus.

- It's important to use a tripod or a monopod when shooting with a macro or telephoto lens; otherwise, just exhaling can move the frame.

- "Big glass" is photo slang for long lenses: 300mm, 400mm, or 600mm. The front element of these lenses is very large because they are designed to gather light at low levels. These lenses are very sharp, but they are also expensive; however, if you often photograph subjects that are hard to get close to, such as wildlife, these tools are a must.

© Joel Sartore/National Geographic Stock.

The right lens choices will give you a lifetime of interesting shots.

Before You Buy…

- The minimum focus distance is the smallest distance between an object and a lens where the focus is still sharp. Pay attention to the minimum focus distance when purchasing a lens or a camera with a built-in lens. Think about the subjects you like to shoot—such as wildlife close-ups or portraits—and consider the distance you want to be from these subjects.

- With lenses, you get what you pay for. Don't buy a telephoto lens if the best aperture is an f/8 or an f/11. You would have to shoot in very bright light if the opening is that small. A larger opening in the lens is needed to make pictures in soft light, such as an f/4 or an f/2.8.

- With the right lens choices, you will find a lifetime of shots right in your own town—everything from the local marching band to the state fair. If you are truly curious about the world around you, you'll never run out of subjects to shoot.

Assignment
- The best way to get a sense of how different lenses function in photographs is by trying them all out with the same subject. The assignment for this lecture is to photograph the same person or pet from the same distance, using three different lenses (wide, normal, and telephoto).

- For extra credit, try a macro lens, or if you don't have one, figure out what the minimum focus distances are on your other lenses. Compare your pictures once you're done, and pay attention to how the choice of lens changes the end result. Ask yourself: How are backgrounds affected? What does lens choice do for facial features?

Suggested Reading

Iooss, *Athlete.*

Latimer, ed., *Ultimate Field Guide to Photography*, pp. 50–59.

Homework

Photograph the same person or pet from the same distance using three different focal lengths (wide, normal, and telephoto). For extra credit, try a macro lens. Look at how the choice of lens affects the end result.

Lenses and Focal Length
Lecture 3—Transcript

Well everybody. Now we're going to be talking about focal length and lenses. Most good pictures are good for one of two reasons. They're of something that no one's ever seen before, and that's truly a tall order these days—Big Foot, Moby Dick, the Abominable Snowman, giant squid. Those are really tough things to get pictures of, though.

The second way to make great pictures is to show something in a way that nobody has seen it before. That's where we come in. That's what we're most likely to photograph, really—everyday scenes that are shot so well and unusually, they become interesting.

Your camera lenses are tools you need to get this job done. That's what we're going to talk about, lenses. They are the basic tools of photography. In this lecture we're going to go through several lenses and talk about what they can do. Let me show you what I mean with a short film I made with the Great Courses team. Let's go into the field now and see these different lenses in action.

OK, so now we're out at Raptor Recovery, Nebraska near Elmwood, Nebraska. We have Doug Finch back here, and he has a Great Horned Owl on his fist, and we're going to use this opportunity to photograph something very interesting—the Great Horned Owl, no offense Doug, of course—with a long lens.

We are going to talk about lenses today and how different lenses give us different effects. We're going to go with a telephoto first and work our way up to wide angle—right against this owl. This is a very tolerant owl.

So, we're going to start with the long lens. What does a telephoto do? A telephoto basically reduces the world to a pinpoint. It's what most wildlife photographers will use, or sports photographers will use, because we can't often just walk right up to our subjects, especially wildlife. You can't just walk up to an owl in the wild. So, the telephoto brings that wildlife up, fills the frame, and makes things interesting. Now the disadvantage to a

telephoto is that you don't see much of the world. You just see your subject. The advantage to it is that is fills the frame, as I said, but it also makes the background a nice blur of soft color. So in this case we have prairie grasses in the background. We're going to try that with our telephoto first and just show you how backgrounds are really, really cleaned up well with a telephoto lens. I have a 200–400-mm lens here, and we'll get started.

OK, very nice. Beautiful. So, this owl is outstanding because he is standing right there. He's not going anywhere. We're able to use our telephoto. This is a 200–400 mm, could be a much longer lens if we wanted, but there's no need for that, really. So I've done a couple of shots showing full body, and I'll move in a little bit tighter now. We'll see the talons tight, and we'll see the face tight. Very nice. Beautiful, just beautiful. So we get in tight, we can show just the eyes. They glow this beautiful golden color. I can show the talons all covered with feathers, and I can work this all day, actually. The light is soft, beautiful soft, soft light. It's a great day for this.

We could work this all day, but we're not going to. I want to move next into a normal lens. More as our eye sees it. There are basically three components to this: telephoto—really bringing in the subject, blurring the background. The normal lens, kind of like how we see the world, and then we will end with a wide-angle lens.

OK, so now we are still with the telephoto but I moved up closer, didn't I? Look at this. I'm almost on top of this owl. Most people think with a telephoto you have to stay back. I use a telephoto, actually, as almost a long-lens macro, if you will. So I will get—I will do people portraits like this, especially with this owl. He's not going anywhere. The light continues to be very soft, so I'm going to spin around and just do tight shots of the eyes and the talons. Whatever he'll give me. He's a very tolerant bird. Look at that. Perfect, beautiful. That's very nice. Nothing but the eyes, those glowing eyes. Of course while we're standing here we may as well do a picture of Doug's eyes. Liven things up. Got to keep the talent happy.

Alright. So, we've done a few shots that are very tight with this. It's a great lens for actually getting very, very close. Again, you don't have to stand way back. Getting close with the telephoto will really do some amazing things. I

have a tripod for this lens because it's big, and it tends to shake, it gets very heavy. So we are going to set this aside, right there, make sure it doesn't go anywhere. Don't want it to fall to the ground or you will see a grown man cry.

And now we're going to use a normal lens. This is a normal lens, OK? Look at this. A normal lens is just basically how the eye sees. That's tough to do. It's really tough to get a good picture with a normal lens because everybody sees kind of the same way. You have to have something extraordinary. Well to me, having a Great Horned Owl right in front of you is extraordinary. The light's very soft, so let's see what we can do—just with this, not going anywhere. This is actually a 24–70-zoom so it has a little bit more range. The owl is flying, that's kind of extraordinary. I should have gotten a picture. There you go. Beautiful, beautiful. Look at that. Very nice, very nice. It's called baiting. These birds do that a lot. It's not harmful to them. They're getting the energy worked off. They go right back on that perch.

OK, so we'll try a few shots. Again, the owl's in that same spot, the light's nice. This is actually a good place to work our angles a little bit. High angle, low angle. We have a really pretty barn in the background, grasses, the cornfield is going away in the distance. So we'll just try a few with the normal lens. Perfect, very nice. I mean it's really hard to go wrong actually. This is a visually loaded situation, I like those.

So while we're here we may as well talk about using a little point and shoot camera. This is a little Cannon, but there are a million of them. You have a great subject that's not going anywhere, the light is fabulous, and we're close. We're close. So why not use something that's simple, easy to use, a camera that you will actually carry. Who wants to carry this much weight if they're not working? So just something that fits in your pocket.

Look at this. We can get down low. I mean, how nice is that? Beautiful, let's move over to the side. Frame them up in the barn. Show the landscape, really nice. I mean you can do great pictures with a point and shoot. It's all about being in a visually loaded situation. That's all it is.

So, alright, we can use virtually any camera on this. It's not the box, it's just about being close to something and seeing it well and in nice light of course. OK, so we have normal lenses covered. Let's try wide angle next.

You're not going to believe this, but this owl has turned white and gotten smaller. I mean, I don't understand how it works, I'm not from the country really, but—actually of course, this is an European barn owl. Our other owl, the Great Horned Owl, got a little tired of me, so we are switching owls here to finish out.

We're talking about using a wide lens. So this is Janet. She has Nimbus on her fist. Nimbus is an educational bird, goes to a lot of schools, tolerates a lot of things. So we'll see if Nimbus will tolerate a few pictures right now from really up close. Look at that, no problem. A little bit of low angle, a bit of high angle, right up—what a nice bird, huh? That is a tolerant bird. Does it get any better than that? I don't think so.

So let's go back and we'll look at the difference between these three types of lenses, telephoto, normal or medium lens, and wide angle. Let's really look at the difference between what each of these types of lenses can do.

Aren't those birds amazing? They're really awesome, aren't they? Raptor Recovery, Nebraska works hard to educate the public about these fabulous, beautiful birds of prey, but, back to camera lenses.

So you saw me shoot with a telephoto, a normal, and a wide angle. Take another look at how the images from these lenses compare. Let's look at these real quick.

Long lens. We understand this don't we? Long lens, blurs out the background, pretty beautiful. A wide-angle lens, look at this. A little bit of a scene there, but still the owl stands out well and wide angle. The subject becomes very, very important. The subject's big, and the rest of the world fades away with the wide angle.

Let's talk about the mechanics of how this all works right now, OK?

Lenses are distinguished by focal length. The bigger the number, the longer the lens. When your subject is far away and I want to bring them in closer I'll want to use a longer lens with a longer focal length—if I can't walk up close to it, that is.

With a long, focal-length lens, you're really reaching out and grabbing a single point in the landscape. With a shorter focal length you are showing much more of the world in a wider view.

Camera lenses come in fixed and zoom focal lengths. The more expensive lenses, most of the times they're zoom lenses, and they are labeled by the range of focal lengths they can effectively photograph. Fixed length lenses don't zoom. They're built to capture one width and that's it.

I have four main lenses that I carry. There are others that we'll discuss at the end of the lecture, but they are for more specialized picture taking. I want to start with the basics.

One lens I carry a lot is this one. This is a 70–200-mm lens, OK? I carry this in the side pocket of my vest or in my camera bag because it's big. I don't use it a ton. With this you can reach out pretty well and touch something that's a little farther away.

Let's look here, like, turtle races. OK, that's kind of cute. Didn't want to get in the middle of the circle, use a long lens to reach out. What else can we get? We can kind of fill the frame with the subject a little bit, can't we? Have a nice, soft background of color, just kind of a nice pallet of color back there. Or we can zoom in, zoom in a little bit more—really get a facial reaction. Or you can even zoom into details with this lens. So it's very handy and very versatile. It's a nice lens to have. Weighs a little bit more, but sometimes it's an indispensible lens to have. You can't live without it.

Look at this. This was for a story on wolves. Grey wolves for *National Geographic*. These are wild wolves that have just woken up from sleeping all day on top of a frozen lake in northern Minnesota by the Canadian border. There is no way I could stick a long lens out the window and shoot this. There's no way. Out of a moving airplane? I don't think so. A huge lens?

Forget it—too much vibration, it would fall out, it would be terrible. With this little lens, it works great. Stick it out the window—it's 20 below zero by the way—stick it out, get your pictures. You can shoot a nice, wide view with this because you're up so high. Then we can get in a little closer. Look at that. Now we can actually see the wolves. A little closer yet. Do a nice graphic shot. So that is a really, really handy lens to have. I mean, tremendously handy.

At the other end of the spectrum is what I'd call a really wide lens. A 14–24 mm. That's really wide, but you know what? It's rectilinear and that's very important. Let's take a look. This lens, 14–24 mm, I work with this a lot. Look at that front element. It just looks expensive, doesn't it? And it kind of is; It kind of is. This one's called rectilinear, which means it does not bend or distort the edges, and this is great for landscapes. It's very nice for landscapes. Check it out. Wow, a big scene of bison, right? It's also good for scenes where you can't really back up but you want to show a whole room. Very, very handy—very handy lens.

That lens won't really distort like a fisheye, which is nice. That's what gives the picture a circular look, it's a fisheye lens. In my opinion, I don't even own a fisheye. I don't even think I've shot with one. It's useful but it's kind of a gimmick lens, in a way. It's sometimes appropriate but not very often. With a fisheye you're usually thinking of that curvy, stretchy effect rather than the picture.

Wide lenses are really good for certain things, but not for everything. They're good for use in interiors when you can't back up anymore or exteriors of wide or big things. And they're great at giving us a lot of context in our pictures because they show so much background, but they still should be used with care, and I'll explain more about that in just a minute.

It's hard to show an entire mountain range with a telephoto lens, unless you're way far away from it, but you can show it with a wide lens if you're standing in the right spot. If you're standing miles and miles away from the mountain range, sure. You can try using a long lens, nothing wrong with that, but if you're standing at the base of the mountains, or even in the mountains themselves, I'd probably try a wide lens.

Wide-angle lenses generally have a focal length of about 28 mm, depending on who you're talking to. You can use these lenses to accentuate the distance between objects. They're also useful in very tight quarters, OK? This frame, shot with an 18-mm lens. This is really wide but absolutely necessary in this case. This is my daughter's room after she cleaned it. There's a dog asleep somewhere in that room, sad to say.

Here's something else important to keep in mind with wide-angle lenses. I try to keep from putting people on one side or the other of a wide-angle picture, along the edges. Why? Because it stretches them. Again, by wide I'm talking 24, 20, 18, 16 mm. With a really wide lens, let's say 24 mm or wider, I'll try to center my subjects a lot so the lens doesn't distort them. If I can't do that, really, I'll back up.

Do you ever see a picture like this where somebody's teeth are bigger than their forehead, they look like a horse? That's because a really wide-angle lens was used. This is a 14–24 mm, which is a nice lens, but you don't really want to position your subjects so they're so close up to the frame when it's set to 14 mm—stretch city baby and that ain't really good.

You can get by with a wide-angle lens and no normal lens. You could. I did for years, but that's not really optimal. And this is important: I don't really think you should use a wide-angle lens as a substitute for good seeing.

Let me tell you a little story. When I first started out at the *Daily Nebraskan*, my college newspaper, I got this 24-mm lens and I was so proud of it. And I remember photographing everyone I could with this brand-spanking-new lens. It was kind of silly in a way. You know, I was like, wow! Look at this! I can shove it right into people's faces and get really close to them and get their eyes sharp. I mean, I did Red Skelton, the famous comedian; I did a photo illustration for the Great American Smoke-Out day; I did this friend of mine that was collecting bats; I did a guy that's got a crawdad pinching his finger. I did all these pictures and they're all kind of gimmicky and they're all stretchy.

With my new 24 mm I photographed anybody I could sneak up on, and well, it just kind of made everybody look a little bit freakish. It was a certain look,

but it was because I really didn't know any better. I wasn't thinking about good seeing. I was just thinking about getting close to people and getting their eyes in focus, both new concepts to me at the time. But I thought, if you're close enough and the eyes are sharp, well, that's good enough.

I'm telling you it's a tool. I'm not saying you shouldn't use wide angles once in a while, you should, but not for every single portrait for six months like I did because I couldn't afford another lens.

I mean, holy cow! The worst of it, I photographed Johnny Cash. I snuck into his dressing room. He's a really nice guy, super nice guy, and he put up with me sticking this lens right in his face. I tell you, I wish I had that one to do over again because I would have shot it with a little bit longer lens.

35–50 mm lenses are called normal lenses. They produce images that look natural to human observers because we see it about that focal length. They are often used for portraits because they don't cause the distortions that really wide lenses do. What I like about normal lenses is they allow us to shoot in a straight forward way without gimmicks. It's all how you think at that point. It's hard to show off how well you can see with a wide-angle lens. You're not really sure how much of the shot is lens and how much is the photographer.

Let's look at a couple normal lens shots here. This is a very straight forward picture of the Whitehouse at a nice time of the day, and it seems to work, right? It seems to work. Or this kid holding up a fish in Uganda. It's just basically how our eye sees. So it requires us to look for good moments, funny moments like this, like my kid Spencer throwing a fit at the breakfast table, right?

A normal lens is how we see and I really prefer that. I use a normal lens most of the time anymore when on assignment for *National Geographic*, can you imagine that? I'm traveling around the world and I'm shooting with like a 50-mm lens. Good grief. If you can pull off a good picture with a normal lens, it means you've really done something. You're really seeing something well. If you can take a really interesting picture with a normal lens, it means you've either witnessed something amazing, or you're taking something

ordinary and making it amazing. It means you're not relying on those super-wide or telephoto lenses as a crutch to get you there to an interesting picture.

Most of us walk around and we see the world with a built-in 50-mm lens in our brain, basically. How in the world do you see differently when you have the same focal-length eyes as everyone else on the planet? That's the secret to great photography. That's the million dollar question, isn't it? How do you take a 50-mm lens and make something extraordinary, surprising, something that's never been done before? That's tough, but not nearly as tough as if you hadn't taken this course. We will get there together, I promise.

OK, my secret lens, my workhorse lens, is this one. I mean, it's just a lens. It's a 24–70 mm, 24–70. It just basically sees as our eyes do. Our eyes see about 35–50 mm, in that range. So this lens, a 24–70 mm, sees much as the human eye does, plus some. I use this lens 99% of the time I bet, right? If I could only grab one lens out of the house, because the house was one fire, oh look, a house on fire, how convenient is that? If I could only grab one lens because the house is on fire, I would grab the 24–70 mm, and indeed, that's what I shot these burning house pictures with. It's blowing my mind, right?

OK, so, you've probably noticed by now that my lenses are zoom lenses. Well, why is that? It's because each one can take pictures at different focal lengths. There are many lenses packed inside one zoom lens in that sense, aren't there? There are lenses that have a fixed focal length and they're called prime lenses. As I mentioned earlier that means that while other lenses can zoom in and out, a prime lens is fixed.

For example let me show you this one. This is a 50 mm. Look at this. 50 mm, that's all you get. And there is nothing wrong with that. You just have to carry more lenses to get different effects. If you want to shoot wider than this, you have to put on another lens.

The advantage of prime lenses is they cost less and you get a big hole in the lens, a big aperture for gathering low light, but again, you'll need to buy more lenses to cover as much ground as a single zoom lens. Let me explain that again. With this 24–70, built into this one lens there is a 20, a 24, a 28, a

35, a 50, and a 60, 65, going all the way up to 70. There are about four or five lenses in this one lens.

OK, so the other advantage to these prime lenses is they force you to think through things more thoroughly. That forces you to get more creative. You have to physically get off your rear and back up. There's some advantage to that.

You know your feet provide an ultimate zoom. Just walk closer and back up. They're a great zoom. Just do that, move around. Really, whatever. Non-zoom or prime lenses force you to move and there's nothing wrong with that—not a thing in the world. In fact, I started out working for *National Geographic* with all prime lenses and they do a great job. Your feet in this regard can save you a lot of money, right? It's exercise, you walk up, you back away, that's fine. You're looking. You're thinking about the best view. I'm going to say this a bunch in this course you guys, it's not about the gear, it's about how you see.

There are lenses with longer focal lengths than what we've talked about so far. These big lenses have macro capabilities built into them for specific purposes in photography.

Macro lenses are interesting because they let you get super close to a subject. Let's look at one. This is a Pima Pineapple Cactus, a rare cactus, shot with a macro lens. This macro lens acts as a telephoto, but for close ups of subjects. The Salt Creek Tiger Beetle in Lincoln, Nebraska. Look at the detail, and this thing's the size of a sunflower seed. You're zooming in with a macro on one small area of life and you're blurring that background out completely. You're just blurring it out.

Now, most macros have a very limited depth of field. This is a little bit of a tripping point for them—very shallow depth of field. That cactus picture, lots of depth of field. We'll talk about that in a little bit, but you know what, most of the time when you're just shooting handheld with a macro lens, very, very shallow depth of field—similar to a telephoto.

Now we'll discuss depth of field in more depth in a later lecture, but just as with the telephoto, a little camera movement goes a long way towards blurring your images with a macro. A long lens—and I consider a macro a long lens too—can be difficult to use. You should use a tripod. What's a tripod? Well you know what a tripod is, it's just a stand with three legs, holds the camera still, or a monopod. A monopod is just a single leg, steadies the camera somewhat, but gives you a little bit more flexibility of movement. Not as steady as a tripod though.

When using a macro or telephoto your whole world vibrates radically with the slightest movement, so a lot of times you'll want a tripod or a monopod to calm things down a little bit, to steady. Just as exhaling moves the frame around sometimes, I like to think of the macro as a telephoto in miniature. That's what it is. The difference being, you're zooming in on that little bitty spot instead of zooming out on something larger. But don't worry. We will have a whole lecture on macro photography later in the course.

Both macros and telephotos are challenging to use, but if it were easy wouldn't everybody do it? It's not easy. You can really tell when someone's trying to become a better photographer when they step out of their comfort zone and buy a macro.

Now, on the other hand, when we have really long lenses, "big glass," this is kind of where people go once they get into it for a while. They want to get a big piece of glass, and that's photo slang for a 300-, a 400-, a 500-, a 600-mm lens. What am I using there? That looks like a 500-mm, F4 Nikon in this picture. Well, the front elements of these lenses are gigantic because they are designed to gather low light, light when it's at its lowest, very subtle, beautiful light. They can get it usually. These lenses are also very sharp and they reach out. They really reach out, but they are very expensive. Thousands of dollars each when purchased new. However if you photograph a lot of subjects that are hard to get close to, you have to have these tools don't you? You do!

Like for example, if you have to get close to wildlife, like let's say, a grizzly fishing for salmon, wouldn't you really want to have the money to use on a long lens? Now if you've got the money to, let's say, go to Antarctica,

where you can just walk up to the penguins, and they'll sit there and you shoot this with your 24–70-zoom lens, that's fine, but most people don't have the money to go to Antarctica, right? They don't. So, what else? I don't know. Most of the animals around here in North America, have been shot at. Their ancestors have been shot at so they're naturally fearful. A lot of times in wildlife work we have to use a long lens to get close to them in most situations. Same with sporting events. We can't just run out onto the field any time we want to. Use the long lens to get that action.

Every lens will have a minimum focus distance, right? That's the distance, the smallest distance, between an object and the lens with the subject still in focus—that minimum focusing distance. Pay attention to this when you're buying a lens or buying a camera with a built-in lens. Why is this important? I'll tell you why it's important.

Let's say you want to photograph the head of a praying mantis, but your macro lens won't let you focus close enough to fill the frame with your subject. You'll be in real trouble then won't you? Similarly, if you're shooting portraits with a zoom, but your subjects have to stand 20-feet away from you in order to be in focus, that's another huge problem. It means that you were probably too cheap to buy a good lens and you've bought junk. Pay attention to your minimum focusing distance before you buy that lens. Again, go to your local camera shop and try out the gear. Think about what you want to photograph and then try it out in person. Take a tape measure with you it you think that it'll help you to figure out what the lens is, what the distance is.

Remember, with lenses you get what you pay for. I cannot stress this enough. You can buy a junk camera, but do not buy junk glass. You get what you pay for. I would not buy a telephoto lens if the best aperture was like f/8 or f/11. You'd have to shoot such bright light to get enough light in through that small hole in your lens, forget it. You need a big hole in the lens—and that costs more money—to make pictures in soft light. That means you need to spend more money. Don't be cheap about this. Think about the money you spend traveling to these exotic locations only to bring junk gear with you? I think not. Remember, the cheaper the lens, the bigger the aperture number and consequently, the smaller the hole. You need a big hole in that

lens, a wide-open aperture. An f/4 or better yet an f/2.8 or even bigger. You don't want to go much higher than f/4 if you can help it. In this lecture we cover this in detail in a lecture on aperture and depth of field coming up. You might want to watch that one too before you go out and buy your lens. Try to understand this concept of little hole, big hole and the expense of these lenses before you go buying stuff, OK?

To sum up, with the right lens choices there's a lifetime of shots you can do right in your own town. When people start out they often think, hey, in my town it's Lincoln, Nebraska, what in the world am I going to shoot? Well if you're an old timer, or you listen to an old timer, you know that there are endless stories to tell in your own backyard. Right in your own town. Everything from your local marching band to your county fair.

If you're truly curious about the world around you, you will never run out of material. You just won't, and subjects to shoot, they are everywhere. We're talking about the dance of life here. Plug into that. You can do an essay on anything in the neighborhood and use the right lenses and people will love the results. I guarantee you.

So, your assignment. The best way to get a sense of how different lenses function in photographs is by trying them all out on the same subject. Your homework for this lecture is to photograph the same person or pet from the same distance using three different lenses: wide, normal, and telephoto. For extra credit try a macro lens, or if you don't have one, figure out what the minimum focus distances are on your other lenses. Compare your pictures once they're done and pay attention to how the choice of lens changes the end result. How are backgrounds affected? What does lens choice do to facial features?

In the next two lectures we're going to go into more detail about shutter speed and aperture settings. I have a lot more pictures to show you and some work out in the field to help you understand how to use it all, how to use all this information to make it come together. Stay tuned.

Shutter Speeds
Lecture 4

In an earlier lecture, we talked about the faucet as a metaphor for the aperture and the shutter speed: You can choose to open the tap wide and let a lot of water flow, or you can open the tap just a bit and let the water trickle into the sink. When we think about light being like the water going into the sink, shutter speed is how long you leave the faucet running. As we'll see in this lecture, proper use of a slow shutter takes a picture from being a mere rendering of an event to being something iconic, something that goes far beyond the original moment.

Experimenting with Shutter Speeds
- A shutter speed of 1/500 of a second is literally 10 times faster than a speed of 1/50 of a second, but you can't hear the difference. Both are tiny amounts of time, nearly impossible to perceive, yet in still photography, the shutter speed makes a world of difference.

- A field shoot of sparks created by grinding metal shows the difference between fast and slow shutter speeds.
 - At a full second, the sparks are arcing everywhere—the image looks as if it was taken on the Fourth of July. With a speed of 1/500 of a second, the sparks are still present, but they aren't as exciting.

 - Note that the camera was on a tripod and a cable release was used for this shoot. You want to slow the shutter speed down, but you don't want the whole scene to be moving.

- It's interesting to experiment with different shutter speeds while shooting flowing water. An image shot at 1/500 of a second shows individual water droplets suspended in air. In an image shot at 1/10 of a second, the water blurs together in a continuous stream.

Using Shutter Speed Purposefully

- Most mid- to advanced-level cameras (film or digital) offer some way to control the shutter speed.

- If you are using an SLR or advanced point-and-shoot, the easiest way to start experimenting is by using shutter-priority exposure mode.
 - This is often indicated by an "S" (for shutter) or a "T" (for time), depending on what kind of camera you have.

 - In shutter-priority mode, you choose and control the shutter speed while the camera changes the aperture. This is a simple way of experimenting because you're letting the camera do the thinking when it comes to the exposure. You can then concentrate on the effect you want.

- A good rule of thumb for choosing shutter speed is this: the longer the lens, the faster the shutter should be. Use 1/20 of a second, minimum, for a 20mm lens, 1/500 of a second or more for a 500mm lens, and so on.

Fast Shutter Speeds

- A "fast" shutter speed means that the shutter isn't left open for very long. This is useful for capturing action, such as sports or other fast-moving subjects. The faster the subject and the closer it is to your camera, the faster the shutter speed must be to freeze it.

- Fast shutter speeds are more difficult to use, simply because you have to fire the shutter at exactly the right moment—just as the action you want to capture occurs.

- Photos of sandhill cranes illustrate the results that can be achieved with various shutter speeds.
 - Images in which the birds are completely in focus are taken in plenty of light with a fast shutter speed, up to 1/6400 of a second.

 - In other images, the heads and bodies of the birds are fairly sharp, but their feet and wingtips are a bit blurred because those parts are moving more than the rest of the body. These

images were taken with a shutter speed of 1/320 of a second, which allows both some sharpness and some movement.

o A shutter speed slowed down to 1/30 of a second makes for dramatic images. Here, the birds on the ground are fairly sharp, but the ones in the air are smudged and barely recognizable—mere impressions of cranes.

• The choices of shutter speed you make depend on what you're trying to achieve, how much of an artist you want to be, and how fast or slow the subject is moving.

• When you're shooting with fast shutter speeds, anticipating the moment is crucial to getting the shot. Generally speaking, with an SLR camera, if you see a fast-breaking moment, you've probably missed getting a picture of it. Watch an event for a bit before you try to shoot it to get a sense of what will happen next and where.

Slow Shutter Speeds

• Of course, a slow shutter speed means that the shutter is left open for a relatively longer period of time. Another world of creative possibilities opens up using slower shutter speeds.

• Used properly, a slow shutter can convey motion in a still image. Just a slight bit of blurring is all it takes for our brains to translate a still image into a moving one.

• After you've practiced for a while, you'll discover that slow shutter speeds, used well, are surefire ways to add artistry to an otherwise unremarkable setting.

• An added bonus is that slower shutter speeds let in more light, making the exposure brighter. This means that you can shoot much later in the day and take in all the nuance of the last light.

Panned-Action Images

- A fun experiment to try with slow shutter speeds is to shoot a panned-action image, where you move the camera to follow the subject. In the final image, the subject is mostly in focus, and the background is blurred.

- There are two ways to shoot a panned-action picture. The first is with the photographer stationary and a moving subject. The second is with the photographer moving parallel to the subject at the same speed. It's often hard to find an opportunity to use the second technique.

- When you are the stationary photographer and your subject is moving, position yourself perpendicular (at a 90-degree angle) to the subject's path.
 o Pre-focus on where your subject will be when it passes in front of you. Then, follow the subject with the camera. Get a good start, shoot, and follow through. Don't stop moving when you press the shutter, or you're liable to ruin the smoothness of the long exposure.

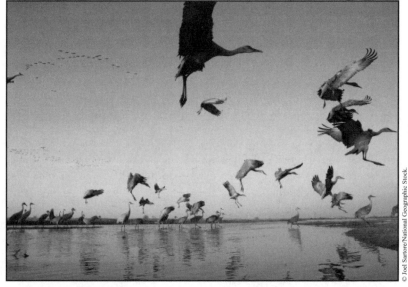

© Joel Sartore/National Geographic Stock.

In this image shot with a fast shutter speed, the birds are tack sharp—in focus from wingtips to beaks to toes.

o Panned action is something that only still photography can do well. It creates a beautiful blur in the background with the subject sharp, although it can be hit and miss.

o Make things easy on yourself by choosing the right subject. The faster your subject is moving, the better the pan will be.

Behind the Lens

I hang out once in a while with a friend of mine, a daredevil named Dr. Danger. He is one of the last old-time daredevils or stuntmen out there. Dr. Danger decided he was going to drive a junk car through a wall of flame into a pile of junk cars. That's great. We have this huge explosion. ... That needs a fast shutter speed—1/4000th of a second or so. I had the advantage of it being very, very strong light—bright daylight—and, of course, the explosion gave me another little burst of light, and it all resulted in a very fast shutter speed.

 o Finally, embrace the blur! We're trained to think that images have to be sharp, but that doesn't always result in the best image.

- In the second technique for shooting panned action, the camera is moving parallel to the subject at about the same speed. The camera does not move from side to side but stays with the subject.

Ghosting and Long Exposures
- Combining a slow shutter speed with flash and ambient light can create an effect known as "ghosting." No matter how many times you try this technique, you will get something different and unexpected.
 - o This technique involves "dragging the shutter," which simply means choosing a very slow shutter speed in order to gather as much light as possible. The flash is then introduced as a way to freeze something in the frame.

 - o Ghosting takes a lot of practice to do well, but again, the results can be amazing. Much depends on the speed at which the subject is moving, the amount of ambient light available, and the right amount of flash.

- Long exposures can work well for shooting images that build up the light from things like traffic, weather, and fireworks. Such exposures are the opposite of capturing a moment; they use very slow shutter speeds to show the passing of time.
 - o To take a long-exposure image, you will need a tripod and a way to trigger your camera without touching it.

 - o In situations where the light is very dim, longer, slower shutter speeds are a necessity. With practice, you can make them work to your advantage, shooting images of fireworks, for example, or a thunderstorm.

- In using all of these techniques, remember that patience is your greatest ally. Great pictures don't just happen; they're the result of many attempts—and many failures.

Assignment

- Shoot something that's moving—traffic, a kid on a merry-go-round, water; choose a subject that is moving repeatedly so that you can get several chances to shoot it.

- Slow your shutter speed down to less than 1/30 of a second and speed it up to 1/500 of a second or more. Try this at different times of the day and notice how the change in light affects your pictures.

Suggested Reading

Latimer, ed., *Ultimate Field Guide to Photography*, pp. 120–125.

Peterson, *Understanding Exposure*, pp. 74–95. (This book is now in its third edition; the page numbers may be different, but the content is more or less the same.)

Sartore (with Healey), *Photographing Your Family*, pp. 60–61 and 70–71.

Homework

Find something you can photograph in two different ways using fast and slow shutter speeds for different results. Moving people or vehicles work great, or you can do something as simple as water running from a tap. Use a tripod and cable release with slow shutter speeds for the best results.

Shutter Speeds
Lecture 4—Transcript

Hi everybody. I'm going to talk about shutter speeds today. This is another really important concept. Do you remember the kitchen sink metaphor? You have a faucet, you have water filling up a sink, and you can choose to open up the tap wide and let a lot of water in and fill the sink up fast, or you can open the tap up just a little bit and trickle it in. We're going to think about light being like the water going into that sink.

Shutter speed is how long you leave the spigot running—simple as that, right? Fairly simple, but now—if you'll allow me to wax poetic for a moment—proper use of shutter speed takes a picture from being a mere rendering of an event to becoming something very iconic—something that goes way beyond the original moment. I mean, If you look at pictures in which the shutter speed has been used well, man! Learn to use this setting, and people are going to think you're a genius. They're going to think you're brilliant. That's kind of nice.

So, I want you to listen to something here. Listen to this. This is all about shutter speed. OK, various shutter speeds on your camera are imperceptible to hear—believe it or not. But listen to this (camera click). A $1/50^{th}$ of a second, do you hear that (camera click)? A $1/50^{th}$ of a second. Now listen—something that's ten times faster, a $1/500^{th}$ of a second (camera click), a $1/500^{th}$ of a second. Do you hear any difference? I don't. Both are tiny amounts of time—I mean, tiny—nearly impossible to perceive. Yet, in still photography there's a world of difference between a $1/50^{th}$ and a $1/500^{th}$—something you can't even hear.

How much difference? Let's take a look at some Cayman pictures from the Brazilian Pantanal at a $1/500^{th}$ of a second and a $1/50^{th}$, big difference. Even slower, even slower yet, say, a quarter second. Really super slow pictures, really. Shutter speed matters. Big difference. You can't hear it, but you can see it. Your camera sees it. Your camera sees it.

I often think of something my dentist said a few years ago when he told me he was going to need to enlarge one of my old fillings by a millimeter. I said,

"A millimeter's nothing." And he looked at me and he said, "You know, Joel, in dentistry—his dark, Italian eyebrows raised—In dentistry a millimeter is a mile." I thought that was kind of funny, and he did too, but it is the same way with shutter speed, huge difference, huge difference. Nothing to laugh about, really.

Let's go back out in the field and take a look at the difference between fast and slow shutter speeds. I think you'll find this interesting.

OK, so we want to talk about shutter speeds. How do we illustrate shutter speeds? A lot of these shutter speeds, they're in such minute increments, we can't even hear the difference with our own ears. Well, I thought of a way to illustrate this for you, and I think it'll be a lot of fun.

In the background I have Wilfred and Emma Devries, grandfather and granddaughter, and they are good at using grinders on metal, and they are going to throw sparks. And as they throw these sparks up, I'm going to shift the shutter speeds on my camera from very slow—a second to two seconds—all the way up to $1/500^{th}$ of a second to show you guys the differences between shutter speeds.

Notice, my camera is on a tripod and I have a cable release, and the reason is I want to slow that shutter speed down, but I don't want the whole scene to be moving, and if I was any slower than, say, a $1/60^{th}$ or a $1/30^{th}$ of a second handheld, the scene would be all blurry. So, everything is locked down. Everything is stationary, except the sparks will be flying everywhere with that slow shutter speed. It should really be something, so you ready guys? Excellent. OK, I'm putting on my safety glasses. I'm putting in my earplugs—safety first—off we go. Hit it! OK. Excellent. Thank you, guys. Beautiful.

So, that's a lot of fun. I can already see on the back of the camera the effect. When you're at a full second, the sparks are just arcing everywhere—it looks like fourth of July. If you're at $1/500^{th}$ of a second, there are sparks but it's just not as magnificent. So, you can see that.

Now you're saying, OK, great. That's fine, Joel, but I don't have industrial grinders at home. That's fine. This is just an illustration to show what a stationary situation with things moving around you can do. You can do this too. It can be as simple as going to a park and putting your kids on a carousel that's moving around and around while your camera is stationary on a tripod. It could be something as simple as running water, water in a stream, water anywhere, swimming pool moving, even. It doesn't matter. It could be something like fireworks, the slower the shutter the more beautiful and dramatic.

So you can do this too. The key, though, is experiment, experiment, experiment. Always. Try these different shutter speeds. That's the only way you're going to learn. I promise though, if you take the time to use the tripod and the cable release and pick an interesting subject, it is well worth it. It's a lot of fun.

That was kind of interesting, wasn't it? The picture with the slow shutter speed was really the only picture worth looking at in that situation, in my opinion. Check it out. It looks like fireworks on the 4th of July, doesn't it?

Now, I mentioned in the field video that you could experiment with different shutter speeds, the flowing water. I wanted to show you a few photographs now to illustrate my point. You'll see some parallels to the effect shutter speed had on the sparks from Emma's grinder. But with water now, so take a look.

This is at 1/500th of a second. The water is frozen solid here—not literally, of course—but so much so that you can see the individual droplets suspended in the air. Remember, we could see the individual sparks flying at the same shutter speed, 1/500th of a second or so, in the video.

Now look at this image. Wow! Better in a way, at 1/10th of a second here. The water blurs together in a continuous stream. I always think slow shutter speeds on water, like shutter speeds on sparks, is a very cool effect. Something we can't really perceive or see with our own eyes, but the camera can see it. But look also at how that stream of water blurs the background.

That's something we can use to clean up chaotic backgrounds a bit then, eh? That's a bonus, total bonus.

OK, now that you've seen examples of the difference, let's dig a little deeper into fast and slow shutters—how you can use them to purposely improve your photos, fast and slow shutters.

Most mid- to advanced-level cameras, film or digital, offer some way to control shutter speed if you look around a little bit. If you're using an SLR or advanced point and shoot, the easiest way to start experimenting is by using shutter priority exposure mode. This is often indicated by an "S" for shutter, or a "T" for time, depending on what camera you have. Let's take a look.

So, on my camera, I literally pick up my shutter by spinning a knob on the back—shutter priority. That's it. I choose shutter speed mode whenever I want to basically tell the camera what shutter speed to choose, right? When I choose shutter speed priority, the camera changes the aperture for me. A nice, simple way of experimenting with this, because I'm letting the camera do the thinking when it comes to the exposure, and you can try this too. I want you to be able to concentrate on the effect you want, not fighting the gear all the time. So it's a very simple adjustment—just a couple of buttons on the camera.

When I experiment with my camera, I try to keep things as simple as I can in the beginning, which is why I recommend using shutter priority to experiment with shutter speeds—one less thing to worry about, OK?

So what's a good rule of thumb for choosing a shutter speed? Well, it depends. In simplest terms, the longer the lens you use, the faster your shutter should be. A 1/20th of a second, for example, for a 20-mm lens, a 1/500th of a second or more for a 500-mm lens and so on. I try to match increments of shutter speed to basically the millimeter of the lens, OK?

So, simply put, a fast shutter speed means that it isn't left open for very long. Pretty simple. This is extremely useful for things like sports or other fast-moving subjects. Fast shutter speeds are more difficult to use simply because

you have to fire the shutter at exactly the right moment, just as the action you want occurs.

So, in this image I used a fairly fast shutter speed of 1/250th of a second to slow these skinny-dippers down. Right when they're jumping in mid-air, that's when I wanted to get them. Now here's another shot—same deal—1/250th of a second jumping off of a hay bale.

Now look at this one, 1/160th of a second, pretty close to those other exposures, but look, it's mostly blurry. Why is it just the feet of the frog, why are they sharp and nothing else is? Well, it's because the frog is jumping really quickly. He's moving very quickly and he's closer to the camera. So 1/160th of a second wasn't quite enough to freeze the action.

We have the exact same shutter speed, basically—or very close—in all these pictures, but one subject has the action stop completely, and the other doesn't, simply because the frog is moving faster, and I don't mind a bit.

You know, in the end result, he's a hopping frog. That's what he's born to do. If I wanted the frog frozen and sharp, I would have needed maybe 1/1000th of a second or more to freeze him tack sharp. But you know what? You don't need everything tack sharp all the time. The bottom line: The faster the subject and the closer it is to your camera, the faster your shutter speed should be to freeze them.

My favorite subject for using fast shutters, though, is really a bird's wings in flight. This is a nice way of illustrating it. Back home in Nebraska, each spring, we have the annual migratory stopover of the Sandhill crane. Some half-million of them descend on the Platte River each March and the photography is very, very fantastic. Actually, it's great. The birds are in the air morning, noon, and night, and it's a great place to practice photographing birds on the wing because the species is so large—about four feet tall. It makes for a huge moving target—as far as birds go—and I can try varying shutter speeds on them.

So, in this image, for example, the birds are tack sharp; They're all in focus from wingtips to beak. You think it's a fast or a slow shutter speed? Fast

shutter, of course. There's plenty of light so we can crank that shutter speed up beyond what's needed to even a 1/6400th of a second if we wanted to.

OK now, the next frame. The heads and the bodies are fairly sharp, but if you look at the feet and the wingtips, we have some movement there. They're a little blurred, because they're moving more than the rest of the body at a faster rate. What do you think? Slower shutter speed, of course. We're down from 1/6400th of a second to a 1/320th of a second here. I think this is a nice pleasing shutter speed because it gets the eye of the bird sharp, still getting some movement in there. That's fine.

OK, let's slow it down some more. Let's get dramatic. Even more—now we're at 1/30th of a second. The birds on the ground are fairly sharp, but the ones in the air are smudged and blurry, barely recognizable. They're kind of impressions of cranes, really. So that's OK though. I kind of like that feeling.

You see how much play we have, just with shutter speed, though. We have a lot of choices to make, and the choices you make really depend on what you're trying to achieve. What do you want to do? Just how much of an artiste do you want to be? Also, how fast or slow is your subject moving? That's going to determine things quite a bit too. It really is. It all depends. That's the answer. It all depends.

Sometimes, only a fast shutter speed will do the trick though. I hang out once in a while with a friend of mine, a daredevil named Dr. Danger, OK? He's one of the last old-time daredevils, or stuntmen, out there. So Dr. Danger decided he was going to drive a junk car through a wall of flame into a pile of junk cars. OK. So that's great. We have this huge explosion. There he goes. That needs a fast shutter speed—a 1/4000th of a second or so. I had the advantage of it being very, very strong light—bright daylight—and of course, the explosion gave me another little burst of light, and it all resulted in a very fast shutter speed. Dr. Danger is in and out very quickly. It's all on a motor drive. By the way, Dr. Danger, he has a hard time getting health insurance. Hard to believe isn't it.

But fast shutter speeds. When you're doing that, anticipating the moment is crucial to getting the shot. You really have to anticipate. Generally speaking,

with an SLR camera, if you've seen a fast-breaking moment through the viewfinder, it means you've missed getting a picture of it. So, anticipation is key. You watch an event for a little bit before you try to shoot it. You get a little bit more of an anticipation there. With a better understanding of what's going to happen next and where, you have the best chance of getting something really great.

Let's take another look. This is a, one of the famous fishing bears of Brooks Falls, Alaska. These bears wait at the top of the waterfall with open jaws hoping to snag a salmon when they're flying through mid-air. This picture was shot at about $1/1000^{th}$ of a second; It was on a motor drive—so bang, bang, bang, real fast, happened in less than a heartbeat. In fact, I never even saw it happening with my own eyes because it was so fast. My camera was on motor drive the whole time. The fish jump, the bear snapped, it was all over in just an instant.

So I needed that fast shutter speed to really freeze the action. If you look, you can see splashes of water around it. Everything is frozen in time, yet more than anything, I needed the exact, perfect moment captured in an instant. That is a very tall order. In fact, I spent days working to get this; shooting with a motor drive; really fast shutter speed; morning, noon and night—all the time. I knew I had to take at least—I bet I shot 2,000 pictures to get that one keeper. Look at the salmon. He's got claw marks from another bear that almost got him.

With digital cameras though, you can shoot a lot. It's no big deal. You just delete images that you don't think are worthy. So in something like this— you know what I mean—you're a $1/1000^{th}$ of a second too early, too late, both the fish and the bear are out of position. And I had a lot of things come and go out of position. I wasn't worried though, right? Most of the time, if I keep shooting, I get something. I shoot, and shoot, and shoot until I get something. Look at this, the bear's head is just out, the bear's head is in, there we go. As we say in Nebraska, even a blind hog gets an acorn once in a while.

You know, conversely, let's talk about slow shutter speeds for a second. Slow means the shutter is left open for quite a while., and there's another

world of creative possibilities that open up using slow shutter speeds. It is very amazing. And this to me is where the magic really starts to happen. Used properly, slow shutter can convey emotion in a still image. Nothing else does it like this, and this is very exciting. This is the best part about still photography to me is slow shutter. Just a slight bit of blurring is all it takes for our brains to translate a still image into a moving one, and that is so fun.

Now you remember our shot of the bear catching the fish, right? OK, here's another image of the same bears, at the same waterfall, on the same day, but with different shutter speeds. This is 1/4 of a second or slower. Look at the feel now. It looks like they're standing in whipped cream. Isn't that amazing? The water that was frozen in our earlier images—frozen because of a fast shutter—is now running over those falls just dreamlike, flowing all around them. These bears are standing fairly still, obviously, they're not moving, they're concentrating, and man that looks good, doesn't it? Look at that. Hard to believe. It's a little faster shutter speed, not as much movement in the water, but there we're slower again. More of that whipped cream feel. Water is a great thing to do slow shutter speeds on. Look at that. Really slow really slow. That may be as much as a full second there. Really, really slow.

You know, with each situation you shoot, ask yourself, if the same scene would lend itself well to either a fast or slow shutter speed. I do this all the time. I think about this constantly and my favorites, most of the time, are slower shutters used in low light. I do this a lot.

After you practice for a while, you'll discover that your slower shutter speeds used well are really nice ways to add artistry and really liven up an otherwise very common setting. For example, this is just at a little county fair in Idaho, and I love the movement, and the lights coming up, and the fact that we have joy and a connection there. It's one of my favorite pictures, it really is.

You can take a look also at this demolition derby in Nebraska. For those of you not familiar with demolition derbies, this is an event where drivers purposely run their cars into each other over and over again. The last car moving wins. Usually it's a trophy of an upside down car that they win. That's about it for demolishing their own car, but it is a chance to make some great pictures.

Your first instinct might be to only shoot fast shutter speeds, right? Of course. So maybe you're shooting with a fairly fast shutter speed there, but the light's dropping, so what do you think? Let's slow it down. Let's see. We go from a photo of record to something much more dream like, something much more iconic. You go beyond being just a photo of record. Now we have big color moving around, like lumbering dancers on a dirt floor, and the fact that this referee holds stock still during the exposure, that makes it really sing. We're down to about $1/15^{th}$ of a second here and that's very slow. That's very, very slow.

You know an added bonus—slower shutter speeds let in more light, making the exposure brighter. This means we can shoot much later in the day and really take in all the nuance in the last flow of light of the day. The stands, the cornfields, the fire trucks back there. This is the kind of picture that hopefully goes beyond the obvious. It's not just about wrecking cars anymore. Now it's about the color palette, and the movement, and about a big Saturday night in a very small town.

You know, another fun thing to try with slow shutter speeds is a panned action image, where we move the camera to follow the subject. In the end result, the subject is mostly in focus and the background is blurred.

There are two ways to shoot a panned action picture. The first is with the photographer stationary and a moving subject. The second is with the photographer moving along with the subject, parallel, same speed.

The second is often hard to find an opportunity to do, so for right now, let's talk about how to shoot the first kind of panned image with a stationary photographer and a moving subject. So, let me just show you how that would work. I'll get a nice, slow shutter speed, let's say, half second so you can really hear it, and we're just going to pan along. You can hear it. Hear that shutter open? Look, that's a very slow shutter. I very seldom would shoot pan at a half second, but sometimes, it can be great, you know?

You want to position yourself, by the way, perpendicular—at a 90° angle— to your subject's path, pre-focus on where your subject is going to be when it passes by in front of you, and then follow your subject with the camera. You

get a good start, you shoot, and you follow through. You don't stop moving when you press the shutter or you're liable to mess up the smoothness of such a long exposure. You want to follow through.

We did this when we were filming in Nebraska in my backyard. So we made a little video to show you this. Let's take a look.

OK, so I'm going to try a little panned action right now. Panned action is a beautiful effect. It's something that only still photography can do well. It's where we slow down the shutter and we move with our subject, and we just create this beautiful blur with the subject sharp, hopefully. It's hit and miss in panned action. Once in a while you get lucky though.

So, what I'm going to do, I have Kathy and our big dog, Muldoon. They're just going to run through the backyard, and panned action is not only going to get us this kind of lyrical picture, we hope, but it's going to clean up our background. That's really key—cleaning up backgrounds is something that panned action does great, because it just smoothest out the world. So, let's go for it. Let's do something. OK, you ready, Kathy? OK, hit it. Perfect. OK, hit it again.

OK, so one other thing. I have this camera on continuous high motor drive. Hear this? Lots of frames, lots of chances. I want this thing to be going as fast as it can, because it's hard to get a good one.

Let's try it again, shall we? Go ahead, just try one. This will be fun. OK, go! Good. OK. OK, one more time, Kathy. You can never have too many. OK, here we go. Ready. Alright. Hey, I think we got a good one, that looked good. You know what? You can never take too many. Let's do it again. OK, ready?

Yea, you know, that's really not true. You actually can have too many, especially if your wife is irritated with you for having her run through the yard all afternoon.

First, make things easy on yourself by choosing the right subject. The faster your subject is moving, the better the pan will be. Embrace the blur! We're

trained to think that an image has to be sharp all the time, but that's not always the best. Still photography is a great chance to experiment with this.

Now I also told you there's a second kind of panned action. This one taken by a camera that's moving along with the subject at about the same speed. The camera does not move side to side, but instead, stays right with the subject. I've used this technique before a couple times, once, when I was on assignment in the Sandhills in Nebraska. I'm on a horse here, literally. I'm out on a ranch that does things the traditional way in the Sandhills. I'm on a horse riding right along with this cowboy, and I shot such a slow shutter speed, mainly because it was getting dark out and I couldn't get a fast enough shutter speed to freeze any action. So I thought, well, I'll just try this. I was shooting film back then, and the results were a nice surprise. The cowboy isn't tack sharp, but this photo does effectively convey the constant movement at branding time and it's a nice break in shooting fast-action pictures with high shutter speeds all the time. It's just something nice and different. Visual variety—that's what we're looking for.

You know, in some situations, panning can really save the day then. I was assigned to cover the Atacama Desert a few years ago, and one evening found myself watching a woman way off in the distance herd llamas just after sunset. It's a pretty tough situation photographically, though. I was almost out of light and there really wasn't anything else to shoot, just this woman with her llama herd out there, and the light was so low I could barely see her, really. I knew I wouldn't be able to get a sharp shot of the woman moving her herd around. I though, huh, how do I handle this?

The backgrounds were pretty messy too. The llamas were all different colors, it's kind of a jumbled landscape, bushes popping up. I got out of the car and I ran up with my interpreter and asked her permission to shoot and that's kind of of the scene. It's OK. It's alright, nice soft light.

But you know what? When she started moving those llamas around, that's when you really get something nice. A hint of motion in the woman's clothes lets us know she's moving, gives us a sense of what it's like to be on foot there. The mountains in the background are in focus just barely enough. They're kind of back there to give an impression that we're high in some

remote wilderness and that it's very remote. So, panned action really saved the day in that case.

You know, now that we've discussed these basic fast and slow shutter speeds and panned action, I want to bring another new element into play when we're talking about this. When you combine a slow shutter speed with flash, it can create an effect known as ghosting. I kind of like ghosting sometimes. You get ghosting when you mix ambient light with a flash and a slow shutter. If your subject's in total darkness, except for the instantaneous burst of your flash, you're not going to get ghosting. Remember, you need some ambient light for ghosting to happen. Ambient light is found light—light that is just coming in steady stream from your surroundings.

Using this technique can be a lot of fun because no matter how many times you try it, you're going to get something new and different and unexpected every time. I'm certainly surprised every time I try it.

So this was a few years ago, covering Mardi Gras—big celebration, lots of ghosting here. The flash froze the action, but if you notice, look at how the hands and faces are sharp throughout. But it's that long shutter speed that really makes the shutter sing, right? It really makes the picture sing. In this case, it's about $1/30^{th}$ of a second, it slows the motion in the streamers, shows all that motion, motion in the hands, in streamers, the beads on peoples' necks flying around. Anything that's moving, that ambient light is going to ghost it. It's going to cause it to move. So that's really a nice look. I like the look a lot.

In all these cases, I'd say I was what we call dragging the shutter. That simply means I was choosing a really slow shutter speed in order to sop up as much of that low light as I could. The flash is then introduced as a way to freeze something in the frame. This takes some practice to do well, but again, the results can be really amazing. It just depends on the speed the subject is moving and the amount of ambient light available in the room. Throwing in the right amount of flash is critical too, and I'll talk more about that in the flash lecture, but here's an example.

This is at a night Husker game. The stands are fairly dark, in fact, you could say the stands are really, really dark. The only thing lit is the field. I knew I'd need a long exposure to get the field properly lit, since there's no way any flash could reach that far, obviously, from where I was. So I used a longer shutter to soak up the ambient light that's shining on the playing field, and since I didn't want the foreground to be black, I popped just a little bit of flash in there and by little, I mean about as little as the flash would produce and still fire. The fan in front of me was waving a little red flag, so with just a hint of flash, I got the light to balance out perfectly. So problem solved there. A little bit more interesting foreground than if I'd had nothing other than an ambient light exposure.

Now, long exposures can work great for images building up the light from things like traffic and weather and fireworks. I use long exposure for those things all the time.

In a way, this is the opposite of simply capturing a moment, isn't it? Long exposures use very slow shutter speeds to show the passage of time. How cool is that?

Now you'll need a tripod and a way to trigger your camera without touching it in some of these cases. This is because you don't want anything bumping the camera—including your finger pressing the shutter button—when you're on a slow shutter speed. In situations where the light is very dim, longer, slower shutter speeds are a necessity. Why not make them work to your advantage?

Let's take this—this is one of my favorite pictures. This is at my wife's cousin's farm. The shutter here was open a full 15 seconds—one of the longest exposures I've done in a long time. It's at a July 4th party. Why 15 seconds and not 30? Well, because there's a little bit of ambient in the sky and I want it to look like nighttime. I want the shutter to stay open as long as I can to get all these other activities going on, but I don't want to blow that sky out. I don't want it to look like daytime. I want a little hint of light, but I don't want to leave it open so long it's overexposed.

So, how do I know if this picture is working? That's a long exposure. I chimp. I look at the back of the camera. I'm experimenting all the time. There is no right or wrong, I'm just doing what pleases me. In this case, I want the sky to show up ever so slightly, so I was making decisions based on what I was seeing on the back of the camera and what I wanted it to look like eventually—what I wanted to achieve with this. I wanted to show the arc of the fireworks as they're set off, and this image does a pretty good job of that.

People were holding still, like my wife's cousin there, he's tired out laying on the hale bales in the front. He's done a lot of work to get the place ready—that's his place. But the fact is, the majority of the scene on the ground is sharp and helps to anchor the frame, but there's other movement.

That other movement happens—it's just gravy. For example, one kid's running around with a green light stick around his neck. You can only see the green there, you can't see him. I like that. The trail that he leaves adds an interesting angle. Plus there are kids out in the water firing off fireworks and that exposure being so long with lots and lots of streaks in the sky, just has this timeless quality of a hot July night. To me, it's successful that way. And it means something to me personally, because I love going down there.

So finally, I wanted to show you a photo that's basically the longest 15 seconds of my life. It was a thunderstorm, a very violent one, rolling through southeast Nebraska. Instead of doing the smart thing and heading for cover, I took my camera and tripod and went outside, of course. At least I hunkered down under the wheel well of my truck while shooting.

Now the long exposure I'm going to show you not only captures the lightning strikes, but also gave the ambient light in both the sky and some green security lights on this farm enough time to build up so that we could get a good exposure, right? So that's a long, long exposure—15 seconds. Those bolts probably came a couple seconds apart or so, and I'm just hunkered down with a tripod and a cable release the whole time.

I should say this too. You should use common sense when you try to photograph weather like this. Don't put yourself in danger unless it's a long time between thrills for you, I guess, then I completely understand.

We've talked a lot about what shutter speed is, showing the difference between fast and slow, as well as when to use both. We've also looked at different techniques you can try using slow shutter speed for artistic effects in your pictures: panning, ghosting, long exposures. Just think, all this from one simple camera setting. Hard to believe, isn't it?

Remember this too, patience here is your greatest ally. Great pictures don't just happen, they're results of lots and lots of attempts, many of which will be failures. It's amazing what you can do, though, with a frozen moment, or even one that's slightly thawed, believe it or not.

You know, something like this goes way beyond the original moment, when I was there. Or this, a wolf running in the snow in Yellowstone, to me it goes way beyond it, and it sums up not only the experience of being there, but it moves it beyond that. It makes it art simply by slowing the shutter speed down. That's the remarkable thing about still photography. It's why I love it.

Your assignment. I want to see you shoot something that moving: traffic, kinds on a merry-go-round, water. It just has to be something moving repeatedly so you get several chances at shooting it. I want you to slow your shutter way down to less than $1/30$th of a second. You can shoot it fast also at $1/500$th of a second to see how it looks if you have enough light to do that. I want you to try this at different times of the day and notice how the change in light affects your pictures.

OK, now we've checked out the equipment and we've checked out the lenses and the shutter speed. In the next lecture, I want to discuss two extremely important factors in photography: aperture and depth of field. Shutter speed, aperture and depth of field, we are working through the basics here first. That's what it's all about, so don't miss it. Come right back.

Aperture and Depth of Field
Lecture 5

In the last lecture, we talked about shutter speeds and, before that, about lenses and larger and smaller apertures. In this lecture, we'll take some time to focus more closely on aperture. As we've said, the aperture is the variable hole in the lens that the light passes through on its way to the camera's sensor or film. Different shutter speeds let in different amounts of light through apertures in the lenses, and different lenses permit different f-stops, or aperture settings. In this lecture, we'll see how the size of the aperture affects depth of field and the effects you can achieve by controlling depth of field in your photos.

What Do Aperture Numbers Mean?

- Lower aperture numbers (f/2 or f/2.8) mean large openings in the lens; higher aperture numbers mean smaller openings. These f-stops represent a ratio—the ratio of the focal length of the lens to the diameter of the aperture.

- Standard f-stops, from largest opening to smallest, are: f/1.4, f/2, f/2.8, f/4, f/5.6, f/8, f/11, and f/16.

- Aperture can control exposure, create visual effects, and solve compositional problems.
 - A wide-open aperture can solve certain problems by having only one layer of the photo in focus. In a complicated, chaotic world, you often want a wide aperture for shallow depth of field.

 - The smaller the hole in the lens, the more things are in focus—a small hole equals more depth of field. The bigger the hole, the less depth of field, or area of the photo that will be in focus from front to back.

Why Not Focus Everything?

- Having everything in focus often creates a chaotic image; your image includes power poles, vans passing by, and so on. But having a shallow depth of field allows you to simplify and really get what you want in focus. In photography, a good image is often not about what you leave in but what you leave out.

- In a photo of a grizzly bear bobbing for salmon on a river in Alaska, notice that the light is very weak; this situation required a wide-open aperture. Notice, too, that there is nothing in focus except the bear and the fish.

 o When you are shooting in very low light on a subject that is moving, even if you are using a flash, you want the fastest shutter speed you can get; otherwise, everything will be blurry.

 o You want a big hole in the lens to make your subject pop out and to increase your shutter speed. Remember, aperture and shutter speed walk hand in hand.

- The shallow depth of field produced by a wide-open aperture is especially visible when using a long lens, such as a telephoto or a macro lens. If you are using a macro lens up close, you get very little in focus. To focus a bit more, try changing to a higher f-stop.

- A field shoot demonstrates how f-stop is used to control depth of field. With a tiny hole in the lens (f/22), the background is too sharp; the tree limbs seem to stick into the model's head. At f/8, the limbs become a little softer, and at f/2.8, they almost vanish, giving us just a hint of forest.

- Try shooting a scene with a cluttered background using all the different apertures on your camera. See if you can tame that background with a shallow depth of field.

Greater Depth of Field

- It's not only the larger apertures that are useful. Sometimes, you want different subjects at multiple distances in focus. For those situations, you use smaller apertures, that is, those with high f-stop numbers.

- In a series of photos on America's state fairs, greater depth of field allows the viewer to see all the visual noise and color that characterize these events.

- Apertures are a fairly straightforward subject, but figuring out how much depth of field you need can be complicated. Often, this

© Joel Sartore.

Getting close with a macro lens means that you get very little in focus; here, only a bit of the insect's head and its eye are sharp.

decision is purely subjective and depends simply on what you feel like doing. Experiment with spinning the aperture dial around and see what you get.

Amount of Light and Aperture Setting
- It's important to understand the amount of light available and the aperture setting. For a narrow aperture, say, f/22 or higher, you need to have either a strong light source or a slow shutter speed. With a slow shutter speed, you generally want to put the camera on a tripod and use a cable release.

- "Fast lenses"—ones with wide maximum apertures and low f-stop numbers—allow you to shoot in low light, which is often the best light. They cost more, but they are worth the money.
 o Cheap lenses are generally cheap because the optics aren't as good; they sometimes won't be tack sharp, which forces you to decrease the aperture to get your subject in focus.

 o Then, of course, you've got to worry about whether you've got enough light for that small hole; in addition, you may increase the distractions in the background with the increased depth of field.

Behind the Lens

This [photo was shot with] an f/16 aperture. Now, this is kind of a gray day, but I am hitting this northern spotted owl in a clear-cut with a lot of light from a big flash with a softbox on it. He's an educational bird that at one time had been injured; you can see the little leather straps coming off of his feet indicate that he isn't flying anywhere. It is a captive, controlled situation, which means I have time to work it, which is nice. This was for a story on the Endangered Species Act for *National Geographic*. I wanted to show that northern spotted owls can't live if you cut all the trees down. It's a pretty obvious thing, but something most people don't think about.

The aperture is set for f/16, and I get tremendous depth of field. Everything is sharp, from the straps off of his feet all the way to the mountains in the background, even the clouds. I wanted to show the mess and the chaos. I didn't want just the owl to be sharp, I wanted everything sharp, hence the need for a tiny hole in the lens. You'll find there are some really good reasons to have everything in focus in your pictures—sometimes.

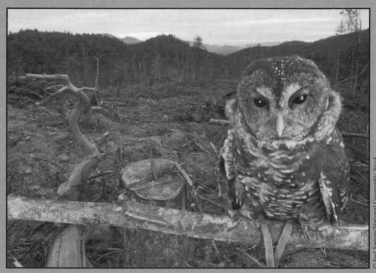

© Joel Sartore/National Geographic Stock.

- Long lenses come in handy for quickly cleaning up the background when shooting portraits; they're also essential for shooting wildlife and sports. It's well worth your time to try a long lens before you buy one. You can even rent one and see if you like the feel and weight of it.

- When we're talking about depth of field—what's in focus and what's not—we're also talking about aperture and focal length. You can change depth of field using a short- or wide-angle lens. With a wide-angle lens, things will be more in focus, including much of the background.

- As you learn more and shoot more pictures, you will find yourself making more interesting choices—when to blur the background and when to leave the complexity and chaos in your pictures. There's a time and a photograph for everything.

Assignment
- For this assignment, shoot the same scene, one that has a subject in the foreground, and then bring things into focus in the background by making the hole in your lens smaller. This will show you the relationship of aperture to depth of field.

- Again, in the first frame, there should be no depth of field (f/28). Then, make the aperture a bit smaller in each frame to increase the depth of field.

Suggested Reading

Latimer, ed., *Ultimate Field Guide to Photography*, pp. 79–83.

Morrell, *Camera Obscura*. (This book offers extreme examples of the use of small aperture and a brilliant illustration of doing something different with an old technique.)

Sartore (with Healey), *Photographing Your Family*, pp. 66–69.

Homework

Shoot the same scene—one that has potential depth to it, such as a person in a landscape—at every aperture available. Go from wide to restricted and then compare them. Look at how depth of field works, how just one thing is sharp when you're wide open and nearly everything is sharp when you're "stopped down." For bonus points, get up close to your subject and shoot the scene at every aperture again. Even with a small hole in the lens, you may not get the background sharp if you're focused close, but you can easily see how changes in aperture affect depth of field.

Aperture and Depth of Field
Lecture 5—Transcript

So aperture and depth of field. In the last lecture I talked about shutter speeds and before that about lenses—what we call bigger and smaller apertures. In this lecture I want to take some time to focus more closely on aperture, because it's one of those basic, basic controls.

The aperture is the variable hole in the lens that light passes through on the way to your camera sensor or film. Different shutter speeds let in different amounts of light through the lenses, but apertures, apertures. It's so critical, so key.

So let's pick up our camera again. We're going to put that strap around our necks so we don't drop it. But listen, here's the thing. Different lenses permit f-stops. Different f-stops are aperture settings. Here's how I change the aperture on my camera. Your camera may be different. Very simple. Set that, rotate the dial, that's it. Simple as that. Pretty easy these days, OK? Most mid-level cameras, film or digital, offer you a way to control your aperture, so take advantage of that.

So again, aperture is a basic camera setting that scrolls through the numbers and makes the lens opening bigger or smaller. Let's talk about why that's important.

We talked about aperture settings in an earlier lecture, but it is critical. I'm not kidding. I'm going to go over it again it's so critical. Lower aperture numbers mean big openings in the lens. Higher aperture numbers mean smaller, smaller holes in the lens, right? A big opening means a smaller number like, f/2.8 or f/2 even. The smaller the number is, the bigger the hole. These f-stops represent a ratio. The ratio of the focal length of the lens to the diameter of the aperture. Standard f-stops, from largest opening to smallest are, with a few exceptions, f/1.4, that's a really big hole; f/2; f/2.8; f/4, getting smaller; f/5.6; f/8; f/11; and f/16 is tiny. Some lenses will go to 22, 30 something, 45. It's amazing.

Let's look at the effect here of these different apertures. OK, this is my daughter, Ellen, looking a little sullen because she has to pose for her dad yet again, for another picture. She's awful gripey. I have to bribe her with ice cream every time. Now let's watch this. Look at the background here. Blurry, blurry, blurry. What's that going to be? That's going to be a big hole in the lens, isn't it? Let's go through these and look. Look at this. As we go—look at that. The background all of the sudden got sharper. How in the world did that happen? Well it's happening because the hole in the lens is getting smaller, that's how it's happening. We're on a tripod so the scene is locked down. She's moving a little bit because she's fidgety, she doesn't want to be there of course, but as we're going through, look at this. The background is getting sharper and sharper and sharper as we go through.

Now back to the first one, let's compare. The first picture, wide open hole in the lens. Last picture, same girl, same moment in time, same living room. Lots of depth of field, small hole in the lens. Big hole in the lens no depth of field at all. Simple as that. That's it. OK. That makes sense, doesn't it? I get it. Alright, let's try it one more time.

Same girl, same bad attitude, alright. I don't blame her. I've photographed her since the moment she was born. She's been photographed hundreds of thousands of times. OK, shallow depth of field. Watch this hole getting smaller. Here we go, watch it getting smaller. Watch that background get sharper and sharper and sharper. Look at that. Very sharp now. Back to one. Big hole in the lens, f/2.8 here, no depth of field. Tiny hole in the lens, lots of depth of field. But you know what? Sometimes you don't want a lot of depth of field. It just depends on what you want. It really does. Think about this.

Aperture can control exposure. Certainly does, but it creates visual effects that solve compositional problems. A wide-open aperture can solve these problems by having only one layer of the photo in focus. In those pictures of Ellen, maybe you don't want picture frames coming out of her head. That big hole in the lens, that softens the background a little bit, it makes her stand out. So in a complicated, chaotic world, we like shallow depth of field. We really do. It's a great tool.

The smaller the hole in the lens, the more things are in focus. Easy. Small hole equals more depth of field. The bigger the hole or aperture, the less depth of field, or area of the photo that will be in focus from front to back. I know I'm going over this like you're in kindergarten, but I cannot tell you how important this is. This is a big one, OK?

Right away, I can hear you guys thinking this, why wouldn't I want a tiny hole in my lens so the whole world's in focus all the time? That seems like such an appropriate and right thing to do. I can tell you why. You are going to have everything in focus all the time? The world is a chaotic place and this is going to be a problem for you if you care about your backgrounds, right? If you live in any place that isn't, say, Antarctica, where there's nothing but ice and penguins and nice and clean, that's fine. Have a tiny little whole in your lens, lots of depth of field. But you live in a modern day society, don't you, like me? You're looking at power poles and houses and bridges and white moving vans and people and buildings. The world is a busy place visually. Maybe you want to clean that up. Maybe you want a shallow depth of field.

But having a shallow depth of field allows us to simplify, really. Doesn't it? And really choose what we want in focus and what we do not. It really allows us to get directly to the subject and it helps make our subjects pop. I heard this years ago. There was a great guitarist who says, "It's not the notes I play, it's the notes I don't play." So what do you want to exclude? What do you want to exclude? That is so critical. It's not what you leave in, it's what you leave out.

There are times that, sure, you want the whole world in focus, but there are many other times that you want to be selective in how much depth of field you have. Be selective. Be discriminating. Discriminate.

All right. Let's look at this first picture so you can see what I'm talking about here. Let's look at this. OK, we've seen this. A grizzly bear bobbing for salmon on a river in Alaska, alright?

It's very late in the day, very late, so there's hardly any light left at all. It's well after sunset. His eyes are glowing gold, believe it or not. Grizzly bears have gold eye shine because I'm hitting him with a little bit of flash. It's

nearly dark out. I can barely see anything. I have to make a good exposure, so we want a big hole in the lens, a wide open aperture to try to soak up as much of that weak light as possible. If you shoot in very soft, subtle light like I do all the time, this will become a very familiar concept to you in short order. Big hole in the lens, small aperture number, OK?

Now notice how there's nothing in focus in this picture, except the bear and the fish, and, you know, that's great. It was the only choice I had. I had to have a big hole in the lens, no depth of field. But look, the water in the foreground is soft, the water in the background is out of focus. Well, I had no other choice. Wide open aperture, f/2.8, that's what you get. Just the bear and the fish. They were very close and so that means you get an even more blurring effect in the background. All that water with ripples on it just goes away. In this case it's great. I didn't want anything in focus besides the bear and the fish anyway, but no choice, as I've said. When you're shooting in very low light on a subject that's moving, even if you're using a flash, you're going to want the fasted shutter speed you can get, otherwise everything is going to be a blurry mess, and in late light that means a big hole in your lens, alright.

So you want a very big hole in the lens which gives you very little depth of field in this case and it makes your subject pop out. You want as big a hole in the lens as possible in order to increase your shutter speed. Aperture and shutter speed walk hand in hand remember. When you're shooting in low light you're going to want that big hole in the lens. That river has a lot of ripples and waves on it, we don't see any of it. We are not distracted. So in this case it all worked out great. We just wanted to see the bear. That's what I wanted to see. So, I'm shooting a wide-open aperture to help me isolate my subjects from the background. It's very important.

Let's look at one more picture here, OK? This is a katydid on a leaf. Backyard. Look, the only thing in focus here is a little bit of the insect's front end and its eye. It still works because it's so clean. Very few distractions. That's the nature of macro lens isn't it? Very little depth of field. I don't have any depth of field here really, and this shallow depth of field produced by a wide open aperture is really visible when using a long lens, which is a telephoto or a macro lens. I consider a macro lens a long lens because of the

blurring effect it has and that fact that any bumps of jostles really blur your world. You have to keep the camera fairly steady.

This is very typical of a macro lens, by the way. Very little in focus. You can try changing to a higher f-stop number where you have a tiny whole in the lens and you'll get a bit more focus, but you really get very little depth of field if you're close to the subject with a macro. No matter what your f-stop is, you don't get a whole lot of depth of field. There are some exceptions, but not really. We'll talk more about shooting with a macro lens in a later lecture but for me with this picture, having a little sharp is just fine.

So now, let's go into the field to see how depth of field can really help you or hurt you back home in Nebraska again.

OK, it's assignment time everybody, and we're going to talk about aperture and depth of field. This is kind of a tricky one isn't it? We know what to do. We know that a big hole in the lens, very little depth of field. Tiny hole in the lens, lots of depth of field.

So we have three lovely models here and we have a terrible background. We have tree limbs sticking down into their heads. How are we going to fight this? How are we going to really craft this image so it reads well? Well, I know already that if that f-22, the tiny hole in the lens, I'm going to shoot that right now. I can see tree limbs, sharp as can be. Everything is sharp in this frame—from where I'm standing all the way to the horizon, to infinity, because I'm at f-22, the smallest hole in the lens, and I see tree limbs sticking right into Esther's head. Right into her eyes. No good.

Let's try to open that up a little bit more—make the hole a little bigger. Let's go to f-8. That's about middle of the road. Let's try it again. Here we go. A little bit better. I can still see the other girls in the background. I know we're in a foresty scene. I know we're in walnut trees, but the limbs are a little bit softer.

You know what? I already know if I open this thing up all the way, biggest hole in the lens f-2.8, I shoot this, those limbs just really vanish. It's the implications of limbs back there now. They're not sharp, it's just a hint of a

forest. It's a hint of other girls in colorful dresses, and I have solved a visual problem right there by my depth of field. I have made that depth of field very shallow. I'm just sharp on Esther's face. Problem solved.

So that's what I want you guys to do at home, alright? Try all the different apertures on your camera. Shoot something in which you have a cluttered background and you make that background, you tame that background, by going with a real shallow depth of field. Or, conversely, try to get everything in focus. I know a lot of people like everything in focus. That's fine, but really watch it. If you're on f-22, you watch what's in that background. Don't let it kill your subject. Don't let it get in the way of what you want to say. Go ahead. Try it.

That soft focus, or very shallow depth of field, is really outstanding, isn't it? It's the way I fix tree limbs and power lines sticking out of heads all the time. I do it all the time with what I call soft focus, or very shallow depth of field.

If I take a picture of somebody in the woods, I don't want every tree in focus. I want to imply there are trees there, softy and subtly. All I want is my subject in focus most of the time. There are exceptions, but most of the time I just want one thing to be sharp—something interesting, compelling, a good feature—usually the eyes of the subject, but not every single detail. To make a subject stand out in a very busy, busy place like the woods or a city scene with a shallow depth of field is a lovely way to handle this. It really is the mark of a professional, really.

I love the way that a shallow depth of field gives you just a hint or an impression of a place without really showing you the place. It's more lyrical and subtle and not obvious. I'm a big fan of going beyond the obvious, which everybody does, right? A shallow depth of field is a beautiful way to handle the chaos of life.

Let's look at some photos here now that give you just a hint of what's behind you. Example, red bud trees, OK? They're implied and they're soft by nature. They just look beautiful and lyrical in the spring. So the background in these pictures—look at how it adds to this, but doesn't distract.

We're going to start out kind of wide—watch this—everything's there. We know it's a red bud because of the color, but watch. We're going to go through these. A little bit closer now, a little bit closer, OK? Now we're talking, look at this. Little less depth of field—a lot less, actually. A longer lens coming in closer. We just get the implication of trees in the background. See there? You can do it when there's a little sun on as well. You can imply there's big mature trees in the background and really make these things pop out, but we use a little bit longer lens and kind of zoom in and have a very, very shallow depth of field to make these work—very shallow depth of field, f-2.8 here—look at that. Just the stuff that you want is in focus. That's the way to go.

Again, very shallow depth of field—daughter Ellen is standing there—there we go. So that's how you do it. I hope you'll try shooting that with a wide open aperture—a big hole in the lens whenever you can. It'll really make your subject stand out, and it's really necessary when you're working in low light, anyway, because you want that big hole in the lens to gather in all that low light and really embrace it. Work in low, subtle light.

Now, I don't want to give you the impression that it's only the bigger apertures that are useful—you know, the big holes in the lens. Sometimes you want different subjects at multiple distances in focus, and for that you have to use the smaller apertures—those with the high f-stop numbers.

So that you don't think that I'm anti depth of field, let's take a look at a few photos here that make use of high f-stops and why they work just fine as well.

OK, so, these are for a story on America's state fairs that I did for *National Geographic* magazine. I was shooting a story on, in this case, the opening of the Iowa State Fair to start this story. Fairly strong light in most cases, lots of color, lots of stuff going around, and I wanted to try to show everything that was cooking, in this scene especially. I wanted to show subtle light and some vibrant, visual noise in others—all stuff that state fairs are all about. So I often had a small hole in the lens in order to show all this. The start of the Iowa State Fair, the midway barker at the Texas State Fair, this is actually a mirror illusion and it's very cool. But look at how we have lots of depth of

field back through this picture. A lot—not a ton, but an implication. We've at least got here, and we get the feeling of where we are, where we are—a feeling of it. Again, enough depth of field so that we can see where we are. We know that this guy is a high diver. Plenty, plenty, plenty depth of field here. Look at this, most of the stuff is in focus sharp—not as sharp as they are, of course, but enough to really see where we are.

And this, well, lot of depth of field here. This is, again, at the Texas State Fair during their auto show. Look at all the advertising. It's very busy; It's a very busy scene. I chose a lot of depth of field here to make it look even more chaotic and cluttered. I wanted that look. I wanted everything focused. That's fine.

In this case, a little less depth of field, but still pretty chaotic. These yellow shirts really helped stand out and give us an anchor point besides here.

I don't know if there's a right or wrong way to do this, by the way. I'm just winging it. I'm just winging it. I'm just trying to make things work. In this case, I wanted a little bit more depth of field. Believe it or not, they're spaying and neutering dogs and cats in vet surgical tents at the Iowa State Fair. I wanted to show the crowd watching this. A lot of people pass out when it's bloody, believe it or not. But I wanted to show this. There's a couple of fairs that do this now, and they have a picture window here that's plastic—people look in, and I wanted to show that. So I needed a little depth of field to carry that through.

And this, a little auction down at Texas—lots of depth of field here, and here, and here, and back—lots of layers here, lots of layers. We want to try to show that. So sometimes it's critical. If this guy had been all blurry, it wouldn't have been as effective a picture. I wanted lots of things in focus. Fortunately, it's a nice bright, scene, which allows for a tiny hole in the lens, and we can get lots of depth of field.

So, let me say that again. Smaller apertures—those with higher f-stop numbers—can help you make sure that everything is in focus, or at least that most of the stuff is in focus, and you kind of imply where you are. Apertures are a fairly straightforward subject, but it can get complicated to figure out

how much depth of field you need. Lots of times it's subjective. It really depends on what you feel like doing.

So, let me show you a good variety here, so you can begin to get a feeling for the range of options. Always, always, I encourage you to practice. Spin the aperture dial around and see what you get. If you don't like it, try, try again. Look, a guitar only has six strings on it, and yet, it's kind of difficult— takes a lot of practice, right? Same with photography. There's just a few basic controls. It's just a matter of practice, running lots and lots of pictures through your camera. So, let's look at a few more frames.

OK, what about this one? Here we are in Antarctica in bright sun. There's lot of potential for depth of field here. I'm at f-16 or f-22. It's the middle of the day, the sun is beating down, these penguins aren't going anywhere, it's the height of summer. Everything is sharp because I'm standing a little far away from the birds and I have a really small hole in the lens. So everything is sharp, OK?

Now this one is about an f-16 aperture. This is kind of a gray day, but I'm hitting this northern spotted owl in a clear cut with a lot of light from a big flash, with a soft box on it, OK? He's an educational bird—one that's been injured—and you can see the little leather straps or jesses that basically keep him there, so this is a controlled situation. He's not flying anywhere, it's a captive, controlled bird, so I have time to work this, which is really nice. This was for a story on the Endangered Species Act for *National Geographic*. I wanted to show that a northern spotted owl can't live if you cut all the trees down—pretty obvious thing, but something most people don't think about, and so, there we go.

I wanted a lot of depth of field. We're set for f-16 here, OK? Everything is sharp, from the straps on his feet, all the way to the mountains in the background, just about—even the clouds. I wanted to show the mess and the chaos, I just didn't want the owl to be the only thing sharp. I wanted everything to be sharp. The owl stands out because he's lit a little bit brighter—that's how we're doing it in this case, right? But a tiny hole in the lens, right? You'll find that there are some really good reasons to have everything in focus in your pictures sometimes.

Let's look at this one. Monarch butterflies down in Mexico. It's the middle of the morning, the sun is blaring middle of the morning! You see a little flare from the sun in the background, that's an f-22. Tiny hole in the lens gives you that little starburst pattern. Everything is sharp from top to bottom, and sometimes that's OK. In this case, it's perfectly appropriate. And I didn't know how to do it, anyway, because I'm competing with the sun. Even at 200 ISO or 100 ISO, a lot less sensitivity to light on that sensor. You still have to really crank that aperture down to compete with the sun in the middle of the day.

In each of these images then, the backgrounds were critical to how I wanted the viewer to read the photo. A narrow aperture or a small hole can come in handy when you need to show background detail, but as you probably know about me by now, I generally find myself avoiding it. I tend to blur background. It's hard enough to make your subject stand out when the whole world is in focus. Remember, everything does not have to be in focus to make a good frame, so make choices. Don't just default to a single aperture setting for every single picture. Experiment with your camera and see what you can come up with. You'll surprise yourself.

OK, aperture and depth of field go hand in hand. Another relationship that's really important for you to understand is between the amount of light available and your aperture setting. For a narrow aperture, let's say f-22 or higher even, you need either light, really strong light, or you need a slow shutter speed. A lot of light or a slow shutter, or both sometimes.

Hope that makes sense to you. If you've got a tiny hole in the lens, you want bright light or a slow shutter speed so that a enough light hits the sensor to give you a properly exposed picture. Does that make sense? I hope so.

This complicates things, doesn't it? You remember for the last lecture, when you used a slow shutter speed, you were going to have to put the camera on a tripod because of camera shake and use a cable release. Sometimes you're just going to have to hand hold it and that's OK too, if you can stand it and you don't have any other choice.

So, again, for this picture, I come back to it again, but it's talking about a lot of things in this one picture. I did not have the time to set up a tripod and a cable release. I was in a boat, on a river, bouncing all over the place. There's no doing any of that. Even if I was on land, because he's bobbing for salmon and he's moving everywhere and so was I. Again, a low f-stop number for the grizzly eating salmon. Low f-stop—big hole to let all the light in—you'll be able to make that shutter speed increase as much as possible. That's the key. So you can't use a tripod all the time, you just can't.

"Fast lenses" the ones with wide maximum apertures (big holes) and low f-stop numbers will allow you to shoot in low light, which is often the best light to me. They cost more, but they are so worth it. Cheap lenses are cheap for a reason. The optics aren't as good. They sometimes won't be tack sharp too, so in desperation, you have to make that hole smaller in your lens to get the subject in focus. And then of course, you've got to wonder about whether you've got enough light for that small hole. You may increase the distractions in the background too with all that increased depth of field. So spend your money on good lenses if at all possible, please. It's really critical. I learned that in college. Spend your money on good glass, OK?

Here's a photograph I took recently—just out at a pond with a friend of mine and her boys. This is one I could not have shot without an f-2.8 lens and a modern digital SLR, right? This is well after sunset. Look at the light—soft and glowy and even, well after the sun's gone down. The kids are wiggling and the fish is flopping, everybody's excited. I needed a fast shutter speed to freeze the action. This frame is at an 1/800th of a second. Wow!

That my camera can produce a good image at ISO 1250 didn't hurt either. Remember, ISO is the sensor's sensitivity to light, right? How sensitive is it to low light? Back in the days of film, I would've had to pick up and go home at this point in the evening. So long after sunset, there's no way, you couldn't shoot back then this late. But now, look at this. It's like middle of the day almost.

I'm back far enough from the subject so we have good depth of field here. It goes throughout the boat, doesn't go beyond the boat much. You can see the moss and the hills in the background, but they're all soft. Everybody in the

boat is sharp though, even though I'm at a wide open aperture, because I'm back a little farther from my subjects and I'm using a wide angle lens. Very important there.

Here's another one. Nice, soft light at the end of the day, I'm in focus, the rest of the world goes slightly out of focus. This is a nice effect using a wide open lens and a wide angle, wide open lens. You can see I'm holding a 400 mm here, it's a nice lens to use in low light. To say the least, one I use all the time. This is an f-4, an f-4 aperture, a really nice lens. You can see how big the end of that lens is? It is not for impressing your fellow photographers. It is heavy, you get over that really fast. It's for gathering lots of light when the light is low. I know it's heavy, I know it's cumbersome to carry with you, it gives you pain in the neck, but you know what? Boy, it's worth it. That is a really nice lens—a fine lens. My assistant, Katie, took this picture. Again, I'm in focus and the rest of the world goes soft. That's a nice way to shoot this.

Long lenses like this also come in handy for portraits. It's a quick way to clean up a background as I mentioned in the last lecture. Long lenses clean up background wonderfully, OK.

What else? This is one of my little boy, Spencer, being fed out in the backyard. He's a little messy, isn't he? He's like his dad, I guess. You know that's woods. We're in the woods so we have a nice open shade source. It wasn't like we're out in a cave or anything, it's just that long lens with dark woods behind him really fall off well.

With that long lens, I've exposed for the highlights here in the white, in the brightness of Spencer and everything around him, so everything else goes dark because of the long lens. There's no detail in the background, even though it was complicated, chaotic woods, no detail—nice and smooth and dark, and that's nice. It makes everything we want to see pop out nice and clean. The background is just full of bushes and trees and vines and other stuff I didn't want showing up. By using a nice lens with a wide open aperture, a big hole, or a small number, I clean up my backyard visually. Boy that's handy. A lot handier than actually cleaning up the backyard, I can tell you.

You remember from lecture three when we were at Raptor Recovery Nebraska in Elmwood taking pictures of the owl, right? Let's look at a couple of these again to refresh our memories. Remember when I got up right next to that owl? Remember that? OK, look at the backgrounds here, OK? High depth of field, look at this. See how the background shifts? Do you see that? That's what we're talking about. Depth of field. Let's run these again, look at this. Lots of depth of field—small hole in the lens. Little bit less—maybe we're at f-5 or f-6 here, maybe f-8.

Look at that. We're at f-2.8 now. Look at this. We're talking about focal length. We're talking about how we can change our depth of field, just using that aperture. It's so beautiful, using a shorter, wide angle lens in this case. It really, really helps. Even though we're right on top of this bird and we're in very, very chaotic grass, it works. He pops right out. I like this the best out of those three.

With a wide angle lens, more things will be in focus and the whole world will be there, right? But you pick—you pick—what you want to. You choose it. Use your brains and think. As you learn more and shoot more pictures, you're going to find yourself making more interesting choices: when to blur the background, when to leave in the complexity and chaos. There's a time and a photograph for everything.

I'd like to say a word about buying a longer lens here, too, while we talking about them. It's worth your time to try it before you buy it. You can even go rent one and try it out on the subjects you want to photograph, but you really should hold it in your own hands before you buy something online, let's say. You can see if you like the feel of it, the weight of it especially. You don't want to buy something that you don't want to lug around. It's going to just stay in your closet gathering dust because it's too heavy or cumbersome? That's no good. So rent one and try it before you buy it. They are big, they are heavy, and man they are expensive, but they are absolutely essential for a lot of wildlife or sports. Remember that.

So your assignment. I want you to shoot the same scene, one that has a subject in the foreground and then bring things into focus in the background

by making the hole in your lens smaller. This will show you the relationship of aperture to depth of field.

I tried this myself in my office with my staff just for fun. Here's Katie in the foreground, then Rebecca and Grace. OK, watch this. We're really putting it together now, OK? Look, we're just making that hole in the lens a little bit smaller in each frame. A little bit smaller hole. We started out on 2.8, look at this. We're getting smaller and smaller. Look, now we've got lots of depth of field here.

Now, just to repeat. First frame, no depth of field, f-28, just Katie sharp. Now lots of depth of field, small hole in the lens, just about everybody sharp. Really easy little thing to do. Quite easy.

So, look at this, equipment, lenses, shutter speed, aperture, depth of field. Now we need to talk about light next. Light, because it's going to be the subject of your pictures next.

There's a lot to learn about light itself and how to use it, but to me it's the most fun thing—to control light and make your photos better. Man, there is nothing better than light. It's variety is infinite. I love it. It's a fun, fun lecture, so come right back, please.

Light I—Found or Ambient Light
Lecture 6

Quite literally, light makes a photograph. Light, along with composition, are the two basic building blocks of photography. We'll have three lectures about light in this course. This first one is about found or ambient light, light that you don't create. You'll learn how to see and identify great light. In the next lecture, we'll talk about color and light intensity, and the third lecture will be about flash. Along the way, we'll be rolling in more information about lenses, apertures, depth of field, and shutter speed because all these elements work together and because adjustments in one always affect the others.

Shooting in Ambient Light

- A photo of a rare baby bird—an Attwater's prairie chick—is lit by just a single reading lamp. This weak light gives a sense of tenderness, warmth, and caring that matches the delicacy of the tiny bird.

- The fact that the background of this photo is completely black eliminates distraction. The depth of field is very shallow—just on the bird's eye. That was out of necessity because the low light required a wide-open aperture.

- This simple but effective photograph tells the viewer that the future of this species is, literally, in our hands.

Exposure Compensation Setting

- There are two ways to adjust light: making adjustments in the environment and in the camera. Getting a picture well lit is about doing both.

- Three things are involved in adjusting the camera for light: the exposure compensation setting, the ISO setting, and the histogram. We'll look at the exposure compensation first.

- The exposure compensation dial on the camera is like a dimmer switch on the wall of your home. When your camera is in an automatic exposure setting—in program, aperture priority, or shutter priority—dialing up or down on the exposure compensation dial increases or decreases the exposure.

 o It's often good to dial down the exposure compensation to a little bit under the optimal exposure as chosen by the camera.

 o Subjects often contain a good deal of contrast between light and dark areas, and you should expose for the highlights. Consider the brightest part of a scene when making exposures so that you don't overexpose anything.

 o Making the entire exposure just a bit dark (underexposed) allows you to retain some detail in the highlights and makes the colors richer.

 o This technique also prevents you from clipping out the highlights. You can bring back details in the shadows, especially in digital photography, but you cannot bring back detail in the highlights if they are blown out.

- In some scenes, such as a snow scene, you may want to overexpose. Very light or very dark scenes can fool your camera, and you need to compensate for that.

 o Try putting your camera in manual mode and going up close to the subject. Check the exposure level, lock it, move back, and shoot.

 o You can also try this technique if you're shooting against a black background, such as the mouth of a cave or a dark wall.

ISO Setting
- The ISO is simply the sensitivity of the sensor in a camera to light. It is set in increments of 100. An ISO setting of 400 is more sensitive to light than 100. In a dark scene, you need a higher ISO to make the most of

whatever light is available; in a brighter scene, you want a lower ISO so that you don't overexpose the picture.

- Don't be tempted to shoot at a high ISO setting all the time. You may think this will allow you to keep your shutter speed high and your aperture small to get your subject sharply in focus, but if you shoot at a high ISO during daylight hours, you'll overexpose the picture.

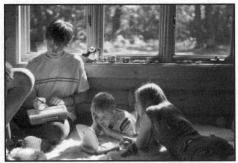

Before you take a photograph, analyze where the light is coming from and its relationship to the subject.

- Often, it's better to choose the lowest ISO you can in order to blur the background somewhat and make the subject pop.

- The quality of photographs is generally better with a low ISO. Higher ISOs result in images that are grainy or "noisy."

- Higher-end cameras tend to have a tremendous ISO range, allowing you to shoot in almost no light. This range of settings also allows for faster shutter speeds in low light, which may eliminate the need for a tripod.

The Histogram
- The histogram is a graph you can call up on the back of most cameras that allows you to see whether your images are underexposed, overexposed, or perfectly exposed. Keep the peaks of the histogram in the middle if you can.

- On a histogram, the left is dark and the right is bright. If you have few peaks in the histogram and they're off to the left side, you know you've underexposed the image. If the peaks are off to the right, then you know that you've overexposed the image and lost some information and detail.

Behind the Lens

This one is a very simple photograph of a very rare bird. This is a minutes-old chick, an Attwater's prairie chicken—a very rare bird in this country—just hatched out of its egg. You know how I lit this? It's a reading lamp. Just a single tungsten bulb, like a reading lamp, bedside table lamp…. They had this little lamp turned on in the incubator room at a place called Fossil Rim Wildlife Center, which was doing breeding with these animals in Glen Rose, Texas. I'd spent the night on the floor of the incubator room hoping to photograph the hatchings of these birds. This one is just out of the egg. There's a weak light on in the corner of the room, throwing off just the faintest, warmest, graceful, colored light, this golden glow, and I thought, "Yes, that's good enough to shoot in." I didn't want to introduce flash. It's a delicate little chick. I didn't want to blast away. I just wanted something very subtle, tender, warm, caring. This light matched the delicate feel of the subject. I could see it at the moment.

© Joel Sartore/National Geographic Stock.

- The histogram gives you more information than you can get by just looking at the image on the back of the camera.

Quality of Light
- The first step in engaging light in a photograph is analyzing where the light is coming from and its relation to the subject.

- Front lighting is seen when the light is coming from behind the photographer and onto the subject. This is the most common way that photographers light things, but it also can be the most boring. If the sun is low on the horizon, then front lighting can work, but if the light is at all harsh, front lighting can flatten out a photo, offering fewer shadows and less depth.

- Backlighting is seen when the lighting is coming from behind the subject. It is also called silhouette lighting because the subject often goes black, becoming a silhouette.

- Hatchet lighting is when the light is very harsh and hitting one side of the subject. One side of a person's face, for example, might be brightly lit and the other in complete shadow. This lighting can be dramatic.

- With ghost lighting, the light is coming from below. This is the creepiest, most unattractive kind of lighting.

- Overhead lighting is, of course, lighting from above; it's sometimes called interrogation lighting.

- Classic Rembrandt lighting is wonderful for photography. Here, the light is subtle, and it comes in from both the side and a little to the front, kind of three-quarters on the subject. That creates a triangle of light on the side of the subject opposite the light source. The shadows created by this type of light give a picture depth and richness.

- Try to find ways to vary ambient light. Walk around the subject and pick out the best spot; then shoot in that direction, keeping in mind that subtle

light is better than harsh. Finally, be patient. Sometimes the ambient light will vary itself and solve your problems for you.

Light to Look For

- Gray light on an overcast day is perhaps the most lovely kind of light, but when you shoot on this kind of day, be aware that not all gray skies are created equal.
 - o The sky is the light source, and on some days, it becomes a big light dome that can blow out white completely.

 - o One solution to this problem is to get higher than your subject and shoot down so that you eliminate the sky. You can also use a building or trees to block the sky.

- "Found" lighting that happens indoors can also be beautiful. If the sun is low and you're shooting near a window, you may be able to capture direct beams of light.

- The warm glow after sunset is another lighting condition that is hard to beat.
 - o A field shoot at a small pond illustrates the benefits of waiting throughout the day to get the best light. Remember, there's no excuse for bad light in a landscape; the landscape is not going anywhere.

 - o Again, walk around the scene and shoot from different angles to get the best image. At the pond on this shoot, the boat gives us a leading line into the scene.

 - o Add elements, such as people, to the scene to go beyond the obvious. Have fun with it!

Assignment

- Pick a sunny day, start early, and shoot five shots of the same subject: one early, one at high noon, one in late afternoon, and one before and after sunset. Then compare the results; watch what happens to one subject at different times of day.

- Remember, too, to walk around your subject in different light; once the light is good, do something to go beyond the obvious. Bring in people, a pet, or a surprising object.

Suggested Reading

Brandenburg, *Chased by the Light.*

Peterson, *Understanding Exposure*, pp. 8–45.

Homework

Pick a day that's forecast to be nice and sunny, and photograph the same subject outdoors in the same spot from the same angle (always facing east, for example). Start as early as possible and do five shots: one each in the early morning, at high noon, in the late afternoon, before sunset, and after sunset. Compare the results.

Light I—Found or Ambient Light
Lecture 6—Transcript

To, this is one of my favorite lectures, you guys. Quite literally, light—it makes the photograph. Light, along with composition, are the two basic building blocks of photography. We're going to talk first about light, found, ambient light, and then we'll go into composition.

A veteran *National Geographic* photographer named Jim Stanfield, who gave me my break there, at *National Geographic* magazine, used to say, "It's not the light, but where you are in it." That is so true. It really is true.

It doesn't have to be high noon harsh light, of course. I often bag on harsh, high noon light. I don't like it. It's really tough. Look at the shadows.

But you know what? Same time of day—look at this. Oh, well, gee, maybe it is where you are in it. Same time of day, but now we're looking straight down on that beach. Look, a guy is feeding seagulls, all the colors come out great. Isn't that something? It works, doesn't it? And you don't need a $2,000 an hour helicopter either. You can just shoot right off the roof of a building to get a look like this. In this case, light is key, but you have to look down. You can't look across. People wearing the colorful suits, gee that's nice, and that's in the worst light of the day. Would it look great at ground level? No, we just saw it. It didn't look great. It looked awful. The shadows are terrible. They just kill you.

You know, the bottom line, we have to think about where we are in the light. It's not the light, but where you are in it. That Jim Stanfield was a very wise man.

So we've got three lectures on light in this course. This one is about found or ambient light. What's found or ambient light? You haven't created it; you've only found it. That's my favorite kind, where I didn't have to do any work. I want to teach you how to see and identify great light, at least. In the next lecture we'll talk about color and light intensity. And the third lecture will be about flash. Boy do I have a lot to say about controlling the use of your flash. Along the way we'll be rolling in more information about lenses and

apertures, depth of field, shutter speeds, because it all works together as a team. How you adjust one and it affects all the others. So let's get started.

OK, this one. This is a very simple photograph of a very rare bird. This is a minutes-old chick, an Atwater's prairie chicken—a very rare bird in this country—just hatched out of its egg. You know how I lit this, how I lit this? It's a reading lamp. Just a single tungsten bulb, like a reading lamp, bedside table lamp, that's it. They had this little lamp turned on in the incubator room at a place called Fossil Rim Wildlife Center, which was doing breeding with these animals in Glen Rose, Texas. I'd spent the night on the floor of the incubator room hoping to photograph the hatchings of these birds. This one is just out of the egg. There's a weak light on in the corner of the room, throwing off just the faint, warmest, graceful, colored light— this golden glow— and I thought, yes, that's good enough to shoot in. I didn't want to introduce flash. It's a delicate little chick. I didn't want to blast away. I just wanted something very subtle, tender, warm, caring. This light matched the delicate feel of the subject. I could see it at the moment, right?

There are several things that help this photograph. It's a very simple one, but it works in a couple of ways. One is that it's a baby chick. We like those, and we get a sense of how small and fragile he is because he fits in the palm of the man's hands that's helping to raise these birds. The down is still wet. You can tell he's just out of the egg. We have this very soft, almost firelight gracing this bird in this hand. The background is completely black, so there's no other distraction—so that helps. Depth of field, very shallow. Just the bird's eye, that side of his face is sharp, that's it. There isn't much light in the room, so of course, I have a wide-open hole in the lens—wide open aperture—just enough to have enough shutter speed so things won't be blurry. We get a sharp eye.

The thing is, this is a very simple photograph, but it's effective. I'm trying to tell viewers that the future of this species is in our hands, and literally, it is. This species would be extinct now without captive breeding centers such as this. So for this photo, anyway, mission accomplished, and it's all thanks to the light.

There are two ways of changing and adjusting light: adjustments in the environment and adjustments in your camera. Getting a picture well lit is about doing both.

Let's talk first about adjusting the camera. Three things to remember here: in exposure compensation, the ISO setting, and the histogram.

On many cameras there is an exposure compensation setting, just to start out. Look at your manual to see where yours is, if you have one. Most of the advanced cameras, they all have one. The exposure compensation dial is very handy, because it's like a dimmer switch on the wall of your home. When your camera is in an automatic exposure setting, either in program, aperture priority, shutter priority, by dialing up or down on that exposure compensation dial, by adding or subtracting, it will increase or decrease the exposure, or the brightness or darkness, of your picture. Just like turning up and down a dimmer switch on the wall of a home.

On my camera, most of the time, I dial it down a little bit, maybe 3/4 of a stop—a little bit under the optimal exposure. Why do I do that? Because the things we all photograph contain a good deal of contrast between the light and the dark areas and I always expose for the highlights. That means I consider the brightest parts of my scene when making exposures. That way I don't overexpose anything in my pictures. I don't want the highlights in the pictures to be blown out because I can't get that lost information back. Does that make sense?

So I make the entire exposure just a bit dark, underexposed to retain some of the detail on the highlights. I do that routinely. Dark, dark, dark—that's kind of what I do. I make the whole image a little bit darker, just as when I was shooting slide film.

So, when I do that, not only does it make colors richer, but it also prevents me from what we call clipping out the highlights. You can bring back details in the shadows when you're shooting digital, but you can't get back detail in the highlights if they're blown out—if the camera didn't record detail because you overexposed it. Not without a tremendous amount of work and foolishness on your computer. We're trying to get it to where you don't have

to mess with the computer very much. We want everything coming out of the camera to be as good looking as possible. Saves you time in front of the computer. Who needs to be in front of the computer more?

Now, sometimes you'll actually want to overexpose. For example, in a snow scene. Look at this snow scene. You're going to want to overexpose for that. You don't want it to be gray. Your camera meter is going to want it to turn gray. You're going to want to think about that.

The beauty of it is, look at the back of your camera, look at your histogram. You can expose this properly. You can compensate for the fact that the scene is almost all white. You can try putting your camera in manual mode, if you have that setting, and going up close to your subject, check the exposure level—let's say on the face of the boy here, check that exposure level, lock it in, move back, and shoot. It's a scary thing now, you're going to be moving back and your meter is going to be going crazy saying, whoa! There's too much light, but I'm telling you, you've already gotten your exposure because you walked up close and then you step back and you shoot it. And you know, you look at the back of the camera and it's a beautiful thing. You can see whether you're blowing it out or not. It's OK.

You can also try this technique if you're shooting against a black background, of course, like the mouth of a cave, or a black wall, or a dark forest. And always, keep looking. Check the back of the camera and see what you have.

Now let's look at three pictures to see how they look when they're under, over, and properly exposed. Let's look at this.

This is daughter Ellen's pet Cockettail, Jimmy. So, look at the difference here. What does that one look like? Does that look underexposed to you? No, not quite. Looks a little blown out, doesn't it? How about that one? Under or over? Looks a little underexposed to me. See the difference? Now look. That looks proper, OK? That looks like a proper exposure, simple. Look at the back of the camera, look at the histogram.

A lot of cameras, my camera for example, those blown-out highlights will literally flash at me if they're overexposed. If you've messed it up, they will

flash at me saying I'm overexposed, I'm overexposed. That's really handy, that's really handy.

There's another exposure setting that's critical here too, ISO. We mentioned it briefly before but I want to take some time with it here.

Most cameras have an ISO setting. The ISO is simply the sensitivity of your sensor or film, if you're still shooting film, to light. You set it in increments, 100, 200, 300, 400. Four hundred ISO is more sensitive to light than 100. In a dark scene you'll want a higher ISO to make the most of whatever piddly light you have available. In a brighter scene, you're going to want a lower ISO so that you don't overexpose the picture.

Now you may ask, heck, why don't I just crank it up to 2,000 ISO all the time? I remember asking that at my camera store when I was first starting out with film in college. Why shoot it at 100 if I can shoot at 2,000? I can keep my shutter speed nice and high. I can get have a small hole in the lens, get everything in focus nice and sharp. Well, let me tell you. If you shoot with a high ISO during daylight hours, you'll overexpose your picture. All the highlights will be blown out, no matter what your hole in the lens, because there's too much light coming in for a high ISO, OK? Also, with a high ISO, you've made your sensor very sensitive to light.

Look at this. Let's take a look. OK, this is really, really typical of a high ISO image. Look at all the grain. Look at that. That's my little dog Baxter, barky thing that he is. I'm glad to be at the teaching company. He's not barking in the middle of the night waking me up here. It's really pleasant for a change. OK, so, look at that ISO. It's really, really grainy. That's a very high ISO picture—probably like 5,000 or 6,400. The higher the ISO, the more noise there is. So, that's the thing, that's totally the thing. You want to watch that, if you can, and I hope you don't want everything in focus anyway. You've heard this before. Sometimes, a really good photographer will just want one little sliver of something in focus to really make a point. We don't need the whole world to be sharp all the time—even most of the time. So, I'll often purposely choose the lowest ISO I can get away with in order to blur the background somewhat and make my subject pop out. I'd suggest you try that too. You don't need everything sharp and you don't need high ISOs all the time.

The quality is going to be better in a low ISO frame. It's no fun to make a large print out of something that's as noisy or grainy as that last picture you just saw of the dog. Conversely, if you shoot something on a digital camera on 100 ISO, you should be able to blow that thing up as big as a billboard and it'll hold up very, very nicely.

On the back of my camera here, it goes from 200 ISO to 6,400 ISO. Can you believe that? Let's check that out, 6,400, is that possible? Yeah, it is with this camera, but this is kind of expensive. Wow, how do I change that?

That's a tremendous range. I'm going from 200, wow, all the way up to 6,400 ISO, and beyond. And some cameras go higher than that now, 12,000, 24,000 ISO. When I started out I was shooting 50 ISO film, 25 years ago. Tremendous range. With higher end cameras, you can shoot in the dark. If you can see it, you can get it. It also allows for faster shutter speeds in low light, which might eliminate the need for a tripod or even a flash. Amazing. I used to have to carry a tripod with me constantly. I still carry one all the time, but I don't need it as often, right? High ISO, man!

What do you think about this? Is this high ISO or low? Obviously, it's going to be a low ISO because it's very bright out. Or this picture, high ISO or low? It's going to be a high ISO. I can see a little bit of grain in the sky, but that's very late in the day. Kathy and Ellen, wife and daughter, their faces are lit up by the screen on their camera—a little pre-focus for the flash—just lovely to be able to shoot at that time of the day. Absolutely.

So, ISO, are we getting it now? ISO is the sensor's sensitivity to light, simple as that. That's it. Most advanced cameras give you a way to change that ISO. Take advantage of it.

We've talked now about your camera's exposure compensation setting and the ISO or light sensitivity setting. What else is there in the camera that can help?

I've mentioned the camera's histogram a bit before and they're not difficult to understand. They're very important though. Histograms are an excellent little tool that will allow you to look at your pictures in graph form—at least

the light that's in your picture in graph form—so that you know whether your images are under, over, or perfectly exposed. The histogram is simply a rectangular display or graph that you call up on the back of most cameras. It looks like a mountain range sometimes. So, I like to say, keep the mountain in the middle. Keep the peaks of information in the middle if you can. The histogram shows you whether or not you have enough meat on the bones of your exposure. The left is dark and the right is bright. Easy to remember. Right is bright.

If you have a few peaks in the histogram, and they're all the way off to the left side, well, you know that you've underexposed the image. If, on the other hand, most of the peaks are off on the right, and even touching the right side, you know that you've overexposed the image. And if you've actually clipped, touched the right, and clipped off information in detail. Sometimes that's OK, but most of the time, not. Remember, if you have a really dark scene, you're going to have a lot of information on the left. If you have a bright snow scene, you're going to have information on the right. It's not necessarily good or bad, it's just interpreting this, OK?

Sometimes you can get back information that is in shadow, by the way, but you can never get back information that you've lost because you've overexposed things. Naturally, if you're looking at a dark scene, again, most will be on the left. If you're in a bright scene, it's going to be on the right. The right is bright and that's OK, that's fine.

I really work though, when I'm exposing things, I try not to touch the right side of the graph with information, or overexpose the highlights anyway, because it means you've cropped out detail. You've cropped out data or information in digital. I try not, also, to have too little exposure on the left. It could be a really dark scene, you underexpose, you get very little there to work with.

I use that histogram all the time, at least when I'm starting in on a situation, especially in tricky light. Why? Because I don't really get the whole true story by looking at the image on the back of the camera—that picture that comes up—it lies sometimes. It's designed to render a really beautiful, beautiful picture, even if you're wildly under or overexposed. You have to

know that. They trick you a little bit with that. That's why the histograms a good thing to know how to read.

You must do things well in your camera if you can. Otherwise, when you go to download your badly exposed images, it's crying time. You're going to think, how am I going to salvage this thing? The answer is, you don't want to have to fix your pictures later on the computer. That's where the histogram comes in. It helps you tailor your exposure. It helps you get it just where you need it.

Exposure compensation, ISO, and the histogram, those are your three really important camera settings.

Now let's talk about the quality of the light you're working in, the quality. Boy, I love this part. The easiest place is to start outside in natural light and how we make the natural environment work for us. This is something I love to talk about. Most of these you can do with natural light, but a few will come off better using flash or artificial light sources. It just depends, OK.

The first step in engaging light in a photograph is analyzing where the light is coming from and how it's relative to where the subject is, right? Let's look at a few pictures here.

Here we have my assistant, Grace, and she's going to show us the way on lighting. First off, front lighting. Simple. That's when the light is coming directly from the front. That's it. The light is behind the photographer, coming right at the subject. That's great. OK, that's the most common way that photographers light things. We learn that when we're kids, basically. But it can also be the most boring, straight on. If the sun is low on the horizon, then that could work if there's nice color in the light, but if the light is harsh at all, front lighting really flattens out shadow, flattens out depth. Very few shadows, you get less depth of field feeling in your picture.

OK, back lighting. This is when the lighting is coming from behind the subject. Sometimes we call this rim lighting or silhouette lighting because the subject often goes black and becomes a silhouette. So, backlighting.

Hatchet lighting. I learned this term in college. I don't know how many people use hatchet lighting, but to me hatchet lighting is as if you split the face. One side is very, very harsh and one side is very, very dark—complete shadow. It looks like somebody's splitting the face with a hatchet. The brow line and the nose basically keep the light from reaching over on the other side of the person's face because the light's so far off to the side. We call it side lighting, too, if you want. Hatchet lighting is dramatic, but tough to look at, at times.

Ghost lighting or also called Vincent Price lighting, whatever you want to call it. They use this a lot in Halloween movies, Halloween commercials. The light is coming from below. Call it chin music if you want. It's the most unattractive lighting used known to man, basically. Shooting the light straight up underneath a person's nose makes people look super creepy. And sadly, I kind of like that look. My daughter Ellen was along that day. She decided to do a little Blair Witch Hunt and do this little ghost lighting thing. She's a big fan of horror movies, OK?

Next, what else? Lighting from above. I call it interrogation lighting. In the movies, if a person is being interrogated by bad cops, there's always a bulb hanging over their head, and they're sitting in the middle of a room in a lone chair. It's like a single light coming from above. It can be effective, but it has to be done well. Like if you get somebody looking up into the light, that's better than this. The brow ridge gives us a little bit more of a harsh shadow. We've got assistant Rebecca here sitting underneath a single bulb in my kitchen. Look at this, very, very harsh, raccoon shadows in the eyes. This is interrogation lighting, actually. You can see the light source there. See how that's done. Not as effective. Of course, this is a harsher light because it's not in a little soft box, like my flash was with Grace. But you get the idea, of course.

Of course, there's zebra lighting. Actually, there's no such thing as zebra lighting. We just took Grace over by a window with a venetian blind when we were doing this shoot. It's just a weird effect, right?

Let's talk about my favorite kind of light, for real. Rembrandt lighting. With Rembrandt lighting the light is subtle and beautiful and it's coming in from

both the side and a little to the front. Kind of three-quarters to the subject. We have a little triangle of light there on the face opposite the light source. Rembrandt the painter was famous for doing this. The side of the face that is closest to the light source is fully lit, but you have this other side of the face that is mostly dark, just a little bitty kiss of light on that side, just past the bridge of the nose. It's really effective because it's the shadows that give our pictures depth and richness. I really like that look.

You can probably see that I always like to think about ways to vary ambient light. Ambient light is infinite and so it's very exciting to me. I never get tired of this. There are a lot of ways. Sometimes it's as simple as opening or closing a door or drapes. Sometimes, believe it or not, it's as simple as removing a floorboard, which is not simple, but in this case, let's look at a few pictures here.

This is my friend Beau helping me out in a barn. We were taking the floor out of a barn to put in a staircase. There's a subtle difference here, but it's very important. I want to talk about the variation of light.

OK, so in this first picture, look at this, Beau's face somewhat lit, but his arm is a little brighter. Now watch this, he's going to pry this floorboard up and look at that. Oh! Beautiful, beautiful! It's because the light is bouncing off the barn floor down below—the sun is—it's just indirect, reflected light. Look at how well his face is lit up there, and his body goes soft. I really like that. It looks like a painting. His face really pops out. It helps tremendously, tremendously.

Think about this, that the background is dark. We have light bouncing off the first floor, coming up, kicking through that hole he's just made, and lighting him up beautifully, just beautifully. It was just a matter, really, of waiting patiently until he got enough boards up and leaned closer to the hole.

Let me show you how this came about. We started out, I'm working the scene. I'm just working it, working it, thinking about how to show this, because this is an old historic barn, we're putting this floor in, my friend Charles is helping him. There we go, sawing a little hole in the floor. Alright, so I'm just working with whatever light is kind of spilling in from above,

getting ready to pry up the floorboards. When he pried that first one up though, I was like, holy cow, I should pick a spot and wait, wait for the direction the light looks best and shoot in that direction. I tried from down below. Well, it's fine, it's fine. He's getting lit, but really, it was this. This thing right at the end where the light is just really, really sweet. I'm always looking for light that looks like a painting. How about that?

So what else, what else? Let's look at a couple more pictures. My boy out at Leech Lake, Minnesota, Spencer. Here he's probably seven years old or so. We go to vacation there every year with my wife's family.

I started out with a very under-lit frame, in a way. He's looking away from the light. The exposure is actually right. It's OK. It's very late in the day after the sun has set or just as it's setting, but I need to improve things. So it is exposed well, but look, he's totally in the shadow. Maybe that's the look you want. I don't know. But in this next one, I've moved a little bit and he has too. A little bit better, wish his finger wasn't up his nose. Let's turn a little bit. On the third one, there you go. Same scene, same time. Why does this one work better? Because he turned into the light. I haven't moved much. I'm using that lake as a nice background, but his face is illuminated. The back of his shirt is now dark. We don't need to see the back of his shirt. I wanted to see his face. I wanted to know how he looks at this point in time. That's the opposite of how we were two frames earlier. Nice, clean background. Very subtle light, good time of day, and he is quiet and content. That's it. It's very simple. It's just a matter of him spinning around. Waiting for him to spin around, or in this case, bribing him with ice cream to get him to turn around.

So, subtle light—let's talk about subtle light. It's better than harsh. and believe it or not, you can have harsh light right at sunset. I'm always bragging about sunset light, but look at this first photo. Look at that. Really, really quite harsh, isn't it? Taken just moments before sunset, and yet it has a very direct feel, very harsh. The last few moments of sunlight, and look at how harsh this is. It's almost as harsh as the middle of the day with that exposure. The shadows are very long, the shadows are very harsh on people's faces. They're squinting, their expressions aren't as natural.

Now let's look—step forward in time a few minutes. Now we're talking. The sun has set. We're relaxed. The shadows—those harsh shadows are gone, and now we have this nice, soft, even light. I'm watching my sky. I don't have a lot of sky coming out of anything, just a hint of it there. It's not going to blow out on me. Dark trees, dark cabin, everything is easier to look at in this nice, soft glow after the sunset, in my opinion.

On the one we harshly lit, we lost the shadow detail, but in soft light we get good shadow detail here. So my advice, wait for it. Be patient and wait. Try different things. Sometimes the ambient light will vary itself and solve your problems for you. How nice is that? That's great.

Best loved light, the kind of light that I love and most people don't think to shoot in is gray light on an overcast day. Most people put their cameras away when the light gets gray. I like to take the camera out, believe it or not. Gray light can be lovely. One of the things to think about, is that not all gray skies are created equal. Your eye sees this gray cloud on the horizon so you naturally shoot your subject towards that horizon, but I'm telling you, sometimes a gray sky can blow out white completely. It depends on how dark that cloud is and where the light is coming from.

Remember, the sky is a big light source, it's like a big light dome out there. So it really varies, it really varies. Where is the sun? Some days, yes, the sky is thinner in one spot than it is somewhere else and you've got a nice dark, gray background if you look in a certain direction, like that, right?

A lot of days however, you can have an overcast day and it'll just blow out. It'll be really bright. Your camera meter will make a silhouette out of whatever you try to put in front of your subject.

Look at the difference here, blowing that out, silhouetting. Now we're looking a different direction. Now we have some detail. Or this, my friend Charles up a tree, blown out. We're going up at what looked to be a very dark gray sky but the camera sees that as the light source, and that's white, and it'll underexpose everything that's not clouds. Clouds are exposed right, everything else goes silhouette. Same here. Offloading gear onto a beach. The camera is reading the scene and it underexposes or silhouettes our

subject. You really have to watch this. It's a common mistake you learn by exposing lots and lots of pictures.

What do you need to do, really? You need to get a little higher up and shoot down on a gray day to eliminate the sky. I do that all the time. I'm constantly getting up to look down to lose that gray sky if it looks like it's blowing out on me.

A couple more frames just to illustrate that. This is a gray day in New York City. This is just out my hotel room looking down. No hint of that sky. I use buildings, I use trees to block the sky all the time. This is a gray day and actually quite a gray day on Time Square. I'm using buildings and billboards to block the sky.

So, you can even throw a little flash in there to help your subject balance out with the sky. You could do that. I try that all the time—pop a little flash. This last one, though, the flash, is a little tricky. We'll talk more about that in a future lecture.

You know, I also love found lighting, the light that happens indoors. The sky could be blazing bright outside, or dark as can be, but you get this nice glow on everything if you go by a window on a bright sunny day. Let's take a look.

Look at this. A bright sunny day, you get inside and look at this. You get this nice, nice look. Beautiful look. Same here. The light's coming in, you have this beautiful color, little beams of light shooting in. Is this overexposed? Yeah, it's probably going to be flashing on my camera, on my histogram. It's probably going to be clipped, but my exposure is good here and I like the scene, and sometimes it's OK if it clips highlights. Sometimes it is. The first rule is there are no rules. Expose it the way you like it. Really, it depends on the time of the year, whether there's trees blocking things, where your house sits. Generally, though, I just shoot what I like and I'm looking for that light all the time. I'm working with things all the time, and I'm ready. I'm ready for it.

Now look at this. This breaks all the rules. That is totally blown out. There is no detail in that. I couldn't get detail back if I paid for it, right? But it's OK, because I'm allowing that washout—that highlight area to just blow out—so I can concentrate here, because those curtains were striped and there's trees and messes outside. I don't want to see the backyard. Just let it blow out. I'm exposing here and I let the white become a nice, smooth background. I don't do that often, but I'm ready. I'm thinking about it. Think about what you want to shoot. Always think about it if you can.

So, another example from a vacation, from a vacation, again up at Leech Lake, Minnesota. We go there every summer. Another example here. Again, the window is blown out, but I love the red light, the last light of day. She's gotten out of the shower, she has a towel on her head, she's looking out to see if her cousins are playing outside. I ask her to look at me for a second. Cole's finishing his dinner. The window is blown out. I don't really care about that too much, though. I couldn't avoid it, and I love this almost Rembrandt-ish thing she has going on with the light. It's subtle. It's a nice record of my daughter at age 14, and man, you cannot beat that late light like that. Gee whiz, that's tough.

Now, you don't have to be having direct beams of light coming through an open window, really, you can get bounced or reflected light, which is light that is really reflected nicely off something nearby. It can be something sophisticated like a reflector, or something as simple as a dirt floor or a white wall.

Take a look at this. My friends, Clark and Lisa Devries, very good friends of mine. This is just in their bedroom, Thanksgiving. Just took them aside, did a nice portrait of them at this age, in their 40s, and it's just bounced light—very, very soft light. It was a sunny day, middle of the day, but it's just very subtle, very subtle. And they're happy and they're young, and they're always this age in this picture. That's what I love about still photography. It freezes time. They're always going to be healthy and happy and in love in that picture. Love it. Nice, clean background. It's just in their bedroom, in the corner of the bedroom.

There's this wonderful variety you can get using found light, ambient light. Remember, as light bounces and reflects, it picks up colors, wonderfully! It picks up colors. Love that, love that.

Here's another thing, another thing. This is just bouncing light around real late in the day. My parents, their house is actually tan, but the light shifted blue. It was so late in the day. And they're yellow because they're washing their dishes and that kind of glows them up yellow and you can really read them there. You can really see them there. So I really like that, just that feel, and we've just had a nice meal. And my mom is putting up with me taking her picture, which she generally doesn't.

By the way, you know that this house, I've shot so much in this house. I've shot my dad especially. He still considers me to be a man without a job. In fact, he's constantly saying to me, why don't you get a good job down at the college? There's a guy offered you a job down at the college, right? And I said, Dad, that guy has been dead from cancer for ten years. I don't think I'm going to get a job down at the college. He says, well, you know, if you were me, you work a steady job for 30 years. I've got five checks coming in right now—five checks. I'm like, fantastic Dad, but I do think I have a job. I work for *National Geographic*. And he's like, I don't know, you freelance, son, you freelance. You're a man without a job if you freelance. OK. Anyway, great guy, though, great guy.

Outdoors again, I want to stress that the warm glow after sunset is really hard to beat. It's beautiful. The sun's been down maybe 10-15 minutes. Right there at my folks house as it sets, it gets warmer and warmer and more pink, and then it just vanishes. And all the colors vanish at some point, just by magic. This is why, when someone shows me a picture of a landscape that was shot in the middle of the day, I say, what were you thinking? Why didn't you wait until the light gets good?

A lot of people show me pictures of cemeteries shot in lousy light, and I'm thinking, that cemetery's not going anywhere. Nothing's going to change. Wait until the sunset. Why not wait until the end of the day when the light's great, huh? That's what I did with this field crew from the Great Courses back in Nebraska. We scoped out a location, a little pond behind a farmhouse, to

see when we thought the light would be best. What light would be best? And then watch what we did here. I'm going to ask you do something similar to this in this lecture's assignment. Watch this.

OK, so rural landscapes. Here's another great scene. We have a little pond and a rowboat. It's nice. It's idyllic. The fixings are all here for a very beautiful picture, but, you know the light. It's all about the light. You have to have great light to make a great landscape, in my opinion. I came out here very early this morning. It was kind of foggy and moody, but I don't know. Now I'm checking it throughout the day. In fact, I'll take a picture right now, just to see how it looks, but I know in advance it's not going to look great, yeah. I mean, the light is very, very harsh right now. Really tough. So I'm going to come back later on in the day, maybe even toward sunset, just see what I can get as far as reflectivity, maybe a silhouette, maybe a person or two out in that boat, really make it sing. Remember, there's no excuse for bad light in a landscape. The landscape is not going anywhere. So, let's just wait a few hours, wait until the light tames down, calms down a little bit and we'll try it again then.

OK, so it's almost sunset and we're back at the pond, and the light has tamed down some. I'm going to take a picture. And I'm looking at the back of the camera, and it has tamed down indeed, but, something I didn't anticipate—as the sun's setting the trees—there's a few trees blocking the light on this end of the pond. The end that I've been scouting out all day waiting for this, waiting for this. But I see it's lit on the other side. There's light over there. So, sometimes you just have to adjust and be flexible. I think we should go to the other side. So, come on, follow me.

OK, so, look what's happened. We've come to the other side of the pond, and, I mean, it's magic. The sun forced me over here. The other side of the pond was dark. That's the side I was scouting all day, but look, we're over here, the light is great, and we have great reflections. We can see the buildings in the water. We see farm buildings. The landscape rolls away. There's a lot of interest here. This is a much better side. I should have been looking at this side all the time. I should've done what I preached. I should have walked 360 degrees around this pond and seen what was on the other side. Well now the sun has led me here, and it's a beautiful scene.

I think I'm going to take a picture, obviously. Take a couple maybe. One from up here, normal, one from down low—worm's eye view as we say—and it's really nice. The boat gives us our leading line into the scene, we've got our buildings back there, there's reflectivity on the water, it's all these things we've been thinking about. You know, just near-far perspective and depth of field and getting a feeling for a place and having everything pretty much sharp. I've got a pretty high aperture, small hole in the lens. I don't know how we could beat this, really.

It's very satisfying. I've waited for the light to calm down. I've waited for good light. I've thought about where to be in that good light. And it works out. It's really that simple if we just think about it a little bit. We have to put some time into it, sure, but it is that simple.

Now that I've said that though, I would say, once you think you've got the shot, put in another card and shoot that too, and really try to go beyond the obvious. So what's beyond the obvious? I don't know. Let's play with it and let's have fun. Who know what you'll get.

OK, so, to go beyond the obvious, to liven things up, I love having people in the scene. I have my son Spencer and our friend Emma there in the boat, out on the pond. And it's really lovely. There's great reflection, they're having fund. Aren't you guys having fun? Sure. And you know what? It kind of completes the scene for me. It shows us how big or small the pond is. It really gives us a nice feel. The grasses are lit along the tops. They're lit. And you know what? Even after the sun has set, we're going to continue to get that nice reflectivity off the surface of the water. They'll stand out eventually, even, as a bit of a silhouette if you're at the right angle.

So let me work this just a bit. You can splash around, Spencer, all you want. I mean, low angle looks good. A little bit higher up looks good though, because I want Emma's head within the pond. Once I go down too low, her head's up in those weeds. I don't want to see that. I want her in that nice clean pond surface. You guys paddle around and have fun. Thanks for holding still.

So anyway, I mean, this is really nice. I thought I had a nice picture before. It's even nicer with people in the boat. So, that's it. Like I said, go beyond

the obvious. Try something new and different, and most of all, have fun. That's what this is all about.

So, it really is about having fun folks. Don't you think putting people in the scene really made a difference? I sure do.

So here's your assignment. Do what I did in the video. Pick a nice sunny day, start early and shoot five shots of the same subject. Shoot as early in the day as possible, high noon, late afternoon, before sunset, after sunset, and then compare. The point is to watch what the light does to one subject in one place at different times of the day.

Also, remember, take that walk around your subject in different light, and then once the light is good, do something to go beyond the obvious. I always like to bring people in, but you don't have to do that. You can bring in a surprising object if you like, or a pet, or whatever you like. Give us a surprise—something interesting in that really good light.

So, we have a good idea of the sort of the light we can find around us, both outside and indoors. It's light that we haven't manipulated or changed, it just pours down on us and our subject. What a blessing. The important point is to pay attention to the way it's interacting with your subject. Is it above them, behind them, to the side? Is it harsh, soft? Remember your exposure settings and your ISO settings on your camera. Now let's move on to more light, the color of light and intensity. Don't go away.

Light II—Color and Intensity
Lecture 7

In the last lecture, we talked about ambient light, but in this lecture, we go a little further, looking at how light embraces the world around us, how it caresses subjects, and how it can "make or break" an image. As we'll see, the first step in taking a photograph is figuring out the relationship between the subject and the lighting. We've also talked about harsh light and soft light, and we've learned to avoid the former and embrace the latter. Here, we'll go into more detail about light quality, and we'll talk about color—both the colors of objects in pictures and the colors of different types of light.

The Color of Light

- The sun is the ultimate white light source, and our brains have evolved to perceive all light as white, just like the sun. This makes it harder for us to see color in light, but our cameras aren't fooled; they will capture true colors.

- For example, a camera can "see" blue light from a cool light source. A photo of an iceberg in Antarctica on an overcast day illustrates the refraction of blue light. Such blue light sources can convey a feeling of relaxation and serenity or eeriness. In contrast, warm light can imply danger or romance.

- You can often take advantage of the color of light to get a better photograph than you would if you used a flash and cleaned up all the light to white. If your light is warm or cool—if it has color in it—your picture will have one more point of interest. In some cases, the color of light alone can make your picture interesting.

- Note, too, that light can bounce off colored objects and reflect their colors.

The White Balance Setting

- The white balance setting on a camera does just what its name says: It balances out the different hues of light and makes them all white.

- A photo of a bride before her wedding shows three different color treatments, with and without the balance setting.
 - The camera originally sees the scene very yellow (daylight setting), which lends a sense of warmth and romance to the picture.

 - The tungsten setting corrects the yellow back to white, and the white balance setting shifts the yellow end of the spectrum toward the blue for a much more neutral result.

- If you like getting true colors—not a cleaned-up version of the world—leave your camera set on daylight. Often, this setting results in images that look like paintings.

- As we said, the automatic white balance setting on a camera cleans everything up to white. You might use this setting if you were in a green room with fluorescent light, but in that situation, you could, of course, also use the fluorescent setting.

- The sunny or daylight setting is a neutral setting for sunlight. Images shot on a daylight setting look warm and relatively saturated.

- The tungsten setting gives a much cooler white balance. It lends everything a blue cast to combat the yellow light put out by tungsten bulbs. You can use it indoors to combat the yellow effect—or not, if you like the yellow.

- The fluorescent setting adds a layer of magenta tint to eliminate the green given off by fluorescent bulbs. In terms of color temperature, it's between daylight and tungsten. You might use that in a workshop or wherever you find fluorescent lighting on your subject.

- The cloudy day setting, used in overcast conditions, tends to warm up the scene. It uses a white balance that's a bit more than the daylight setting.

- You should play with these settings from time to time, but again, you'll probably generally want to use the sunny or daylight setting.

- When you're out shooting, try to fix problems in the viewfinder so that you get the picture you want while you're on site. If the subject is too far away, walk closer to it. If the scene is too yellow, fix it with white balance or with flash or move the subject to a window.

- As we said, the color of light is one area where the way your camera "sees" is different from the way your brain and your eyes see. Light intensity is another area where your eyes and your camera see things differently. Intensity is the term that covers hard light versus soft light. When the light is harsh, it is intense; when it is indirect, soft, and diffused, it is less intense.

Dynamic Range—In Your Eyes and in Your Camera

- Your eye has a tremendous exposure latitude or range, which translates to an ability to forgive high-contrast situations. The difference between the brightest bright and the darkest dark is called a dynamic range. When the light is very harsh, your eye can see into both the shadows and the highlights. Human eyes can handle a wide dynamic range and retain details in both bright and dark images.

- The digital sensors and film in your camera, on the other hand, have a much smaller dynamic range. In a bright situation, when you can still see detail in both the light and dark areas, your camera will lose details; it can't handle both really bright and really dark things in one picture. For this reason, it's important to check your camera's screen and histogram.

- In softer light, the range between the shadows and the highlights is narrower. The differences come together, resulting in a dynamic range that the camera can handle. If everything is soft and evenly lit, every detail becomes visible.

Behind the Lens

Here's a picture of [my wife,] Kathy, coming home from Antarctica. It's one of my favorite pictures. It's a total grab shot. Is it a great picture compositionally or light-wise? No, but this is when the kids met up with their mother again. She'd just gotten off the plane. Is the color good? Not necessarily. Is the background perfect? No, it's kind of sloppy, pretty junky actually. Are the people perfect? No. But the reason this photograph has worked for me is because it's a real moment. I wasn't really analyzing a lot when I did it. This is the exact moment when the kids ran up to her after she was away from them for

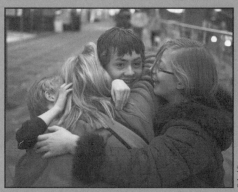

© Joel Sartore.

the first time; she was gone a month to Antarctica with me. This is the moment they ran up and hugged her, and it shows how much they love her and rely on her. She's their life raft. ...

It's about the moment sometimes. It's not always about getting it perfect—the intensity of light, the color, or the background—it's just about the moment you want to get.

I always have my camera with me. It's ready to go. It's on aperture priority. I knew in this case I wanted to be close. I wanted to be right there with a wide-angle lens. I knew I'd need a fast shutter speed, so I cranked the ISO to about 2,500 or so; had a big hole in my lens, f/2.8; no flash here. This is about getting close, being intimate, and shooting. I shot 10 frames or so, but this first one, when they first come in contact, that's when the emotion is the best. It works. [It's] one of the few pictures of my own I have up in my house out of all the hundreds of thousands that I've shot.

- It's important to be aware of how the camera sees, especially in terms of light intensity, dynamic range, and color. Realize the limitations of the camera. In other words, when the light is harsh, you need to expose for either the bright or the dark. It's often best to go for the highlights so that you don't blow them out and lose information in the image.

Making the Best Use of Light
- As a rule of thumb, if you or your subjects have to squint because of the light, the light is probably too harsh to shoot in. The sun high in the sky is a primary source of harsh light. Wait until the sun has moved closer to the horizon—first thing in the morning, late in the afternoon, or in the evening. Colors come alive in softer light, as well. You don't need harsh light to get vivid color.

- When you can control the background and the light, take advantage of the situation and shoot. When you can't, it may be just a good time to watch; get a great shot later. Don't make the mistake of shooting something when the light is too harsh.

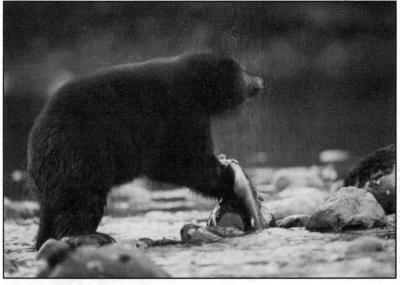

Dark objects are easier to photograph in shaded light.

- On the other hand, sometimes you may want a picture at a bad time of day, or you may not have a choice.
 - o In a field shoot with a member of The Great Courses team, it's impossible to get a good picture in the harsh midday sunlight, but it can be done by pulling the subject into the shade and using fill flash.

 - o With a flash, 1/250 of a second is the fastest shutter speed that can be used; any faster and the shutter blades will be visible in the picture. For this shoot, the aperture was set to f/20 or f/22, and the ISO was dialed down to 200 to slightly underexpose the background. Fill flash was then used with a softbox to diffuse the light, resulting in a studio-quality portrait.

 - o Fill flash is so-called because it fills in the shadows. It brightens up the subject to set it off from the background, which is slightly underexposed.

 - o You're likely to use the fill flash technique often. Dial down the exposure on the background and then use a softbox on your off-camera flash to illuminate the subject.

- Dark objects are much easier to photograph when they are shaded or in overcast light. These kinds of conditions make it easy to bring out detail.

- Bright light used to capture strong colors creates instant richness and vibrancy. It's also interesting to focus on color when the surrounding scene is monochromatic.

- Keep this in mind, too: When you are shooting in less-than-ideal conditions, focus on the emotion and action and wait for the moment to happen. Powerful photos are not always about the intensity of the light or the color.

Assignment
- Find and shoot some great color—anything at all, from the glow of a reading light to the red of your car's taillights. Be sure to photograph

a subject *in* that color, not the source of the color itself. Try for some cool blue scenes and warmer red scenes. Also try to get some reflected color—off of a coat or off water, for example.

- Experiment with the white balance settings on your camera. Try out every one of the options and see what happens when the camera adjusts for various kinds of light.

- Experiment with light intensity. Find a spot you like and photograph it when the light is at its most intense. Then return when the light is softer. Experiment with shutter speed, aperture, and ISO. Remember to increase the ISO to let in more light when you need it.

Suggested Reading

Crewdson, *Twilight*.

Maisel, *Jay Maisel's New York* (or anything else of Maisel's you can lay your eyes on).

Meyerowitz, *Cape Light*.

Homework

Find and shoot great color right at home. The source can be anything at all, from the glow of a reading light to the red of your car's taillights. Be sure that you photograph a subject *in* that color, not the source of the color itself.

Light II—Color and Intensity
Lecture 7—Transcript

OK, so we have talked about ambient light. Now we need to go a little further. It's critical to really see how light embraces the world around us, how it caresses subjects, or how it can ruin everything—and I mean, everything.

The first step in taking a photograph is figuring out the relationship between the subject and the lighting. It sounds obvious, but there's a little bit more to it than you might think. You can make adjustments to your camera that will compensate for or enhance the natural light you've got around you, but you can also make adjustments to your position, and thus the camera's position, in relation to both the light and the subject.

I've talked about harsh light and soft light and told you to try to avoid the former and embrace the latter. In this lecture, I'm going to talk more about light quality, including color. Now, by color, I mean two different things. The color of different types of light—all light is not created equal, it's not the same—I'll explain that in a minute. And also, color means the colors in your pictures, like this, the colors in your pictures. What are people wearing? What colors are things throwing off towards you? How about the objects in the background? We really want to think about that. We really do.

We never really think about light, though, do we? Not really. We don't think about great light, and that's what I want you guys to be thinking about from now on. I'm telling you, though, it's going to ruin how you watch movies, even, because you're going to notice changes in light. You're going to get good at seeing really good light and when that light doesn't work just quite right.

So what, exactly, is great light? Let's take a look. What's great light? Great light is when the sun is low on the horizon, or, on an overcast day, sure, overcast light. It could be introduced light, like flash. That can be great light. It can also come from something as simple as a single reading lamp—just a reading lamp, just one tungsten bulb with a shade on it. That's all it is.

Great light can come from anywhere, but you have to be aware of it and look for it. Great light could be in a couple of little light wands practicing around the living room. It could be anything. So let's get started.

The color of light—very important. Let's talk about seeing the color of light. That may be a new experience for many of us. We don't think about the color of light very often. Why? Because our eyes and our brains adjust for it automatically, automatically. Check this out.

Look at how blue this is. That's late on an overcast day and it was snowy, blue, very, very blue, but your eye doesn't see that. Your eye sees it as white. Your camera picks up the blue though. Or, how about this? Really, really red—late in the day, that red light bouncing off the clouds throwing red light all over everything.

Why is it that our brains don't see this? Why is it that our eyes don't see this? Well, mainly because our brains evolved thinking all light should be white, just like the sun. The sun is the ultimate white light source. So today when our eyes and brains come across a colored light source, it just adjusts the light as much as it can.

Now you don't see that really when you're walking around and you're looking at a sunset. Of course, it appears red to you. That's pretty obvious. It's easy to see that color. But sometimes our cameras show us where our eyes and our brains are fooled. Don't think so? I'll prove it. Check this out.

You've been driving around after sunset. You see the lights coming up in houses around town? Sure. A little twilight in the sky left? See the yellow lights coming on in houses?

Well, why is it if you were walk up and into that home and see a newspaper, for example, that newspaper would be snow white. Why is that? Why is it? My brother with a school bus mask on for some reason while he reads.

Your brain corrects that yellow light back to white immediately, because our brains did not evolve with anything but fire, and that was very late in the

process. So, all light, if it's even marginal gets corrected back to white by our brains.

Your camera is going to get the true colors, though, and that's a good thing! I love the fact that we get extra color and variety out of things with our cameras. That is fantastic. Love it! The colors of light perceived by your camera are things that we usually can't, not unless it's really obvious like a sunset, like I said. There are very warm and very cool light sources, man-made. So let's talk about cool light first, alright?

Sometimes it's not even man-made—overcast day, a blue subject for example, the whole thing is cool. This is in Antarctica on an overcast day. The predominant light source in these clouds is going to be kind of a bluish gray. The iceberg itself is very dense, and that means the blue is the only color that can be refracted out—blue refracts out the easiest—so we have a shaded subject here and it's blue. It's just all about blue. Blue is relaxing and serene and calming. Blue light sources are something I think about all the time, and I think they're lovely, very legitimate, very legitimate.

Let's look at a couple other light sources, though, and just talk about what's going on here. Here I am holding hands with my wife. We're sitting on our back porch, it's late in the evening, we're in the shade. What does blue do to this? Well, it makes us think we're relaxed. It could be we're talking about something deep, philosophical—we're not talking about photography, I guarantee you that—but it's contemplative light. It's just a light that makes you want to slow down, relax, and think.

What else can blue be? Blue can be kind of creepy, kind of eerie. Daughter, Ellen, at a computer there, huh. If an adolescent girl is on a computer and she's bathed in a creepy blue light, what are you thinking? What's she looking at? What's she gotten herself into? Blue can imply lots of things, then. Mood, slow motion, thoughtfulness, tranquility, or eeriness.

Let's talk about reddish light a bit, reddish light. Wow! I kind of like this. This is from a rattlesnake hunt in Oklahoma, believe it or not. A Rattlesnake Derby in Mangum, Oklahoma. Now check this out. This is a place where all the snakes are brought into a tent, a big rattlesnake pit. These guys are with

the Short Grass Rattlesnake Association, and they actually wander around the pits with these snakes, and they don't get bitten. They wear long boots under their jeans to prevent that. They explain why snakes are important in the ecosystem, which is great—how snakes eat mice, and rats, and insects.

The thing I loved about this visually is that the ceiling of the tent was translucent and red, and it's in the middle of the day when the light is just burning harsh outside. The light outside this tent is awful, but inside, it's really red, and that's great. Why? Because red implies danger. You have all these western Diamondback Rattlesnakes in a pit and there's guys walking around, that's dangerous. Dangerous light for a dangerous subject. How perfect is that? I love it.

Some people would see the light and immediately want to get their flash out to clean it all up to white or make it brighter. No, no, no, no, no, do not do that. The color of light is really important to find all of its infinite varieties. This is the good stuff, and this is what I'm looking for, man. This is what I'm looking for. By the way, look at this background right there. You would not be able to read that snake's head unless it was right against that white box. I'm thinking about all this stuff all the time. Not just quality of light, but backgrounds, and apertures, depth of field, shutter speeds, the whole thing. But, man, with a nice background you can really make something pop in a chaotic situation.

OK, back to light, back to light. What else? What does reddish light say, really, about this photograph? It's bright, late in the day, it's warm and natural. Sometimes red light can be romantic, which is also kind of soothing, can fuel the heart. Sometimes it can be exciting. Sometimes it implies danger, as I said. Sometimes, it's none of those. Sometimes it's just a beautiful, lovely light source for a scene in just a beautiful color palette, and that's good enough, OK?

What else? Yellowish light. Picture a hailstorm coming in at sunset near Hayesville, Kansas. The lights actually have a greenish-yellow cast, very ominous. This is that hue that you get when a really violent storm comes through. Hailstorms absolutely devastate crops out here in the heartland where I live. This is something that happens every summer, every summer.

When I shot this, almost 20 years ago, I didn't realize there was something outstanding or unique about it. I hadn't been thinking about light that long. But after all these years, the picture still holds up, in a way, because the color of the light is so unusual and weird. So, the bottom line is this, if your light is warm or cool, if it has color in it, your picture will have one more element—one more point of interest. This alone can save your picture. So, there is the color of found ambient light.

OK, reflected light. Let's talk about reflected light a little bit. The color that reflects off other objects around your subject. Let's look at this picture of my little boy, Spencer. He's right in there nuzzling up to a red coat in my wife's closet. There's a little bit of indirect bright light coming in from a window that's out of the frame. Notice the red cast right there kicking off that red coat and lighting his face. It's subtle, but you can see it. A little bit of shift of the light. It picks up the color of the things it's bouncing off of. Beyond introducing a little bit of color, though, that light source is really, really, it's pretty soft. There's not harsh shadows there, and it picks up color. I love that! Reflected light is such a good thing. It's really great. Dare I say, one of my favorite light sources. Better than throwing flash in on something, even. People want to get out that flash, but, man, you do not have to, you don't, OK?

Alright, how about this next one? Blue, blue light. Well, there's more than that going on here. Look at this. She's wearing one of those sparkle cowgirl shirts—one of those rodeo-queen shirts, and it's kicking reflected blue streaks up onto her face from all those sequins. It's adorning her face, just like reflections off a crown.

So it doesn't need to be yellow light from a tungsten bulb. It doesn't need to be a translucent red tint at a snake festival. It can simply be an article of clothing that's shiny or reflective. It can be anything, it can be anything.

Let's talk about white balance a little bit. Now, if we want to control color again, there's more we can do. There's a shortcut. There's actually a shortcut. There are settings on your cameras, most cameras, that balance different hues out and make the light simply correct back to white. We call this white balance. Let me pick up a camera and show you what I mean here.

White balance settings on this camera are pretty easy to use, pretty easy. Basically this does WB. Your camera is going to be different now, you never know. And I can literally switch the different ways that this camera interprets the color of light. Pretty easy. Sounds good, doesn't it? Well, you know, sometimes yes, sometimes no.

Let's take a look at another picture. This is a scene of a friend of mine that was getting married and her sisters helping her out backstage on wedding day at the Lincoln Country Club. And I've given it different color treatments here to show you what we're talking about. You know, we could show this as the camera saw it, all tungsten, very, very yellow. Now this is on the daylight setting of my camera, which is going to read the light color in the room, the yellow tungsten light, for exactly what it is—yellow. Now, I like warm colors, and I like it in my work. Nothing wrong with this.

But, with that white balance on the camera, look at what you can do. Isn't that cool? OK, this is correcting all the light back to white. This is the tungsten setting. The tungsten setting in your white balance, just like old tungsten film adds a blue layer, it just adds a blue layer, and it corrects that yellow out. So look at how we've corrected that out up to white. Fine. That's fine.

Or, how about another setting? You go half way, split the difference. Wow, not as yellow, not as white. It's kind of nice. This is called your auto white balance setting, which kind of balances things out, no problem there. That might be a good solution. Leave your camera on auto, OK?

Personally, I really like it yellow. I like it as the camera originally saw it. I leave my camera set on daylight all the time, because I want different colors. I think that's more attractive, in a way. It looks like a painting. It looks very romantic, and it almost looks like firelight. Again, this is using the daylight setting, which I use all the time in order to get the real colors that are out there, not some cleaned up version of the world. Your white balance really changes the mood of the picture, doesn't it? Totally does.

You know, the filament in incandescent bulbs is made from tungsten, which throws off a very yellow light, obviously. It's evident in those bridal shots. if I'd shot that same scene with my camera set to tungsten the whole time,

which corrects for yellowness, it would look like it's all cleaned up. The white balance correction shifted that color temperature, literally. It shifted the yellow end of the spectrum towards blue for a neutral result. But again, do I want that all the time? Not really. I don't want to clean the whole world up to white like an operating room. I'm not interested in that. I want variety. I really do.

Your camera has a lot of white balance settings on it. So let's talk about that for a minute. On my camera, A is for automatic. It cleans everything up to white. I don't use that one very often. Maybe I would if a room was very green with florescent light, but then again, I'd probably just use—that's right, wait for it—the florescent setting on white balance. And even then I'd sometimes clean it up because I don't want green, but maybe not. I don't know. It just depends on my mood.

Remember, you have to look at each situation and think about it. Look at it. Think. What do I want to do with this scene? There are no hard rules. It's just a matter of shooting; chimping; or looking at the back; and making adjustments; and shooting again. That's the beauty of digital. You can just look at the back of the camera and you can figure it out.

So let's look at the same scene using different white balance settings on your camera. Let's start looking at scenes and thinking about that. With man-made light, artificial light, start trying to do that. Fiddle around with the dials and see what effects you like.

Let's start here with the sunny, or daylight, setting, which is the one that I use most often. It's a natural setting for sunlight. Images shot on the daylight setting look a lot like the images off my old Velvia transparency film, or slide film. Warm and relatively saturated. I leave my camera on that one a lot because it looks right to me. Blue looks blue, yellow looks yellow. In general, I like the different colors that daylight settings give me. I really do. Everything's pretty much as it should be. Let's look at this setting here. Daylight setting. That's just as it should be. Kathy at home with the dogs in the living room. OK, so great, there's a white light source, it's the sun reflected in my living room, and my camera is set to daylight.

Alright, tungsten setting is next. Kathy was patient enough to stand there for me, while I ran the settings. Tungsten—look at that. We're introducing that blue layer, much cooler, much cooler. Basically gives everything that blue cast to combat any yellow, any yellow. It doesn't have to be that tungsten bulb coming in there, any yellow is negated by that blue. You can use this to shoot indoors if you want to combat that, or not. If you like the yellow effect, don't, OK?

Let's look at another one. Fluorescent. There's a fluorescent setting, as I mentioned, which adds a layer of magenta tint to get all that green out from florescent bulbs that we run into. In a daylight scene like this, you can see that layer of magenta, can't you? In terms of color temperature, for me, it's between daylight and tungsten, right? You could use that in a workshop or wherever you find florescent lighting on your subject, easy enough to remember, easy enough.

OK, what's this setting? This is one we haven't talked about yet. Cloudy day setting. This is an interesting one. I use this once in a while. A cloudy day is a very gray day, right? Well, cloudy day setting in white balance, at least on my camera and many of yours, is basically a setting that warms up the scene a little bit. It uses a white balance that's a bit more than the daylight setting in terms of warmth. Pictures are going to be warmer rather than cooler with a cloudy day setting. If it's a cloudy day setting, I can put it on there, and it would just warm up the world just a little bit, OK?

And finally, what do we have here? This is your auto white balance. The auto white balance that looks so good of those girls in that really yellow room? I don't care for it here that much. It's a little bit bluish, and I don't use that auto white setting too much, as I mentioned, because it makes things just a little boring, to tell you the truth, just a little boring. I want variety. That's why I'm in photography. I love it.

So I play with these settings from time to time, but usually I keep it simple. I leave it on the sunny setting, mostly, when I'm shooting. I really like to be surprised, don't you? I like these happy accidents we get.

Remember, use all this color in the light that you find on the street and in your home or at that mall or wherever you are. Use it to your advantage. Good photographers pay attention to these differences. Sometimes you might use the white balance setting, but sometimes you won't. Sometimes you might be daylight. Sometimes you might be tungsten. Don't feel that you have to correct the light to white with the white balance all the time. Sometimes, most of the time, I don't correct anything. I leave it on daylight and I go.

So, again, try to get the picture right, by the way, when you're shooting it. Here's something to think about. When I'm out shooting, I want the picture to be right the first time. I try to fix things in the viewfinder as I'm shooting. If a picture is too far away, I walk up closer to it. If a picture is too yellow for my taste, I would fix it with my white balance or with a flash, or I would move the subject over closer to a window. It saves me a lot of time afterwards, and I do mean a lot.

Think about that. Don't tell yourself, I'll fix it later in the computer. Get it right in the camera. Don't you spend enough time in front of the computer already? Good grief! Whatever you do with the computer later will be stuff you want to do, or choose to do, rather than stuff you have to do in order to save yourself and get decent pictures.

So, the color of light is one area where the way your camera sees is different from the way your brain and your eyes see. We've established that. Light intensity is another area where your eyes and your camera are going to be seeing things differently. Why is that? Intensity, by the way, is the term that covers hard light versus soft light. When the light is harsh it is intense. When it is indirect, soft, diffused, reflected, it is less intense.

So why is that? It's the dynamic range, dynamic range. Your eye has a tremendous ability to forgive harsh, contrasty situations. We call this exposure latitude, OK? The difference between the brightest bright and the darkest dark in the scene you're looking at is called the dynamic range. When the light is really harsh, your eye can see into the shadows, the same as seeing in the highlights. Human eyes can handle a world of dynamic range and retain details in both the highlights and dark. That's why you can be

sitting in your house, looking out the window on a sunny day, read the paper, and look outside with the dog chasing a cat. Not so with film, not so. Digital sensors or film cameras—it's too hard for them. They can't get a great, great, great dynamic range. That's where you have to come in. That's where you have to help it along. You really do. Let's take a look at a couple of images.

Look at this. We're going to talk about a real bright situation. This is in the Galapagos Islands. Marine iguanas, very cool animals. This is a very bright situation, and you can still see some detail, I guess, kind of, but your camera can't really deal with the dark shadows and the highlights at the same time. It can't. It just can't deal with them. When I was there, I could see into the shadows and the highlights, but, it's really important for me to check my camera screen and my histogram because my camera is seeing the intensity of light differently than my eyes are.

Now look at this. Maybe a little better. Look at that. We can even see that there's color. There's a little bit of red and green in these animals. In softer light, maybe earlier or later in the day, the light between the shadows and the highlights is less. They match up. You're lowering the difference. They come together.

The camera can handle that exposure difference, that dynamic range, but only if you help it out. You really have to work at the right time of day. You have to work at the right time of day to have a soft, soft subject, or have it shaded, or help it out with flash. It just can't handle that high dynamic range like our eyes can. That's really key in thinking about why your pictures work and why they don't. If everything is soft and evenly lit, like we are here, you can see every detail. It just makes shooting easy. That's why I love waiting for the sun to go down. Nice, beautiful glow all over everything.

Light intensity and dynamic range are areas, in addition to color, where you, as a photographer, need to be aware of how the camera sees. You have to realize limitations, though. In other words, when the light is harsh, you need to expose for one or the other, the bright or the dark. Again, I usually go after those highlights so I don't blow them out and lose all the information out of that part of the image.

Here's a general rule of thumb, right off the bat: If you or your subjects have to squint because of the light, it's probably too harsh to shoot in, probably. Your subject is going to be sweating and kind of squinting and they won't be able to get out of there fast enough. They'll hate you for putting them through that, you know? People's eyes will tear up. I really watch shooting in harsh light. Harsh light to me, again, is mainly when the sun is still way high in the sky. There are other harsh light sources, surely, but that's the main one. Wait until the sun has calmed down a little bit. Wait until it's closer to the horizon. Lovely pictures generally come from low intensity light, first thing in the morning or late in the afternoon or evening.

Let's look at this. This is in fairly harsh light, believe it or not. The highlights are almost blown out. This is little baby Spencer here. We've about lost all the highlights in there. I don't know what the histogram looked like, but it's very close. The highlights have almost no detail. I like the perspective that shallows out the field and getting down low on the grass, but even the grass is kind of blown out. It isn't very green or lush.

Now let's look. Look at this, a little later on. Same lawn, but look at what happens in softer light. The grass is lush and green. The kid's eyes are opened wider because he's not squinting. He is staring down and he's not worried about the sunlight. He's looking at me, I'm calling him. The frames better because he's in a better mood. He's not out cooking in the middle of the day. It's just a better frame. It's a better time of day.

Colors really come alive in softer light as well, I've found. The greens are rich in the second photo. That's the thing about saturation and softer light, we can often get better results. You don't need harsh light to get vivid color, believe it or not.

So, when you can control the background and the light, take advantage of it. When you can't, maybe it's just a great time to watch, get a shot later. Think about things, anticipate things, do your homework a little bit. It's a very common mistake though, insisting on shooting something when the light is too harsh.

On the other hand, sometimes you really want a picture at a bad time of the day, you don't have a choice. So let me show you what you can do. Remember that light box we used with Nimbus the owl, that little soft box? I know you've probably always used flash for nighttime or indoor shots, and you haven't thought about reflections, but I hope you're getting the idea that it's great when you use flash outdoors too, if you do it well.

Now, when we were out in Nebraska, I wanted to get a photo of Marcie from the Great Courses Team, but we were in the harsh, intense light in the middle of the day. So, let me show you how we got a really nice picture of her anyway, despite the middle of the day timing.

OK, so we've tried a couple of pictures out in the sun, no good, no good. Marcie is squinting, it's painful. Let's get into the shade and relax a little bit. Now Marcie is wide-eyed, relaxed, comfortable. OK, great.

Now, how do you deal with this? Marcie is in very deep shade here, and the whole world is lit brightly. What do we do? We're reverse lit aren't we? We need the world to be toned down a little bit light-wise, and we need Marcie to be a little bit brighter. We need to really craft this well, so how do we do this?

Well, first of all, our camera needs to be underexposing the background. We are limited a bit in that the shutter will only go to $1/250^{th}$ of a second with a flash. Why? Because if you try to go faster than $1/250^{th}$ like to $1/500^{th}$ or $1/1000^{th}$, you'll catch the shutter blades in the picture. That's just the mechanics of it. Because the shutter is a mechanical thing and it can't compete with a quick burst of light from the flash. It's just how it is. Alright, so $1/250^{th}$ of a second, make a really small hole in your lens, F/20, F/22, and I have my ISO dialed down as low as it'll go on my camera, 200. And I know from looking through here that will slightly underexpose the background. That's where I want to be, slightly down, slightly dark back there. I don't want the background to compete with my subject Marcie.

Alright, so now we introduce fill flash, our buddy fill. We've got our cheapy softbox on here to diffuse the light. We have or flash cranked up to where we about want it. The closer the flash is the softer the light, and that looks great.

That looks like a professional studio, believe it or not, and it's just a softbox over a flash, and it looks fantastic. That's great. Mission accomplished. Problem solved, and Marcie is not squinting. It's much more comfortable, we have more time.

I know you guys are going to have lots of events, family events, social gatherings, parades, whatever, where you're going to have loved ones that you want to get pictures of and it's going to be the middle of the day, the worst time of the day. Pull them off, get them into the shade, light them a little bit. With a technique like this you cannot go wrong. Problem solved.

So, fill flash. That's a term you've heard me say, right? It's fill flash because it's filling in the shadows. It's brightening up your subject to set them off from the background that's slightly underexposed in this case. Basically, a lot of people are lucky if their fill flash just gets them to match the exposure of the overall scene.

Now, it's a technique that you want to use over and over. Dial down the exposure on the background and then use that softbox on your off camera flash if you can to bring the subject out of the shadows, to really illuminate them well. It's a very nice look. Love it, but it has to be done well.

Now remember, this is another little nugget of wisdom. Dark objects are easier to photograph in shaded light. It's true. Shaded or overcast light really, really works on dark objects. This applies to birds, people with dark skin, dogs, you name it. If you can get dark subjects in soft overcast light at the end of the day, or on an overcast day when everything is subtle, it's really easy to bring out detail.

Here are a couple of classic examples. A black bear feeding on salmon in a stream in Canada a few years ago. Look at how that's all blocked up. Totally blown out flesh on the fish, black as can be, no detail there at all. OK, same bear, same stream, later in the afternoon. Look at this. Very soft and subtle. Now we're seeing detail on the fur, we can see detail on the water flying around, everything is rich and nice. That's great. That's excellent. We're just waiting for a soft, subtle amount of light. That's what you have to have if you have a dark object.

What else? What else? Well, we can look at strong colors as well. We can go for strong colors. Colors like this in strong light create this instant richness and vibrancy to any situation. This picture of cranes, sandhill cranes, in Nebraska, is a good example. Look at how bright yellow and bright orange help this go to work.

Color is also really good when the scene is monochromatic, believe it or not. Monochromatic? Yeah, fairly monochromatic. This is Spencer wearing a bright blue coat, red mittens, Color is holding this picture together more than anything else. The color in the picture really, really works. That's great.

This is a shot of snow near my house in Lincoln, just after the sun has set, but still it works. Why? Because the light is nice and even. We're not fighting the sun. We're not fighting the sun. That's a good thing to remember.

So, listen, even when the light isn't perfect, it can still be good. When you're shooting in less than ideal conditions—and trust me, you will—do what you can. Focus on the emotion and action and wait for the moment to happen. It's a powerful photo still, even if it's less than perfect.

Here's a picture of Kathy coming home from Antarctica. It's one of my favorite pictures. It's a total grab shot. Is it a great picture compositionally or light-wise? No. But this is when the kids met up with their mother again. She'd just gotten off the plane. Is the color good? Not necessarily. Is the background perfect? No, it's kind of sloppy, pretty junky actually. Are the people perfect? No. But the reason this photograph has worked for me is because it's a real moment. I wasn't really analyzing lots when I did it. This is the exact moment when the kids ran up to her after she was away from them for the first time, and she was gone a month to Antarctica with me. So, this is the moment they ran up and hugged her and it shows how much they love her and rely on her. She's their life raft. You know, at first it really bugged me that I couldn't see Spencer's face, but I really love it now. I like this picture more as time goes by.

It's about the moment sometimes, you guys. It's not always about getting it perfect. The intensity of light, the color, or the background, it's just about the moment you want to get.

I always have my camera with me. It's ready to go. It's on aperture priority. I knew in this case I wanted to be close. I wanted to be right there with a wide angle lens, I knew I'd need a fast shutter speed, so I cranked the ISO to about 2,500 or so, had a big hole in my lens, f/2.8, no flash here. This is about getting close, being intimate, and shooting. I shot ten frames or so, but this first one, when they first come in contact, that's the best. That's when the emotion is the best. It works. One of the few pictures of my own I have up in my house out of all the hundreds of thousands I've shot.

So your assignment. I want you to scope out, find, and shoot some great color right at home. It could be anything at all, from the glow of a reading light, to the red of your car's taillights. Make sure that you photograph the subject in that color, not the source of the color itself. Do you understand me? Don't look towards the sunset and shoot those red clouds. Shoot the reflected light off those clouds the other direction of sunset. Shoot to the east. Shoot some reds, some warmer scenes. Try getting some reflected color off a coat, off the water, for example, whatever.

Experiment with your white balance settings. Try every one of the options and see what happens when the camera adjusts for various sorts of light.

So experiment with light intensity. Find a spot you like and photograph it when the light is at its most intense. Then return when the light is softer. Experiment with shutter, aperture, ISO, all these things. Remember to crank up that ISO to let in more light sensitivity when you need it late in the day and indoors. Try several different settings. Chimp the image on the back of your camera. Do all these things.

We have one more issue to cover on the subject of light. What can we do with the found light, the ambient light, when it won't get us the picture we need. That's when we need artificial light. Flash can get the job done, so can other things. I've been referring to flash and artificial light sources a lot. In the next lecture we're going to talk much more in depth about each. So come on back.

Light III—Introduced Light
Lecture 8

As you should realize by now, you can't be afraid to craft light when you need to. You don't have to accept what's present in a scene; move around and see where the best light is, move lamps, shift your subject, and slow down the shutter. But in some situations, when found or ambient light isn't sufficient, you'll have to introduce light. In this lecture, you'll learn about reflectors, and we'll go into detail about using flash in a variety of situations—even outdoors and in the daylight.

Crafting Light

- Modern cameras can shoot in very low light levels. You can create a beautiful mood in your pictures using just the light from a table lamp, as long as it has a shade on it, which softens the light.

- Place the light off to the side at about eye level. Overhead lighting creates harsh shadows, just as the sun does when it's directly overhead.

- Firelight, too, can work wonderfully—usually, it is off to one side or slightly lower in the frame—as can sunset light, coming in from the side, not overhead. Look for opportunities to experiment with unusual light sources, such as car taillights.

- A photo of a lion in a tree in Uganda's Albertine Rift shows a dramatic use of introduced light, in this case, a bright floodlight purchased for less than $20. Without the introduced light, the lion would not have been visible in the tree.

Introducing Light with Reflectors

- Reflectors, which can be purchased at a camera store, represent another form of introduced light. They're used to bounce ambient light to where it is needed, often, to fill in shadows.

- Try using the gold side of a reflector, rather than the white or silver side, to get warm light. It's difficult to hold a reflector and shoot at the same time, so try to get someone else to help.

© Joel Sartore.

- If you don't have a reflector, you can use something as simple as a white poster board

This photo was actually taken outdoors on a rainy day, but overexposing the ambient light source turned the gray sky to white.

or even a T-shirt—anything that is bright—to bounce light. Remember, though, that the light will pick up the color of whatever you are bouncing it off of.

Flash
- The other main kind of introduced light is flash, which is not continuous because it lasts only an instant.
 - ○ Continuous light sources—those that stay on—are generally better because they allow you to craft the light and take note of the shadows and highlights.

 - ○ You can craft with non-continuous light, too, but you have to chimp it. You have to look at the back of the camera to see what the light is doing.

- Modern flashes use strobe lighting—a super-intense burst of light that lasts just a microsecond.

- If used incorrectly, light from a flash can bleach out subjects. Light from flash is also cool in color, meaning it's not true. Many cameras have an automatic pop-up flash, but you may be better off not using it in most situations.

- The secret to using flash correctly is to use fill flash, which lights the subject subtly but not too much. This technique requires taking time and making multiple adjustments to craft the light. Get in the habit of shooting, chimping, adjusting, and shooting again until you've gotten a shot you like.

Field Demonstration
- A field demonstration at Raptor Recovery Nebraska shows numerous options for using flash.
 - The worst flash technique is called direct flash, which shoots light straight on at the subject. Unfortunately, this is the only option with many point-and-shoot cameras that have a built-in flash. The result is very harsh light. Remember, the farther back you are from your subject, the harsher the light.

 - One technique to get better results with flash is to get the flash off the camera—hold it off to the side and use a sync cord. This technique reduces the red-eye effect and results in more natural-looking light. You can also try diffusing the flash by wrapping a tissue or a napkin around it, and you can darken the scene by adjusting your shutter speed and aperture.

 - A low-cost device called a softbox, which is mounted to the flash, spreads and diffuses the light from the flash to create much softer light. The key here is to hold the softbox close to the subject. The closer the light is to the subject, the softer it is.

 - Remember, to check the menu settings in your camera for instructions to adjust your flash and dial it down. If you have a standalone flash, there should be a way to adjust it on the flash itself. You can generally dial a flash down a minimum of two-thirds of a stop; you may sometimes want to dial it down a full stop or even more.

 - As always, you should take multiple shots. Get in the habit of shooting, chimping, and adjusting until you get a shot you like.

- If for some reason, you can't diffuse your flash, the next best thing is to bounce it off of something, such as the walls, the ceiling, or even yourself.
 - You can't bounce your flash if it is built in to a point-and-shoot camera, but you can if you have an external flash unit that can tilt or rotate.

 - Of course, you'll probably have a hard time bouncing flash outside. But if you're shooting inside and you have a unit with an adjustable flash head, bounce that flash off another surface—even an index card taped to the flash head.

- Flash doesn't travel too far. You should be within about 10 feet of your subject when you are using a flash.

Using Flash Outdoors and in the Daytime
- Flash isn't just for nighttime or indoor shots. You can use flash to eliminate shadows during daylight hours.

- A field shoot demonstrates how you can reverse the situation of bright background light outdoors and subjects in the shade.
 - In these conditions, increase the shutter speed to darken the background, then use the flash with a softbox to brighten up the subjects.

 - Move around your subjects to get different lighting effects; try ghost lighting, overhead lighting, and Rembrandt lighting.

Behind the Lens

Flash comes on and off in such a short amount of time that it can really hurt you, actually. As wonderful as flash is, it can really hurt your subjects, even bleach them out if done wrong. It is brutal! In fact, I would argue that people are better off never using their flash rather than ruining every situation they come across when they take it out because they can't control it.

o As you shoot, look for ways to add depth to your image. Include objects that recede into the background and objects in the foreground that highlight your main point of interest.

o Note, however, that the light from a small flash carries only about three feet. You need to get very close to your subjects.

Flash for Freezing Action
- Beyond simply lighting your subjects, you can take advantage of the lightning-fast nature of the flash to freeze action.

- When you are shooting flash in a dark situation, the results can look as if your subject is in a cave. To eliminate this effect, you can either use a long shutter speed to collect what little ambient light is present, or you can put other flashes in the background to light up the scene.
 o In many cases, the best choice is to keep the shutter open long enough to soak up the colors, the ambient light, and perhaps some of the background.

 o As long as the subject in the foreground is sharp, it's all right if the rest goes a bit blurry.

- In dark situations, experiment to determine how slow the shutter should be. Check the display on the camera and look at the histogram to make sure you have enough light but not too much.
 o If anything is touching the right side of the histogram, that means you are clipping information that you can't get back.

 o If the histogram seems to be hugging the left side, that means your exposure is getting too dark, which may be acceptable, depending on how you want your image to look.

Assignment
- Take a series of four photos using four different introduced light sources.

- Remember, lighting well takes time, so don't be in a rush. By experimenting and training your eye, you can take an ordinary scene and make it extraordinary.

Suggested Reading

Balog, *Survivors*.

McNally, *The Hot Shoe Diaries*.

Musi, photographer, "Taming the Wild."

Homework

Take a series of four photos using four different introduced light sources. Be creative and try these both in the middle of the day and at dusk to see what works and when. Lighting things well takes time, so don't be in a rush.

Light III—Introduced Light
Lecture 8—Transcript

So this lecture is about introduced light, which can be tricky and not always what it seems.

Take this sequence. This is a series of pictures that are a complete lie. Now these are bumblebees, and they are on sunflowers, but you would not believe how this day looked. It looks like it's a total studio thing, doesn't it? Totally. Do you want to know how it really looked? I'll show you how it really looked. It was that. Can you believe that? It's hard to believe isn't it? This is more of an exact exposure, but, I'll tell you what, the first shots look like they were shot in a studio on a sunshiny day, whatever. But it was on a rainy day. It was raining actually. So how did this happen? Well, that's what we're going to talk about.

In this case, I slowed the shutter down so much, and the flash is just a fast burst, remember, but I slowed the ambient light source down so much with my shutter speed, that that gray sky turned white. I way overexposed the sky. Then when I hit the scene with the flash, it illuminated the flower and the bees perfectly. Weird, huh? Really weird. Well, sometimes you have to bring your own light to the party. When found or ambient light isn't enough, man-made light can get the job done!

Don't be afraid to craft the light when you need to. You don't have to just accept what's there. Move around and see where the best light is. Move lamps, shift subjects, drag that shutter, slow the shutter down. If you actually get out a supplemental light and work it and craft it—like a flash—at the right times of the day, it shows that you have done your homework. And man, it really pays off sometimes.

So, this is a shot of my sleeping daughter. She's wearing some Cinderella dress we got at a thrift store, probably. This is lit with just a reading light—one of my favorite ways to do it, with just a single tungsten light bulb off in the corner of the room. The light's got a shade on it though, which makes the light very, very soft.

I put my camera on a tripod because I would have to have a very slow exposure—a very slow shutter speed. I didn't want the camera jiggling in any way. And there you go; it's a very simple picture. It's very subtly lit with a warm, little light, and she's not griping because she's unconscious. That helps a lot, OK?

Same thing with this, in a way. It's just lit with a little reading light. Now my white balanced changed a little bit—I'm correcting the yellow a little bit here with more of an auto white balance setting. And granted, I had to stand directly over them, but they ignore me by now. My little boy Spencer, he really likes to be with his mother, and she's trying to sing him to sleep here. I don't think he felt that well that night. But even in that sea of blankets and pillows, they stand out because that light really helps to craft them and to define them. It really does. It's the light that really speaks to us. Light is all we have, really. Light is how we build our photographs.

You would not believe how many pictures I've shot this way, with table lamps and reading lamps. You would not believe it. I mean, again, that is just using a normal daylight setting. Look at how rich and warm that light is. As long as the light has a shade on it—if it's a tungsten bulb, one of your round light bulbs—that's really nice light, but if they don't have a shade on them, the light is going to be really harsh, so you have to watch that. You really do.

Look at this. Just a tungsten light with some Christmas lights in the background. There is no reason you can't be shooting this way at home. Really easy. Now, modern cameras can shoot in very low light levels. You can create a beautiful mood in your pictures off of small light sources, like reading lamps, very easily.

Now, all these lamps are off to the side, and that's part of the reason they work so nicely. Think about the sun: when the sun is directly overhead, it creates these really harsh shadows, doesn't it? But if the sun is on the horizon, lower, it's a very nice, pleasing light, more directional that way. Overhead lighting, like normal lighting fixtures, where the light is coming down from above, not so great, not so great.

So, you can do the same thing with lights in your home. If the light is overhead, unless someone is looking up into the light, it's not such a great look. If the light is off to the side—like light from table lamps at about eye level—beautiful and soft, that is lovely.

Let's look at a couple more. It's great that I've been a photographer so long. I have all these pictures to show you guys.

Firelight. Firelight is wonderful, especially when it's late in the day and there's hardly any light left in the sky. Usually firelight is going to be off to one side or lower on the ground, lower in the frame, right? Sunset too, when it's coming in sideways, that's great. Again, modern cameras can handle these really low light levels like this, with the right adjustment of shutter speed and aperture, it is just beautiful light, just lovely. It's very, very hard to beat it. It really is.

I'd like you to think about taking advantage of unusual light sources, too. What do I mean by unusual light sources?

Well, how about this one? You know how that's lit? Car taillights, car taillights. My son was taking this picture when a farm couple we know drove by and they saw us and they stopped. And they said, "We'll get out of your way." I said, what? No way. This was a couple that was on their way home to Cortland, Nebraska, to their farm—a couple that I know. They stepped on their breaks before shifting it into gear and I saw this light on Kathy and I thought, "Woah! Woha! Back up! Back up!" and that's what lit us. That's what I want. I wanted that light. It was after the sun had set for a while, it was dark enough now, and we got a little hint of red and that lit us up just beautifully.

By the way, that's them, that's them. Did the same picture of them in their taillights, as well, looking the other way. Actually, in the bounce from their headlights, it looks like, doesn't it? Nice. Taillights, headlights, it's OK. It's all a big experiment, right?

Keep your eye out for unusual light sources whenever you can. Try different things. Experiment. That's why it's so fun. Even for me after all these years, it's really fun every day. I love it.

We call something that stays on, a subjectlight source, a continuous light source, like the reading lamps, or even the car taillights or headlights. Continuous light sources.

Here's another shot taken with a continuous light source, this time a spotlight on a lion in a tree in Uganda's Albertine Rift. This is a clear-cut example of introduced light. Even better, it shows what you can do with introduced light. You can use it without needing a ton of gear and getting real technical. That's nice. This is a lion picture. I guess it represents something like Zen in lighting—very, very minimalist approach—with good results. Plus there is a little story to it. Here's how we got this picture.

I was out with a lion researcher, and we knew there was a pair of male lions sleeping in this tree—one of them was radio collared. The researcher knew that. At a store back in Nebraska I'd bought a two million-candle power floodlight, which ran off the cigarette lighter in our vehicle. We knew lions were nocturnal. I thought, I'll bring this floodlight, you never know what we can use it for. We thought, if these lions slept until it was dark enough for us to use this light and light them up in the tree, this might make a picture. I was hoping that there would be some ambient light in the sky. So we parked there and waited around for an hour and a half until the lions started to move around just as it got dark.

Sure enough, a female lion roared in the distance, and this male stood, and we popped the spotlight on him lit him up for a second. Before the spotlight, you could barely see him up there, but that introduced light really made him pop. That cheap little light, 17, 18 bucks, plus tax, made this lion stand out in the tree very, very well. Without that introduced light you wouldn't have been able to see him. We wouldn't have a picture, no way. You wouldn't have had a picture that led the story in *National Geographic,* certainly. But this picture works because of the time of day, and we introduced the light, right?

By the way, you may see this picture several times in the course because it's one of the few I've ever been happy with. But a very simply done thing.

You know the best part of all this, don't you? It's that you can do this too. A spotlight and the right time of day—that's all you need. That's simple, really simple.

So, now, don't forget too, there are other ways to introduce light to your subjects as well. A reflector counts also. A reflector. Now check this out. I used to think reflectors were too Hollywood. You can pick them up at a camera store. But now I use reflectors quite a bit. Watch this. Stand back—this thing is spring loaded. Look at that. Holy cow! Pretty beat up too—kind of dirty. I don't think I can send it to the laundry mat. I use reflectors all the time to fill in shadows, constantly do, constantly. Here's the best part, watch this, watch this. I got this trick. Oh, man! I'm just like a magician—roll that off.

Alright, so I use reflectors all the time, all the time. Here's a little flower. This flower is a half-inch tall, tops. I shade the subject near the sun, I put that reflector right in the sun, and I kick a little bit of light on. It looks like firelight. It's lovely. That's in the middle of the harsh, harshest light you can imagine out in the desert. The reflector has a white side and a gold side. I like that gold side the best. I seldom use the just the white side or the silver side. I love that gold look. Super easy and cheap! Nothing to it. It's tough to hold a reflector and shoot at the same time, though. Try to get a friend to help you, so you can really see the effect of the reflector.

When else have I used a reflector? Lots of times, lots of times. This is using a little gold reflector off to the side. My wife's holding it here as daughter Ellen picks petals off of daisies. In these photos you can actually see the gold on her upper arm, or the side where that reflector's coming in. You can see the gold on her face, right in there. Easy to see. 'Cause the sun's actually coming from behind her, isn't it? The sun's all back here. That's all reflector, and that reflector is right there off the camera, easy.

If you don't have a reflector, you can use something as simple as a white poster board, or even a t-shirt. You can use anything to bounce bright light.

Remember, this is another fun thing, the light that's bouncing is going to pick up the color of whatever you're bouncing it off of. So if you hold up an orange t-shirt to someone who is in the shade and that orange t-shirt is a little bit in the sun, it's going to throw off orange light onto them. Very cool. If it is a yellow shirt it will throw yellow light onto them, red, same way. It can be a really interesting effect, but be aware. Chimp the back, look at the back of the camera, check things out, and make sure you know what you're doing.

Let's talk about flash now. The other main kind of introduced light is flash. It is NOT considered a continuous light because it only lasts an instant—a little burst—whereas a continuous light source, like a table lamp or car tail lights, those last for awhile, however long you want them to last. I like continuous light sources because you can really craft them and you can actually see what the shadows and the highlights are doing. But with digital now, you can do the same thing with flash. You can look at the back of the camera and see what it's doing too. Check that histogram.

You can do that with non-continuous lights, obviously, but you really have to look. I can't say it enough. Flash can really ruin your picture, so I'm cautioning you, look, check the back of the camera. Check it.

You know, entire books, blogs, you name, it have been written about flash. I wouldn't be surprised if there wasn't a master's thesis or two written about flash. Modern flashes use strobe lighting—a super-intense burst of light that lasts just a microsecond, just hardly anything.

A couple of frames here. Just a little burst of me and baby Spencer. Just a little flash burst. Somebody else's flash going off. I'm not using flash at all. Somebody else's flash going off there, huh.

How did we get to flash anyway? Well, the flash was invented by this man, Harold 'Doc' Edgerton. He's a Nebraskan, I am proud to say. He's an inventor from my home state.

I got to meet at the end of life. He was speaking at the University of Nebraska campus when I was in college, and I remember going to his lecture. Afterwards, we were standing around out in the hallway talking to

him—my photography instructors and I—because it was a big deal, him coming to town, and a young lady showed up late to the lecture, she'd completely missed it, in fact. She was from the college newspaper, *The Daily Nebraskan,* and she was assigned to get a picture of Doc Edgerton. We all called him "Doc." She had no clue who he was. She just had a little slip of an assignment sheet saying go get a picture of this guy.

She had a flash on top of her camera. It was an old Vivitar 283 model, as I recall. He was so nice and funny, and he asked her about the flash, and kind of smiling, because he knew she missed the lecture. He said, "What's that thing do?" And she said, "Well, this is a flash," and he says, "A flash? What's that?" And she said, "It puts light on you in dark situations." And Doc said, "Well, I am in a pretty dark situation in this hallway. Could you use that thing on me? Will it hurt my eyes?" She said, "No, it won't hurt your eyes a bit, it's really safe. It'll light you up really well." So, Doc Edgerton, the guy that invented the flash says, "OK, let's try it then. I'm ready," and he made this big show out of it. And so she counted to three and she lit him up and took one or two pictures, and she walked away happy. And he looked and he winked at me. He actually winked at me. The guy that invented the flash. I was so impressed by that, that he was so kind to her, not embarrassing to her at all, and yet had a bit of fun at the same time. But I digress, I digress. What a great guy.

Listen, flash comes on and off in such a short amount of time that it can really hurt you, actually. As wonderful as flash is, it can really hurt your subjects, even bleach them out if done wrong. It is brutal! In fact, I would argue, that people are better off never using their flash rather than ruining every situation they come across when they take it out, because they can't control it. I would argue that.

Oh ,let's see, yeah, like this. This is my dog Muldoon. This is typical for a flash. Look at this. It's just blowing out everything. The highlights are blown out. Absolutely terrible. Just awful. Terrible.

Another thing—light from flash is cooler in color. It has a natural blue feel. By that, I don't mean hip or funky, Right? It's just the color is not quite right, it's not daylight. Most of the time it is a little bit bluish to me. You might

have a little flash pop up on your camera, even, if it's more of a point and shoot style; it might come up automatically, but that doesn't mean it's the right thing to use.

So, what's the secret? Soft flash or what we call fill flash—using the flash to subtly get just enough light from that flash, but not too much.

That requires some time and some thought. It's no big deal, but you actually have to think about it. You have to really craft that light. What does it mean, to craft the light? Watch how I work this scene—again I'm at Raptor Recovery Nebraska. I'll start with just aiming a flash at the bird and then working through some options until we get a really lovely photograph with just the right amount of soft or fill flash. Watch this.

OK, we're out with Janet and a lovely European Barn Owl. Janet did you know you have feathers stuck in your hair? You do. We have a direct flash. We're going to talk about flash. You know, this is a situation that's fairly well lit, you would think, why would you need flash? Well, I'll use flash all the time to fill in shadows and to darken backgrounds. I do that all the time. I love the dramatic effect it gives.

And, we're going to start out with kind of the worst technique for flash, it's called direct flash. Flash is bolted to the top of the camera. A lot of your point and shoots will have direct flash too. You won't have a choice. It'll just be a flash built in. Even the owl hates the term direct flash, I can tell. So you'll have a flash built into a point and shoot, right? And it just blasts the subject. Remember, the farther back you are, the harsher the light. So we're just going to do things—as I would say—the wrong way. I guess really wrong would be trying to bounce the flash. What would you bounce it off of? It's good technique on a ceiling in a room, but for here, we're just going to fire away. We'll be back here, blast away. Alright. So I can see right now I don't like it. It's very harsh. It's a very harsh technique—straight on, OK?

So how can we do this on the cheap and get this flash so it looks a little bit better? Well one technique is to get the flash off of the camera. Get it off. We do that by using a sync cord or a lot of cameras will talk wirelessly, remotely, back to your camera. Keep this simple. We're going to do this with a little

bit of a sync cord. We're going to get this off to the side. It'll make it a little bit better, I think. Little bit more directional on the light. Still kind of harsh, though. What can we do to make it better?

Oh! We can take a Kleenex, look at this, or a napkin, put it right—hopefully not a used napkin or a used Kleenex—put it off to the side with this wrapped around it. This is called a diffusing device. It's simple. The front of the flash has a little diffuser on it. That's not enough. Let's diffuse it through a napkin or a tissue, whatever. Let's put it off to the side and let's see how that looks. Alright, let's try this. A little bit better. I can already see it is better. Isn't that something? Alright. So we wait until the owl looks, we get the eye. That's fine.

And you know what? I'm exposing that sky down. I'm turning the houselights down with my shutter and with my aperture here. It's one thing I can do. I'm going to darken it just a bit, make that sky a little bit more dark, and make it more dramatic. We like dramatic. We like the owl to look at us too, but we just have to wait. There we go. Nice. Alright, good. OK. So nice and subtle. Very nice, very nice.

Now the Cadillac, the Cadillac of lighting is what I call a softbox. This is a softbox. It's $50 maybe. Really easy to use. It's just a little piece of cloth that goes over a wire frame. You kind of bracket it. The bottom of the sync cord has a little screw hole in it—a little quarter, twenty screw hole—and you get a little nut that comes with it, and you mount that flash right to the bottom. What this does is it really, really spreads the light out well and diffuses the light. And that's key, because you want it to soften up—always soften up. You can't have the light too soft, really. And, do you know what's amazing? The look that you get with this, if you hold this close enough to the subject— the look you get from this is as good as if you had a $1,000 lighting kit. You just have to have it close to the subject. So, let's try this. We're going to put it right here, and we're going to see how this looks. Now that's just lovely, I mean, lovely. It looks like a million bucks.

And then, also, we want to move the light around from underneath, off to the side, from overhead. We're going to dial the light down. We can dial the light up and down, meaning make it brighter and darker, just from the back of the

flash. You can use TTL, through the lens, or you could put it on manual. The beauty of a digital camera is you can look right at the back of the camera, check the histogram, just look at it and see how it looks to you. That's great. Such an improvement over film to be able to actually see what flash is doing. So we're going to do this. Look at that. Just lovely. Go overhead. There you go. Beautiful, beautiful. Alright. Janet, of course, you are too, I'm not just talking about the owl. OK, so we get a little closer, just the face. And then I know I've gotten too close, haven't I because the owl baited off or flew off. No harm done. But just lovely, lovely. We've dialed down the sky, got a hint of the barn, and the owl is lit just perfectly thanks to just a little $50 attachment. But you know what, a Kleenex over the end, or a milk carton, something translucent will do the same thing. So, that's fill flash. Easy as that. Nothing to it.

Now, did you notice how many pictures I took? I shot, and then I looked at the back of the camera, made some adjustments, and then shot again. Get in the habit of shooting, adjusting, shooting, chimping, until you get what you like. Let's go over just a few things you saw me do in that field demonstration.

First, dial down your flash. The manufactures of flash think you must want to light your subjects like they are standing on the surface of the sun or something, way too bright. Check the menu settings for how to adjust your flash down.

If you have a stand-alone flash, there will be a way to handle that on the flash itself. Generally, I dial my flash down 2/3 of a stop, a full stop, sometimes more than that.

Get your external flash off that camera, by the way. Use a sync cord. It'll soften the light and actually, also reduce the red-eye effect, which is the bane of photographers everywhere, just getting that flash off the side.

More importantly though, it looks more natural. Most of the time things aren't lit with a light source shooting out of your head, does it? It looks natural if you get that flash off to the side.

You also saw me diffuse the light with a little tissue at Raptor Recovery. Diffuse, diffuse, diffuse. The softer you can make that flash, the better. And it will look more natural. Also, getting that flash closer to your subject, that'll soften the light too.

With a softbox, the best thing of all is the softbox you saw me use with the owl. It's kind of an inexpensive little thing, but I use it all the time on subjects from frogs, to babies, to flowers, you name it. If I can get close to it, then I'll beautifully light it with that little softbox.

You may have been surprised to learn that the closer the light, the softer it is, right? Softness is what we're all about. If for some reason you can't diffuse your flash, the next best thing is to bounce it off of something, like the walls or the ceiling or even another person or yourself, if you're close enough. You can't do this if your flash is bolted into your camera, built into a point and shoot, but you can if you have an external flash that can tilt or rotate.

Let me just show you what I mean. On this flash, the little Nikon right here, check this out. This flash, the head rotates and it tilts all at once, like that. So I can bounce it off the ceiling, I can point it around, go all the way backwards on it. That's the side that's towards me as the operator, very, very handy. It shouldn't just be used like that all the time. Lots of different ways to do it. Sometimes, I'll be shooting with it. I'll turn it and bounce it off my shirt if I'm wearing a colorful shirt. Beautiful reflected light off that, but the subject has to be very close to be able to do that.

Listen, if you're shooting inside and you have a unit with an adjustable head, bounce, bounce, bounce. Or put an index card behind that flash head. Tape a little card to the back of it—it could be a playing card—and it kicks a little light forward. Makes things a whole lot better.

Flash doesn't have to travel too far, though. It doesn't travel very far at all. You're better off being within ten feet with a flash, if you can. It just doesn't go very far. It really doesn't.

So, let me be clear. Flash isn't just for nighttime or indoor shots. You got that now, right? You can use it all times of the day. All times of the night too.

Let's look at a picture out in the front. Just a flash used to get rid of shadows, try to highlight my kids, especially my girl, because see, the flash doesn't go all the way out back to the boy, just her. Look at that. The sky is darkened, just a little bit of pop in there. We call that fill flash, right?

If I'm photographing in the middle of the day, but I want to use fill flash for the shadows, what do I do about the ambient exposure—about the rest of the scene? During the day, the middle of the day, that sunlight is really bright. I am going to add a little flash in there, if I can, to really beat the ambient light and soften my subject, and yet bring it out. I'll do that all the time. You bet.

I want to take you into the field again now and show you how I worked through this situation in my backyard in Lincoln—with my two assistants, Rebecca and Grace. I'm working with the ambient light here and with the softbox. So take a look.

OK, so, I want to talk about a problem situation when it comes to light. If you look at this scene, the lovely Grace and Rebecca are here. They're dressed up for no apparent reason, and we have tremendous light in the background, and they are in total shade. But this is the situation I want to work in, so what do we do? What do we do?

We're totally reverse lit here—what I call reverse lit. The background is lit, they're in shade. OK, so how do we handle that? When I shoot a picture of them standing there and I look at the back, I say, wow, is that the wrong way to be. They need to be lit and the background needs to be darker. So how do we overcome this? What do we do?

There are lots of ways of solving this problem. I could use a longer lens and kind of choose my background a little bit more carefully and find a darker spot. And then, basically, with a longer lens, blur out that background. I could do that. But in this case I'm going to use flash. I'm going to use a softbox to be exact. It's a little bitty box, I'll grab it here, and it goes onto my flash, right here. It's just a little wire frame. This is called a softbox. It's just a box. That's all it is. It's hollow. It just has a little translucent fabric on the front, and my flash is bolted to it. I'm going to get that flash off the camera, of course, with a cord, we call it a sync cord, just allows the flash to talk to

the camera, and what I'm going to do now—this is not very effective far away—It'll light them up, but it'll look a little harsh. So what I'm going to do is, I'm going to go up and get close to them and I'm going to expose the sky a little down, I'm going to turn the houselights down by increasing my shutter speed. I'm going to make the ambient light in the background get a little dark, and then I'm going to brighten them up with this.

A good rule of thumb to remember is the closer the light is, the softer it is. So I'm going to put this light right on top of them and see what we can do and just play with this a little bit and see what kind of effects we can get from what otherwise is not a really usable scene, because they're in such deep shade against a bright background. So let's give it a try.

OK, Grace come on up here. Come right on up, right up to me. Come on up close. I'm also going to try to do a little bit of, a little bit of near/far perspective, where one person is ahead of the other. OK, so right now I've shot a picture. The background is still very bright. That was at about 1/125th, so I'm going to go up to 250 and I'm going to see if that doesn't darken the background some more, because I want the background dark, and I want these guys lit, and it does work. And I'm going to move, so I have my background exposure, just right.

And by moving this around I can create all sorts of different effects, OK? I can go underneath for horror movie lighting. Alright, they don't like that very much, I'm sure. Then I'm going to go off to the side for Rembrandt lighting, which is often the best. I can go above for more police interrogation lighting—not that either of these gals would know what that's about. I really like this light that's three-quarters, kind of off to the side like that. It gives me a pretty good look.

And what's happening is, as I've lit them, these trees up against that sky, they all go into these silhouettey lines—gives us kind of lines, and they recede into the background, so it gives us more of a feeling of depth.

Photography in general, is a two-dimensional subject. It flattens everything out. Did you ever see a picture of the Grand Canyon that did it justice? No, because still photographs tend to flatten things out. So a good photographer

will always try to add depth and that means objects in the background that kind of recede away and get smaller, then you have an object in the foreground that's basically your main point of interest.

So I'm going to play around with this. I'm going to change the intensity of this light. It's a flash, obviously. It can do what I want it to do. I'm going to dial it down a little bit more. I have it on manual, and I had it on a 32^{nd} power. Now I'm going to go to a 64^{th} power and just have it down a little, little more, just a little bit more. Let's see how this looks now. Alright, a little bit too dark. I'm going put it back on a 32^{nd}, and I'm going play with the ISO just a little bit. I'm just going to shave the ISO down a little bit. There's lots of ways to get into this, alright?

Rebecca, come on up close to Grace, because the flash falls off very quickly. When you light a subject with a small flash like this, it doesn't carry three feet. You have to have things very, very close. You can basically light one thing. That's the disadvantage with this, but man, when you get it, you really hit a homerun. So let's try this. I'm going to put you right there, right behind her. Good, good, good. OK. Very nice. Let's see how this looks. Much better.

I'm going to hold the light out here so both of you are lit a little bit. Look right into the camera for me. OK. Very nice. Grace, turn your face this way a little, we'll get a little bit more light on both sides of your face. Very nice, OK. So, I really like how this looks. Look right into the light, both of you, right here. I'm going to attempt to blind you, alright. Now, let's see. Rebecca, look right here at me. OK, good.

Now I want to switch positions on you guys. So, there we go, just like that. Good. And just to mix it up, we'll put Grace on that side, Rebecca on this side. Get a little closer because we know this light can't go both ways. I'm going to cross this light, and I'm going to come this way. We're just going to do everything reversed just to see what we can do, just to see how we can do with it. That's kind of nice. It is.

My background still has plenty of light on it, and these guys have good light on them, and the colors are nice. I'm going to get back a little bit, show a little bit more of the red dress Rebecca is wearing. And I'm going to come in

a little closer to them. Good. They don't look like they hate me too much yet because it's not too cold outside. It's nice and warm still even though it's the fall. And let's see, what else can we do?

So, for this situation, just as far as a nice portrait of these guys, we'll try crowding them a little bit more like that, just for what we're trying to do here, I feel like this is pretty much what I can do with this light right now. It looks fine, looks fine. Look right here at the camera, both of you. Good, good, good. Rebecca, lift your head up a little higher, OK? Very nice.

Now I'm going to back up, and I'm just going to see the effect of this light as I get a little farther away. It's just a little darker. So as I back up, I'm going to increase the strength of this light. A lot of flashes will do this automatically. I like to work on manual mode quite a bit, if I can, because it just gives me a little bit more control. I'm going to increase the power of this light to an eighth power, shoot there. I'm going to get a little bit lower so I get more of the sky as I back up. I want to have the angle right. OK. That's not quite right. I'm going to get right in between and I'm going to go vertical to mimic the trees and to get the full waistline of their dresses, the length of their dresses, I should say. And, I'm going to get a little closer.

Alright, so, as far as what we can get here, I feel like I've exhausted this in what we can do right this minute, because they are just two people standing there. But it's a good way to illustrate how we can overcome bad light in the background.

Again, you can see what it takes to get a really good shot—you have to work and craft your pictures, really work it, and work it, and work it, but it pays off. It pays off.

I also use flash for one other thing, freezing action. Besides simply lighting my subject, really, strobe can be lightning fast and can freeze stuff.

For example, look at that. A hula-hoop frozen in mid-air. It's just fine. I popped a flash, just long enough to freeze the action. The background is kind of funky looking because I shot this handheld, no tripod, long, slow shutter speed, a 1/20th of a second, I'm guessing. Gives us the swirl of light.

Or, how about this? A horse trying to knock the blocks off of three cowboys who are trying to saddle it up. It's all right too. A little bit of flash. A little bit of flash.

Let's talk about dragging the shutter a bit. When you are shooting flash in a dark situation, you can have this bat-cave effect. It looks like your subject is in a cave. There are two things you can do, use a long shutter speed to collect what little ambient light is there—sometimes by long I mean a minute, 30 seconds—or put other flashes in the background to light it up, which can be a little bit complicated because of the necessary extra equipment. But you shouldn't be afraid to try it.

Since I don't want to carry a ton of gear all the time—life is to be enjoyed, not to torture myself, I figure, I'll just drag the shutter. That is, I'll have the shutter open long enough to soak up all the ambient light, and sometimes that's really good color, and maybe we'll have some people in the background that add color too.

As long as my subject is in the foreground and is sharp, it's OK if the rest of the world goes into a blurry mess; we call this ghosting and that's all right. To me, if the background is a little bit jiggly, it's OK as long as my subject or whatever is in the foreground is sharp. That's what I want. So I leave the shutter open to try to soak up as much light from the background as I possibly can.

How slow should your shutter be? I can't really tell you—you'll have to experiment with that. Work the situation. When I'm tinkering with light, I'm constantly checking the display on my camera. I'm looking at that histogram. I know that I have the light going long enough, I know my shutter speed is long, but maybe not too much. I don't want to blow things out. When you're adjusting light, especially flash, having that screen and histogram is a really good thing. It's a definite bonus and one that you want to take full advantage of.

Here's all I do. On my advanced SLR, I look to see that nothing is flashing in my viewfinder, meaning it's overexposed. Even if your camera doesn't have that feature, just open up the histogram and look. Is there any information

touching the right side of the graph? If so, that means you're clipping the highlights, you're blowing it out. If you want that, fine. If you don't, dial it down. Talk to your flash. Work with it a little bit and dial things down. Conversely, is most of the information hugging the left side where it's dark? It means your exposure is under, but that may be OK, depending on how you want your image to look.

Alright, for your assignment, I want you to take a series of four photos using different introduced light sources. Really be creative, and try these both in the middle of the day and at dusk to see what works, and when. You should be able to make a picture sing in most situations, provided that you've got a bit of time and good, close access to your subjects. Don't be in a rush. Lighting things takes a lot of time to do it well. If you do this correctly, you can take an ordinary scene and make it extraordinary, no question about it.

So we've covered the most important issues, really, of lighting in the last three lectures—found or ambient, color, intensity of light, and man-made lighting. We've learned how to manipulate aperture, shutter speed, and ISO settings in order to get the right amount of light into the camera and create an image on the sensor—or on the film. We're going to continue to learn more about all of these elements of photography through the course, but you've got the basics now.

Without light there is no picture, and crafting the light well is the mark of a caring, thinking, and practiced photographer. Do these assignments I'm giving you—not just once, but over and over again. And not only will you have some fun with this stuff, but you'll also be able to train your eye to understand the light you're seeing in the way your camera does.

So where do we go next? Composition—what do we want that light on? How do we translate that beautiful, three-dimensional life and world of ours into a two-dimensional art form like photography? That's a rich topic, too, and it'll take us another three lectures, at least, to dig into.

Now that you've got the basics mastered, this is what great photography is all about. We will see you then.

Composition I—Seeing Well
Lecture 9

Composition and seeing well are really the heart of what this course is about. All successful images are composed so that different elements in a photograph come together to tell a story. Composition involves looking and thinking and then deciding what it is you want to say with your pictures. It's one way of making order out of the chaos of life, but it's also perhaps the hardest thing about photography to master. Just about anybody can master nice light, focus, and exposure, but it takes patience, thought, and honest self-criticism to learn how to make well-composed photos.

Introduction to Composition
- There are times when your subject matter is so interesting—a stuntman on fire, for example—that no matter how you frame it, it won't be boring. Most of the time, however, you are trying to capture the every day in a way that's worthwhile to look at. That's a tall order.

- A photo of a bear catching a fish offers some hints about good composition. The bear was shot in soft light with a long lens to clean up the background. Its head and the fish are outlined perfectly against the white water.

- Good pictures, generally speaking, are well framed. Whether you're using an advanced SLR or a point-and-shoot camera, shooting with film or digitally, framing with the viewfinder is the first and most critical step in getting a good photo.

Photo Analysis: Bubble Series
- Let's analyze a series of pictures of a boy blowing bubbles on a summer day. How can we tone down the visually cluttered background of this scene and focus attention on the boy?

- First, think about the light; in this case, the day was overcast, so the light was fine, but moving around the subject didn't eliminate background

distractions. This situation calls for less depth of field and, thus, a bigger lens—a 70-200mm or even 200-400mm. Stepping physically closer also unfocuses the background even more from the subject.

- With the background nothing more than a wash of soft color, the next step is simply to work the scene. Take your time and shoot multiple images to get a shot that looks professional.

- Keep this maxim in mind: If it's in your picture, it's working either for you or against you. If you have distracting elements in your photograph, figure out how to get rid of them. Move the subject if possible, change your angle, change your perspective, change your lens, and get closer to the subject.

© Joel Sartore.

With a shallow depth of field, the background gives us the little information we need; we know that we're in a wooded setting, but our attention is on the subject.

- Every portion of your image counts, and every element must be there for a reason. Don't keep things in your picture just because you didn't take the time to figure out how to eliminate them. If something is in your picture, it should be there because it's what you want, not because you couldn't solve the visual problem.

- Another series, this one of kids on a trip to the grocery store, again shows how a photographer works a scene to get a good photo: First, find the direction where the light looks best. Look for what you want in the background, and change lenses if necessary to blur the background. Always think about what's inside the viewfinder. And take the time to experiment.

The Rule of Thirds

- The rule of thirds has been applied by artists since the time of the Renaissance to dramatically improve composition.

- Imagine a tick-tack-toe board dividing an image into thirds vertically and horizontally. The four points where those lines intersect are the power points—at the top right, top left, bottom right, and bottom left.

- In an image of a mother and daughter, positioning their faces on the top right power point and their hands on the lower power point makes for an aesthetically strong composition.

- As you gain experience, you'll learn to apply the rule of thirds intuitively to create dynamic tension in your photos. Centering your subjects is acceptable, but often, putting them to the side is even better. The more pictures you run through your camera, the better feel you'll get for this rule of composition.

- In a series of photos of pigs, note that there isn't something going on in every corner, but the rule of thirds holds the photos together compositionally. Keep in mind, too, that you still need to think about other elements—soft light, a clean background—as you shoot.

- With this rule, you can make interesting pictures even without an exotic subject.

Vertical Framing

- Vertical framing is another way to switch up the composition of your pictures and create dynamic images.

- A horizontal image of a giraffe doesn't really emphasize the height of these creatures, but vertical framing highlights the elevator quality of the giraffe's neck.

- In a photo of a baby at a window, notice all the elements in the image that suggest vertical framing: vertical lines under the baby's feet, his

upright stance, vertical lines behind him, even the vertical stripes on the cushion.

- In an image of a mountain goat licking salt off the rocks in Glacier Park, vertical framing shows how high up the goat is on the cliff walls, adding interest and tension to the frame. In fact, the whole point of this picture is the vertical nature of the situation, the fact that the animal will die if it slips and falls.

- Look for opportunities where shooting vertically will make your composition or storytelling stronger.

"Photography Is Hard"
- In order to improve your photographs, you need to evaluate them honestly and critically. You need to judge every aspect and element of

Behind the Lens

Here's another secret from behind the scenes at *National Geographic*, and this might help you if you think you aren't getting any good pictures. Less than 1/10 of 1 percent of what I shoot makes it into a published story. I mention this because it's easy to get bummed out when you're reviewing your photos. None of them [is] going to look better or good enough, to you at least. You wouldn't believe the garbage that I've shot over the years or that I *still* shoot. On assignment for the *Geographic*, I shoot junk daily! My editors could tell you; they could verify that. Do I let it beat me down? Sometimes I get a little discouraged, but I pop right back up. I have to. My job's on the line. I'm only as good as my last story. If I didn't do my job well, somebody else would. There's a line around the block to work for *National Geographic*.

So what do I do? I pull myself back up again and I start shooting again. Besides, I know, and you should, too, that every bad image you look at and evaluate will improve your work, if you're honest about your evaluation. If you shoot 100 pictures and come out with 1 that's outstanding, you should celebrate that as a success. I, as a *National Geographic* photographer, may only get 1 out of 1,000 that I'm pleased with—1 out of 1,000—or even less.

your images to determine what works and what doesn't. Be your own toughest critic and never be satisfied. No one will care more about your photographs than you do.

- Those who can't see what their work is lacking will never get any better. Nothing changes human beings faster than being a little uncomfortable. If you want your photography to improve, then get uncomfortable with the level you're at now. If you make yourself uncomfortable enough mentally, you'll force yourself to do a better job.

Assignment
- Pick a subject—a person, a pet, or something else—and try to make three very different photos of it during the same session. Frame your photo with just a small portion of the subject or show it very small in a grand scene. Make three visually separate images of the same thing.
 - o Consider carefully what you want in the frame and what might be better outside the frame—for any reason—the more interesting, the more surprising, the better.

 - o Try the assignment with three different pictures of something fairly common, such as dollar bills.

- As you work, think about the rule of thirds. What power points will you put in your pictures? Move around and build your pictures from the background forward. Examine your entire photograph to make sure the context is right for the subject.

Suggested Reading

Bendavid-Val, ed., *National Geographic: The Photographs*.

Stout and McMillen, eds., *The Pictures of Texas Monthly*.

Homework

Pick a favorite subject (a person, a pet, a doll, or whatever) and try to make three very different photos of the same subject during the same photo session. You can fill the frame with a small portion of the subject or show the subject very small in a giant scene, for example, but think outside the box.

Composition I—Seeing Well
Lecture 9—Transcript

Hi again, everybody. Composition and seeing well is one of my favorite subjects, and really the heart of what this course is, in a way. All successful images are composed so that different elements in a photograph come together to tell a story. Composition involves looking and thinking and then deciding what it is you want to say with your pictures, and it is one way of making order out of the chaos of life.

Composition really is the hardest thing, though, out of everything to master. Just about anybody can master nice light. You just wait for the sunset, right? And just about anybody can master focus and exposure. Modern cameras can do that for you, but, finding something interesting, or showing something commonplace in an interesting way? Now that takes talent.

I want to show you a set of photographs that I consider interesting, and then we'll talk about how to compose a picture well, OK? Now there are going to be times when you run across something so interesting that no matter how you frame it up, it's not going to be boring.

Take this, for example. Here's a picture that's not necessarily composed well, but it's a guy on fire, so I think that qualifies as something interesting. This is actually a stuntman friend of mine named Dr. Danger, and, you know, when you see this guy light himself on fire at a state fair for a half-time show, it's going to be interesting, no matter what. So you get a frame and that's great. That works, but most of the time, we're not dealing with stuntmen on fire, are we? We're trying to capture the everyday in a way that's worth our time to look at. That's a tall order.

So, I want to look at a couple pictures now that were actually seen fairly well and talk about what makes them work, and there's nothing on fire in these pictures, although, we do have a big grizzly bear in this one.

Look at how this one works and let's talk about it a little bit. It looks clean, doesn't it? It looks like it reads fine, but why does it read well? What is

it? You have to actually stop and think about this, unless you're told by somebody like me why it works, it's a little tricky to figure out.

First of all, long lens choice and soft light. We have a dark animal, we have nice, soft light, a long lens, cleans that background up, but beyond that, look at that. That bear's head is etched in the white water there, isn't it? And, look at that fish. Perfect. A little lower, it'd be kind of junky, but that fish stands out perfectly where that bear has it. And it happened in a split second, obviously, didn't even know that I got the frame until I got home later and processed the film. This is back in film days, but nice and clean and the fact that the fish is perfectly outlined against that water, that's what makes it work.

But, you don't have to have, let's say, bears in a waterfall to make it a nice-looking picture. Let's say you're in a taxidermy store. You can make this work too, even if you're in a taxidermy store. These are dead bears, and one dead wolf. They're being turned into rugs, and this is actually during the drying process. Why does this work?

Well, the light is fairly subtle. We have leading lines going in there. We have rule of thirds, kind of here, and there, and the other. Beyond all these different compositional techniques, though, what do we have? We've got a bunch of bears that look like they're singing in a chorus, and that's kind of interesting.

OK, let's say that we're not at a taxidermy story in Alaska. Can we make a good frame closer to home? I can. This is just guys out hunting Canada geese, but they happen to be sitting in giant, magnum-sized goose decoys. That's interesting! That will work too. And look at this, we have off-center composition, we have beautiful light, very early in the day, sunrise, little things sticking in, a bit of depth of field going back to this other guy—not much depth of field, but enough to see that we have another hunter sitting back there, and that works because it's interesting. It didn't work for them too well, because I was outside the blinds, and I don't think they got a goose that morning, but it made good pictures. It made *National Geographic*, and they got geese later that night.

But, what does it take to make a good picture? Something interesting. Really, truly, that's where it starts. So, good pictures can come from anywhere? Yeah! And even if it's a miserable situation. In fact, I don't get disgusted with things anymore. I just see everything bad that happens to me as good material, believe it or not.

We can look at something like this. This was in the Amazon many years ago in South America, and this was dinner. They prepared this big feast for me of fish and puppies to eat. I'm just kidding about the dogs. They were just sleeping. But, I digress. You know, it's nice, soft light, and we have things holding the corners of the frames together very well. Something interesting, a little bit of action. You know, it's a pretty miserable situation for me, because I'd never really been out of the country much before. This was many years ago, and look, that's dinner? That was a big feast down there. So, it's kind of a miserable situation, but it makes pictures! And that's what I'm there for, making pictures.

So, good pictures, generally speaking, are well-framed, right? Whether you're using an advanced SLR or a point and shoot camera, shooting with film, or digitally, framing with the viewfinder is the first step and the most critical, in my opinion.

Let's compare and analyze some other pictures that we'll see now in terms of their composition, OK? I've done a whole little sequence here of my son blowing bubbles on a summer day. We're going to talk through how we basically take kind of a lousy, visually cluttered situation and really make it sing.

In this case, this is what I would call just a jumble, or it's chaos. There are a lot of things working against me here. This is a time when there are things in the background, and we're trying to concentrate on the foreground. It's like a visual traffic jam, isn't it? It's just a cacophony of stuff here going on. Let's talk about how to fix this situation. I shot this just for you to illustrate this. And it was hard for me to do, I mean, it was.

So, how do we make this sing? I'm thinking about which way the light is best, first of all, and which way is the background best? What's the center

of attention? That last one is the easy part; it's Spencer who is the center of attention, obviously, with his bubbles, but how do we get there? How do we fix this? Well, let's just walk through it, let's walk through it.

First, I think about the light. The light's overcast. It's OK. It's fine. No matter which way we look, boy, that's kind of rough. Now, I'm not going to touch any of the elements here. I'm just going to go with them having fun and be a fly on the wall. I come around here, a little bit wider lens. Got a little bit of a distracting cooler back there, I don't know, maybe it's color, but there's a lot of junk. There's a lot of stuff going on. It's just not as good as it could be. It's OK. I hate this stuff coming out of his head though. I hate that.

What else? Well, let's see. Let's get him over a little bit. You see? I've moved his head from in those chairs over to those bushes. That might work a little bit better. My wife's expression is not as good here. I can't see the bubbles as well. It's pretty jumbled. It's still pretty cluttered, isn't it?

Let's get out a bigger lens. This calls for less depth of field. Let's get a bigger lens. OK. Now we have the 70–200 mm on there. The last lens was probably a 28–35 mm. Now we have the 70–200 mm on there, probably set it about 200 mm. Let's look at this.

OK, we're getting there. Now we're clean. That's fine. I just want to show Spencer and his bubbles, that's it. But we've got a little bit too much depth of field. I'm really seeing a lot of distracting things. Let's try to use a longer lens.

OK, now we're talking. Now we're moving. Maybe we're a little closer with the 200 mm. Stepping physically closer makes the background go a little bit more out of focus from your subject. The closer you get, the better it is. So I still have a post. I have a bird feeder there, or birdbath there. I'm just not sure. There's a bench. I want to make it really clean for the point of this illustration, because we're just kind of learning about how to clean up the chaos of life, so I want to make it really clean.

Time to get out the big glass—the 200–400 mm. Look at that. Now we're talking. That background really just goes to a wash of soft color—really

working this now. Now I'm finally where I want to be, and now I can take my time and kind of work this, and really shoot as he's moving around the background—the problem's solved, the problem's solved. So now I just wait and work it and see what opportunities I can get. And there's the frame I like the best. I love the fact that you can see his eyes through the hoop. There's one bubble. That's the frame I like the best. That's the one I landed on.

So the last couple pictures out of the entire situation, and I probably shot 30 or 40 images here, maybe more, using that lens, now we're finally to the point where it looks like a professionally shot picture, aren't we? The rest of them just kind of look like amateur hour. They really do. Just snapshots. A lot of depth of field, wide angle things.

With the shallower depth of field, the background here gives us not much information, just the right amount, I'd say. We're sharp on him. That's all I want. No distractions, just little Spencer. The green and brown colors let us know that we're in the woods, and that's fine. That's where we get our keeper picture. That's good. Problem solved.

I like to say this in general: If it's in your picture, it's either working for you or against you. If you have distracting elements in your photograph, figure out how to get rid of them if you don't want them in there. Move your subject if possible, change your angle, change your perspective, get high, get low, move around or, in this case, I just used a different lens and shot towards the woods to blur out that background. Get closer to the subject. That'll blur out your background a little bit more.

That's what we had to do with Spencer. That was my only option here, because I couldn't figure out how to get rid of that clutter in the driveway without using a long lens and blurring the background. I wanted to use the trees and branches as kind of my soft palate of green back there.

Just remember, every portion of your image counts, and every element must be there for a reason. Truly, don't have things in your picture because you were too lazy or couldn't figure out your way around it. If something is in your picture, it's there for a reason, because you figured out that's what you want; not because you couldn't figure out your way how to solve the visual

problem. It's really that simple. You have to spend some time with this, but it gets easier as you go, trust me.

So how about another example? Another one we can try with your own favorite subject. In this case, it's my kids.

I took my kids to the grocery store one night, and out in the parking lot I tried to shoot a situation kind of lousy for you guys and then tried to work towards a good conclusion. They were not very happy about this. It seemed that I'd deceived them. I told them we were going to the store for ice cream. I didn't tell them they'd have to earn it by posing for me. It was hot and way too sunny. They wanted to stay in the shade of the car. There they are, looking real, real happy, and off we go.

So, how did we do this? Well, went to the gas pump to fill up the car, got them out while we're filling up. Look at this. What do you think? Is that a successful picture, do you think? I don't think so. Big distractions everywhere and besides, look at this. They're squinting into the sun. They're having a terrible time. Look at that. Could that picture be any worse? Big, white post, a lighting post coming out of Ellen's head, a big white truck. I don't see how it could get any worse. This was a very tough situation, but on we pressed, on we pressed.

I though, OK, we'll get away from the gas pumps. Let's go a little closer. Let's go a little farther away from the gas pumps and a little bit closer to the store and see how this works. We'll shoot across. Still no good. The light's no good. She's got a post coming out of her head. There are a lot of distractions. It's just not a good vibe there.

So, I'm thinking, OK, let's go across the street. There's a little storage area in a parking lot across the street. Let's go across the street and see what we can do. This shows you what we're dealing with here. OK, what do you think? Is that a nice situation to do a portrait in? Does that look good to you? Of course not, but watch how we work this, watch how we work this.

First of all, I do the same thing I did with Spencer and the bubbles. I look for the light. Which way does the light look the best? Not that way, that's more

into the sun. I don't care for that, OK? Now we're turned back towards the east, because this is late in the day. OK, that's fine. Now I'm starting to see something here. Big blue sky with little clouds. Is that the direction I want? We're looking north. No, look at this. This looks pretty good. I think we can make a picture here actually, provided we can clean all this stuff up. How do we do that? Watch this.

Now, I'm very excited about this picture. Ellen's not very excited. She griped the entire time we were doing it. I still paid her in ice cream, though. But look, we have these distractions, but look, now we're getting somewhere. Big, epic blue sky, white puffy clouds. We can use that as our background. We sure can. We just need to change our perspective and change our lens.

Ho, here we go. Let's move around behind it, get the post out. We're starting to get there. A little bit longer lens, a little bit lower perspective. I'm starting to feel it here. We're on the back side of the post. Now we've got our background worked out. That's not quite the pose we want, maybe something happy. But look at how we took a really, really tough situation and worked it into something that actually works. They got their ice cream. That's sweet, OK?

Do you see how we can make something good out of just about any situation? Yeah. What did it take? Well, it just took thinking about it. That's it. We had to move around. That's what you have to do. When you're framing things, you have to think about what's inside that viewfinder, what you keep in the viewfinder, what you get rid of. You need to think about this. You need to think about the lighting. You need to think about your lenses, aperture, shutter speed, everything we've talked about so far.

The bottom line is experiment. Look at how much I experimented on that to get to the right frame. I worked it. I thought about it a ton. It didn't just happen. We worked that, I don't know, 10, 15 minutes or so, but we got to a nice point there, we got to a nice payoff picture. It doesn't always work out, but a lot of times it does, a lot of times it does. You have to put some thought into it though, don't you?

Now, I want to talk about rule of thirds. This is a little secret about framing that I've known for a long time. And, this is the way that I and a lot of other professionals shoot. We shoot with rule of thirds to really improve your composition dramatically, and you can too. Rule of thirds, it's a photographic standard that's been around for a long time, long time. The masters used to paint this way in the Renaissance Period. It's very easy to remember and apply.

So, imagine a tick-tack-toe board dividing an image into thirds, vertically and horizontally, easy enough. Tick-tack-toe grid on your picture, OK? The four points where those lines intersect are your power points. See the points right there? Top right, top left, bottom right, bottom left, these are your power points, OK?

So let's look at an example. This is Kathy and Ellen, my wife and daughter, lying on the floor of her bedroom, one of the only clean spots, we have a nice clean background. This image is fairly tightly framed, and it shows the two of them almost dead center, and it's a nice little moment, nothing wrong with it. It's fine. The light is nice and soft, the background is clean, and there's a connection there. It's a very nice little picture.

But, let's try this. Look at what happens when we loosen up the framing. Look at this. Much better, much more interesting. First, we have more context now, don't we? By broadening the image, we show the toys on the floor and we know that we are probably in a kid's room or play area and that they are taking a break. I've also changed their position in the rule of thirds grid. I've moved them to the right. I've just shifted my camera left. Changing your subject's position in the grid can change the mood of an image. A little bit more tension there, alright? Look at this. I love the fact that we're playing off these two and here up there as well.

So here's the same image with the grid laid over it. Kathy and Ellen's faces are smack on the power point, right there, and this doll isn't far from it either, or this, right? So, the upper right-hand corner of the frame, that's really working well. Their hands are close together to this lower power point, below that, so it makes for an aesthetically strong composition. It works, it works.

After a while, you're going to figure this out intuitively, believe it or not. You're going to know how to create what I call dynamic tension in a photo. You're going to know that, while centering your subjects is OK, sometimes putting them off to the side is even better. You're going to know this, and you're going to get a feel for it, and you're not going to have to think about that grid. It's just going to come naturally to you because you're going to do it. You're going to get better through practice.

It's a function of running enough pictures through your camera. That's it. It's a matter of doing this a lot, and I don't expect people to take a marker and put a grid on the back of their camera, but I do expect you to think about getting the subjects off center once in a while, that it is an option for you, you don't have to center everything, and about putting things in the corners of your pictures. I like to apply this rule of thirds. It's important, but it's more important to pay people off visually. Remember, if it's in your picture, it's because you want it, you want it.

I really call that picture a picture that you can walk around in a little bit. With Ellen and Kathy laying there, you look at the doll, the clutter in the top left. Everything's working here, everything is. You can look at the other doll's feet. You can look at the interaction between Kathy and Ellen, the way they are holding hands, the way Kathy's hair is splayed out on the carpet. It all works. It's a nice picture. It's clean, it's something interesting, the light is good and the composition is fairly strong. And guess what, folks. This was not shot in Timbuktu or in some stream with salmon and bears. This was shot in my daughter's bedroom. You can do this too, it is that easy.

And a key thing here, remember, is our perspective. By getting up on a chair and looking down, I'm taking a bird's eye view, aren't I? In a terribly cluttered house, my house, boy does it help to clean things up visually, with three kids, two dogs, and a cockatiel. I often get up on a chair and shoot straight down on the floor because that's the only space left in the house for a clean picture. I do that all the time. It's kind of pathetic, but it's true.

So, now let's get a little more complicated by going outside my house to apply this rule of thirds on one of my favorite subjects—pigs. Look at how the rule of thirds works in these examples.

First, pigs in the mud. It's kind of dark, we've got a little bit of extra light coming in here in the front, and look at this. Rule of thirds here and here and here. Maybe not so much in the top corner. We don't have to have something in the corner of every picture, but you know what? Here and here and here, we have things going on. It would have been a lot better, this picture, if these two pigs had been looking up as well, but they're not, but rule of thirds, that holds together.

OK, now, vaccination time at a pig farm. Maybe this does a little bit better job of rule of thirds. This corner, this corner. We have something holding the center and up here as well. Not much going on here, but we really have a lot of things. So this is a picture that kind of blends everything. Centeritis, I call it. Something strong in the center. I love shooting things center weighted, but also, we have other things going on here. There's a visual payoff in every corner of the picture.

What else? We're using a fairly shallow depth of field. We have them fairly sharp, we go way in the background. The background goes soft, and the light is nice. The light is very, very soft. Here's the other thing. Think about this. Remember the salmon held in front of the stream by the bear? Look at this, nice, clean, perfect blue background. Pose of the salmon against that white background, these little piglets really stand out because they're against this perfect blue background of her jumpsuit. So I'm thinking about all these things. Soft light, a clean background for what I want the eye to go to. Great.

How about this? A pig on parade. I love the rule of thirds going on here. That's fine. Hate the white van, the big white van back there. That's tough. What can you do about it? That's the best moment for the pig when he didn't want to go just for a split second, the girl is laughing, this is the moment. You know, that's it. This was the moment out of the whole parade there, but that white van, boy that's tough. Can't do anything about it. Wish that I could see more of that house. It's a matter of shooting a lot of pictures. I've never shot a perfect picture yet. This one is far from it, but it's cute and it does have rule of thirds going on in it.

Finally—another rule of thirds—my kids looking just like pigs through a screen door. Look, more up here. Rule of thirds, rule of thirds. It's soft light,

it's got off-center composition, and it's fairly interesting. My kids don't look like that anymore. They're a little older now, so I have this nice little memory of them being goofy, and so that's fine. Screen doors are a nice technique, by the way. That's good. That'll work, that'll work.

Obviously then, it doesn't have to be too exotic to make an interesting picture or two, does it? No, it doesn't. Now one thing you haven't seen me do much yet is frame things vertically. I tend to stay away from verticals, and I get razzed about that a little bit by folks at *Geographic* and elsewhere.

But you know, vertical framing—this is another way you can really switch up the composition of your pictures, and it is a legitimate way to frame thing up. I don't shoot a ton of verticals, because I've always thought that's not how we see. Our eyes are side by side on our heads for a reason. I figure, if we were meant to shoot vertical wouldn't our eyes be vertical on our heads? In some situations, truly, though, all kidding aside, vertical composition is very appropriate and can create a very dynamic image, so we should talk about that. We should take a look at it a little bit.

Look at these pictures of a giraffe, for example. I shot them in South Africa not too long ago. He's got a couple of little ox pecker bird on his neck, looking for ticks. It's fine, it's OK. It's a horizontal on a giraffe. That's unusual, right? It doesn't really emphasize, though, the way these creatures are made. They're almost made in an alien way.

These verticals—another horizontal. These verticals really show that. They really show how the giraffe has almost an elevator-natured neck. It's almost like an organic elevator the way that the heads move so far above the shoulders. Giraffes are built that way, obviously, for a reason. They can out-graze everything else. Because they are the tallest, they can get leaves that other animals can't get when it's really a tough time to get food. It's a very ingenious way of allowing that species to survive, and it's also a very easy way for me to show you why verticals are sometimes very appropriate. Look at this. Maybe that's the most interesting thing, maybe that is. I'm not even showing the head. It's just a study and it's totally appropriate to shoot this vertically, totally is.

Moving on, this is another picture that actually shows why you need to think vertically. I need to think vertically more often, by the way. I actually hurt myself by not thinking about vertical as a possibility. I really do. As I've gone through my career, I've noticed that. Vertical, vertical, vertical.

Little baby Spencer in the window of a hotel in a big city. This thing is begging to be vertical. Vertical lines under his feet. He's standing vertically. Vertical lines behind him. Everything about this scene is vertical, even the stripes on the cushion, everything. Everything points up and down. For me to shoot vertically, it just has to about hit me over the head like a plank for me to be able to get that. It has to be that blatant, but I do it, I do it, and there's a payoff for it.

Now here is one that is much easier to see why it should be vertical. This is a mountain goat licking salt off the rocks in Glacier Park. If you look at it you think, well, it's kind of poetic I guess. He's stretched out, he's shedding fur, and the rocks are craggy looking, the light's soft, but what's the big deal?

Well, now look, horizontal, now we get what the big deal is. Now you realize this is a life or death situation for this mountain goat. They're licking rocks to get salt off of them, by the way, to get the minerals off the cliff walls.

Now, only by looking at this vertically can we see that it is a long way down, and this adds interest and tension to the frame. The whole surprise about this picture is the vertical nature of it, the fact that this animal dies if it slips and falls. That's the whole point. So, it does not cut it as a horizontal. Sometimes you absolutely must go vertical. You absolutely have to.

Generally, the way I work is to only shoot vertical if it makes the composition or storytelling stronger. It must really add something to the final product. There really must be a legitimate reason for it. Now that's just me. Some people may love shooting nothing but verticals, and that's fine. Photography is really about pleasing yourself in a way. So, that's just fine. That's OK.

Now, this section I like to call Photography is Hard. In order to improve your photographs you need to evaluate them honestly and critically. What does that mean? You need to start judging every aspect and element of your

images to determine what's working and what's not. You need to be your own toughest critic to improve. I'm not kidding. You can never be satisfied. You have to be brutally harsh on yourself. No one is ever going to care more about your photographs than you do. It is essential that you learn this. You have to be harsh on yourself. You have to be critical. I promise. This is really worth remembering.

You know, the people who can't see that their work is lacking, will never get any better. Nothing changes human beings faster than being a little uncomfortable. If you want your photography to improve, then get uncomfortable with the level you're at now. If you make yourself uncomfortable enough mentally, you're going to want to move to comfort, and that's going to force yourself to do a better job. It's that simple.

Now here's another secret from behind the scenes at *National Geographic*, and this might help you if you think you aren't getting any good pictures. Less than one tenth of 1% of what I shoot makes it into a published story. I mention this because it's easy to get bummed out when you're reviewing your photos. None of them are going to look better or good enough to you at least. You wouldn't believe the garbage that I've shot over the years, or that I *still* shoot. On assignment for the *Geographic* I shoot junk daily! My editors could tell you; they could verify that. Do I let it beat me down? Sometimes I get a little discouraged, but I pop right back up. I have to. My job's on the line. I'm only as good as my last story. If I didn't do my job well, somebody else would. There's a line around the block to work for *National Geographic*.

So what do I do? I pull myself back up again and I start shooting again. Besides, I know, and you should too, that every bad image you look at and evaluate will improve your work, if you're honest about your evaluation. If you shoot 100 pictures and come out with one that's outstanding, you should celebrate that as a success. I, as a *National Geographic* photographer, may only get one out of 1,000 that I am pleased with. One out of 1,000, or even less. Man!

So here is your assignment for this lecture: I want you to pick a subject—a person, a pet, a doll, whatever—and try to make three very different photos of the same subject during the same photo session. I want you to take it and

frame it with a small portion of the subject or show it very small in a grand scene. I want you to do whatever it takes to make three visually separate images of the same thing. Consider carefully what you want in the frame and what might be better outside the frame—for any reason, OK? The more interesting, the more surprising, the better.

I did the assignment just recently to keep things interesting. I used the most common everyday thing I could think of to do this—money, money. So I thought, money, that'd be a good one to illustrate this for you guys. What about money? I thought, let's just do paper money.

Now keep in mind here the rule of thirds and power points as you're going through, but I wanted to do money. What about money? I went to the bank, I got some fresh $100 bills, put them in the grass. OK, it's soft light, we've got rule of thirds going on here, it's kind of interesting, it uses a very wide angle lens, there's some leaves to add accents. It's just kind of a nice, little soft picture. I don't know. It works.

Oh, here's a second way. Remember the assignment? Do three different pictures of something, OK? That's fairly common. What else? Tight shots. I did $1 bills as well. That's kind of interesting how they did the drawings and how they do the engraving. It's kind of good. That's alright. OK.

Now what? Now let's take for that third shot and really go for something here. Wow, OK. Maybe it would be better if the money was falling. Yeah! Maybe it would be better if there was a big pile of $100 bills falling from the sky. So I worked this and worked this to try to get it right. Look at this. That's the shot I ended up with. That's OK. That's good. It only took an hour and a half. I mean, over and over and over again.

Look at what I did with this, right? What power points will you put in your pictures? Are you thinking about rule of thirds? Are you thinking about that grid? Move around. Build your picture from the background forward. No telephone poles sticking out of people's heads. Examine your entire photograph and make sure the context for your subject is right.

Like I did. I worked it and worked it and worked it. By the way, check this out. This is how we did it. We had $100 bills blowing all over the place, over and over again for an hour and a half. Yes, it takes a long time to get $100 bills in the perfect spot.

OK, so, in our next lecture we're going to talk more about composition. I'm going to teach you more about backgrounds and show you how moving around your subject in new and interesting ways, taking a different visual perspective, can help you improve your pictures. I'll also give you a few more insights into the tricks of the trade. So, don't go away.

Composition II—Background and Perspective
Lecture 10

In this lecture, we continue our discussion of composition. You'll learn how bad backgrounds can spoil a photo and the importance of building a good background before you even start to shoot. We'll also see how moving your subject or yourself around—taking a different visual perspective—can help improve your pictures. Finally, we'll discuss the horizon line in photos and see how this element can contribute to the sense of importance of your subjects.

Bad Backgrounds

- A bad background can ruin the impact of a photo, even if it was taken in nice light. As an illustration, consider several pictures of a display taken in an outdoor outfitter store in which the background is crucial.
 - o The final shot makes people do a double-take. Why is a man dusting sheep in the mountains?

 - o If the camera were positioned a bit to the left or the right or a little higher or lower, other store fixtures, such as stairs and signs around the display, would have given the secret away.

- Clean backgrounds eliminate distraction from your subject and help to focus the viewer's attention. It's important to look at everything when you look through the viewfinder.

- It's true that a cluttered picture can work well, and in fact, a layered look is something that professionals crave. But as you're learning, it's best to stick to the basics and get to the point where your pictures are fairly clean and read well.

- One good technique for fixing bad backgrounds is to use natural screens, such as fog, smoke, dust, and clouds. These screens block the intensity and harshness of the sun, clean up the background, and add drama to a picture.

Behind the Lens

When you put somebody down low—as this drill sergeant literally did—when you are the photographer, it makes them look small and diminished.

I like this picture for a variety of reasons. The horizon line is way up, so it's not really distracting. I like the way that the kid's head stands out of that bush here. I like the fact that that drill sergeant is right in his face. I like the way the light is subtle. I like the way that the cleaned-off street makes the sergeant pop out. I love that you can see the rest of the platoon standing there, all in a row, all nervous, listening to what's going on in that exchange. This … young man … actually turned out to be a fine soldier. This is one of the first days of hell week, so the sergeant is really getting on him. That sergeant is actually a very good and decent guy, but man, he's tough.

We know where we are. We are on a military base.

Look at the rule of thirds going on here. The platoon is in the upper right. This is all going down in the lower left. And it's something interesting: a guy's head stuck in a bush and another man is screaming at him. That's excellent visually. It tells a story. I get jazzed just looking at this picture. I really like it. This picture is about 20 years old, but to me, it still holds up.

It's one of the few pictures I've ever shot, actually, that has everything in it: nice light, solid composition, and something interesting. I love the fact that this kid's hands are clenched so tightly. You know he is in pain [and not just] mentally. Lying down in a bush like that? That cannot feel good. Overall, this picture's got all the elements. Again, one of the very few I've ever done that's got everything going on.

© Joel Sartore.

Building from the Background Forward

- Unless something truly amazing is going on, don't start shooting until you have the background figured out.

- In a photo of a girl outside on a snowy day, the exposure, focus, and light are good, but the cluttered background—with houses, trees, and posts—spoils the photo. The problem here is to direct attention to the girl and offer just a hint of her location. Using a longer focal-length lens makes the background a little less distracting, as does shooting from a lower angle.

- In many cases, fixing an image isn't about the equipment; it's about seeing what's going on in the frame and adjusting your perspective and position to find the best scene.

Perspective

- The term "perspective" has two connotations: (1) the ordinary, meaning how we look at things, and (2) the technical, meaning how we present three-dimensional objects and spaces in the two dimensions of a photograph.

- You can use perspective to keep unwanted elements out of the frame by choosing to take a photo from a different angle. Sometimes, a unique perspective allows you to tell a different story in a photograph.

- As an exercise in perspective, pick a room in your home that you think would be a great stage for pictures.
 - Take a 360-degree look around the room through your viewfinder. Ask yourself: Which direction is the light best? Which direction is the background best?

 - Once you find a good position for yourself, bring something interesting, such as people, into the scene.

 - Take some shots at normal eye level, then get a bird's eye view and a worm's eye view. Consider the floor as a possible background for your photos.

- Most people don't think about moving around and changing perspective when they take photos; if you do, your viewers will think you're a genius!

- An aerial shot of a rural landscape is all about perspective. The two pickup trucks in the lower right of the photo serve as a placeholder and catch your eye, while the grass-covered hills undulate off into the distance. Using a fairly long lens makes the scene look tight and ensures that the trucks remain small.

The Horizon Line
- The horizon line plays an important role in the perspective you choose to take when shooting.

- Try experimenting with three different placements of the horizon line: again, at eye level, low, and high.

- As a general rule, in photos of people, keep the horizon line running through the middle of their heads. But if events are happening quickly, you may not be able to accomplish that!

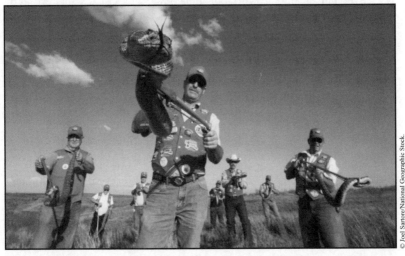

© Joel Sartore/National Geographic Stock.

A low horizon line makes the subjects appear large and imposing.

197

- Often, a low horizon with people in the clear above it makes the subjects look rugged and powerful—larger than life. Running a horizon line above someone's head can make the subject look small and diminished.

- In a picture of a girl on a bus in rural Alaska, the horizon line is in the window of the bus, allowing the viewer to see the village and get a sense of loneliness from the image. If the horizon line were lower, we would see nothing buy sky and the ceiling of the bus.

- A photo of men holding rattlesnakes would have been fine taken at eye level, but the low horizon line makes the men and their snakes loom large. The fact that some of the men are right on the horizon line and others are above it gives a feeling of depth to the photo.

Assignment
- For your next assignment, set up a scene and walk around it. Shoot it from the best spot with the best background and try both the bird's and the worm's eye view. If you're outside, pay attention to the horizon line if it's visible.

- Give yourself time to work out something that's visually interesting by thinking and planning before you shoot.

Suggested Reading

Latimer, ed., *Ultimate Field Guide to Photography*, pp. 93–95.

Sartore, *Nebraska*.

Homework

Walk around and shoot something from the best spot with the best background. Shoot it bird's eye view, worm's eye view, and 360 degrees.

Composition II—Backgrounds and Perspectives
Lecture 10—Transcript

So up next, in our subject of composition, are two critical steps in making great pictures, and they're related: finding a great background and examining perspective, including the importance of the horizon line.

A bad background can wreck a photo even if it was taken in nice light. In fact, I would argue—and I say this all the time—that bad backgrounds ruin more pictures than bad light. I know this is a fact. Bad backgrounds absolutely wreck more pictures than anything else I see. So first, let's take a look at a few photos so I can show you what I'm talking about here.

We're going to talk about this picture. We've seen it before. This is an image of the back of the Cabela's store in Sydney, Nebraska. The background is crucial to this picture. This is a taxidermy display at the world's largest outfitter there. I love that store because it's so visually loaded, and they have good stuff too, obviously.

The overall effect is that in this picture makes people do a double take. Is the sheep in the mountains? If so, why is there a guy there on a lift dusting them? What's going on? Why are they tolerating it? The sheep look like they're looking up at him, actually. It's a cloudy scene, and the light is nice, so we think, at first, this is outdoors. And I love that. The feather duster also has different colors of the rainbow on it.

So, if the camera were positioned a little bit to the left or a little bit to the right or a little higher or lower, other store fixtures like stairs and signage around the display would have been seen, would have given the secret away. Look at this. That's what the scene actually looked like from the balcony I shot off.

You wouldn't have any surprise at all if you'd seen that stuff, would you? I like the fact that that picture that we ended up with isolated it. Look at this. People are shopping around the base of the mountain. You have no idea. It's visually grabbing where we end up with.

So, we end up with something that's just basically a big display—there it is a little bit more loose—to something worth a second look, something that's fun and surprising, just by adjusting the background. Look at this, a little bit too high, no way, no way. Zoom in, we end up with this. That's the shot, because we've left out all sorts of stuff.

Good, clean backgrounds eliminate distraction from your subject and help to focus your viewer's attention. You need to look at the whole picture when you look through the viewfinder, when you're taking it. Remember, look at everything.

Let me say for the record that you can take a very cluttered picture and make it work well. Absolutely. An extremely layered look is something that professionals crave. But for now, I'd like to just stick to the basics and get to the point where your pictures are fairly clean and read well, OK?

On fixing backgrounds, now you know you have to look at your background as well as your subject. You've looked, and it's a mess. What can you do?

Well, I use natural screens all the time, like fog and clouds, that kind of thing. That's one way I do it. Use temporary background screens, if you will. It's fairly easy, not to mention fun, to make pictures in smoke and fog. Big geyser scene in the Atacama Desert, that screen of smoke and fog—look at that—makes these tiny little guys stand out perfectly. Easy. Real easy.

Or how about this, just a foggy scene? Completely makes the subject pop there. That's my friend, Brian, running down the road. Or this, just a little bit of fog makes this elk bugling stand out from the woods, just a little bit, just a little bit. A little bit of smoke, that's kind of nice. Fireworks smoke, takes the background, blurs it a little bit, really makes Ellen and her friend Erin pop out a little bit as they watch fireworks. Really does help. Or just a little bit of smoke in a parking lot really makes Spencer stand out there. I'm not sure how good it is to breathe that stuff, but that's 4th of July for you.

So, I think about this all the time. I think about using this type of stuff. What else? Well, really dusty scenes can help in the same way, dust. dust, believe it or not. Look at this. The biologist watching the bulldozer go by out in the

Mohave Desert, or just really dusty cowboys in the Pantanal, same deal. So fire and smoke and dust and fog block the intensity and harshness of the sun, they clean up the background, they add drama, and in picture taking, drama is very, very good.

So, building pictures from the background forward. I think about those backgrounds all the time, and this phrase is very helpful to me over the years. It's really saved my bacon a lot of times. I build my pictures from the background forward. What's that mean? Until I have the background figured out, I don't even start to think about shooting my subject, usually, unless it's something really amazing going on. Let me show you what I mean here. So this is Ellen in front of our house, right there in Lincoln, Nebraska on a snowy day, OK? Ellen's outside. Every element in this picture needs to be working towards that goal, not fighting it, OK?

So if you look at this, this is an example of a picture that's technically good. It's properly exposed and in focus, isn't it? No problem. It's a nice, soft light—it's at sunrise. But, you know what wrecks this picture? You know what wrecks the picture. That background. Look at that big post sticking out of her head. There are houses coming everywhere, posts sticking out of her head. Look at this. Trees sticking out of her head. It's really obvious. You know, we have all this stuff, it's just not as good as it could be. There are a lot of problems with this, but we can solve that problem, can't we? We can solve that problem. Look at this. A big part of this picture is the street—concrete. Do we need that much street? I don't think so. Let's work around. Still quite a bunch of streets there, look at that, quite a bit, neighbor's houses. We're trying to get into this mode here where we're really seeing things well. The houses next door are lovely, but they're kind of distracting still. What can we do? We have trees coming out of her head. We need to put everything into the frame perfectly so that we get our attention back on Ellen with just a hint of where we are.

So, look, trees. What do we do? How do we get those out of her shoulders? Use a little bit of a longer focal length. Now look. We've fixed that a little bit. We've made the background a little less distracting. Still not where we need to be, though, OK?

Finally, let's keep working. Getting down a little bit lower, getting the trees out of her head. Maybe that makes the picture work. Finally, we have the impression of the neighborhood, but the focus is on Ellen. It's about her, and maybe this is the picture we end up with because she's smiling, because she knows the photo shoot is over.

OK, so maybe this is it. She's lit a little bit better, we get the impression of a house back there, and it's all good, but we had to think about it. We had to think about our angles, where we were, high angle, low angle, depth of field is certainly important, focal length is certainly important here. We had to think about all these things and work through it. It's a two or three minute exercise, not that hard if you do it a few times. Practice makes perfect.

OK, so we've walked around, we looked, we worked that out. Was that so hard? Fixing the image wasn't about the equipment there, was it? It was really about seeing what was really going on in the frame and adjusting my perspective and my position to find the best situation.

So, I keep saying change perspective. What do I mean by that? There are two different connotations when it comes to dealing with perspective. One, the ordinary, meaning, how you look at things, and two, the more technical meaning—the way we represent three-dimensional objects and spaces in two dimensions that still photography provides.

Why choose this or that? Which angle looks the best in which light, and which background and which lens? These are lots of things to think about. Perspective is a really important compositional element. It not only governs how we look at things, but also what's in, or out of, the frame. Now you can use perspective to keep unwanted elements out of the frame—I do that all the time—by choosing to take a photo from a different angle. I got down low there to get the sky behind Ellen to get the trees out of her head, for example. Sometimes you want to clean up a background. Sometimes you want to create a new way of looking at something, to tell a different story.

Let's take a look at a few more pictures. These are from Queen Elizabeth National Park in Uganda. These are weaver birds hanging on their intricately built nests. But look at this. It's OK. They're silhouetted, but look at what

happens when we move a little bit. Same time of day. All I did was move. Check this out. I moved, you can see a few trees back there, watch. I moved. That's all I did. I moved a few feet, and I put a green background behind them. Literally, it's just trees back there. It's trees in the background. So we get this beautiful shade of green and all of a sudden, we can see the details in the feathers of these, birds and we can really see their nests. All by just moving a few feet. That's remarkable, but that's changing perspective. It's a wonderful thing. I really want you to think about your backgrounds, OK?

Let me show you another example of what I mean. I took advantage of several perspectives in order to get some really nice frames at my farmhouse in Nebraska. Let's go out in the field again. Take a look.

OK. So let's do an assignment on perspective, such an important tool in composition, I cannot stress it enough. How do we get the right perspective? I want you guys to do this at home with me, OK? Find a favorite room in your house, something that you think would be a great stage for pictures, alright? And then look around. I'm here in a country kitchen. Look around, 360° first. Look, look, look, look, look. Which direction is the light best? Which direction is the background best? That's what you need to think about.

So in this kitchen, I have windows on the south side, windows one, two, three, four. I don't want to shoot into those windows. I know that's not the direction. So if I look 360—and I encourage you guys to take pictures, look through your viewfinder as you're doing it. Look here, OK, look. This way the light looks best.

Now how can I make the background good? I need to clean it up. I have all these open doors. I think, in fact, I know—because I practiced before the cameras were rolling—that if I close these doors, I'm going to have a very clean background now. So it's as simple as this. I have a very, very clean background, look at this. Beautiful. Nice country kitchen, very, very clean. I'm ready to shoot.

Now, for a lot of people, they would say, oh, this is enough. I'll shoot old cracked woodwork, and, I don't know. Well, it's not enough for me. I need

something more. I don't have a cat. I don't have a bunch of candles. I don't have anything animate. So I'm going to introduce somebody.

Oh look, there's Carolyn. She just happens to be wearing a chiffon dress with a little shawl. How handy! You were just driving by, and you happen to be here. That's great! Thanks. That's fabulous. So we'll get a picture or two and Carolyn knows how to pose. She knows how to do that doe in the headlight look, like a lot of models, big city models. And, so, I'm looking here. The light is subtle, it's beautiful. I have my camera on aperture priority. I'm able to just basically get the exposure. I've already done the exposure. Whether the sun is in or out of the clouds it doesn't matter. My camera is compensating for it—I'm on aperture priority, OK. So this looks great.

But, I want there to be more of a connection, more of a story here. So I brought along Carolyn's friend, Cole, who happens to be my son. Cole, how you doing? Sit right there. Hop up, alright. So now we have a little bit of a moment, a connectedness. And you can do this, too, with your family members. Bring them into the scene. Find a great scene or stage, and then set the stage with the people that you know and love.

Alright, so, I'm shooting something here, let's see. Carolyn is twirling around, that's good, that's good, alright. Look over at Cole a little bit, because you're connected to him. Very nice, very nice, alright. So, these look great. It's basically a normal eye view as I stand here—as everybody sees. What we're going to do takes it beyond the obvious is we're going to try a bird's eye view from above and a worm's eye view from below and go way beyond what most people shoot, and it's so simple, OK?

Let's try the worm's eye view first. I'm just going to lay down here, same thing, same exact thing. Go ahead, Carolyn. Twirl your twirl. And look at Cole, don't forget, alright, very nice. And just stand there maybe. Sad there. Kind of flare the skirt standing there, both sides. Flare the other side. Cole, you could smile even if you wanted to. OK, and that looks great. That looks great. A little moment, a little connectedness, nice splash of color there in this room with the blue dress. Perfect, perfect. OK.

Now, it's hard to ignore the elephant in the room, and we don't want to ignore it. The stage in this room, believe it or not, is under my feet. The floor is going to be a great stage because it's this big checkerboard pattern. So Cole, hop down, and do not tell your mother that I'm going to do this, OK? Don't tell her that I'm getting up on the countertop.

Alright, so you guys are laying down, outstanding. And now I'm up here and I'm looking, and it's fabulous! We've got these two good-looking people, they're on the floor, I'm looking down, and the stage is the floor—my background. My nice, beautiful background is actually the floor, believe it or not.

So, there you go, a couple of frames that way. Maybe hold hands for one. Show that connection. You guys are best friends, very nice, and perfect. It doesn't get any better than that. Who would have thunk? The floor is the stage? I don't get it. But you know what? Oftentimes the least cluttered spot in your house is going to be your floor, so, get up above and try bird's eye view. Remember, 360°, find the spot where the light looks the best and the background looks the best. And then try low angle, normal angle, and high angle. That's it. People are going to think you're a genius, I promise.

You know, Kathy and I marked out that floor, and she painted it herself. It took her a long time. Look at that. A long time. Couple of days to do it, but it's an excellent background, isn't it? It's very unusual to put your family members on the floor, isn't it, and jump up on the counters to take pictures. But you know what? I want you to try that, too. Just be sure to take off your shoes. Don't tell anybody, and clean the counters off afterwards, alright?

Let's talk a little bit more about perspectives and backgrounds and moving around to get your best photographs. Honest to goodness, nobody thinks to do this, you guys. Changing perspective is a huge deal. You're going to be a hero if you can do this in your pictures, I promise you. Changing perspective—just moving around a little bit, high, low, around the subject—sometimes can give us just the look we want, and that's why you should try all sorts of them. Sometimes you want to do it to clean up a background. Sometimes you want to do it to create a new way of looking at something, to tell a different story. As you saw in the field demonstration, you can shoot

straight on, normal view, or climb on top of something—countertop, bird's eye view, or get down on the floor or the ground for a worm's eye view.

Now, look at this. A little bit more dramatic, bird's eye view. Bird's eye view of a bear coming up a tree—this is actually a captive bear, but he's still, he wasn't happy. Or a worm's eye view, look at this, down low. Look! We're down on the ground. The camera's down on the ground. A little bit of a flash there to light up the guy's feet. Simple things, simple things. But to me that's every bit as interesting as the bear picture. It really is, because we're down low. We're down low. That's it.

OK, so let's look at a couple more pictures and talk about how shooting from a different perspective changes the look and feel.

First, my friend, Carl Simmons, in a truck. This is a big landscape scene, but I've limited what you are able to see out here in the Nebraska Sandhills by using a longish lens. I'm looking at the sky instead of the land, aren't I? OK, now, look what we've done here with perspective and angle. It's a common scene, again, in the Sandhills of trucks, but from a different perspective.

Even though we're still in the Sandhills, the scene is nothing, let's say, you'd particularly notice. We have a long lens that does a couple of things for me, though. It compresses distance—makes everything stack up, makes the whole scene look nice and tight together, and also, it makes the trucks a smallish part of the scene, alright? If I'd been lower and closer to the ground, the picture would have been just about the trucks. But I really wanted the picture to be about the Nebraska landscape.

Now, this one. Take a look. The exact, same spot just a few hours later. This was for a story on Nebraska for *National Geographic*. This is their kind of light. This is their kind of seeing. See how the perspective from above—not very high up, but out of an airplane—really gets at the heart of this place? I wanted to show the Sandhills and the rural nature of this landscape, but you know, you really need something to catch your eye. You need a place holder. In this case it's those pickup trucks.

There are several things going on here. The road is single lane and it's paved, which is kind of unusual. You don't see that very often. It's kind of a dangerous road to drive on. If you come over a hill you don't always know what's coming right at you. It's very rural. Everybody out there is driving a truck.

The people are very good neighbors, and they stop and talk when they see each other on the road. The countryside is undulating, stark, yet tremendously beautiful. No trees, just the world's largest grass-covered dune field, is what they say, and I wanted to show that. By using a fairly long lens, rather than wide, and an aerial perspective, I'm compressing all that. I'm making it seem as though the world is endless there. In a way, I guess it is.

Now let's look at this one as far as perspective goes. It's a very straight forward picture, a white church in the clouds. So what have I done here? What have I done? Well, in this case, I'm thinking about the rule of thirds. It's in action, just as in the Sandhills picture, where the trucks were placed in the lower right-hand corner. I'm a big fan of that lower right hand corner. I've done it again here for this church, right? Right down there. Those big, white, puffy, prominent clouds balance out the other side. They kind of balance out the top, left-hand corner. Again, I'm using a longer lens here to compress distance, to make that cloud look really big, and I'm standing back far enough so that the church is fairly small.

By the way, look at what this looked like when I first got there. Not nearly as good. Waiting a bit for the sun to come out, though, just waiting a bit, reading a book and waiting, really helps make it sing. It really did. Nice job.

So, another Background Element: the horizon line. Let's think about this. This is really, really critical. Where do you place your horizon line? I've been doing this a long time, and I'm still not sure. I'm trying different things all the time. The horizon line is something you have to consider almost every time you shoot outside. It really plays an important role in the perspective you choose to take when you're shooting.

Now watch this. This is at a Celtic cemetery in Ireland. Let's talk about this horizon. Getting down low, that horizon line is a little bit low, isn't it? Look

at what happens. You can't see the cemetery as well, can you? Let's look. We can see the tons of crosses, for sure. We can see that, but that's about it.

Now, let's look. We're getting a little lower. Let's put that horizon line up a little bit. Now the tops of the crosses aren't nearly as visible, are they? Look at this. They don't stand out so well against the sky. So, I did try different perspectives. I tried different perspectives—down low and up high. Let's talk about this for a little bit. I think about this all the time. The horizon line is super high here. I can see all the crosses just fine, and the sky is diminished. It just depends on what you want.

I made all these judgments in just a minute or two. I was on vacation and didn't want to wreck the vacation. Kathy is smiling there, so I didn't overdo it. But I thought about what I wanted to show, and I worked it a little bit. I got three different images out of the same cemetery. That's just a little example of what you can do just by going from high to low and back again. That's it.

OK, so, wait a second, here's another cemetery. Look at this. That's in Nebraska in the dead of winter, so to speak—same thing. I did the same thing here. Look at this. We're a little above. That's just head high, and this is how we're always seeing. Our eyes are up here and we usually shoot from this perspective, and that's not bad, but I think in this case, getting lower really makes it sing. I evaluate each scene on a case-by-case basis. I'm down low. Now I can actually read and see how intricate and lovely that old gravestone is with the hand carving on there. It's just really, really nice.

I always think about where to place the horizon lines in photos, and this has always been a dilemma for me, particularly with people. The general rule is I really try to keep the horizon line from running though the middle of someone's head. Sometimes, if a situation is happening quickly, I don't even get that accomplished!

So, let's look at another one here from a friend's farm. Todd and Susan Rivers and their kids. They're out on the prairie at their farm near Raymond, Nebraska. I tried a high angle, but I liked this perspective, I really did, for a couple of reasons, really. One, it makes their kids all stand up above the prairie and them, and I love the prairie grass in here. I get a feeling of that.

These folks are very tied to the land. They're very connected to the prairie. I wanted to show that connection. They're very green and they're conscious about sustainability as well. They want the Earth to be a better place when their kids grow up. I wanted to show that connection.

The house is also no bigger than they are, really. In fact, it's shorter than Todd and Susan, isn't it? The reason I did that is I wanted it that way. I wanted it to be symbolic. A lot of thought went into this. I got there early. I thought about it for about a half hour, and then I moved us all out—once they came outside, they were ready for their portrait shoot. I moved them out away from the house so the structure wouldn't be as large as they were.

This was about an hour's worth of thought, trying to figure this puzzle out. Do I want to show their farm? Yes, I do. Do I want it to be the dominant thing? No. They should be the dominant thing. It's the portrait about them. They literally moved that farmhouse out to that spot. They saved that farmhouse. I wanted them to look stoic. I wanted them to look like pioneers, modern day pioneers, which they are, in a way. I wanted them to look epic.

Often, a low horizon with people in the clear above it makes people look rugged and big and powerful—larger than life, right? It makes them look like Superman, and that is one of the reasons I got down low on that last picture.

This is an angle, though, that very few people think about, oddly enough. They never want to get their clothes dirty, I guess. Photographers, we're always lying on our stomach. I'm telling you, some of the best pictures that I ever get come from lying on the ground. I have to watch out for chiggers though, quite a bit.

When you run the horizon line well below someone's head it has the effect of them looking larger than life, right? And this is a good thing. That's fine. On the other hand, when you run that horizon line above someone's head, it can make them look small and diminished.

Look at this one, for example, of a drill sergeant. I think that was his intent in this picture, actually. Look at this. When you put somebody down low, as

this drill sergeant literally did, when you are the photographer, it makes them look small and diminished.

I like this picture for a variety of reasons. The horizon line is way up, so it's not really distracting. I like the way that the kid's head stands out of that bush here. I like the fact that that drill sergeant is right in his face. I like the way the light is subtle. I like the way that the cleaned off street makes the sergeant pop out. I love that you can see the rest of the platoon standing there, all in a row, all nervous, listening to what is going on in that exchange. This is a young man named Private Berg. He actually turned out to be a fine soldier, but this is one of the first days of hell week, so that sergeant is really getting on him. That sergeant is actually a very good and decent guy, but man, he's tough.

We know where we are. We are on a military base, and look at the rule of thirds is going on here. The platoon is in the upper right. This is all going down in the lower left, isn't it? And it's something interesting—a guy's head stuck in a bush, and another man is screaming at him. That's excellent visually. It tells a story. I get jazzed just looking at this picture. I really like it. This picture is about 20 years old, but to me it still holds up.

It's one of the few pictures I've ever shot, actually, that has everything in it. Nice light, solid composition, and something interesting. And I love the fact that this kid's hands are clenched so tightly. You know he's in pain, besides mentally. Lying down in a bush like that? That cannot feel good. But overall, this picture has all the elements. Again, one of the very few I've ever done that has everything going on.

Now, in this picture, on this bus, in Point Lay, Alaska, this girl is the only passenger. It's kind of a small, little village in rural Alaska. Look at where we've put the horizon line now. Where is it? The horizon line is just right in the window of the bus. That way you can see the village. You can also get a sense of loneliness in the image, though. You really have to watch the horizon line. If you get down lower, what are you going to see? Nothing but the sky and the bus ceiling, right? You have to be at this height to see this girl's house out the window. You have to be in that height, that's where we're putting that horizon line.

It's pretty common sense, but these are types of things that I think about all the time, all the time. Placement of horizon lines is so important. Like many other aspects of this course, I guess, it's something that took me years and years and countless rolls of film and digital files to figure out. Consider this course, then, I guess, a head start. You are getting to cheat. You get to take advantage of the 33 stories I've done for *National Geographic* and learn how to shoot well, as quickly as possible. You don't have to suffer as much as I did.

Let's look at one more. We're talking about a horizon line here again. This is the Shortgrass Rattlesnake Association in Mangum, Oklahoma, all set for their big, rattlesnake derby. I am down low and the horizon line is down low. Look at that. Way down. That makes these guys and their snakes really big, really stand up above the horizon.

I think this would have been just as solid a picture with these guys each holding a snake. There's plenty of depth of field, and everybody, everybody is in there, and they're sharp from front to back. You have this western diamondback rattlesnake, though, sticking his tongue right at the camera. The tongue stands out so well against that little bit of cloud right there, up in the sky. It really helps it stand out. And the clouds also give us a little bit more depth and really help to break up the sky and make it more interesting.

This is why you need to think about horizon lines. If I was up high, would those snakes stand out? No, absolutely not, alight? And I love that some of the guys are right on the horizon line and some are right above it. It gives the eye a feeling of depth. The fact that they are holding live rattlesnakes that could kill you is awesome. A little something interesting there.

So when you are taking pictures, please be sure to consider these different things: bird's eye view and worm's eye view. What is above? What is down below? I think about that all the time. Every time I shoot, every time.

So here's your assignment: I want you to set something up and walk around it. Shoot it from the best spot with the best background. Shoot it bird's eye view, worm's eye view, and 360°. Really pay attention to the background. If you're outside, pay attention to the horizon line, if it's visible.

Remember how I shot those pictures in the farmhouse kitchen? I looked all around that place. I was looking to see where the light was coming from. Then I brought my subjects in, and I shot from a normal perspective, then from a worm's eye view, down on the floor, and then from above, straight down on Carolyn and Cole on the floor, against that great green and cream colored pattern. Give yourself time to work out something that's visually interesting. Think ahead, plan. It really will pay off. Again, people are going to think you're absolutely brilliant and all you're doing is moving around and looking.

So, we'll see you next time for our third lecture on composition.

Composition III—Framing and Layering
Lecture 11

In this lecture, we discuss framing, leading lines, and layering and look at how you can bring all these compositional elements together. Photographs are two-dimensional, of course, but you can create depth by framing and layering images to move them toward three-dimensionality, just like the world we live in. At the end of the lecture, we'll analyze three scenes of layering in detail, looking for objects that show the difference between near and far in the photos, as well as some of the other elements we've discussed, including lighting, depth of field, and perspective.

Framing and Leading Lines

- Doorways, windows, and fences can serve as natural framing devices, as we see in a shot of an elk framed by the grid pattern of a fence. If you spend a good bit of time in the car, you'll also find that windshields and rearview mirrors make interesting framing devices.

- Leading lines are naturally occurring lines that draw viewers into a photo; roads and train tracks are classic examples. Visually, viewers want to travel down the road they see. The road leads the viewer into the composition—into the frame—and helps maintain the focus on what's important in the photograph.

- A photo of cattle in an arena shows that leading lines don't have to be straight, and they can be wide or narrow. They are really just a way to get viewers more involved in the photograph. They have the same function as an arrow in a graphic, pointing to the emotional center of the picture. They help you show the viewer what to look at and even, in some cases, how to feel.

- Doorways and arches can serve as framing devices and provide leading lines. Arches in particular offer unique framing opportunities.

Bringing Composition Together

- A photo of a man building a dairy barn illustrates a number of the elements of composition we've been talking about: the framing provided by the doorway, multiple leading lines, the rule of thirds, and a broad depth of field.

- As you take more and more photographs, you'll come to realize that every picture you shoot has to take into account these elements of composition. If it doesn't—if the light isn't right or the depth of field is too deep or too shallow—the picture isn't going to re-create the feeling you had when you took it.

- When you analyze your photographs, ask yourself about depth of field, positioning of the subjects, framing, and leading lines. All these concepts come into play every time you put your camera up to your eye.

Unusual Compositional Devices

- Of course, a framing device doesn't have to be completely obvious. In a photo of a kayaker, a tree in the foreground provides intricate framing.

© Joel Sartore.

The doorway serves as a frame in this photo, while the trusses provide multiple leading lines.

The kayaker is basically at one end of the leading lines. This is a complicated picture, with an unusual framing device, the rule of thirds, and leading lines all coming into play.

- Windows also make interesting framing devices. Try shooting the outdoors from inside during the few minutes at the end of the day when the ambient light outside matches the ambient light indoors.

- In photography, you are in charge. Anything you can surround or envelop your subject with works as a framing device, and you can use almost anything for leading lines. In fact, one of the most interesting things you can use to draw the eyes of a viewer into a photograph is the eyes of others.
 - o When a person or an animal is in the frame, its eyes need to be in sharp focus for the photo to be effective.

 - o The eyes serve as connection points with the viewer. We naturally look where other people are looking, so the subject's gaze also directs viewers where to look in the frame.

 - o In a photo of Boy Scouts looking at a live grizzly bear, everything is said with the eyes of one boy standing across from the bear: He looks ready to run.

- A photo taken in a home in the Atacama Desert takes advantage of bright sun reflected off reddish clay, lighting the subjects from below. The subjects aren't looking at the camera, but their eyes clearly show that they're having fun. The eyes personalize the picture and give us an instant connection.

- Focusing on the eyes in a portrait of a drill monkey conveys a sense of consciousness to the viewer.

- Intentionally omitting the eyes makes the subject look mysterious or even sinister, as does having the subject keep a straight face, rather than smiling. Portraits in which people aren't smiling are often more interesting and compelling.

Behind the Lens

This is the kind of framing I hope none of you ever has to do. It's looking through a tomb—a tomb of someone who's been gone more than 150 years—at a woman's feet. See, in the desert, it never rains. So you see people—miners and miners' families—that were buried a long, long time ago—well over a century ago—and the graves have been looted, and the coffins are just lying around on the ground. The bodies are lying around. The clothing is there, the hair is there; they're mummies. It's just like they were buried yesterday....

In this case, we have a tomb that was opened on both ends already; looters had been there 100 years ago. I could literally just put my camera in one end and shoot out the other side. I could see the cemetery in the background and the old turn-of-the-century shoes, those leather shoes. It isn't lit great, but it sure is interesting. ... Above all, it's interesting because it's creepy, isn't it? It's something we don't see every day.... This is well before digital, by the way, so I was using bounce flash, but I couldn't really see what that flash was doing. Now with digital, I could really craft that light. I could take my time on it for sure. Nobody's going anywhere. I could turn that flash up or down and really craft the light.

By the way, at that cemetery, that was the nicest thing I saw.

- Having a subject look directly into a camera is one way to engage the eyes, but your subjects can also be visually connected to someone else in the frame. A picture of a happy couple at a party is probably more effective because the two people are looking at each other, not the camera.

Layering
- A shot of a boy with a butterfly on his nose illustrates the idea of layering. Here, we have direct contact with the camera in the boy's eyes, soft light and a soft color palette, a blurry background of leaves, and an interesting subject—a beautiful butterfly perched on the boy's nose.

- Experiment with layering by including elements in your photo that show the difference between near and far. Try looking for multiple framing devices, such as two doorways or a window next to a doorway.

- Photography is two-dimensional, but layering and framing will help you add that third dimension.

- All of these compositional techniques help us clean up the chaos of the world and capture the feeling of three dimensions in a two-dimensional medium. Layering makes for complex, artful pictures, but it's difficult to achieve. No photographer ever believes that he or she has made a perfect picture.

Photo Analysis: Layered Scenes
- A photo taken on Main Street in Salmon, Idaho, shows the only stoplight for 100 miles in any direction; the photo was meant to illustrate the isolation of this small town.
 - The picture was shot around dawn, so the light was soft and even. An afternoon shot might have been better because the sun would have highlighted the red building.

 - Layering in the picture is provided by the stoplight, the coffee shop sign, the street, the mountains in the background, and the one person crossing the street. Again, taking the shot later in

the day might have resulted in fewer shadows and more people and traffic coming and going.

- A photo of a small town in the Atacama Desert also has multiple layers: a man on a horse, small lights coming on against a pink sky, dogs, people, and signs.
 - o It's important to watch the scene build over a period of time; here, the street filled up and emptied out over the course of an hour or so.

 - o Notice that the blue door makes the head of the horse pop. These are the kinds of layering elements you should think about as you observe a scene. Try looking for them at a fish or fruit market.

- A final photo shows a scene at the end of a long day of pheasant hunting. The huge bales of hay make a great background because they are subtly lit and serve as leading lines all the way to the horizon.
 - o Here, we see a man leaning on the hay, with his pheasants on the ground around him, and other hay bales receding into the distance. Closer to us is a man holding a pheasant.

 - o The dog's interest in the pheasant creates a moment in the photo, making the scene about more than just layering.

 - o A wide-angle lens allows the viewer to see the big background and gives a nice sense of place.

- Whenever you shoot, take time to think about all the elements we've discussed thus far in the course: aperture, depth of field, and shutter speed; ambient and introduced light; colors of light and reflections; and the rule of thirds, perspective, leading lines, placement of the horizon, and layering. Be discriminating in what you shoot and be your own fiercest critic.

Assignment

- Layer and frame a subject in three photographs, but don't use a door or a window as a frame.

- Watch the eyes if you're photographing a person or animal and see if they give you any hints about framing.

Suggested Reading

Allard, *Portraits of America.*

Bendavid-Val, ed., *Through the Lens.*

Homework

Frame a subject in an unusual way using something from your house or driveway. No doorways though—that's too easy! Consider the unusual: You could frame someone sitting at a table through a napkin holder or someone grabbing a bite to eat as seen looking out from the back of the fridge (with some help from your camera's self-timer).

Composition III—Framing and Layering
Lecture 11—Transcript

Hi everybody. In this lecture we'll be talking about interesting framing of the subjects in your photographs and a couple of other important compositional elements. We're going to talk about lines—leading lines—roads are an easy place to start with that. We're also going to talk about layering, one of my favorite things actually. Hmm, layering!

The best photographs are really layered very, very well. Photographs are two-dimensional, of course. The depth you create by layering images is a necessary way to move them towards being more real, more three-dimensional, just like the world we live in. Let's start with framing then.

I always look for natural framing devices like doorways, and windows, and fences, and things like that. These can be a gimmick, but they can also be lovely and surprising, and they can add layers and depth. I use natural framing devices all the time on assignment. Let's look at a few examples.

This is out at the National Elk Reserve in Jackson Hole, Wyoming. This grid pattern, the fencing keeps the elk off of the highway, of course, but it can also be a nice framing device, right there. Let's put an elk in there. It would have been better if I'd had ten elk, one in each square, but I only had one elk, and that's good enough, though. This will work.

Now, what about this? Delicate Arch in Arches National Park in Utah, people go there all the time, and they frame up their family in that arch. It's a very obvious choice. You know, though, car windshields, I love car windshields. They're great framing devices. I love doing that. I do it all the time because I see the world through a car windshield since I drive so many places. I spend so much time on the road. That's actually not a happy site when you're being pulled over by the Chilean police for speeding in the Atacama Desert. We didn't know what was going to happen. I just know that I had to swallow hard, hold my breath, take this one little picture because I was afraid we were going to get in serious, serious trouble and get arrested, but it worked out OK. Everybody loves a camera, it turns out.

In this case, the windshield worked as a great framing device. It would've been better to see the driver's eyes in the rearview mirror a little bit, but I didn't really have the time to work and craft the situation, as you can imagine— just a quick frame and hope I don't get arrested.

Now, here's one where I did have a chance to work the situation. We're in an open Land Rover where the windshield literally folds up and out of the way. This was in the Pantanal of Brazil. That's my driver, who, believe it or not, was named Popsicle. I'm not kidding. So, Popsicle is driving along. We're looking for giant anteaters at sunrise, or whatever other wildlife we can find, and we see him framed in that rearview mirror, and it's nice. And he's lit, and the landscape is lit the same way. Everything is evenly lit. That's great. These kinds of things work out fine.

The next element I wanted to talk about is leading lines. These are naturally occurring lines in a photo, and a classic example of that is roads. You visually want to go down that road. You're not really looking off to the side, you are looking straight down a road. Roads lead you in the compositions; they lead you into the frame, and it continues on. Leading lines are a very basic compositional tool. They've been used since the Middle Ages in paintings. They're very handy, though. They'll help you focus on what's important by really leading your eye through the photograph, very easy.

You know train tracks work the same way, leading lines and train tracks. This is in a small town in Northwest Texas where my grandmother grew up. And these tracks are kind of a critical compositional element here, aren't they, beside the lovely the fall colors. It's just perfect to get you in. It's an old-fashioned photography trick on a very old town, Darrouzett, Texas. Painters use this trick all the time, all the time.

Now look at all these lines in this picture. Wow, lots of lines. It doesn't have to be a train or a road, it could simply be an arena's edge and the cattle inside, anything that simply leads your eye into the frame and involves you into the composition, right? So there are all sorts of different types of leading lines. Or like this. El Dragón, the giant dragon-shaped sand dune in Chile. It's absolutely huge. It has a line going right in. It takes you right into that paraglider.

You could have a leading line, for example, that's super wide, or it could be really narrow, simple. It could just be a crack in the pavement if you're close up on it. It could be a chalk line on a sidewalk leading to a kid. It could be anything. Leading lines really are just a way to get viewers more involved. That's all it is. Leading lines are just one more compositional element to think about. They're another tool in your tool box. That's it.

Leading lines can do what an arrow would do, really in a graphic. They point you to the emotional center of a photograph. They just point for you. They help. They help show what you the photographer wanted your viewer to look at and even how you wanted them to feel sometimes. How about that.

Doorways, doorways are classic examples too, classic examples of a natural framing device with leading lines. Here Kathy and the kids are framed up in the doorway, nice light, they're framed perfectly. It's an easy way to contain your loved ones. How about that? Huh, what else? Another doorway, how about an arched doorway? This is one of my friends, an ace carpenter, named Jon O'Hare in Lincoln. He's standing in the doorway at our little farm house near Dunbar, Nebraska. He has rebuilt this house with his own two hands, basically. It's a doorway alright, but it's a cathedral arch, a gothic arch. That shape frames Jon in a unique way. Keep your eyes open for things like that. The ability to photograph something like this horizontally, as well, is very helpful, OK?

How about this one? A little bit more chaotic, lots of leading lines here. This is a guy at a dairy. He's building a new dairy barn in Seward, Nebraska. He's framed up this big doorway for a big milking shed. Look at the leading lines. Notice how I used the rule of thirds too. Look at the amount of depth of field we've got here. What do you notice about the light? Lots of stuff going on, lots of depth of field because our light is very strong. I wanted all those trusses sharp, small hole in the lens, lots of depth of field.

Realize, as you take more and more photographs, you're going to realize that every picture you shoot has to work for you. It's going to have to have these things. And if they don't—you can't center everything—if the light isn't right, the depth of field is too deep or too shallow, the picture isn't going to create that feeling you had when you took it. What I'm getting at here is I

want you to analyze your photographs. What do you want? Lots of depth of field? Not any? Centered? Off to the side? Rule of thirds? You're getting the concepts, right? We're getting these concepts. All of them come into play every time you put your camera up to your eye, every time. You can frame things absolutely everywhere.

Take this place, the Atacama Desert in Chile, said to be the world's driest place. This is the kind of framing I hope none of you ever have to do. It's looking through a tomb, a tomb of someone who's been gone more than 150, years at a woman's feet. See, in the desert, it never rains, ever. So you see people, miners, and miners' families, that were buried a long, long time ago, well over a century ago, and the graves have been looted and the coffins are just lying around on the ground. The bodies are lying around. The clothing is there, the hair is there; they're mummies it's just like they were buried yesterday. It never rains.

So in this case, we have a tomb that was opened on both ends already. Looters had been there 100 years ago. So I could literally just put my camera in one end and shoot out the other side, and I could see the cemetery in the background and the old turn-of-the-century shoes, those leather shoes. It isn't lit great, but it sure is interesting, and we have this framing device there. And above all, it's interesting because it's creepy, isn't it? It's something we don't see every day, for sure. This is well before digital, by the way. I was using bounce flash, but I couldn't really see what that flash was doing. Now with digital I could really craft that light. I could take my time on it for sure. Nobody's going anywhere. I could turn that flash up or down and really craft the light.

By the way, at that cemetery, that was the nicest thing I saw. You should have seen it down there. It was really... Consider yourselves lucky that I don't show you more. That's my assistant, or my driver, actually. As the light got lower we tried a little bit of a different think with flashlights. You never know. I work stuff and work stuff and work stuff.

Now your framing device doesn't have to be completely obvious, by the way. It could be a, it could be a tree with a kayaker going through it. Look at this. This tree provides all sorts of intricate framing doesn't it? That kayaker

is basically at the end of these leading lines. Rule of thirds are coming into play here. We're talking about soft light, lots of depth of field. Look at what is going on here. A very slow shutter speed, and look at how those paddles are a little bit blurry as he's going through, so lots of things going on. This is a much more complicated picture, but it's using the same types of things, framing devices, rule of thirds, leading lines. It's all coming into play. I use framing devices all the time. I use windows to do that. This is at a wedding up in Minnesota where people are outside playing horseshoes, or whatever it is they're playing. You have windows on a tent, and it helps to make the world more interesting, because you can see through those windows and see what's happening outside, but you've also kind of compartmentalized things in and fit things in.

I was up at Leech Lake, Minnesota looking through our kitchen window with the funky, knotty, pine trim inside our little cabin. The trim has been burned with some sort of a torch to make it look more antique. There is wife Kathy outside swinging on a rope swing at dusk. There are a few minutes at the end of each day when the ambient light outside matches up with the ambient light indoors, and that's right when this picture was taken, right when it was taken.

Really, this is what I love about photography you guys, the world is your oyster. Think of anything that you can surround or envelope your subject with as a natural framing device. Frames and leading lines both help point the eyes to the subject of the photo, and the most important thing is your eyes can be drawn to in a photograph are the eyes of others. I love it when we use the eyes to draw people in. Eyes? Yeah, that's right—one of the most important compositional elements of all—when you're shooting people or animals—is the eyes. That's what we go for when we work for *National Geographic.*

This is a huge thing, really, truly. Even on a small little bird, huge. I've had so many images rejected by *National Geographic* because the eyes aren't in there or the eyes aren't sharp. Your subject's eyes play a major role in engaging viewers. When there's a person or an animal in the frame, its eyes need to be in sharp focus for the photo to be effective. This is my preference by the way. You may like blurry eyes, but boy at *National Geographic*, we

like them sharp. If you're doing close ups, at least one eye should be in focus, anyway. Eyes are kind of the *Holy Grail* in a way, aren't they? You can use them, along with your subject's gaze, to direct viewers into the frame or to lead them off to one side of the frame. They serve as connection points. We look at where other people are looking naturally, so of course we do it in photos. It could be animals as well. It could be anything.

So, here we have boy scouts on a field trip, talking about eyes again. What have we got in the frame? We have a live grizzly bear at a Boy Scout camp out. It's been brought here, it's a trained bear for the movie industry, but look at the eyes on that kid that's standing across from it, right there. You can tell, man, he looks like he is just ready to run. In this photo, it's all being said with that one kid's eyes and his gaze. We're not super tight. We can see the whole scene, but you get a kick out of it or a laugh out of it because that kid is looking so suspiciously at the bear and, I don't blame him.

This is back in the Atacama Desert. What's our composition like here? First, this is just direct sunlight outside, harsh sunlight, middle of the day, but we're not shooting that. No. Instead, we're inside taking advantage of the reflected light, all that bright sun is bouncing off the reddish clay yard that they have right outside their door, bouncing off that dirt and lighting these people from below, picking up color as it bounced off the dirt. It's like ghost lighting in a way, but it's a really lovely light, and it separates them from the background, which is not well lit, and has gone very dark, so we get a real good feeling of what their place is like, what their house is like.

Best of all, you can see their eyes. Only the lady in the lower right is looking at me. The guy is looking at the interpreter. The daughter in the middle, she's kind of looking off to the side, but they're having fun. Note that their eyes don't need to be looking at the camera, it's enough to just see their eyes clearly. It personalizes things and gives us this instant connection. That's what eyes do.

Now, this is a drill. It's a drill. It's a type of monkey, a species of primate, that was being kept as someone's pet on Bioko Island, Equatorial Guinea in western Africa. As a *National Geographic* photographer, I'm constantly trying to educate our readership that animals have feelings, too, that they're

living, conscious, thinking beings. And when I'm doing portraits of animals against black or white backgrounds, I'm often trying to convey that sense of consciousness, in a way, that these animals have value. This was right after the sun had just set on this very hazy island, and I had a friend hold up a piece of black velvet behind his head, he was a pet primate, and just shot towards his eyes. That's it, nothing to it. The eyes are the windows to the soul, absolutely, just a piece of black velvet, and he's sitting there looking at me. That's all, that's all.

Now, if you intentionally omit eyes, that can have an interesting effect too. I don't know that you would want to do that all the time, but in the first frame that's me, cowboy Joel, out on our farm. You can't even see my eyes, but there's something a little mysterious, and maybe even a little sinister, about that.

So it's also much more mysterious, and sometimes sinister, for somebody to be looking with a straight face, rather than have them smile. I think a smile gives things away sometimes. It seems to be much more intriguing and interesting to me if people aren't cheesing it up all the time with a big toothy grin in every portrait. As a matter of fact, lots of portraits I do of people, when they aren't smiling, they're a lot more interesting and compelling. The first instinct is for somebody to smile when you put a camera up and say cheese. I tell people, I'll shoot that, but then I say just relax, just close your mouth, please, and we'll just shoot one normal. I do that all the time.

So, what else? Having a subject look directly into a camera is certainly one way to engage eyes, but your subjects can be visually connecting with somebody or someone else in the frame in the case of this rooftop party in New York, and that's effective too. She's not looking at the camera, but we are engaged. You see this happy couple, two happy couples in fact, other people in the background. They're looking at each other, these people in the foreground. They just got engaged. They don't have to be looking at the camera for this picture to work. In fact, I would argue that this is a better photograph because they are not looking at the camera. It looks like a real scene, and it is.

Now, in the case of these kids, their gaze definitely is not at the camera. It adds tension to the scene. They're all looking at this girl in the top, left. Believe me, there was a lot of tension on this day. These are kids that are all waiting, listening to their supervisor, to see how much they were going to get paid for the day. These kids were detasseling corn. It's a summer job in Nebraska, for hybrid seed production, and they were all intent. They were all listening to her trying to figure out what she's going to tell them, as far as what they get paid, because they all worked very hard in the hot sun that day. It's just a shot on a bus on the way home.

Now sometimes you can have just sweet, kind of, direct contact with the camera. The eyes really, really connect us to this sweet, little kid. This is at our local zoo, when they just opened up a butterfly garden. The fact that this is very subtle light and that he's lying on this nice bed of leaves, and his skin, the color of it, matches some of the leaves. He has a butterfly on his nose. Those all add interesting layers. And as you know, layering is the *Holy Grail*, if you're serious about photography. So yeah, it works, nice soft palate of color, beautiful zebra-winged butterfly right in the middle. Yeah, it's simple, but that's fine.

Now let me show you what I mean with this field demonstration out at the farm in Dunbar. Watch this.

OK, so we're in the field now. We're in a room. We have Emma Devries and her grandparents. Well, how can we really set this aside and make this look great and special. Layering and framing are great ways of doing just that. What do I mean by that? Well, layering, lots of things, near to far. Framing, literally I've put them in a doorway, in fact two doorways, so that's got to up the ante a little bit. Let's see how this looks. Let's see how this looks. I think it looks really nice, actually. It looks beautiful, and the thing is, this is something you guys can do at home. It's a really effective way of, kind of, compartmentalizing things and cleaning up what's otherwise a very chaotic world, isn't it?

But you know what, once you guys have done this and tried this, it's a very straightforward thing to do, and quite fun. I think you can do it even better, so let's try something, actually next door, through a window. OK, so we

tried a few at the doorway. I don't know, didn't really work. It didn't work as well as I wanted, but this seems to. This is a window right next to the doorway, and we've got a little beam of light coming in hitting Emma, and grandparents are right there behind her looking in. So, we've got framing perfectly. She's within this old-style window. They're looking through the glass in the background. It's a nice multi-generational portrait. I think it works very well. The whole thing is, experiment! Look around. There's no right or wrong answer.

It took me awhile to find this, and I'm still not sure this is right, but I'm happy with it now, and I'll come back to this room again and again and again, since I own this room, and I'll try different things, and you know what, it'll get better and better because I'll build on what I learned today. So, you guys can do the same thing too. Find a good room. Look through things and at things and think about adding that third dimension. It's a two-dimensional thing photography. Get that third dimension in there. Layering and framing will do it for you.

So that was kind of fun. I tell you I don't think Emma's grandparents had ever been on television before, and it was really a hoot. I've photographed those guys so many times, they're like my own family really. I've photographed them over and over and over again, and it was kind of an interesting afternoon. You know, one thing about it, though, is I'm still not sure, I feel like I should work this situation a little bit more. I don't feel like I really got what I could've gotten out of it, and I kind of like the doorway one a little bit more, that vertical. It just feels a little bit too forced around the window when they're looking in. It's like, what? Is the room filling up with water or something? I don't know, but I wish I could have had a little bit more time to work that, and I may, actually. It might be a little less forced, though, and a little bit more straightforward, do something very elegant there.

So, this is really important actually. In all this, the idea that we're trying to do anything we can to clean up the chaos of the world, aren't we? We're just trying to capture the feelings of a three-dimensional world in what tends to be a very two-dimensional medium, photography. That is our biggest challenge. It's something that we're always trying to do, but it is very hard and very elusive. You know, framing helps us isolate what it is we want to look at,

but we have to be thinking about layering too. Layering—what's behind and in front of our subjects—trying to get the feeling of three dimensions from a two-dimensional picture. That is something I've struggled with for all 23 years I've worked for *National Geographic*, and it is the highest form, the highest art form really. It's what we all strive to do is make these very complicated, layered pictures that really read. I love it! But it is really the ultimate challenge and very hard to do. And no matter how long you've been at it, you're never good enough at it. Nobody that I know that's any good at feels very satisfied, like they've ever made a perfect picture. We have not ever made a perfect picture, and the moment you think you've made a perfect picture, I tell you, get out of photography, because there is no such thing. I guarantee you, there is no such thing as a perfect picture. Don't ever think that way. The moment you close your mind off, you're done, you're absolutely done.

So, I wanted to talk to you a little bit about a few pictures that I've layered up and talk about what makes them tick OK? This is the only stoplight in the town of Salmon, Idaho, right. For 100 miles this is the only stoplight. This is right on Main Street, and how do you do something like this? I've thought about this because the writer of the story, it was a story on federal lands for *National Geographic*, about ten years ago, I guess. The writer for this story was really trying to think about how to talk about how isolated Salmon, Idaho was at that time, and we thought, well, there's only one stoplight, and that's it for 100 miles in any direction. How do we illustrate that?

Well, easy. I shot it from the street. It really didn't have that feel that I wanted, so I got a bucket truck, or a cherry picker truck, you know, like a power lineman would use to get elevated. I use those all the time. It's like a real cheap version of an airplane or helicopter for me. I wanted to get up right into this stoplight, and I wanted to go up at dawn so the light was nice and even. I had to wait a long time to see people on the street, because see, I wanted to build layers, didn't I? I wanted layers, I wanted more traffic, I wanted more people, but it's early on a Sunday morning, and people just are not up. I should've probably done this in the afternoon, it probably would've been a little bit better because we would've had a little bit of sun on that nice, red building. Instead it's in shadow.

But, basically you have the light, you have the traffic, you have the coffee shop sign, the street, the mountains in the background. There's only one person crossing the street, but that person adds another layer. If I were to do this today, I would probably shoot it with these high ISO cameras, and I would shoot a little bit later in the day when I wouldn't have to worry about fighting shadows so much, and these lights on these buildings would really come up well. So I would shoot this later, after the sun had set, actually, when you have more people coming and going in traffic and going into the restaurant because it's dinnertime rather than very, very early.

Again, depth, dimension. You're seeing a 3D world captured in this one, as best I could at the time on film, but just really trying to get layering, anything I could. It's a partially successful photograph; it's not a totally successful photograph.

Let's take another one. This one's in a town called San Pedro de Atacama. It's in the driest place in the world, the Atacama Desert, as far as I know. Some parts of this place it doesn't rain for 100 years at a time. So, let's look at the layering and take this for a little bit and how this picture is built. The number one thing, I look at this guy on the horse. He was always out there offering rides to the tourists, and I love the time of day because we just see these little lights coming on. I love the fact that the sky is pink, but this thing has a lot going on. And to do a layered picture like this, to do a layered picture, it takes a lot of work. And I will find a corner, and I will camp there, and I will watch the scene build and come and go and come and go. I'm really working it because the dance of life is going along.

I'll often have my camera on a tripod, and I will just sit there, and I will watch the scene build and go, like the tide coming and going, coming and going. At times, during the hour or so I was there, until it was so dark that I really couldn't get any detail in here, or color, I would just sit and watch. I would just watch. At times the street would get totally empty, and at times you'd get a girl wearing a blue shirt and yellow shorts, and you'd get dogs coming in, and you'd get a girl walking in, and you'd get guys unloading a truck. So, this was the best, most cluttered thing that really, really kind of put this scene together for me.

This really helps hold the frame together. The red here balances there. I'm thinking about all this stuff as I go, all the time I'm thinking about this stuff. I've got a blue door there that makes that horse head pop. I really think about this. This guy was moving around, but he'd mainly just sit there and stare at me and wonder what I was doing, constantly. So, I'm always looking at these things. I'm constantly thinking, how can I layer it? I do this at fruit markets. I do this at fish markets. I do this all the time, constantly layering, layering, layering. The key is I'd find a good scene, I'd plant myself there, and I think about it, and I look through that viewfinder, and I really craft it. I really do.

One more scene. This is one of my favorite ones. This is of the One-Box Pheasant Hunt out in rural Nebraska. The One-Box Pheasant Hunt in Broken Bow, Nebraska, OK? One of my favorite layering shots of all time because it came together, and it proves that you don't have to go to Chile to layer something up.

This is just at the end of the day of a long day of pheasant hunting, right? There are some guys taking a break at the end of the day. That's it. Since I build pictures from the background forward, I knew if they stopped anywhere in that hayfield, it would be epic. Because why? These big, huge bales are lit so softly, so subtly, and they get smaller as you go to the background. See how they get smaller? So these leading lines take you all the way to the horizon.

What else? I started just shooting these guys with their pheasants on the ground, in the back right. Here they are. I was shooting over here at first, and then I noticed that this guy's dog was really into these birds. He really wanted to chew on these pheasants, you know, like a dog waiting for you to hand him a treat. So he's holding one, this guy's holding one and talking to another buddy that's off camera here, and all of a sudden this became a picture that wasn't just about layering, but it actually had a little moment. It had a little moment, right here, the dog looking at the pheasant. The pheasant has a little color. The dog helps hold that part of the frame together. This part's good. We've got the dog, the pheasant, the bale, this guy his pheasants, and other bales going right back. So it becomes this epic scene, and it goes away really well into the distance. The light is soft, so there's a lot of space there. It's subtle. There's nothing distracting. It's nice and clean. The guy in

the background isn't sharp, by the way. This is probably an f/2.8 photograph. This was shot on film. That's the biggest hole I have in my lens, but I'm using a wide-angle lens, so you get this nice sense of depth, this nice sense of place. I purposely did not use a long lens on this. Why? Because I wanted to see this big, gorgeous background.

Now, make no mistake, OK? Composition, it is a big deal. I mean it is a really big deal. It's what's going to separate the men from the boys in this situation. So, most situations will require you to actually think if you want your pictures to be any good, and that's why I'm here. I want you to think. I want you to think of me as your visual conscience. I am sitting right there on your shoulder at all times. OK? Got it? I'm right there on your shoulder, all the time.

When you get ready to shoot, I want you to think of me sitting there, and am I going to say, if you go to click the button, the shutter, am I going to say, is that interesting? Seriously, you're going to shoot that, the light's terrible. That's boring. Please, think. If I'm sitting right there, what would Joel do? What would I do? Would I shoot it? Most of the time the answer is no to the question, should I take a picture now? You've got to be discriminating.

So, you're ready to go now, right? You've got your camera, you know it. You understand the relationship between aperture and depth of field. You understand that sink metaphor—how water can be compared to light and adjustments to aperture and shutter speed is a result of a faster or slower flow of that light to your camera's sensor, right? You know about light— both ambient and man-made. You understand that ambient light has different colors, depending on time of day, and source, and reflections. And you can use your white balance setting, can't you, on your camera? You can correct colors to white, but I hope you know, I don't want you to always correct your colors back to white.

I hope you know how to use that histogram. You know how to use your flash a little bit, maybe not at all, only a little, only when absolutely necessary? OK. Craft, craft everything. Just know that everything doesn't have to be in focus, and actually, most of the time you don't want everything in the world

in focus. A little blur can fix a bad background, we know that, or it can add a little sweet sense of motion and movement to a picture, can't it?

And now that you've been through composition—what we take pictures of and how, these are big questions: how we use perspective; how we build pictures from the background forward; how we choose perspective and look for leading lines, the placement of the horizon, the layering to lead the eye into the photo and hang around for awhile. and most of all, you've learned how essential it is for you to be your own fiercest critic. I am on your shoulder, and I'm bugging you. Please be discriminating and shoot well, OK?

So your assignment, onto your assignment. You already know what I'm going to say, right? Layer and frame a subject in three photographs. This is what I want you to do, layer and frame. You cannot use a door or a window. That's too easy, way too easy. Instead, you can use anything else, and believe me, if you think about this; it'll come easy to you. Watch the eyes if you're photographing a person or animal, for example.

Now what? Well, now I want to talk about the special challenges in the next lecture that different situations can throw your way. We're going to talk about taking pictures in both rural and urban landscapes. Some folks have trouble with both, but they sure shouldn't, and after the next lecture you won't either. So let's get to work.

Let's Go to Work—Landscapes
Lecture 12

Now that we've covered the basics of camera operation, light, and composition, let's go to work and try to apply what we've learned. We'll start with landscapes, which are generally easy to shoot because they tend to stand still. Basic landscapes, whether in a rural setting, the wilderness, or a city, are extremely popular subjects for photographers. With no people in the scene you're photographing, you're limited only by the light and your imagination—you can be as artistic as you like. Of course, our goal is to go beyond the obvious, so in this lecture, we'll also look at some unusual landscapes and learn how to introduce animate elements to a scene.

Tips for Photographing Landscapes

- Get to the site early—far ahead of the prime light you hope to be shooting in—and explore. Find the best place to set up and the best possible angles *before* the light is where you need it to be. If it's a sunny day and you're planning an evening shoot, try to visualize where the shadows will be and what the scene will look like just after sunset.

- Use a tripod for photographing landscapes. In addition to allowing you to shoot with a slow shutter and a high aperture—getting everything tack sharp with a nice depth of field—a tripod also forces you to slow down and really think about how you will frame things. It allows you to concentrate on whether the scene in your viewfinder matters enough to be worth a photograph.

- If you're shooting landscapes, there are really only two times each day when the light will sing: before sunrise and around or just after sunset.

Unusual Landscapes

- An image of a road sign shows how you can use something that would otherwise be clutter in a photograph to tell an interesting story. The sky behind the sign looks threatening.

- A photo of a dog wearing a surgery collar offers a good example of the use of horizon and open space to isolate an animate subject in a landscape.

- In an open, uncluttered landscape shot in Montana, the dust kicked up by a truck tells us that we're moving. Interestingly, the dust gives us a leading line from the back of the scene forward. It also makes the antlers of the deer pop out and read easily.

- The time to work out a shot of something that happens quickly is not right when it's taking place. In the case of a fireworks photo, shooting from the audience would have prevented the use of a long lens and turned the trees into visual clutter. In this frame, though, the trees are minimized and serve to give the fireworks a context.

Composition and Landscapes
- The compositional ideas we discussed—applying the rule of thirds, experimenting with the horizon, and looking for natural framing devices—are all important with landscapes.

- You may want to use a wide-angle lens and a bit of height to show the land on a grand scale. If you're too low to the ground, the viewer sometimes loses the sense of where he or she is when looking at the photograph. An inexpensive way to get an aerial shot is simply to go up a ladder or climb onto a roof.

- Long lenses can narrow your field of view on the world, but they also compress distances, making the background look as if it goes on forever.

Layering and Light in Landscapes
- Add layering to landscapes by thinking about the foreground, the middle ground, the background, and repeating patterns.

- A photo taken framed by a muddy windshield shows a man and his horse, hay bales, snow, a building, mountains, and clouds. Even this is a landscape because it tells us where we are.

- Using a wide-angle lens and getting down low sometimes helps with layering, because it allows plants, geologic features, and other elements of your image to stand out. Again, getting down low accentuates the foreground subject, but lowering the camera also means seeing less landscape most of the time.

- Think about adding life, complexity, and movement to your landscapes to go beyond the obvious.

- Another trick to add drama to landscape pictures on a clear day is to point your camera in the opposite direction of the sunset. Everything in that direction will be awash in beautiful red reflected light. Remember, too, that bad weather makes for great light and unusual photos.

- There's no excuse for bad light in a landscape shot; remember, the landscape isn't going anywhere. Return to it in the early morning or in the evening, when you know the light will be good.

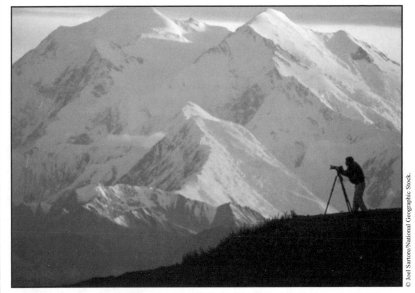

Adding even a small subject to a landscape allows the viewer to make a connection with the photo.

Behind the Lens

… I'm guilty of bad light in landscapes, too. In fact, one of my first landscape shoots nearly cost me my big break at *National Geographic*. This was really quite a traumatic event. It was my first big break; I was doing a story called "Pathways to Discovery." It was for a book on the Potomac River Trail and the highlight of it—the crown jewel—was Mount Vernon, George Washington's home. I was assigned to document George Washington's home, [so] I went there. I was wearing new clothes, and I had shined my shoes, and I had my gear. I had permission to be there, and they opened the gates at 9:00 in the summer, [so] I ran in, and I got pictures of people outside, [just] shooting away—look at that. …[T]he kids are running around outside, and I'm just really working it.

I've got it; there it is: Mount Vernon. I'm very proud of that. Then I move inside. The light of the day is getting a little harsher; it's 10:00 or 11:00, and I shoot inside, and I show the beautiful woodwork and all. [Then] I remember going into my editor's office, and he was looking at the pictures, … going through them as fast as he could. I was like, "What's going on?" and he said, "Well, these pictures, I can't use any of them." I said, "Why?" He said, "9:00 light. It's summertime; what are you thinking? 9:00 light. You go back at 5 a.m.—not 9 a.m.—5 a.m. and get it when the light is beautiful." I said, "Well, they open the gates at 9:00." He said, "You go back and get a squirrel eating a nut, or a leaf, or a guard walking a German shepherd around the place, but do something that's beautiful." I went back, and at 5:30 a.m., indeed, they had German shepherd guard dogs patrolling the place at that time and that ran two pages.

The moral of the story folks is, the editor is always right, and the pictures turned out much, much better. I needed to be working when the light was good.

- The real bonus of shooting before sunrise or after sunset is that few others do it. When the sun is just below the horizon, there are no harsh shadows; you can shoot in almost any direction you want.

Introducing Animate Elements
- It's difficult to shoot a good landscape that has nothing else going on in the scene. Even a small subject gives the viewer something to look at. Think of a great landscape as a starting point, a stage on which you hope players will appear.

- A big, epic landscape can be beautiful, of course, but actors—in the form of a rainbow, people, animals, or even patterns in the land—can enliven what might otherwise be a very quiet scene.

- You don't need to go to an exotic location to shoot great landscapes, and you shouldn't limit your definition of "landscape" to empty scenes. Challenge your idea of a landscape by adding animate elements.

- Keep in mind, too, that you don't have to shoot landscapes in the countryside; it's certainly possible to shoot urban landscapes. To build any landscape—country or city—think about the point you want to get across.

- Start with an anchor of some kind, such as a building or even a fruit stand. Scout the scene, making note of leading lines and interesting light sources. When you're ready to shoot, get close and look for opportunities to tell a story.

- Always keep your camera with you and never put off a good shot. Take your time picking your scene and focus on something that you can shoot repeatedly.

Assignment
- Shoot the same landscape, rural or urban, from ground level, knee high, waist high, head high, and overhead.

- Compare the differences in the various views. They may be worlds apart, even in your own backyard.

Suggested Reading

Burtynsky, *Manufactured Landscapes*.

Rowell, *Galen Rowell's Inner Game of Outdoor Photography*.

Homework

Shoot the same landscape from ground level, knee high, waist high, head high, and overhead. Notice the difference? They should be worlds apart.

Let's Go to Work—Landscapes
Lecture 12—Transcript

OK, so now that we've gone over the basics from top to bottom, let's go to work and try to apply what we've learned. I thought we'd start out with the easiest stuff first, and that would be landscapes because they usually stand still. Basic landscapes, whether you're in a rural setting, like farm country or wilderness, to cityscapes and skyscrapers, are an extremely popular subject for photographers.

I imagine this is because a successful landscape can be a still life, that is, with no people in it. It's just with you and the camera, the light, and your imagination are all that hold you back. You're totally an artist with this stuff, totally. That's quite remarkable. You can do anything you want. Landscapes are a great way to unwind. They're beautiful, absolutely beautiful, when done well and in good light, of course.

But in this lecture, we're going to go beyond the obvious and really make your landscape pictures sing. We want to make your pictures stand out and be noticed. So let's get started. There are a lot of bad landscape pictures out there. I don't want you to make the same mistakes that I have.

For example, get there early, stay late, get there far ahead of the prime light you hope to be shooting in, and explore. Find the best place to set up and the best possible angles before the light is where you need it to be. Give yourself some time for goodness sakes. If it's a sunny day and you're planning an evening shoot, try to visualize where the shadows are going to be and what the scene will look like just after sunset, right, when that golden glow is saturating everything in your viewfinder.

I'll often use a tripod for photographing landscapes. All the time I use a tripod. Besides allowing you to shoot with a slow shutter and a high aperture and get everything tack sharp with a nice depth of field, a tripod also forces you to slow down and really think about how you're framing things, allowing you to concentrate about whether that scene in your viewfinder matters enough to be worth it. This is something I really want you to think

of. Does it matter enough to be worth it? Are you paying the viewer off? Are you paying them off, or are you just wasting their time?

Even with the help of a tripod, you're probably figuring out that if you're truly serious about your landscape work, there is no such thing as a snooze button on an alarm clock. In clear weather, you only have two times each day when the light will sing, and one of those times is way too early, I mean way too early. I have to tell you, getting up early stinks for me. I don't like it, never have, never will, but if I don't do it, I'll miss half of that day's shooting potential when it comes to landscapes outdoors. No can do. I work for *National Geographic.* So when shooting landscapes, I find myself up with the chickens, quite literally.

To prove my point, this photo was shot just before sunrise on an Oklahoma farm. Sunrise, I'm always working sunrises. So speaking of that, let's go into the field now at dawn for a little field shoot out at a farm in rural Nebraska that we own. Let's watch, not only how subtle the light is and how that's so critical, but also how, once we find a good stage, we pray for the actors to appear and really liven up our landscapes.

Text that corresponds to the recording from 3:14 through to 7:54 is missing here. It all seems to be an outdoor scene. The text seems to pick up right after the outdoor scene ends. I've searched for several phrases from the audio within the text, but I don't think the text is in this file.

You know the most amazing thing about that, I really still don't honestly know how I got Ellen and her friends outdoors that early in the morning. We had to leave Lincoln at about 5:30 a.m., and that was not pretty. Let's look at how I handle some other scenes, and why, and notice that my idea of a good landscape is a little twisted. Oh sure, I could show you stuff like this all day long and blather on and on about it, but what fun is that? Nada, that's what. This is way too boring for my taste. It's a totally forgettable picture. I don't want to teach you guys how to do landscapes like this.

But let's start with the simple things first OK? Let's start with the simple things. Nice light, good clouds, and a warning sign. OK, this is a baby step. Sign pictures, they're kind of easy; they're not going anywhere. But this is

an example of using something that would otherwise be clutter. That sign, road impassable when wet, as a compositional element that helps to tell a story, and the sky looks kind of fierce. It looks like a tough place OK?

Next, a good example of using horizon and open space to isolate a subject that's animate, and the dog's wearing a surgery collar, so it livens it up and gives us a little something extra. I'm trying to give readers a payoff. Viewers need to get something out of these pictures. I don't want my landscapes to be boring, if I can help it.

Another landscape, a little more complicated though, right? Here we have an open landscape, uncluttered, big as the west. This is Montana, but from our point of view, we're moving, and the dust tells us that we're in motion, and it adds another element, really. It cleans up the scene, somehow. It gives us a leading line from the back forward, in a way. Really though, with that dust, what does that dust do? It makes those antlers really pop out and read easily. The fact that the road is moving, the road smoothes out too because we have a slow shutter speed. It's cloudy out, but that dust really stands out and helps us there. We have a dead deer in the back of a pickup truck, so a little something interesting to give us a little bit of an edge on our landscapes. OK? What next?

Here's something that happens fairly quickly, it happens all over the country, 4th of July. But if you've thought about this and scouted a little bit, you're going to know where to be ahead of time. The time to figure out where to be is not right when they're blowing the fireworks off, it's ahead of time. You know, if I was up close—where the audience was—I wouldn't have been able to use a long lens, and those trees would have been just kind of visual clutter, in a way, right? In this frame, though, they're minimalized and they serve to give the fireworks kind of context. By staying back and being down low, that smoke and the light, it shows us where we are. We're in the woods of northern Minnesota, and there are people enjoying the fireworks, and we get the impression that is a big burst.

Remember the very first ideas we discussed about composition? They still count with landscapes, by the way. Try out rule of thirds, pacing, putting your horizon at different levels of the frame, and looking for natural framing

devices, all very, very important. I'll often use a wide-angle lens, by the way, and a bit of height to show the land in a grand scale. But if you're too low to the ground, sometimes you'll lose some of the sense of where you are.

You know, aerials are very effective way to convey a sense of place. You can do a cheap aerial, even, by going up a ladder, or on the roof of your house, or other structures, like I've done here. Going up on a little grain elevator— but be careful though. I'm always nervous around ladders, and rightfully so. Falling off a ladder is one of the leading causes of paralysis, believe it or not. Taken from on top of a little grain elevator like this, we see plenty of landscape, and it has the added element of little people in it for scale, doesn't it? Notice that I've used a long lens here too. It compresses distance, and makes those fields look epic, like they go on forever. Or look at this, a little height on the back of a horse can get you an aerial field. It serves you really well. It gives you more of a grand feel, and you're no more than, I don't know, eight feet up, something like that. It works out really well. It does.

Now remember, long lenses can narrow your field of view on the world, but they're also very good for landscapes because they accentuate certain aspects, don't they. They really compress distances. Nice field! You can use a long lens, just use them judiciously when you're talking about landscapes.

Now let's talk about layering. Layering is king, even in landscapes. I think about layering all the time. I think about the dance of life. Landscapes need to be good pictures too, you guys. You don't get off the hook just because it's a landscape. I want your landscapes, and mine, to look unlike anything I've ever seen. I want them layered. Layering your pictures by thinking about your foreground, your middle ground, your repeating patterns. It's so important and so satisfying. The dog, the saddle, the cow, the truck, the big landscape in Montana, layer, layer, layer, all the time.

Look at the layering in this. The muddy windshield of my rental van, my friend Mark Ellis and his horse, the hay bales, the snow, the building, the clouds, layering, layering, layering. That is a landscape. It is, we know where we are. It's a landscape, but it's fairly interesting because it's layered. Now look at this. Let's say we're doing a salt formation. I'll get down low. I'll use a really wide-angle lens all the time, always. I try to do a really wide-angle

lens, really try to get things to stand out. Plants, other little features, geologic features, this is some really ancient bush. It's OK. I'm down low. Get that object in the foreground, and I use the widest lens I can. Let's throw some feet on there to give it a little bit more of, I don't know, something else, a little spice, from Chile, OK?

I use that 14–24mm zoom with the aperture very small, f/11 or so, everything is sharp. I lower that camera, get down, really accentuate that foreground. I do it all the time, all the time. Back here in the U.S. I do it here too.

Look at that, what is that? A hognose snake, now this is a landscape photo, alright? But I'm way down low, way down low. What happens? When you're down low with that type of an angle, wide lens, this hognose snake, he's playing dead. He's playing dead. We're a threat to him standing there. Even though I'm down low, I can see the landscape, right? What does down low do? It accentuates your foreground subject. It makes it huge, right? The gravel of the road allows our subject to read easily. It's not in grass or anything, nice and clean. And although it's a ground level shot, it still reads as a landscape. Where are we? We're in the woods of southern Illinois. Because we don't have grasses, we have no obstructions, we're just on a gravel road, we can see where we are, OK?

So by lowering your camera position, like when he wakes up. You can really make a star out of that snake, or a rock or a bush, whatever, but the cost in being down low is less landscape, in a way, most of the time, OK? Because you have grasses, and trees, and so forth. It's a tightrope walk. Lowering your camera means less landscape, but bigger and more dramatic foreground objects, just something to remember, OK? Sometimes I'll cheat. I'll be low, I'll be low, but I'll be right on the edge of a cliff, and I can get the best of both worlds, so I try to think about that all the time. Can I be down low, can I still see the land because the lower you get, the more interesting that foreground gets, the more impactful, the more dramatic. I wish that snake was right there, that would help that scene.

Let's take this scene of sledders, sledders in Cortland, Nebraska on the DeVries farm. OK, nice little scene, that's fine. That's fine, but watch, watch. What happens, ground level? Oh let's get up. Look, we're in a bucket truck

now. Look at how this helps. Now we have this epic kind of *Currier & Ives* scene. One kid is running trying to catch up because he fell off the inner tube being towed by the tractor. So what I'm trying to get at here, hopefully in a clear way, go beyond the obvious, add life and complexity, and movement to your landscapes. Please, try to do that all the time if you can.

Another trick to add drama to your landscape pictures, on a clear day, point your camera the opposite direction as the sunset. Point it the opposite direction. You will be amazed at what the other direction looks like, oh man the color! Look at the color! That's not looking at sunset, that's looking east, east! That sunset, you get beautiful clouds on the horizon at sunset, everybody wants to shoot that way. I say no, no, no, no, turn the other way, look east, everything is going to be awash in that beautiful, red reflected light.

And also, don't shoot only on blue sky days to avoid bad weather. No, bad weather makes for unusual—and hence great—light and photos. Wear a raincoat if you're afraid of getting wet, but get moving. Nothing but blue skies gets boring, and you don't get a chance for lightening on a blue sky day very often. Listen, there is zero excuse, in my opinion, for bad light on a landscape shot. When somebody shows me lousy light on something that aint goin' nowhere, I just say to them, "Are you kidding me? Go back and shoot it again!"

I've literally had several people over the years show me pictures shot in a cemetery in high-noon light. In a nice way I say to them "Oh, OK. Can you explain why, maybe, you didn't wait for the light to get better?" And they say, "Oh well, I was on a bus tour and we only stopped once that day and it was for lunch at noon and there was this cemetery." And I say, "OK, I understand, but that doesn't make your picture any better. Your excuses don't make your pictures any better." I say, "Next time, drive your own car, and stop whenever you want, hopefully in killer, beautiful light!" Think about this.

Now, before you go thinking that I'm all high and mighty, I've got news for you: I'm guilty of bad light in landscapes too. In fact, one of my first landscape shoots nearly cost me my big break at *National Geographic*.

And man, this was really quite a traumatic event. It was my first big break. I was doing a story called *Pathways to Discovery*. It was for a book on the Potomac River Trail, and the highlight of it, the crown jewel, was Mt. Vernon, George Washington's home. So I was assigned to document George Washington's home, and I went there. I mean, I was wearing new clothes, and I'd shined my shoes, and I had my gear, and I had permission to be there. And they opened the gates at 9:00 o'clock in the summer, and I ran in, and I got pictures of people outside. And they're shooting away, look at that. They're shooting away, and the kids are running around outside, and I'm just really working it.

I've got it. There it is, Mt. Vernon. I'm very proud of that. Then I move inside. The light of the day is getting a little harsher, it's 10:00 or 11:00 o'clock, and I shoot inside, and I show the beautiful woodwork and all. And I remember going into my editor's office and he was looking at the pictures and he was going through them as fast as he could. And I was like, "What's going on," and he said, "Well, you know, these pictures, I can't use any of them," and I said, "Well why?" He said, "9:00 o'clock light, it's summer time, what are you thinking? 9:00 o'clock light? You go back at 5:00 a.m., not 9:00 a.m., 5:00 a.m. and get it when the light is beautiful." I said, "Well they open the gates at nine." He said, "You go back and get a squirrel eating a nut, or a leaf, or a guard walking a German Shepherd around the place, but do something that's beautiful." And so I went back, and at 5:30 a.m., indeed, they had German Shepherd guard dogs patrolling the place at that time, and that ran two pages big.

So the moral of the story, folks, is the editor is always right, and the pictures turned out much, much better. I needed to be working when the light was good. So sure, it's all about the light, but work smart, or get sick, actually. I mentioned that before with landscapes, whether they're rural or urban, they are all about light. Try to get a good amount of sleep. I try to knock off in the middle of the day and not work in the harsh stuff. I can't burn the candle at both ends, you know? Midday is when I'm laying low, I'm eating, I'm resting, trying not to get sick. I'm trying to not get my batteries so low that I actually catch cold, or something. I'm researching my next shoot, taking a nap in the middle of the day, don't tell my boss, but it's true. If I'm working

both ends, I cannot afford to get sick, and I don't want to be miserable. I'm working great light, great light. That's what I want to do.

Now, to get the best light, I'm routinely up a couple hours before sunrise, and in the summer that's a long day. I give myself an hour to get up and get ready, then there's usually some kind of usable ambient light starting about 45 minutes before sunrise. Do you know the real bonus about shooting long before sunrise and long after? Few others do it, and that is a shame. When the sun is just below the horizon, there are no such things as harsh shadows, so you can really shoot anything extremely well and hassle free. Your own shadow won't exist, so you can shoot in almost any direction and get away with it. It's really nice. It's a great secret.

Once the sun comes up, or just before it has set, however, it's a totally different story. You really have to watch your own shadow, or maybe just try to have fun with it, I suppose. I've shot my own shadow a million times, all the time. If there's nothing else happening, I'm out in the desert in Arizona, I'll throw my own shadow on a scene just to liven it up a little bit. I'm wearing a hat, it looks like a cowboy, or something, just to keep it from getting too boring. I do that all the time, all the time, obviously. A lot of times, I'm the only person out there for 20, 30, 40 miles, so I shoot my own shadow.

Which brings me to another topic: I have seen very few—and I mean very few—landscapes that grab me that don't have something going on in them. I really treasure those little moments that happen when something animate is introduced into the scene. It doesn't have to be much, but please, at least when you're showing pictures to me, give me something to look at, some kind of payoff. To me, a great landscape is really a starting point, a stage upon which I hope the players will appear if I wait long enough. I know this isn't a conventional way to approach landscapes, and that an empty scene is more traditional and is quite satisfying for some folks, but I think that's the easy way. I do. I think that's the easy way of doing it, just an empty landscape because you didn't want to bother anybody. You didn't want to get anybody's picture. You didn't want to have to talk to anybody or wait for wildlife. I don't know.

Let's look at some landscapes from Alaska's North Slope. These are big scenes. These ran in *National Geographic*. OK, that's alright. They're big and they're epic, and landscapes without anything else, they work, they work enough for *Geographic*, but I really like it when there's something else, something else, maybe a rainbow going over that caribou antler. Rainbows help, you know. I really try to work things. Whenever I'm anywhere, I really try to give them something special to make them worth looking at, every time.

You know, when I go to Africa, I'm thinking about that as well. I'm trying to tell a story now, but I'm also trying to really, really give our readers something, something that's surprising. I love adding actors. This is on the edge of Queen Elizabeth National Park. You can see the farm ground comes right up to the edge of the park. There are a lot of people there, a lot of small farmers there. This is all park lands for the animals, but what else? What can we do? Let's liven it up. OK, again, nothing really animate here, besides the plant life, but something interesting, more of a pattern, more interesting I guess. It's basically a geological feature. Those are volcanic-formed lakes. Alright that's fine, but where're the actors? Come on where are the actors?

Oh here we go Cape Buffalo, isn't this a little better? We go from these pictures of being quiet and fine art, with those volcanic lakes, to really having some oomph, to singing. Now granted, these are all done out of an airplane, but you know what, they're just big and epic, and they've got some movement; they've got stuff going on. That's what I really want, really want.

This could be, actually, out of a car, you know? Whereas the others were out of an airplane, this is just out of a car driving to the airstrip one day. It's that simple. What else? Out on a lake at dusk as women fill their water jugs. That'll work too, nothing wrong with that. You know what, I consider this a landscape. There's no land to be seen, really.

Let's say we can't afford an airplane. I'm telling you, look at these. You can make frames. You don't need an airplane. You don't need to go to Africa. You can make great frames no matter where you are. So, do these pictures challenge your notion of landscapes? I hope they do. I hope they do. Look at this, dung beetles, dung beetles, yeah, right down in there with them. I

consider this a landscape. We're right down low. Why not? Why not? I think you could do this anywhere. You know you could do this stuff anywhere, don't you? Of course you do, of course you can.

Note that none of those were using 'the landscape photographer's best friend, either, the tripod and the cable release. That's because when I'm in an airplane I can't use it. When those dung beetles are rolling the poop around I can't use a tripod, right? I like getting away with not using a tripod and a cable release. I use them sometimes, and sometimes I don't. It just depends on my mood and what I'm trying to get.

Now let's look at another set of pictures where I did use a tripod and a cable release for most of the images, but right here in the U.S. These are in the Everglades, alright? That's just with my car headlights, before the sun came up, right by the gate, just lighting up the grass, a little bit of ambient. Fine, that's just fine. I'm there an hour before sunrise, not very fun, but you know what, that's the time when your headlights will show up using a tripod and a cable release, absolute must here. This is a very long exposure, probably a quarter to a half second or so.

OK, this is along a walking trail, an alligator right there, a tripod and a cable release, and I'm standing off to the side with a little bit of flash, so the tripod and the cable release become my assistant that day. One of my favorites, off an observation tower where black vultures like to sit on the roof. I didn't use a tripod and a cable release here because these vultures were moving around too fast and too quickly off the roof of this observation tower. The moment one takes off, I try to get him in the frame and, like magic, we have a free aerial because we're up in this observation, right, we're up in the observation tower.

Now notice this landscape is mostly sky. I liked it, and that's enough. I'm trying to please myself here, figuring that OK, maybe somebody else will like it too if I do. Now do you remember our dung beetles in Africa? Same thing here, getting down low, right on the deck, this time with a Florida chicken turtle. He looks a little irritated, doesn't he? He sure does.

All right, so, for those of you who say, "There's no way I'm going out into the countryside. I don't like the ticks, and I don't like to get out in the country, you know, I might get a sunburn." I say, "You don't know what you're missing." But, let's stick to the city. For me, I can get good frames in the city, too, because I'm thinking about that, so I'm totally on board. To build any landscape, country or city, I always think, what's the point that I want to get across? And I start with an anchor of some kind. It could be a building or a fruit stand, you name it. Let's go into the field again, in Lincoln, and see how we might put together a nice urban landscape. It all starts with scouting, and nice light, of course.

SOK, so, it's llandscape time. We have two types of landscape, don't we, rural and urban. Obviously this isain't rural, right here; we're in urban, downtown Lincoln, Nebraska. We're in the Hay Market district, which is their old brick warehouse district. It's lovely down here. This is where it's happening. It's on Saturday night. We're at the world -famous Mill cCoffee sShop—one of my favorite places. WNow we're going to talk about what makes this scene good. I mean, I've scouted this out; I've looked around. I think this is one of the nicest places to shoot an urban landscape. Why is that? TWell, take a look. Look how nice this is. It's like it's made for pictures—brick warehouses going away in a line, little twinkly lights up in the ceiling. Let me shoot a picture real quick and just see how this looks.

It looks just fine, but it aint's not great. I think it can be great, but we need to move in closer. We really need to work this and get in closer to the brick buildings, to the people that are sitting in there. Try to tell a story, a little bit of a story. What's going on with these people on a Saturday night? So let's get to work.

HAlright, so here we are, much closer. This looks like it's more interesting. Gee, these people look familiar to me for some reason. So it looks like Kyle and Rebecca are out on a date and Grace has been stood up; I think that's the story. SAnyway, she's checking her phone. Look at that. She's got just a little bit of sun hitting her—the last light of the day. How lucky is that? Is your man coming around the corner, Grace? Is he coming in from over there, do you think? TOh, thanks for looking that way.

Now look at this. TNow this is nice: a little bit of light grazing her, twinkly lights overhead, and leading lines like you can't believe. All brick all the way, a hundred years old, right down the lane. TI mean, this picture, this is already made up for me; I don't have to work at this. I just see this and it's done. This is exactly what we need it to be. It's a picture that works in layers; it's a picture that works as far as storytelling. And look at that: last light of the day. Perfect.

That is the Hay Market area in Lincoln, by the way, a great place to spend a Saturday night. So let's say you're in unfamiliar territory and not in your hometown. No problem at all. You have the skills to pay the bills now. Let me give you one little last illustration. Look at this.

Amsterdam, I was in Amsterdam a while back and you know what? This is an illustration of why you never, and I mean never, put off a good shoot, ever. Because, this is one time when the canals had frozen solid enough for people to skate, and they had not frozen solid in a long time. So let's just look through these. I had a camera with me. I always have a camera with me, right? Even if you think something's going to be mundane. Carry that camera with you all the time. I'm looking up and down the canal. I'm looking at the people coming and going, and I'm thinking, look at the buildings, and look at the color and layering. I can do everything I want to do. To me, country, city, it doesn't matter. I'm building, I'm building. I'm watching people come and go. Look at that. The light's nice. Once in a while a kid falls down. I'm moving around to the side, and oh look at this, a wooden shoe boat, how cool is that, alright, and the little kid's skating on one leg. That, maybe, is the picture. I was satisfied with that. It looks like a postcard, but that's OK. I liked it. It pleased me, that's good enough. It's not perfect. I stayed there and I worked it a little farther into the night until the lights came up in the houses. These folks are photographing a young one there, but you know what, it was not good. It was not as good as that. That to me was the frame. It pleased me. Shoot over with. Alright that worked, that worked.

So the bottom line is this, pick your subjects wisely and find something interesting please. Try to focus on something that you can get repeat chances at. You'll be glad you did, and so will anyone that has to look at your pictures! Make it worth their while, please.

Your assignment. Your assignment for this lecture, in nice light, of course, shoot the same landscape, rural or urban, your choice, from ground level, knee high, waist high, head high, and overhead. It doesn't have to be that high overhead. Notice the difference. These should be worlds apart, even in your own backyard. Our next lecture, one of my favorites, wildlife. Come back please.

Let's Go to Work—Wildlife
Lecture 13

In this lecture, we'll talk about techniques for photographing wildlife. Believe it or not, there are opportunities everywhere for you to practice taking photos of wildlife, from squirrels and insects in your own backyard to plants and animals in zoos, parks, and even exotic locations. In this lecture, we'll talk about setting up a blind, and we'll learn about some special techniques and equipment that will help you get close to your subjects without scaring them away.

Field Shoot: Backyard Wildlife

- One way to take pictures of wildlife in your yard is to cover an open doorway with a length of camouflage cloth. Cut a small slit in the cloth for your lens and sit quietly, waiting for birds to arrive at your feeder or squirrels to scamper around your trees. Make sure your equipment is set up ahead of time and, again, plan to shoot early, just before sunrise.

- Before you set up your equipment, decide what elements will appear in the frame. In this field shoot, the bird feeder and some fencing will be in the photographs, and the background will be lush and green.

- For this shoot, the camera was set on aperture priority and 1600 ISO (to allow a fast shutter speed); a 200-400mm lens was used to blur the background. A Wimberley head was used, which is a tripod head that pivots smoothly. These settings and equipment allow you to concentrate on shooting the animals, which may be moving quickly.

- As you shoot, don't forget to chimp—check the picture on the back of your camera to make sure it's sharp—and look at the histogram. Make sure the information isn't touching the right (right = bright), so you don't blow out any of the highlights and lose detail.

- A secret weapon you can use in photographing wildlife is a radio remote trigger, which costs about $100. With this, you can set up a camera closer to the action, place the radio receiver on top, then walk away from the scene and take pictures from a distance.

Locations for Shooting Wildlife

- Our set-up with a camouflage curtain is called a "blind" or a "hide." Many wildlife sanctuaries have public blinds for viewing and photographing wildlife.

© Joel Sartore/National Geographic Stock.

Think about photographing animals in the same way you photograph people—up close.

- Check with local nature groups to find out what kind of wildlife events take place in your area. You may be on a migratory path for monarch butterflies, or your county may be a nesting spot for rare birds. If you're near the water, you can find out where shorebirds nest or where they gather to feed.

- Zoos that feature educational animals also offer opportunities to get great photographs. Often, you can get very close to these animals, especially if they are being handled by staff members. You might also visit a local aquarium.

- If your animal subjects are in enclosures, you may have to wait patiently for them to be active. To eliminate the wire of an enclosure, use a long lens, and press it right up against the wire. In most cases, the wire in the foreground will vanish because the long lens has such shallow depth of field.

- Never misrepresent photos of captive animals as wild. Use photo captions to identify whether the situation was controlled or truly wild.

Flower Photos

- Many people shoot flowers when they start out with nature photography, and almost everyone uses a macro lens. With a wide-open aperture and a macro lens, the result is a very shallow depth of field, with only the subject or even part of the subject sharp. Often, these photographs look like watercolor paintings.

- Try experimenting with different apertures and shutter speeds when you're shooting flowers. If it isn't a windy day, the flowers aren't moving, so set up a tripod and a cable release and try using a tiny aperture and a slow shutter speed.

- Visit a botanical garden in your area to shoot photos of a variety of flowers that you probably won't find in your backyard. Be on the lookout, too, for insects feeding on plants or flowers, and remember, the closer your flash is to the subject, the softer the light will be.

Traveling to Shoot Wildlife

- When you travel to shoot wildlife, expect to do about one day of research at home, before you go, for each day you plan to spend in the field. You should find out the peak times for seeing the animals or plants you want to shoot. You also want to know what the weather will be like and how close you can get to the animals without disturbing them.

- If you've done your research, you may be able to find locations where animals in the wild are habituated to people. For example, the bears in Denali National Park are accustomed to seeing people take photographs. In many places, you can drive through wildlife parks and photograph animals that won't run away from your car.

- If possible, scout the location where you'll be shooting ahead of time, talk to other photographers who have been there, or hire a local guide.

- In field shoots, a long lens is often a must. If you can't get close to something, even a 300mm lens will be an important tool.

- You can also use a teleconverter, a device that magnifies your lens, to get closer to your subjects. Remember, if you're using a long lens, you may want to support it with a tripod. If it's dark outside, you may need a tripod and a cable release to keep the camera from vibrating when you press the shutter button.

Standard Kit for Photographing Wildlife
- It's nice to have a variety of lenses for photographing wildlife. A 14-24mm is a good landscape lens, but it can also be used with a radio remote to take pictures of animals. A 24-70 is a workhorse lens that can also be used for wildlife. A 70-200 works well for aerial shots, and a 200-400 is a good-size long lens. Longer lenses are available, but they are heavy to carry. Your kit should also include a flash and a portable softbox.

Behind the Lens

This is at Fossil Rim in Texas. [A] zebra—wow, okay! He didn't really want to do anything much. He was just kind of standing there. Most of the time, he just showed me his rear end, and so I thought, instead of fighting it, let me get out the long lens and make something out of this. By long lens, I mean this one right here, 200 to 400, easy to shoot right out the car window. I did not know that certain species of zebras had stripes on their tails, but I took an opportunity that was presented to me. He just

© Joel Sartore/National Geographic Stock

wanted to stand with his butt to me. That's fine; I'll take a picture of a zebra butt. It's kind of cute. It works out fine. That long lens really compresses things, doesn't it? It's a good way of seeing this—compressing those stripes—just a nice, different way of doing it.

- Think about photographing wildlife the same way you do photographing people. You want to get close and have repeated access to your subject. Keep a macro lens with you because you never know when you're going to need it. Even if you're photographing large animals, you may see a great flower or insect at your feet.

Photo Analysis: Bird Series
- A series of photographs of birds taken in their habitats recalls the work of the famous wildlife artist John James Audubon. The series was taken in consultation with bird biologists to avoid disturbing the birds or their chicks.

- A picture of an eastern bluebird was shot using a radio remote trigger and a softbox. When the equipment is in place and unmanned, the birds don't react to it as something foreign in the environment.

- Cliff swallows can be found under bridges or in other places near flowing water. For this series, part of the goal was to show the type of habitat preferred by the birds.

- The photo of the red-headed woodpecker was taken in the deep forest, using a wide-angle lens on a nest cavity. The subtle light is the result of using the softbox.

- These photos are all close, well lit, and intimate; because they also show some of the context, they're true environmental portraits. All the shots were achieved by learning about the nest sites and feeding habits of the birds.

- For a picture of a Baltimore oriole, dummy equipment was left out in the open for a period of time so that the birds would become accustomed to it. Food was put out for the birds but cropped out of the picture. In wildlife photography, again, research and patience pay off; set up the equipment, go sit in a lawn chair a great distance away, and watch the scene through binoculars to see when your subjects are in good position.

- Cameras that make very little noise are helpful for photographing wildlife. You can also use a remote camera, which sends out an infrared pulse to detect animals, then shoots the picture. Such cameras are expensive, but they allow you to get exceptional photos.

Takeaway Points for Photographing Wildlife
- Show respect and care in photographing animals. Your goal should be to show them behaving normally—sleeping, feeding, playing, and so on—not running away from your camera. Both federal and state laws prohibit people from harassing animals in the wild or forcing them to abandon their nests or their young.

- Use a long lens, a wide-open aperture, and a remote to make sure your background goes soft. You don't need too much depth of field in a busy scene.

- Get close to your subjects, especially small subjects, such as frogs, turtles, insects, and flowers.

Assignment
- Shoot an intimate photo of any species of animal but not a pet. Try to get the animal close enough so that it reads easily and fills a good portion of the frame. The animal can be captive or wild, exotic or native.

- Keep in mind that wildlife photography is a lot harder than it looks. Remember to be patient and wait for a good opportunity to shoot.

Suggested Reading

Audubon, *The Birds of America*.

Mitchell, ed., *National Geographic: The Wildlife Photographs*.

Homework

Shoot a full-frame image of a wild animal. Squirrels count!

Let's Go to Work—Wildlife
Lecture 13—Transcript

Hi again everybody, wildlife time, my favorite. My favorite. In this lecture we're going to talk about techniques for photographing wildlife, which is my particular interest and happens to be my life's work as well. There are opportunities everywhere for you to practice taking pictures of all kinds of wildlife, believe it or not, from squirrels and insects in your own backyard, to plants and animals of all kinds that you have to travel to them. I have a great set up for taking wildlife pictures in my own backyard, actually, from my laundry room, believe it or not, seriously! Let me show you what I mean in this field demo.

SOK, so what I've done here is I put a piece of camouflage cloth over my laundry room door. I have a birdfeeder, not 15 feet away; the birds come in there every day. I'm going to cut a little slit in this cloth, stick my lens through, and go. Real simple. OK, so I'm ready to shoot. That's all there is to it. The birds won't know I'm here; they're going to come right in. Let the magic begin, baby! They're already on the feeder. It didn't take any time.

We want to set all this up when it's really dark out so that we get good stuff once the birds start coming in. We want to be all set to go once it's feeding time. We try to do everything in the dark, just about, before sunrise. WAnd then, when they do come in, the light is nice and subtle, and we're golden. We're all set to go. Here we've already got a squirrel coming in.

So I'm quiet in here; I'm not moving around very much. T, and the wildlife's coming in really steady, just like every morning when we use our feeder out here. During the day when the wildlife's not around, I've already picked my spot, the background is very nice and subtle, I've put my feeder in a good place, and now stuff is coming in. LI mean, literally, we've got nut hatches, hold on a second, we've got nut haches coming in and starlings. See, they're hungry, and they really want to be there and they don't even know I'm here. We've got a squirrel right on the ground. He's going to hop up and feed right on the bird feeder, and they're going to fight with the birds, and there'll be a lot of action, so hold on a second, hold on a second. A lot of house sparrows there.

HAnd, how I'm deciding what to shoot, I've already decided that, before I set any of this stuff up. Before I set any of the stuff up I've already decided that this is going to be my frame: It's going to be this feeder, the light's going to be subtle, the background's green and lush, there's fencing that birds can stage on, we can do layers here, we can do action—it's really, really straightforward. I have a nice, long lens on that enables me to blur the background, and we're all set. If we have everything in place beforehand, we've thought it through a little bit, this becomes very simple, and we can enjoy it and really concentrate on what's coming in, like this squirrel coming into the feeder right now. It looks like there's another one that wants to push him off.

As far as where I'm composing things: I'll throw things off to the sides,; sometimes I'll center them. And since this is kind of a dark scene, I'm underexposing a little bit. I want it rich, I want it nice, I don't want to blow out those highlights. USo, usually, I've got the camera set on aperture priority. It's still veryfairly dark, so I have a big hole in my lens, in this case, on this lens it's 5.6. And I've got it at about 1600 ISO, and that gives me plenty of shutter speed. S, and so I'm using this long lens that blurs things out, it's a 200–400 mm lens. I can back out, zoom out, zoom in, and I've thought this through before I ever sat down in this chair. I've thought this through when there wasn't pressure on, when there wasn't wildlife out there. I kind of had it all thought out already, so b. By the time I get here it's just gravy, and I can enjoy myself and sit and watch if I don't want to shoot everything. It's really nice.

So a couple of things that help this along big time:, I have a device here called a Wimberley head, and this is a little pivot head, actually. It's just a really nice little device that's great for wildlife shooting by the Wimberley Company, t (they're the only ones that make it that I know of). It's just a pivot point. It's a tripod head, but it's a pivot. It allows you to go side to side, and up and down very, very smoothly—. It's a very easy way to shoot things that are moving, like wildlife.

The other thing I have going on is I've got a pretty high ISO on my camera. I'm up at 1600 because the Sun hasn't fully come up yet. That's often when the wildlife is the most active. So I've got it way high on my ISO. Why?

BWell, because I want a fast shutter speed. These birds and these squirrels are moving all over the place. I want to freeze the action with a fast shutter speed. So right now I'm wide open, with a big hole in the lens, (F4). I've got my 200–400 mm lens, F4, I've got about $1/200^{th}$ of a second, and I'm on aperture priority—, OK? And that way I'm not thinking about the light as it comes up; the camera's going to think about the light for me. I've kind of established these parameters, and that's absolutely the way to do it so you're more carefree.

The other thing I do,I'm going to do is at the start of this shoot, I "chimped" it. You know about chimping? Chimping is when you look at the back of the camera, look at the screen, just to make sure things are sharp, and to make sure that you're not getting any camera blur. Look at this. Right in here on this squirrel we can zoom in. Sharp as can be; the color is good, n. Nice and sharp. The other thing I'm going to do is I'm going to check the histogram. ONow, our histogram is just a graphic display showing the information in the picture. The right is bright, remember. The right is bright. I want to make sure I'm not touching the right. I don't want to blow out any of the highlights. There's no detail in a blown-out highlight. Most of the information is over on the left—the dark side. That's OK because it's kind of a dark scene still; there's no direct sunlight here. ISo I've chimped it; I know it's sharp.; I'm looking at the histogram; I know my exposure's good. Now I can relax and go. WI'm just going to shoot. We've got a beautiful cardinal out there right now. How awesome is that? That is so amazing. RSo, right out the back door of my laundry room. How easy is that? Anybody can do this—, believe me. TOK, so these look great; nothing wrong with them. Long lens. Beautiful.

But, I have a secret weapon right here in my pocket. Look at this. This is a radio remote trigger. This one's by a company named PocketWizard. They're very cheap—like about 100 bucks apiece. There's one here, one out on a camera right by the feeder, about six inches away from the birds. To take the picture, I look, make sure they're close, press the button—we just took a picture. Easy as that. And it's beautiful. It's a very new look for us, very intimate. Let's go outside and I'll show you how it looks out there. WOK, so we're out here at the feeder. We're standing right here. We've got two cameras to choose from. One is a little point and shoot. The receiver is right here on top—the little radio receiver on both cameras. This is a DSLR. , Aa

little bit different lens choices, a little bit different ISO ranges. Here's the trigger. I sit inside the house, I press the button, take the picture. That's all there is to it.

So you could see what I set up there with my camouflage curtain is what's called a blind, or a hide. A blind is anything that conceals a photographer from the animal that he or she is trying to photograph. We just want to not let them know that we're there so that they remain calm and do their thing.

So now, if you want to be a little farther out, you wander away from home a bit, many local wildlife sanctuaries have public blinds for wildlife watching and photography. In Nebraska, one of my favorite places to go in the spring every year is called Calamus Outfitters. It's out by Burwell, Nebraska. This is actually a working cattle ranch in central Nebraska where they have sharp-tail grouse and prairie chickens. It's amazing! They come right up to their blinds. Believe it or not, one of their blinds is an old retired school bus that sits on a hilltop in the heart of the Sandhills. It's quite lovely.

You know, I bet you could find great spots near where you live too. Check with local nature groups to see what kind of wildlife events happen in your area. You may be on a migratory path for monarch butterflies or hummingbirds. Is your county a nesting spot for rare birds maybe? It might be. What about when insects are at their peak? Or if you're on an ocean, do you know when the shorebirds are nesting, or gathering in great numbers to feed in any one place?

Take this picture, for example. It was shot not far from my house. It's of the Sandhill cranes migrating through the central flyway. It's an epic show. Half a million of these birds come into the Platte River each spring, many of them at the Rowe Audubon Sanctuary near Gibbon. Now, how is it that I happened to be there with these birds at the perfect time? Well, obviously, I increase my chances for getting a really good picture by researching a bit about the birds' behavior. I learned that these birds stop during March. They come in to rest up for their annual migratory flight from southern Texas and northern Mexico all the way to Canada and the high arctic to breed. They roost in the river at night, and they're out in the cornfields to feed during the daytime, so I'd done my homework. I knew when to be there.

You know, educational animals at zoos are also really good, because the animals are right in front of you. Take advantage of how close they are, and put beautiful lighting on them. There's no excuse not to if they're right in front of you. If you see an animal right on somebody's arm, like an owl, why would you not want to make a beautiful, lyrical picture of that owl's face? The same goes for, let's say, a chameleon, beautiful animal. Whatever that animal or zoo has to offer, take advantage of that. Educational animals are parts of most zoos routines now, like the Lincoln Children's Zoo.

Now these were all shot at the Henry Doorly Zoo in Omaha, a great, great zoo not far from where I live. Now these are shot nice and close aren't they? Look at this. I used a macro lens on this gorilla and a long lens on those polar bears, so this is a nice, easy place to work, a very relaxed, fun place, a crowned crane with a long lens. How nice is that? How easy is that?

Next up, these are Mexican gray wolves at the Sedgwick County Zoo in Wichita, another really, really fine zoo. The Mexican gray wolf is a federally endangered species. Here she's got her pups there, which is a big deal. I went there for an assignment, and I spent almost 40 hours with these wolves just looking into their pen from a boardwalk, and they were in a big, natural-looking enclosure. These wolves were all really rare at the time, they still are, but this breeding program really helped them out a ton. The interaction with mom and dad was great. It was just perfect.

You know, the problem here was that mom and dad would be sleeping during the hot part of the day, which was all day that summer. These animals were just active at dawn and dusk, so I had to stay there all day in case something happened. I had a book, and I sat near their enclosure, and waited and waited and waited, and I guess the key is patience. I mean I waited all day for maybe 20 minutes in the morning and 20 minutes in the afternoon. Patience is absolutely key when you're a wildlife photographer.

Now this one, shot at the San Diego Zoo where they have a breeding program for the California condor, another very rare bird. This is in a big flight pen. There's lot of wire there, how do we handle that? Using a long lens actually, magically, takes the wire out from behind these birds. Check that out. Same pen, I was shooting through a little hatch there. The zoo gave me special

access, I was with *National Geographic*, but that long lens, look at that, if you press it against the wire, the wire in the foreground will vanish most of the time. This is because the big lenses have such shallow depth of field, that if you're wide open with your aperture, you can really clean things up.

I like the framing device here, you know that little hatch in the door. Another framing device, the primary feathers, really frame his face. He's just sunning himself, but I love that, you know. It's a nice little compositional element here. You've got a hint of the wire pattern in the background, but not bad, not bad. And he's given me a little gift, isn't he. Notice the rule of thirds too. I put his face in that upper left-hand corner right in those power points, that intersection point. Makes sense!

So now, flower pictures, a lot of us do flowers when we start out doing nature because flowers are kind of easy, and that's OK. They're beautiful. They're lovely. I use a macro lens all the time when I'm doing flower pictures, constantly like everybody else, and I like to experiment with it. We know that macro lenses naturally have a very shallow depth of field, if the hole of the lens, or the aperture, is wide open. Now, this case, extreme shallow depth of field; there's hardly anything here that's sharp, just a couple of petals really, but I like that. I like how everything goes soft except for just right there. That's it. It's like a little watercolor painting. That's OK.

Now, a more conventional macro shot. I pulled back here a little bit, so the whole flower is in focus and the flower that's next to it, on a parallel plane. Here's our focal plane right there. That's OK. The one on the right is called monk's hood. It's actually kind of a rare flower in Iowa.

Now, next up, cactus flowers. Now these are shot off of a tripod with different apertures. Look it here, we've got a shallow depth of field, or a big hole, in our lens, a big aperture here just to get the flower sharp and the thorns go soft, right? OK, now watch this. A little bit more depth of field, well a lot, actually. Here I'm using a cable release on my tripod because I want a tiny hole in my lens and that's a slow shutter speed if we're in soft light like open shade, right? The cactus isn't going anywhere. It's not a windy day. It's not moving around. We're using a tripod, and look at the depth of field. Everything is sharp there even though they were very, very close, so use a

cable release and really get a lot of depth of field if something's not going anywhere, and that's the effect we want. No reason to be scared of that at all.

Now, what else? You know what? I like to do things that are moving because it's harder. I really like to challenge myself all the time. So, American goldfinches, I thought what can I do with American goldfinches? Let's see. Oh, how about if we put them in the habitat they're supposed to be in. This is out at a little acreage I own near Lincoln. They love thistles, and they love the weedy lots near acreages, and I thought, well, let's show them in the right habitat. How do we do something like this? Well, I'll tell you a little secret. There's a feeder right here. We feed these finches all year long, all the time they get thistle feed from us. So there's a feeder just out of frame, so I know they're going to land on these thistles and wait their turn. There's a big flock, that's it. That's it.

Sometimes when you're out there using remotes, the animal will come and, believe it or not, land right on your camera waiting. So, a lot of times I'll put a remote on my camera and half the fun is photographing the birds as they land right on the camera. They are not afraid. They literally land right on top of my gear. They just want access to the food, and they're very habituated. They're used to me being around. They're used to the cameras. They don't care, and that is excellent. Love it!

You know, don't forget to go to your local aquarium or botanical garden too. They're all great sources of information about the natural world, and you may be able to get a picture there too. One note of caution: Be sure to never misrepresent that your photos of captive animals are wild, of course. You know, this is really doing everybody a disservice, if you try to pass off captive things as wild. In all my captions I clearly identify what's a controlled situation, what's captive, and what is truly wild, and it can get you into trouble if you go to publish, and it's also just plain wrong. So, please, be really up front with that. Put that right in your captions in digital so it rides with those pictures all the way through so you've done your duty, you've done your job there.

Now there's also traveling for wildlife pictures—which of course, I do a lot. I go outside of my home state all the time. In fact, I'd say I spend an average

of one day studying for each day I shoot in the field, one day of research at home for each day in the field, if not more. See, I want to know, well in advance, things like when is the peak time to see the animals or the plants. Or, how close can I get without disturbing the animals? How cold or hot will it be? Is it going to be rainy or sunny? What's going on there? I just want to get a good picture.

The last time I went to Alaska, for example, things went very well because we had preplanned, right, preplanned, certainly. Wildlife work has no guarantees, remember, but doing your research helps a lot. It really puts you in a better position. You know, the grizzly bear doesn't know or necessarily care that I'm with *National Geographic*, so he may or may not show up; that's true, he might not. But I know if I go to a certain place, like the Denali National Park at a certain time of year when all that tundra turns to beautiful colors, I'm more likely to see great stuff happening. It's all about improving the odds.

For example, in Alaska, there are great places to go where the bears are habituated, and the bears aren't going to threaten you, really. They may look menacing, but other people have been there a lot taking pictures. There's safety in numbers of being with other people. These bears are used to it, and it works out just fine. It really does, totally.

So, a lot of times, I'll work with animals that are habituated to people in the wild, and I don't mind that,. I don't mind admitting that. In fact, I kind of prefer habituated animals because they're not going to be running away. They're going to be used to people, and I won't be harassing them. That's important to me, right? It's very important to me to be able to be close and just get these animals hanging out. I don't want to go around stressing animals, and it does me no good to get a series of butt shots of animals running away, OK?

Where do we go? We go all over the place, all over the place, and I look for animals that are just really super used to people being there. How easy this? Brooks Falls, the hardest part is getting there. The bears are wondering right around the shooting platforms. They congregate in great numbers. It's a lot of fun, and it really takes your breath away. They're magnificent

animals. They really are. It's something I think that everybody should go do. If you can get up to Alaska and look around up there, wow, it's really quite amazing, quite amazing.

So, let's talk about going to, let's say, a drive through a wildlife park. This is at Fossil Rim in Texas. Zebra! Wow, OK! He didn't really want to do anything much. He was just kind of standing there. Most of the time he just showed me his rear end, and so I thought well instead of fighting it let me get out the long lens and make something out of this. By long lens, I mean this one right here 200–400 mm, easy to shoot right out the car window. I did not know that certain species of zebras had stripes on their tails, but I took an opportunity that was presented to me. He just wanted to stand with his butt to me, that's fine. I'll take a picture of a zebra butt. It's kind of cute. It works out fine. That long lens really compresses things, doesn't it? It's a good way of seeing this compressing those stripes, just a nice different way of doing it.

So, what gear are you going to take with you wherever you're going to go shoot? Scout the location first, if possible, and see what kind of lens you're going to need, or talk to other photographers who have been there. They'll tell you if you find somebody who's giving with information, which you should always be, too, by the way, once you go. Long lenses are often a must, even if the animal is in a pen, believe it or not. We saw that with the California condor. If you can't get close to something, a long lens—a 200, 400, or a 500, a 600 millimeter lens, even just a 300—will be an important tool for you.

You can also use a teleconverter to reach out and touch a subject a little more. Now a teleconverter is something that just magnifies your lens a little bit. There's a 1.4, a 2x, which doubles the focal length, just a little magnifier you put on the back of the lens. And, you know what, as you get a bigger lens, bigger, bigger, bigger, you might want to use a tripod to support those long lenses because they get heavy and you get a little shaky trying to hold them up. If it's a little dark out, you may need a tripod and a cable release to keep that camera from vibrating when you press the shutter button.

So let's look at our lenses here. My standard kit for photographing wildlife varies. I have my 14–24, which is a really nice landscape lens, but you know,

I've used in wildlife, too, with those little remotes that I showed you in the demo. I have, what else, a macro lens 105. I have a 24–70. This is kind of my workhorse lens for people, but I use it a lot for wildlife too. And a 70–200, kind of an intermediate thing, works fine. It's nice for aerials actually, getting closer to wildlife when you can't use a big lens, and, the big gun here, this 200–400, and this isn't that big. It's not hard to carry at all, a 500 or a 600 f4, that's a really nice lens, but boy, a 600 f4 weighs about 14 pounds. That's a lot of weight, it really is, and sometimes I carry it. It just depends on what I'm doing.

You know, I view shooting wildlife the same way that I view shooting people. I think about getting close enough and getting repeated access to my subject. I can't stress that enough. Repeated access, that's a big deal! You know, I'll also take a flash with me. You know that small portable softbox that I used in the demo there? I use that all the time, like a Raptor Recovery where we lit up the owl. I use that all the time if I can get close to a subject and light it, those goldfinches, believe it or not, were lit with a little softbox, alright. If it's a frog or a turtle, interesting plants, I'll take that softbox, I try to get that light right next to the subject, very, very close. The closer that flash is in that softbox the softer the light becomes.

I always have a macro with me, always. I never know when I'm going to need it. Even if I'm on a story on grizzly bears, I may see a great flower or insect at my feet. Those provide great macro opportunities. Let's say all the bears are sleeping and I want to be shooting something. They give you a chance to do something different and to see something differently, and that's very important. I like to stay busy through the day. I love to shoot so that's just that.

Insects on flowers, obviously, are excellent subjects for this, because they don't really run off. A lot of times insects are really busy feeding. They're hunting. They're feeding on nectar. If you carefully work and don't scare them off, you can get beautiful, well-lit shots from very, very close up of insects. It's the same way with smaller critters, it is. This is blowout penstemon, a rare plant, with a little insect crawling around on it feeding. What else? A spider that's caught a little mayfly, turtles, that's alright, toads

lit at night with a flashlight. This is actually a very rare toad called the Houston toad in Texas, you know.

I would actually argue that the small stuff of the world is better to photograph, in many cases, because you can really make that light sing. Remember, again, it's counterintuitive, but the closer your flash is to the subject, the softer your light will be. It's very counterintuitive, but it's true. With my little softbox I move right on top of these animals. I get right on top of them and really, really craft beautiful, beautiful results with that.

So next I wanted to show you a few pictures in which I did just that. I used that little softbox and a remote trigger for both my large Nikon SLR, single lens reflex, and also a small Canon point-and-shoot camera, and I shot little migratory birds, tiny ones, that nest in Nebraska. And these pictures were all shot in Lancaster County, Nebraska, where I live. I wanted to kind of replicate the work of John James Audubon, one of my favorite wildlife artists of all time. He always painted the bird in its habitat. He wanted to show typical habitat for that animal. He was a storyteller, he really was.

So, first, the eastern bluebird, which is an animal that really likes to forage on the ground, and it likes short grass, and it likes peoples' gardens, so this is using the little softbox right on top of that animal, right on top, OK? Nice, close perspective, right? The camera is triggered with a little device, that little radio trigger you saw on the demo. It fires the camera. I'm actually sitting in the car looking at the perch, there where my light is, with binoculars. You saw that in the field shoot.

OK, what's next? A cliff swallow, look at this. With my cameras in place, by the way, the camera just becomes another perch to many of the birds that I photograph. The camera's not moving. It just must look like a tree limb to them or something. It's often big and bulky right there, especially with the flash and softbox, but you know what, that's OK. I just really watch for a spot and an opportunity and I take a picture, and the result it looks like we're right there living with these animals, and we are. Some of these are shot with a 14 and some with a 20 millimeter, some are shot with a 28. These are really wide, really close, and really intimate.

In the case of these cliff swallows, they've very common. They nest in urban areas, or under bridges, anywhere where they can be near flowing water. Here's one making its nest under a bridge. You can see the others foraging out there. They feed on insects a lot, mosquitoes; that's very critical because I want to give each image depth and a real sense of place, You know, most importantly, I want to show the type of habitat that each bird prefers. That's important for *National Geographic*. It's important to me.

Next up, an interior least tern. I go out with a tern and plover biologist for this, and I was with a cliff swallow biologist on the picture before. And she guided me to the right nest where the chicks weren't too vulnerable. I set my camera there very quickly, walked away. It has a little radio trigger; we're right there with mom and her chicks. Get it very, very quickly.

This one was a little harder to do, as you can imagine. The red-headed woodpecker, it's a bird that lives in deep forests. Here we're using a wide-angle lens on a nest cavity. Again, I'm working with the biologist. We determine how old the nest is, whether it has chicks. We don't want to disturb things, we don't want to interrupt things. I always work with biologists that when we study the birds, we see where they are in their nest cycle. We don't want to do any harm, we just want to get our picture and go. We're using a wide angle lens, the light's very subtle, and you can see that this is a bird of the deep forest. That light's very subtle because that's that softbox again, and it's right there next to the nest cavity. It's right there.

We're using this quiet camera in this case, that little Canon G12 because it doesn't make very much noise. You can't even here it go off. They can see the flash going off, but they tolerate it. The thing about all of these is that they are close, well lit, intimate, and you can see the context, you can see where we are. They're true environmental portraits. Now, how did I do this? Well, by now you've guessed. It's nest sites, or its food. That's it. In the case of this red-bellied woodpecker here, this is actually one of the early attempts I had at this. You can actually see this is next to a feeder I have, I've drilled a couple of holes here and I put peanut butter suet in there. I just wanted to see if the technique would work, and it did. They come right in. They want that food. This is just on that same farm where the thistles were.

In all these cases, I also did my homework. I went to a local place, in Lincoln, called the Wild Bird Habitat Store, and I asked them who was buying the most bird food? Who was the most avid feeder in the area, and what kind of birds do they like to bring in? What do they feed their birds the heaviest? Who feeds the most? The guy that owns the store, a really great guy, a generous guy named Dave, with lots of knowledge, he says, "Well, you want to go out and see Steve and Cheryl outside of town. They feed Baltimore orioles slices of oranges and certain types of grubs during the mating season to really fatten these animals up for breeding. They have tons of orioles. Their birds are very habituated and come right up their feeders."

So, I called Steve and Cheryl, I introduced myself, got permission to put my camera right out by their oriole feeding station of oranges, and this resulted in what I think of as my favorite image. So, this is what we ended up with. The Baltimore oriole is a bird of forest edge, basically. He likes forest edge where it breaks out into the open. There's a couple of geese with their babies on the lane there. How's this done? I want to show you how this is done. You'll be amazed.

Look at all this. That's the stuff. That's the rig, the softbox, the flash, the camera. There's an arm there that's basically supporting everything. That is a lot of stuff isn't it, but look he's hungry, he wants the orange, and there he is eating. And all that stuff yields this. A little deceptive, isn't it? But you know what, if you leave that gear there, the birds are hopping on it. There are lots of males. They all want in, and they actually hop on it, and we left that rig there over a two-and-a-half week time's span. The birds know, and we put dummy cameras out too, so they really get used to it, and they know that this contraption won't harm them.

I position it so it's shooting off to one side, so I don't see the feeder, I don't see the orange, and you know, there we go, there we go. That's how a lot of these are done. I compose the photo so that we've cropped out the food, obviously, and it just shows the bird in the environment. Again, research and patience pays off. Each of these pictures, with the exception of, let's say, the nest, these feeder pictures took about 40 hours a week to do, 40 hours over a week's time. It's a long time, maybe over two weeks time. It takes a long because you really want to set up the camera, go sit in a lawn chair from a

great distance away, and you watch through binoculars, and you don't take any pictures until they come in and they're in a perfect position. It really takes awhile. Patience pays in wildlife photography.

In the case of the little Canon camera, that camera is virtually silent, by the way. It's a little G-12. It doesn't bother the animals at all, and they don't notice the flash much. By the way, I made sure that Steve and Cheryl got a nice print or two as a thank you for helping me out. Follow up with a little print gift, and you'll always be welcome back. That's a great way to do it.

Another way to shoot wildlife is with camera traps, where you don't even have to be there. Camera traps send out an infrared pulse and the animal takes its own picture. Let me show you a couple of these. Camera traps, I ran these in Africa on assignment for *National Geographic* in Uganda. They're a nice way of getting something intimate and close, and again, the animal breaks an infrared beam. We put the camera on a mud hole or a game trail, and we really get some lovely pictures like this. A hyena at a den, how about that? This is a camera trap set up in Medicine Hat, Alberta, in Canada for pronghorn antelope. There's the camera, there's the receiver, there's a little trail there. These animals, the pronghorn, like to crawl under it. I do remote cameras all the time. It's pricey, but you do get some lovely pictures.

I want to show the effect of fence on these animals. A barbwire fence is kind of hard on them, and our caption said if you raise that barbed strand to 18 inches and put a smooth wire there, that's easier for animals. That's much easier for them to navigate, so I'm trying to make a point out of these pictures, trying to get some education into the magazine as well. That's what *National Geographic* is great at.

Now, if you are visiting an area that's unfamiliar to you, especially a foreign area, I'd consider hiring a guide, or taking a guided tour. I've had a number of wonderful guides over the years. I call them fixers because they fix my problems. It's amazing how much time and money they can save you, especially if they also happen to be local wildlife photographers. They know where to go, they know the best times of the year, and they know what the shooting restrictions are. Another nice thing about hiring an assistant is a lot of times you spend so much time with that person, you often become friends

with them for life. All the people you're seeing here, I'm still in touch with them many years later, whether it's Brazil or Africa or Bolivia, all these people become fast friends, because you go through a lot with them. They are excellent people, they're fun hanging out with, and they know and care about nature, and they save you a ton of time.

Common mistakes: Don't harass your subjects in the wild. I'll say it again, do not harass your subjects. Most states have laws and federal laws that really hammer you if you force animals to abandon their nests or young if you press them. You do not want to do that. It's not the right thing to do. Shoot these animals in the right way with some respect. Allow them to have their picture taken doing the things that they do. Show them looking well and fine and behaving normally. Besides that, do you really want pictures of animals running away? I don't think so. Fighting, sleeping, feeding, playing, mating, that's what you want. You don't want pictures of animals that run away. That isn't it, and it's just wrong, and it doesn't make good pictures, so if you can't figure out how to do it, don't go. Do your homework. It's not worth making a bird abandon its nest or a deer abandon its fawn, because you're trying to get a good picture. We're just talking about pictures after all, it aint life and death, OK?

Use big glass, a long lens, remotes, wide-open apertures, make sure that background goes very soft. You don't need too much depth of field in a really busy place. Another common mistake when shooting wildlife is being too far away. You can't get close to everything, but you can certainly get close to a lot of things, especially the small stuff: the frogs, turtles, insects, flowers. Flowers can't hop away. They stay right there, a totally captive audience. Your flower pictures should be among your best.

So get close, just like with people. Intimate, repeated access to your subject is what's really needed. That's what makes it sing. Figure out a legal way, like setting up a birdfeeder, that you can put a camera next to, where you can get an intimate picture of that animal in the wild.

OK, your assignment: Shoot a nice, intimate photo of any species of animal (no plant pictures on this one, no pets, OK, too easy). Try to get the animal close enough so that it reads easily and fills a good portion of the frame. The

animal can be captive or wild, exotic or native. Once you've tried out wildlife photography, by the way, you'll realize it's a lot harder than it looks, but it is so fun and satisfying when you finally nail it. People will just be absolutely amazed. In our next lecture we're going to talk about photographing even more complex and difficult subjects, people. Come right back.

Let's Go to Work—People and Relationships
Lecture 14

S till photographs literally stop time in its tracks and help us create lasting memories of the people and events in our lives. This is really the reason that photographs become icons, too. They stay with us all of our lives. In this lecture, we'll view lots of photos of ordinary people that capture interesting moments in the "dance of life." We'll also learn tips for putting subjects at ease, finding a good stage in your home, and getting wonderful candid shots of family members and friends.

Meaningful Photos
- The power to evoke memories is often what we treasure about photographs. A picture of a woman catching snowflakes on her tongue on a day shortly before she was diagnosed with breast cancer is beautiful because it recalls a time when she was carefree.

- Another photo of a mother tending to a child's skinned knee captures a simple moment in the life of a family.

- A photo of a grandparent can be an honest representation of a life that has passed, evoking both the subject's personality and life experiences. Such photos also ensure that we won't forget the people who have been important in our lives.

Where Would We Be without Cameras?
- Photographs help us preserve our memories throughout our lives. Interestingly, the mind tends to remember things in terms of still photographs.

- This ability to capture memories is one of the reasons it's important to take pictures in your own home and of the people and pets who live there. Most of the time, those people will allow you to shoot anything you want, enabling you to get great candids.

- Of course, you shoot special events, such as Thanksgiving or other celebrations, but don't forget the everyday moments, such as kids gathering in the kitchen to help make cookies. Keep a camera close by where the action occurs in your home; set it to aperture priority with a high ISO, so you'll always be ready.

- It's much better to photograph what people are really doing than to force an activity on them. And just try to get two or three shots when a fun or surprising moment occurs; don't prolong the shoot and risk annoying your subjects.

Photo Analysis: Genuine Moments
- A photo of two sisters laughing captures a moment just after they had been caught gossiping.

- Another photo shows a young boy throwing toilet paper around a room. Shooting the picture was a better response than getting angry at the boy and ensures a lifelong memory.

© Joel Sartore.

Shoot anything that goes on in your house that's interesting, or different, or colorful.

- Still another photo shows a girl and her friend wearing mud masks made out of green food coloring and oatmeal at a sleepover.

- A real photographer can make pictures out of anything, even the daily grind of a household—people eating dinner, a mother helping a daughter with her homework, a boy getting a home haircut, a girl getting a quick kiss from her mother. These are the types of pictures that we sometimes just don't think to shoot.

- It's fun to capture happiness, smiles, laughter, and love, but you can photograph tears and dramatic scenes, too. Crying babies often make better pictures than smiling babies.

Putting Your Subjects at Ease
- Of course, if you live with your subjects, they're probably generally at ease around you, but if you're photographing people outside your home, it's good to smile yourself to help your subjects relax.

- It's also important not to put your camera immediately in your subject's face and keep it there. Be discriminating in choosing appropriate times to shoot.

- Learn to read body language to determine if your subject is shy or if he or she is ready for a break. Don't push a subject to take more pictures if it seems as though you aren't making a connection. You can also often tell how animals are feeling by observing their behavior.

- Try to be a fly on the wall; that is, don't interfere with your subject's behavior. The goal is to be unobtrusive; let subjects get used to your presence so that they'll behave naturally. If you interrupt the action to fix something in the frame, you risk derailing the mood of the shot. Minimize the amount of noisy equipment you use, and if possible, don't use flash.

Candid Shots and Slice-of-Life Moments
- It's a truism of photography that if you can be patient enough and keep your camera up to your face long enough, people will do something interesting. If you wait even longer, they'll do something amazing.

- Look for opportunities to shoot everyday scenes of family life—a child sitting on a parent's lap or sitting on the potty.

- As you shoot, keep in mind all the things we've learned thus far in the course: color palettes, softness of light, depth of field, composition, and backgrounds.

- It can also be rewarding to document people at work. A photo of an accountant in his office shows papers and books encircling the subject, drawing the attention to him.

- When you take portraits, try centering the subject but have something going on in every portion of the frame. Keep the background behind the subject's head simple so that the viewer's focus is on the eyes.

Behind the Lens

Crying babies, to me, make better pictures sometimes than smiling babies. Not many people think to photograph crying babies; they just don't. I tell you, when these kids grow up and you've got them throwing a fit as a baby, those are the ones that are going to [cause people to] stop. Everybody's going to pore over and marvel over [those shots] when you actually pull open the photo album, so I think about doing this a lot. Actually, as the kids get older, they really hate getting their picture taken when they're crying or misbehaving. Now, when I get that camera out on the youngest one, he hates it so much he actually behaves himself. It is a wonderful disciplinary tool, getting that camera out. They may have some sort of psychological problem from it when they're adults, but at least I've gotten them to behave a little bit once in awhile.

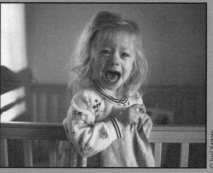

© Joel Sartore.

- Try to get some shots of people when they're asleep. In a photo of three sleeping children, note the soft, golden light and the classic use of the rule of thirds. Remember to work the scene—try shooting from different angles and heights.

- Look for the best stage in your home—places where the light is good, the background is relatively clean, and people come together. Shoot fast, but be aware of objects in the scene that might distract from the subjects—shelves, doorways, and so on.

- Again, always be ready to shoot, but don't overwork the scene. Take your camera wherever you go, even if you don't think you'll use it. Don't direct your subjects; just sit back and let the action take place.

- When you think about documenting special events, go beyond the standard holidays. Photograph a girl getting her ears pierced or a boy baking a batch of cookies by himself for the first time.

- The more you practice photography, the choosier you'll get about such elements as background and light. This means that both your creative eye and your photos are improving.

Assignment
- Try to capture a real emotion in a candid photo. The subject should not be performing for the camera in any way. The photo should read as if you, the photographer, do not exist.

- The emotion doesn't have to be a happy one, and it doesn't have to be from a person; your subject could be an animal. The goal here is simply to convey emotion in a real situation.

Suggested Reading

Bown, *Faces*.

Lanker, *I Dream a World*.

Latimer, ed., *Ultimate Field Guide to Photography*, pp. 130–142.

Seliger, *Physiognomy*.

Wilson, *Avedon at Work*.

Homework

Show a real emotion in a candid photo. This means the person is not performing in any way—it's as if you don't exist. The emotion can be laughter, of course, but forced grins don't count.

Let's Go to Work—People and Relationships
Lecture 14—Transcript

Welcome back everybody. You know, still photographs literally freeze time. That's the great thing about them. It's amazing. It's one of the reasons I love photographs so much, they literally stop time in its tracks and help us create these great lasting memories of the people and events in our lives. Nothing else can do that. It's really the reason that photographs become icons too. They stay with us all of our lives.

As an example, I wanted to show you a few shots that mean something to me. These are emotional pictures for a lot of reasons for me. The picture of Kathy catching snowflakes on her tongue was taken not long before she was diagnosed with breast cancer, so this means a lot to me. She's just very carefree. It's a simple moment, but she's worry free here, pretty, dressed well, nothing on her mind other than probably being a little cold, but having fun with Cole. It's a few minutes after he got out of school one day, and this picture means as much to me as anything I've ever shot or had published in *National Geographic*.

Or this one. This is a shot of my youngest son, Spencer, after he'd skinned his knee. He came running into mommy. Kathy is tending to him, he'd skinned his hand too, and he's in the bathroom of my parents' house before we had dinner. The light's soft, he's in these cute little shorts, and he really seems upset. He was all better five minutes later, but look at how a simple moment can become just a beautiful photograph. Man, did I get yelled at for shooting this picture, too. They both turned at me and yelled at me. I got one frame, one frame. I'm terrible, aren't I?

This last one is of my grandmother and my mother. My grandmother's parents are in the portraits on the walls, so it's my grandmother and my mother in the mirror. You know, my grandmother has long since passed away, but this is an honest way to remember her. I remember she wouldn't let me move her bed so I could get a little bit better angle. No way. I'm not going to rearrange her furniture.

She was this tough lady from north Texas. She kept a very tidy and clean house. She did not suffer fools, she didn't complain, and she kept going. She'd lived through the Dustbowl, and had made the journey to California when the family lost the ranch, just as Steinbeck had written about in the *Grapes of Wrath*. There were a lot of people that went through that. And this photograph to me is an honest representation of all that, and both endures and ensures that I'll never forget her, and I won't. I just wish that I'd put myself right here. It would've been a four-generational portrait. Anyway, all these photographs have an emotional weight for me, and I love that. I really do. As I said, it's something that only still photographs can really pull off well.

So where would we be without cameras? I'm sure glad I didn't live in a time when they didn't have photographs. Photographs help us preserve our memories all through our lives, and the mind tends to remember things in terms of still photographs anyway, anyway. What a great invention, kind of like flight. I marvel every time I get on an airplane and sail up and over the clouds, and I fly all the time, nearly every week. Same thing when I see photographs. It is really marvelous that we can do this, you know, the process of photography. It's amazing to me still. And let me stress again this idea of taking pictures in our own homes and how important and relevant that is, every bit as important as photographing something for *National Geographic*.

I mean, the people there, the pets, the relationships, everything about it. We love this. We love these people we live with and our pets most of the time. They know we're not going to do them any harm with our cameras, and we are just there. And these people we love, they'll let us shoot whatever we want, within reason, and hopefully they ignore us so we can shoot wonderful candids. That's my own hand feeling Cole's head before he goes to school. Does he have a fever, should he go to school? He wasn't quite feeling good. I just shot one or two frames, but it's a nice little candid of him when he was a little boy. He's 18 years old now, so, the dance of life goes on and on around us, all captured well in still photographs.

Some friends of mine that ran a café, they'd taken a print I gave them, tacked it up on a bulletin board in their café. They made the most wonderful pies.

These are all things that mean something to me. You know, special occasions count too, very easy to do, really nice pictures if you're there.

Take Thanksgiving at my house. It's a very happy celebration, my mother and my mother-in-law there with a couple of pies they have handmade. Everybody is healthy and happy in this picture, and what a nice way to remember this moment, especially now that my wife's mom is too frail to participate much now, let alone cook. What a nice little moment, and this was just a few years ago, and they are always and forever in this picture healthy and happy. That is the beautiful thing about still photography, it really is.

You know, I usually have my camera downstairs, on a little table out of the way. It always has a fresh card in it that has been cleaned off. It's always set to aperture priority, with a fairly high ISO because I'm most likely to see something happening indoors, I want to be ready to go. I'm ready. It's sitting there. I'm ready. So when I see little things like this in the kitchen, when the dog and Ellen and Spencer are all crowding in to get mom's attention in the kitchen, I can shoot it, you know? They all want to get in on whatever mom's doing all the time, probably making chocolate chip cookies here or something, but you can't really recreate things like this. So it won't look as good, or the same, so I just grab it fast. I'm ready to go, I grab it. It's really quick that way.

It's so much better to photograph what people are really doing than to force something on them, by the way, and have them doing what we think they should be doing. After awhile, it's all going to look the same. It's the infinite variety of real human behavior, in different situations, different settings, rooms, different lights, times when we feel good, times when we feel bad, that's the infinite variety, and that makes for a rich experience when it comes to creating good photographs that don't overdo it, just a frame or two, but if you're ready to go, you can do the same thing. You can do the same thing.

Here are some genuine moments, genuine moments where I couldn't reproduce it if I tried, right? Kathy and her sister, I had busted them for gossiping. I'd said should you guys really be gossiping like that? And they realized they'd been busted, and they just can't control themselves, they

cannot stop laughing. Now, this picture of my little boy, Spencer, he's just as happy as can be. He just had a bath. Usually he doesn't like to get a bath, I don't know maybe his mom was making faces at him or something, I don't know.

Or this picture, one where he's gone a little nutty, I have no idea why he got all the toilet paper out. I have no idea, throwing it all over the room. Instead of getting mad at him, I took a couple of pictures. More fun that way, and you know what, he's half grown up now too, so I'm really glad I shot this. I came across Ellen and her friend one night. I came downstairs. She was having a sleepover. They'd decided to make mud masks out of green food coloring and oatmeal. I had my camera. I was ready. I was totally surprised by it, but I was ready. Anything going on in my house that's interesting, or colorful, or different, I shoot it. I have three kids and two dogs, it's a madhouse. I shoot whatever I can get away with. I don't just mean I shoot birthday parties and Christmas morning, I try to do something new all the time. I have that camera there and I don't beat a dead horse. I shoot just a few, very quick, the good stuff just happens for a moment anyway.

Remember, a real photographer can make good pictures out of anything, even the daily grind of a household. It could be something as simple as my parents having dinner. They have this routine. They live by themselves. It's very quiet, very measured. They sit across the table, they don't talk much, a very measured thing, lots of color. My mother believes in eating healthy. This is very typical of their tidy little house in Nebraska. It's a good representation of them. It could be a friend of mine, helping her daughter with her homework. you know, this is the type of picture we just don't think to shoot.

It could be Kathy trying to feed little Spencer when he was little outside. It could be anything. It could be my son getting a haircut in the kitchen, or the time that Spencer decided to run around naked for some reason before we sodded the backyard. I don't know what was going on there, but I shot it. I like the way the tree splits this up, dog, Spencer, Kathy, shovel, I like the leading lines and framing devices in there I guess. The thing that I love to do really is to capture happiness, smiles, laughter, love. I really do.

Like, this picture of Kathy kissing Ellen on the cheek, in the bathroom. It is so sweet. I love it because it shows the bond between them. They're not too terribly conscious of the camera. It just happened kind of quickly, and my daughter will forever be five years old. That is so nice. She's always going to be five years old in that picture. You know, I also, though, as you know, I photograph the tears and the dramatic things just as well.

Crying babies, to me, make better pictures sometimes than smiling babies. Not many people think to photograph crying babies. They just don't. But I tell you, when these kids grow up, and you've got them throwing a fit as a baby, those are the ones that are going to stop and everybody's going to pore over and marvel over when you actually pull open the photo album, so I think about doing this a lot. And actually, as the kids get older, they really hate getting their picture taken when they're crying or misbehaving. So now, when I get that camera out on the youngest one, he hates it so much he actually behaves himself. It is a wonderful disciplinary tool, getting that camera out.

Now they may have some sort of psychological problem from it when they're adults, but at least I've gotten them to behave a little bit once in awhile, once in a while. This one, especially, Ellen, she's going to hate that when she grows up. She might not like that one either, believe it or not. What else?

Putting our subjects at ease is a big one, really big, and it's really important. Now if you live with these people you've already put them at ease, right, unless you shoot them too much. You want to be measured and do not go overboard, but if you're getting to know somebody that you don't know intimately, if you smile, you're throwing off a great vibe to people saying, "Hey, I'm worth having into your life. I'm a good person. You're going to enjoy spending time with me, I'm not going to cause you any problems." It's worth it. I just smile a lot, and it helps to gauge your subject's mood when they see how they react to you smiling and being kind. That's a good thing. If you smile and they're frowning back at you, it really tells you something, doesn't it?

Putting your subjects at ease also involves not putting a camera in their face immediately and then all the time. You need to really be discriminating and figure out when is an appropriate time to shoot and when isn't. You shouldn't torture your friends and family just because you have access to them, nor should you torture strangers. Figure out some ground rules. It's important you establish trust with your subject and that they know that you're a normal person who's not just going to be insane because you have this camera. You're not going to be shooting every second.

Reading body language is a big deal. Much of the time we humans use body language and facial expressions in a more honest way than talking, certainly. This is a big deal. A lot of our communication is nonverbal. If a subject is shy, you can see it just with their body language. They might do this and they might not look at you. If someone is avoiding eye contact, their arms are crossed, their brows are furrowed. If they're shaking their head no as they're talking to you slightly, that's a clue that you're not connecting. If they are slightly shaking their head no, I've seen people smile and say that's a great idea Joel, fantastic, let's take pictures. It tells you something. They don't mean it, right? Without a word, really, you're going to know when your subject's had enough, or if they're up for more. I wouldn't push it. Maybe it's not picture-taking time. Maybe it won't ever be. I don't know, but I really look at body language a lot.

First, a pair of actors at a movie ranch out in the West. In the first one, look at this body language, closed up, they're mad. Without a word you can tell that they're irritated and closed-minded and defensive, and not open to new ideas, and could shoot you because they've got guns right, especially to what a photographer has to say, they're not open to that. Look at them, crossed arms, it doesn't get any plainer than that. These guys are serious. They mean business. They do not suffer fools like me.

Now let's look at this one, much more of a candid. You can tell these guys like each other. This is when we stopped acting for a second. They work together every day, they're friends, they're having fun, leaning into each other, and they're smiling. Arms are apart, no more crossed arms at the chest, and the firearms are put away. It's just a much more relaxed, fun picture really.

The radical shift between those two pictures is a great way to illustrate body language or I wouldn't have thrown them in here. I wouldn't have wanted to take a second picture of the two guys that were mad, right? Maybe you wouldn't even live long enough to take that second picture. But you could shoot all day with the two guys that were happy. Often, it's the unspoken stuff that's more important than the spoken stuff. You can even tell how animals are feeling just by looking at them. You can read animals that you're photographing quite easily.

Here's another thing to learn. Learn to be a fly on the wall so that you're not interfering with the subject's behavior. Now the littlest one, Spencer, at my house is a real good example. He likes to throw fits all the time. He'll go upside-down at the dinner table at home when we're trying to have a meal. He likes to take his show on the road too. My wife is so good at ignoring him that she can just go on with whatever's going on. It doesn't matter if we're in public or in private, she just doesn't pay any attention. To me, that's the great part, and the payoff of the picture, really, a picture like this, she is just going to have her dinner. It doesn't matter what Spencer's doing. If he's throwing a fit in a public place, in a café, that's fine, you know.

We're in New Mexico. I love the way that his pants match the color of the booth, by the way. I'm thinking about that too, but she's just eating her lunch. She doesn't even hear him. So, when you're trying to set up a comfortable and friendly relationship to your subject, you also need to be thinking about color palettes, softness of light, depth of field, composition, everything we've talked about so far in the course. If you can get a little bit of this in there, like real interesting stuff, fun stuff, that's gravy.

I just try to be a fly on the wall most of the time, really. People have to get used to me. I smile when I'm introducing myself and so forth, tell them I'm a fun guy, but they have to get normal again. They have to quit paying attention to me. If you stop the whole train, say hey here I am would you move a little bit to try to fix something in the frame, you've derailed the whole mood of the shoot, and you've brought attention to yourself, made people uptight. They're going to be conscious of their actions. Just let things unfold and happen naturally. Minimize the amount of noisy gear that you

have and movement. Maybe put that flash away, don't use the flash. Find the best spot to be, and then try to just hang out, try to vanish.

And when working in delicate situations, you're really going to want to minimize the movement, the noises, and the flash as well. Flash really takes its toll on situations that are delicate. You know, Kathy might get embarrassed if I use flash to take a picture of her upside-down boy next to her in a roadside café like that last one. I mean it would draw attention. I'm just shooting a couple and putting the camera down and eating my lunch. There is plenty of beautiful, soft, natural light in there anyway, and that works fine. I don't need to hit that with a flash.

All these things, also, are nice, candid moments, because you're not interrupting; you're just sitting there. You're just hanging out. A photographer named David Burnett, who I really admire, he once told me: if you can be patient enough and keep your camera up to your face long enough, people will do something interesting. If you wait even longer, they'll do something amazing, and that is so true. If you just hang out, people will do the most amazing things; things that you could've never thought of, ever.

So let me take you through this situation very quickly. These are my friends Ralph and Linda. They live in Washington, DC. Ralph also is actually an outstanding wedding photographer, and his wife, Linda Corman, is a great writer. They have a couple of little kids, Sam and Julia, and whenever I go to DC, to the *Geographic*, I stay with them. They're good friends of mine. They live in a historic home, and they have a lot of nice window light, and I just go there and as a little payoff, a thank you for allowing me to stay there I take my camera.

When I get my camera out, they just ignore it. I've known them a long time, for 20 years, and when they had kids, I really started taking pictures of them around the house, and I'm just part of their family, and I am a part of their family in a real way. And I just hang out, a fly on the wall. So, I take these pictures as a way of thanking them for allowing me to stay there, but they have this nice little record of their kids growing up, don't they, the little things, just the dance of life, you know, the family hug, and Julia sitting on mom's lap, and Sam sitting on dad's lap, and all the stuff. It's real. They

don't care that I'm there. They have a great time. We hang out together all the time when I'm not working. This one, especially, Julia getting a book read to her while she's on the potty. That's going to be so embarrassing to her when she's older, but I get a kick out of it, you know?

This picture is going to grow in value, though, as both of them age, isn't it? It's so cute, and it's just a little slice of life and nobody ever thinks to photograph this kind of thing. It's just this cute little thing. And look at how her head stands out perfectly against that. I'm thinking about backgrounds all the time when I'm shooting. I want her head to be kind of haloed here, not over here, not with these lines in it, pops right out. Linda's face is framed by her hair, everything's clean. It was just shot at night, no big deal. It's just this cute little slice of life, trying to get the kids fed, get out the door, put into bed at night, most people would not think to shoot this stuff. But you know, a couple times a year, I'm there for this stuff. I shoot, and I get it. Ralph tickling Julia in the kitchen or being very tired at the end of the day, just Ralph being tired, I like that too.

Of all of the pictures I have done though, this one is absolutely my favorite. It's of Ralph looking so dejected because Linda, who I'm not sure she knows how to do laundry well, she has put Sam's baseball shoes in the washing machine and filled them full of soap. So he has these wet, sudsy, baseball shoes, and he has to go out and play now, play this game in these shoes, and Ralph looks so disappointed. He cannot fix this problem in time. They don't have another pair of shoes for the baseball field, and Ralph has totally had his bubble popped, and he's trying to decide whether to yell at his wife or just pack it up and go out the door. And I still hear Linda in the background, "What can I do about it now Ralph?" And they're arguing about it, and Ralph looks so sad, and he knows that Sam is going to be in wet shoes for the next three hours, and won't play as well.

Sam doesn't like it, but he's not saying a thing, he's just standing there. He wants to stay out of the argument. It's just a classic to me. I laugh every time I see it, but there are lots of good pictures, though, from this family. After the kids have gone to bed, even, just Ralph looking at the dog who wants to steal his ice cream. Ralph has such a good, expressive face, and he's a

photographer. He knows that if they don't pay any attention to me, that's when I get all the really good stuff, and it's a joy to be there.

You know, it can be rewarding to document people at work, too. Most people don't take the time to show themselves doing their jobs, so you could start a trend. For example, I take pictures at my accountant's. This is my friend Kyle Sitzman, he's been my accountant for a long time. His office is very cluttered, and yet that reads somehow. Let's talk about the mechanics of some of these pictures. Look at this; his face is lit. He's smiling; he's kind of this space in the center. It could be a little cleaner. If I was a little higher, that shelf wouldn't be in his head. But it still reads because he's kind of the center of attention. Look at all this stuff swirling, it creates kind of a circle, and you're looking back at him, but every corner is used, isn't it? Every corner is used.

You know, the mechanics of pictures, I think about the mechanics of pictures when I photograph my mechanic, Kendall Warnock at A-1 Automotive. Here he is, nice soft light. I center people a lot when I do portraits. I just like that look, but look at this, something going on in every portion of the frame. I try to pay off the viewer, and I try to keep the background as simple as I can behind people's heads. That's where I'm going, right for the eyes.

What else? I do detail shots all the time. Look at how we have these leading lines going right into where we're working on this car, on the other side, leading lines taking it right to the point, right in the center. That's alright It's just a framing technique; that's all it is, but you know about framing techniques, don't you? Or my doctor, Mark Hutchins, my wife and I, just very simple, elegant light, just during an appointment, you know the eyes are the windows to the soul here again. A little splash of color, it's good, it's fine; it's very simple. He's slightly off center, though, isn't he? Thinking about rule of thirds again, he's more up into the upper, left-hand corner. It's alright.

You know, of all the places I go though, as far as work pictures, I really love going to my insurance agent's, because he lets me do wacky things while I'm there. I've been friends with the guy for a long time. He has a good sense of humor, and he allows me to bring friends in who are models and we kind of goof off, and we take all sorts of crazy pictures just for fun. I don't know why.

This is done very intentionally here. I don't like the way that's very, very empty, but, I love the way that she is framed up perfectly in that doorway, perfectly like that. She just stands out. She reads so easily. This picture really needs something up here to hold it together. You know what would be perfect? A photograph, a family portrait of a whole family with bags on their heads. Maybe I should go redo this picture. I think I probably should, rule of thirds, framing, the whole thing. It just needs that one last piece. I think I will go redo it, I think I will.

You know, whenever I go to these places, beyond doing stuff that's goofy, I'm thinking about, let's just break up the monotony of the day. It's fun and interesting. And you know what, these guys put these pictures up on their walls. They do—even if they're crazy. They start a lot of conversations with these pictures with new clients. They make a better living by having interesting pictures of themselves, plus they get a laugh out of them over and over again. And I'm really trying to do things that other people haven't done. Whenever I can surprise somebody by shooting a nice picture of daily life, I mean, I do it. I really do. I try doing that all the time.

What else do I shoot? Sleeping people, especially kids, it's really excellent. They can't backtalk you when they're asleep, kids can't. They're not going to try to hold you up for bribes for candy or sweets or ice cream. You can put your camera on a tripod, get lots of depth of field, and really work stuff. I work sleeping kids all the time. Look at Spencer's room here, holy cow! What a mess. It looks like I have a fish coming out of my head, but I wanted to illustrate, you know what, it's good stuff, and it's easy. It's very easy when they're sleeping.

Look at this, the composition in here. Again, just a reading light, this is a single, tungsten bulb. Just like I showed you earlier in the course, that little chick in the hand, same thing. We've got one beautiful, golden light source, rule of thirds going on here, classic rule of thirds here and here, leading lines going all through the picture, three faces. This picture has a lot of stuff going on in it, and it took me awhile to craft this. I really worked it. I really did. I got down low. I got up high. This angle, just like this, three in a row, leading lines, rule of thirds, soft light, and a tender little moment. Everything is working in this picture for me. I've looked at this picture again

and again over the years. I probably shot this ten years ago, but I really like it. Everything's working in it.

So, in this one, more of a simple picture, not really much depth to it, but funny and very embarrassing to my daughter Ellen someday. I'm hoping to embarrass her with it. It's right in her face. I don't know, curlers, really? Seriously? Curlers when you're seven years old?

So, let's take a look at a couple of other situations, other things I've done at home. You know, when I'm at home I'm always looking for the place where the light looks the best. I'm looking a stage, always a stage. I look for that best place, and then I'll often hang out just to see what develops, but what do I mean by best place? I mean light. I want good light, I want a clean background, and something happening—all the time. I look for this type of thing. The world is a stage, whether I'm at home or about, I look for which direction the light's best, and then I hope that something good is going on in it.

So, a lot of times, in my house, anyway, it involves my wife Kathy because she is really the center of the house. The dogs gravitate to her, the kids gravitate to her. This is just a little stage, just a little scene in the back of the house, top of the stairway, Spencer and Kathy there. Here we go, just a nice little intimate moment. Really quick, they love each other, and Spencer is very clingy. He's on her all the time. Nice, clean background because I'm close. I block the background with their heads; a little bit of a stretchy thing going on, though, a little bit too wide and too close and kind of stretching the back of the head, but it's a nice moment, so I shot it.

I'm shooting fast because these moments don't last long, and then I continue to do something else. What am I doing? I'm working it. I'm working it. I'm not going to stop. I'm going to keep working it. Nice, clean background here. Look at that. We're separating that face out. Even though I backed out, I'm moving a little bit to make sure that her face is not being broken by a vertical line of a doorway back there. I'm really conscious about this.

Now what? They're just hanging out, and they're goofing around. I'm trying a lower angle here, uh maybe, maybe not. I don't know, I'm really hoping somebody else comes through that doorway back there. Oh! Look! The big

dog Muldoon, he shows up, so I get around. Again, her face reads because I'm putting her against this doorway. I don't have any lines going through her face. What else? We just stay and work it. Spencer comes back into the scene, he wants the attention of mom. She has a good face going there. She still reads, rule of thirds.

What else? I just stay and work it for a while. I back up, the other dog shows up. What else? What else can we get? Maybe that. That's kind of nice. The dogs are good, they're both perfect, everything reads, I'm down lower. Now that one, that's the one. Maybe this is the one. Look, everything's clean, it reads well, there's nothing sticking out of their heads, the light's nice. This took about five minutes, boom, boom, boom, very fast, very fast.

What else? Whenever I see a chance, I shoot it, and I don't overwork it. I have my camera ready, you know that, we're all set to go. Ellen blows bubbles all the time. She chews a lot of gum. Let's look at this. There she is. Of course the moment I get my camera out now Spencer wants to be a part of it, so he's right in there jamming his finger into it, so I'll work this a little bit. Does it ever get any better than this? I don't think so, but that was the first frame I shot. What else did I get? That, this, kind of cute, kind of. I don't know whether that helps us or hurts us, centeritis. I have centeritis. I like shooting things in the center. I don't have to get things off to the side.

Then my son Cole grabbed another camera and shot a couple of pictures, just to show what that was like. Lots of good light coming in through that doorway in the back of our living room, most of the time. The bubble's popped. This is just a nice shot. I don't have many pictures of me, so I appreciate it. It's just an afternoon. We shot a few, probably the best picture was the first one, I think so, I think so.

So, oftentimes I take my camera wherever I go, even if I know I'm not going to be working. If I go to my brother's house, I'll have my camera there. I don't tell people to do anything, though. When I show up at a friend's house, I don't direct them. I just hang out. That's all I want to do. In this case, sister-in-law, Laura, picks up her little boy, Sam, spins him around in the living room, and I get a couple of pictures. The light's nice. I know to have my camera set on that nice, high ISO. I have a good lens that I've paid real

money for with a big aperture, a big hole in it, f/2.8, so I can get a shutter speed fast enough. I don't have to introduce flash, right? Our cameras allow us to shoot indoors now, any time, day or night, so it's just a frame or two. He's this little boy, it's a tender little moment that we can reach out and grab, and there you go. That's it, soft and easy.

Of course, I try to document special events as well, times in people's lives where it's a big deal, a rite of passage. Ellen getting her ears pierced, here she goes, she's in the store with her friend, Marris, they're picking out her earrings, OK? The actual moment when she gets her ears pierced, not much of a frame, not much of a frame, really, neither of them, but it was a big deal. I made a couple of pictures. They're for the record. It's not all high art.

What else? Maybe Cole making his first set of cookies. You get a little hint of mom smiling back there, and the spatula. It's a little busy back there, but you know what? It's life. I'm not there to torture them. I don't want to torture myself. I don't have to work every minute. It's just trying to get nice frames here and there that's all, that's all. This actually came together well. Easter Sunday, Kathy had made a bunny outfit, Ellen takes the head off. Look at that nice light. She stands out well in that tree. I don't know what Cole's doing there, but I love it. He's in the rest of the bunny outfit at my parents' house. It works.

What else? Just little things, you know? You've got to know that this is stuff that's going to happen throughout your life, not just right now, throughout your life. In the next few weeks and months, as your interest in photography builds, hopefully you're going to see things, but after awhile you're going to get choosy. You're going to get choosy about what you shoot. You're going to want a better background. You're going to want something interesting; you're going to want something different. You're not going to shoot everything. You're going to get choosier and choosier, and that's a good thing. It means that your creative eye, and hence your photos, are improving. Wow, improving your pictures. How about that, can you imagine? Getting better and better and better, that's alright.

For your assignment, I want you to capture a real emotion in a candid photo. This means the person is not performing in any way for the camera. It's as if

you don't exist. A real emotion in a candid photo, that's the goal. It could be laughter, of course, but it cannot be a forced, cheesy grin, like when you've got everybody lined up saying "cheese." That doesn't count. It has to be a real emotion in a candid, non-posed photo. You know what? It could be someone having a bad dream, a happy one, crying, whatever.

Think you can do it? I bet you can. Doesn't have to be a happy thing, remember. It could be tears. It could be an animal. It doesn't have to be a person. It just has to convey emotion, OK? Like this. It could just be something as simple as your little girl playing dress up with a friend or posing in bunny ears. That's it, that's it. OK, in our next lecture, one of my favorite topics—making something special out of the mundane. Don't miss it.

Let's Go to Work—From Mundane to Extraordinary
Lecture 15

etting extraordinary photographs out of mundane situations is about thinking, seeing well, having fun, and trying to surprise yourself and others. Not many people think about taking photographs in visually quiet situations, but it's actually not difficult, and if you can get a great frame out of a bad situation, you've really accomplished something. In this lecture, we'll look at photos from some of the most boring places you can imagine—a hotel room, a hog farm, your office, and yes, even Nebraska—but we'll see that there really are no mundane situations; you can find something interesting to shoot almost anywhere.

Boring Scenes? No Way!
- Nebraska may be one of the quietest places on earth, but a photo of a wheat field there showcases some of the elements we've been talking about: an interesting framing device and horizon line and soft light.

- Another shot taken in Nebraska—a man standing before a mountain of corn—has lots of color and drama, even though the subject seems mundane.

- A photo taken at a mud volleyball game—popular in Nebraska—shows the rule of thirds at work; notice the smiles of the subjects, the pointing finger, and the puffy clouds.

- The background for a photo of a horse on its back is nearly perfect; the horse's legs just miss interfering with the people.

- Two children waving to each other at the end of the day, a statue on top of the Nebraska state capitol building, a marching band, a display of mastodon skeletons, and the Stealth Bomber—all are interesting shots taken in what some people would consider the most mundane of locations: Nebraska. The key to making a boring location or situation interesting is layering.

Practicing in Boring Locations

- A hotel room may be the most boring location you can think of, but it can also be considered a clean, uncluttered stage. The next time you're at a hotel, challenge yourself to make good pictures in your room.

- Of course, a family can trash a hotel room quickly, which may give you something interesting to photograph. Look, too, for soft light, interesting framing opportunities, and leading lines, but don't overwork the scene; go for grab shots.

- Another way to get good photographs in almost any location is to consider relationships between people. Kids get excited in hotel rooms and are likely to interact more with their siblings. Look for interesting ways to show relationships, such as the feet of an adult and a child as they watch TV.

- You can even show relationships between inanimate objects, such as a laptop set against palm trees.

© Joel Sartore/National Geographic Stock.

If you learn to think differently, you can get great pictures of the most mundane scenes and subjects (even pigs!).

- If you get really bored in a hotel room, you can also photograph yourself.

The Marvel of Quiet Situations
- People will marvel at your work from quiet or mundane situations because nobody bothers to shoot them. You often get better results from a shoot where nothing is expected of you than a high-pressure situation where great photos are demanded.

- If you cover a small-town football game, you can have complete access to your subjects—unlike what you would ever get with athletes at the Olympics or in professional sports. You can sit with the players before the game and ride the bus with them—in this situation, there's not a bad seat in the house.
 - In the photo of the players downtown, notice the subtle light; a long lens was used here to compress distance.

 - In the photo of the players praying before the game, note the movement of the car, captured using a camera on a tripod with a slow shutter speed and a cable release.

 - On the field as the game is about to get started, the sky with its lovely pink light acts as another character in the scene.

- It's usually true that people in little-photographed places are delighted to find that someone is interested in documenting their lives.

Photo Analysis: Mundane Shoots
- Some people might consider pigs the epitome of mundane subjects, but to others, they're naturally interesting, even personable. In shots taken on a hog farm, a bit of flash helped to balance out the daylight. Again, in these situations, be on the lookout for leading lines and framing devices, and experiment with different angles and shutter speeds.
 - Adding the people who raise the pigs makes for more layered photographs, as in the shots of the girl holding the piglets. The final shot shows a tender moment between the girl and the piglet, although another figure in the photo—a dog or another pig—might make the shot even better.

Behind the Lens

Years ago, I worked on one of those *Day in the Life* photo books. Do you remember them? Big coffee-table books, where they sent teams of photographers all over the world in the same week to document a place.

They had several exotic locations on a list for me to choose from, and I could have chosen Israel, the Middle East, Russia, but then I noticed that on the bottom of the list was one location that all the other photographers had passed up. It said, simply, Flatville, Illinois. I said, "…I want that one." And my bosses there on that project were shocked. … They didn't think they'd be able to give that assignment away.

…I could've traveled anywhere in the world, had assistants and all this stuff, why would I want to go to Flatville, Illinois? I knew that if this place was flat as a pancake, the light was going to be great there at sunset. There wouldn't be any mountains to block the light. I knew it would have really clean backgrounds, because in Illinois, everything's been cleaned up for farming…. I knew the people would probably be nice, and I thought I would probably get to eat homemade pie and sweet corn…. That's a great bonus.

© Joel Sartore/National Geographic Stock.

I went there, and it turned out it was all true. I made frame after frame that my editors liked, and the best part was there was nothing expected of me because it was supposed to be very boring. ...[T]here were tons of pictures to shoot there, and I would say they were probably better pictures than if I'd gone overseas. The farm family I concentrated on was so happy. They never had any attention paid to them. They loved having me there. I had complete freedom and complete access, 24-hour-a-day access to these folks. They were very happy I was there. It was like I was a part of their family, and that was exactly what I was looking for.

... We went here from what other people thought would be mundane to extraordinary because of the access I had there. I was able to be there when the light was good, and these folks were happy to have me. It was a great experience. Now, I mentioned pie right? I love pie. Oh yes, they had pie. Do you think any of those photographers going over to the Middle East got homemade pie? I think not. I was quite happy to be there, thank you—quite happy.

- o Note the angle in a shot of young women working on a pig farm; if it were any lower, the sky might be too bright. If you're working without a flash, keep the horizon line high so that you're not fighting a bright sky.

- o Stick around after the shoot to catch unexpected moments; here, the young women stick their tongues out at each other as they head back to the barn.

- Photographs taken at a cattle ranch convey a bit of a feeling of the Old West.
 - o Again, notice that the shot of the horses, cows, and men was taken from a high angle to try to minimize the sky.

 - o In another shot, the lariat perfectly frames the rider's head. In yet another shot, the head of a black dog stands out starkly against the white snow.

- o A shot of cowboys against a rainbow proves the point that there is opportunity everywhere you travel. Don't think of any situation or location as mundane.

- An office setting might seem even more ordinary than a farm, but you can find opportunities for good shots in the clutter of most offices.
 - o A photo of a hand on top of a desk buried in paperwork shows that the woman is going under quickly.

 - o A series of black-and-white portraits and office scenes tries to show a little something about the personalities of the people who work there. A stuffed duck tells us that one man is a hunter; an autographed football belongs to a sports fan.

 - o Objects in the office, such as a tangled phone cord, a can of soda, or an adding-machine tape, also tell a story.

 - o As an experiment, try to capture some personalities in your office in just 15 minutes or so. In a shoot with The Great Courses team, we see the producer, a fitness enthusiast, tossing an apple in the air; the content editor, smiling behind her mighty pen; and the steely-eyed senior director of content development, looking straight at the camera.

 - o In the everyday working world, you may not initially expect to get great shots, but you can make something out of an office situation by bringing out each employee's personality.

Additional Tips for Tackling the Mundane
- If you can't find anything to take pictures of, you need to start thinking differently. Look at your everyday surroundings with an eye toward opportunities for taking photographs. Great pictures can be made everywhere and every day.

- It's also true, though, that some situations and conditions are better than others. Don't take pictures just to take them, but do try to look at the mundane in a new way and elevate it.

Assignment

- Go to the most visually uninteresting place you can think of and make an interesting picture. You can take a friend or a pet with you, so you have a subject, or you can take a picture of yourself in a mirror. Think of that boring place as a stage, and wait for something to happen!

- If you can pull off this assignment, you'll be a great photographer. It's easy to make great frames in an exciting situation, but the mark of a real professional is to shoot a good photograph from a dull scene.

Suggested Reading

Leibovitz, *Photographs, 1970–1990*.

Salgado, *Workers*.

Homework

Find the most uninteresting place you can think of and make a truly interesting picture. Remember, think of that "boring" place as a stage and wait for something to happen; wait for a character to appear.

Let's Go to Work—From Mundane to Extraordinary
Lecture 15—Transcript

Hi again everybody. Believe it or not, this is one of my favorite lecture topics. In fact, it is my favorite, because it's not technical, and instead it's about thinking, seeing well, having fun, and surprising yourself and others with the great pictures you pull off. Really, if you can pull this one off, making something special out of the mundane, you can do anything.

What I especially like about trying to make something special out of a visually quiet place is that nobody does this, really. Very few, anyway. So when I'm able to get a killer frame out of something that everybody thinks is a dog of a situation, it really makes me feel good. So, do you want to know a secret? It's not impossible, and sometimes it isn't even that hard. At my brother's house here in Atlanta, his son, it's just a tender little moment. His son's not feeling very well, you can really see the connection here, and little Sam's face, lit perfectly, stands out against that chair. It's just a nice, little, tender moment of both of them at this age. I just love this.

One I like a little bit more, even, we've even put it here in *The Teaching Company* stage, is this one. Little Sam, very, very upset over having to lay outside in the leaves. He was a little cold, he said. He didn't like it. We didn't take very many pictures of him, but the color, the way that red, that red leaf stands out against his shirt, and the emotion, the nice, soft palette of color. And he's really upset. He's out in these cold leaves. He doesn't like it. Oddly enough, ice cream seemed to revive him a couple of minutes later. He was just fine. It's amazing, the healing powers of ice cream.

So, you know, I live in Nebraska, on purpose. People say that if you can make good pictures in Nebraska you can shoot good pictures anywhere, taking something special from the mundane maybe. At first glance, it looks visually quiet, but they don't know a little secret. You can take good pictures no matter where you are. All you have to do is think a little bit. That's all there is to it.

So, literally all the pictures you're seeing right now were shot in Nebraska, very quiet place. All were made from what we call fly over country, the

places that most people only see out of the window of an airplane, and then they just close their window, mainly to take a nap. But look closer at the place. It's not boring at all. Look at how we have a framing device here in this wheat, nice and dramatic. Beautiful! Look at this, perfect, a little framing device. We know where we are. We're down low in the wheat. The light is soft, all the things we've been talking about.

Or this. This is a little twisted. What kind of dad takes a picture of his daughter as she's coming out of anesthetic for having her tonsils removed? Well I do, because Spencer's poking her cheek like he pokes her bubble gum with his finger. He's poking her cheek to see if he can wake her up. But look at this, perfectly, perfectly presented against this bed, perfect with light coming down from above. It doesn't get any better than that. Now, I don't overwork it, I just shoot a frame or two. It's one of my favorites. There must be something wrong with me, huh? I just love good visuals, that's all there is to it.

Or this, lots and lots of color, lots of drama, one ear of corn there, rule of thirds, rule of thirds. There it is. Lots of color, soft light, he stands out well from the background. I get it. It's dramatic, it's dramatic. Nebraska's a dramatic place. In fact, it looks great.

Mud volleyball, talk about rule of thirds, right in here, that's where the action is. Smiles, smiles, pointing finger, white puffy cloud holding the other side together. Mud volleyball, have you ever heard of that? We have it in Nebraska. Or a horse that's dead, actually it's not dead, he's just rolling around scratching himself on his back, but at *Chimney Rock*, our most famous landmark, this is just out on a trail ride. Middle of the day light, but look at how we're perfect here in terms of the background against this horse. We've really got its leg sticking our here. We don't really want to have those legs up into these horses or those other people.

Or just Ellen and Cole, my kids, waving to each other at the end of the day, that little figure down there waving, just that little extra touch. The picket fence and the tree and they're silhouetted, nice, just nice. Or in a helicopter photographing "The Sower," the statue on the top of the state capital building. Helicopters help. Or on the top of a parking garage getting

the marching band, or in Morrill Hall in the big room where they have the fossilized elephants hanging there. We used to have elephants in Nebraska. Just right there, Joel Nielsen, one of the curators, stands out perfectly. He's using a light to see where he's dusting the skeleton. Or at the end of the day at Lake McConaughy, just a nice relaxing scene, a little bit of ambient light in the sky, good light, down low.

Or a B-2 stealth bomber over Nebraska, look at that, perfect, perfect. Do you know what's amazing to me? There were people that knew where their farms were in that photograph down below. If you look in here, there were people that knew where there farms were located. They called and asked for prints. I sold a lot of prints of this picture, a B-2 stealth bomber over Western Nebraska. Or the Middle of Nowhere Day in Ainsworth, Nebraska, why does this picture work? Soft light, the kids stand out and read easily right here being towed along, little guy in the background. It's just about cleaning things up and making things read, making them understandable. That's it, that's it. But there's a lot to it, isn't there? There's a lot to it.

This layering we've been talking about, layering and really building information into your pictures. It's tough, it's a bit like if you were a musician. It's different being able to play *Row, Row, Row Your Boat* on a piano, versus being able to play Mozart. It's very different. It's just a matter of practice, though, it really is, paying attention and practicing.

You know, there are great photos to be taken no matter where you are. I don't care where you live. Great pictures are all around you, and I mean that. I live that every day. For the subject of this lecture, I want us to take the most boring places we can and make great frames. Places like hotel rooms, yes indeed hotel rooms, the most boring places possible.

I travel all the time for my job and I'm constantly in hotels, and I challenge myself to make good pictures in hotel rooms, always. I just want to stay sharp, really, mentally. But a hotel room to me is excellent because it's cleaned off. It isn't cluttered like my house, and so there's a stage there. There's usually a nice window source. It's a stage. See what kind of pictures we can make. Let's see what we've got going on.

Of course, when I'm with my family, that's easy to do, because they are always doing something. They can trash a hotel room in no time flat. Nice, soft light, I'm always looking for that nice, soft light, every time. This is in a hotel room where Kathy and I didn't have the kids in Moscow. We actually stayed on Red Square, and here she stands out perfectly in that dress on the white. This blows out a little bit, it's too hot there isn't it, overexposed. It's just a grab shot when we first got there after flying all the way from the United States. Spencer running around, just the dance of life, grab shots. I'm not working these things overly hard. I'm not shooting over and over again, they're just grab shots. That's what I try to do.

You know I think all the time how can we make good pictures in the most boring places. Can we make excellent pictures in hotel rooms? Yes, absolutely. I do it all the time.

For example, my kids, they do unexpected things in a hotel room. Spencer decides to show me his muscles while he's wearing special swim trunks, right? They're walking around, they're hopping around, they're wearing these weird outfits all the time, constantly. I like the way we're right in the face of Sponge Bob here and he's pointing at his sister. He's trying to wake her up. He wants to go swimming and she doesn't want to get out of bed. Again, nice, soft light, down lot, it tells a little story. Is it a perfect frame? No, it's not a perfect frame. It's not, but it's something that means something to me, and it's fun, and it's lit well, and sometimes the composition's there and sometimes it's not.

I'm not really working these things, I'm just documenting, and I'm trying to use my techniques. I'm trying to think about rule of thirds, leading lines. Mainly I'm just trying to get something sharp and interesting and quick because I do not want to ruin our vacation, right? So, we see all sorts of stuff. It's different than home. They like those mundane hotel rooms, my kids do, just because it's different, and they're very excited about that. But, to me it's all about the relationships, just like we were talking in the last lecture. It's all about relationships.

How do we show relationships in a different way, in a way that we haven't seen before? Well, how about this? This speaks to relationships, Spencer

laying on top of his mom as they're watching T.V., feet piled on top of each other. It can be a little relationship picture. It could be something that's very stark, hardly anything to it. It could be just my laptop and glasses and showing I am in an exotic place. I email that back home, say here I am, this is the dead of winter back home, I'm someplace where they have a tropical feel and palm trees.

It could be hair draped over the back of a chair. My editor from *National Geographic*, Kim Hubbard, stopped to visit me. She stopped by my room on the way out. She has this beautiful hair, put it right there, a little bit of light, fine. I wish it didn't have this line coming out of her face there. I should've moved over a little bit, I should've, but it was about the luster of the hair and the clean room. I shoot this kind of thing all the time. I'm always looking. I love working in hotel rooms, kind of weird huh?

Or this, a friend brought a toad by for me to photograph because he knew that I liked photographing in hotel rooms, and the color here matches the chair. And we're down low, and it's intimate. It's fun. It's different. It's just weird. It doesn't have to make sense you know.

Sometimes when I'm really bored—I go on the road a lot to do public speaking and yes, I am for hire—I think what can I do with this room that I have, stark as it is, by myself. What can I do right now? Well, here I am in a hotel room one day, and I decide, I have some duct tape. I'll put duct tape on my mouth to see how that looks. Anything to make an interesting frame, things I haven't tried before. And I realize well, maybe that's a little bit over the top, so this is a little bit more thoughtful. I don't know maybe it's an illustration of freedom of speech, I don't know, but it's just something. I like the way the shirt is, and the tape kind of has that colorful feel to it. The background's very, very clean and neutral. The light's soft. It's a nothing frame, but it's something. It's something. And you know what? It makes me realize that a hotel room is not the most mundane thing I can think of. Instead, hotel rooms are opportunities. They're cleaned off, and the light's great. What an opportunity. OK, it makes sense.

So we're talking a bit more about the mundane here, aren't we? I wanted to tell you about something that happened to me a few years ago that proves

the mundane is often the best situation you can find yourself in. Years ago I worked on one of those *Day in the Life* photo books. Do you remember them? Big coffee table books where they sent teams of photographers all over the world in the same week to document a place.

They had several exotic locations on a list for me to choose from, and I could have chosen Israel, the Middle East, Russia, but then I noticed that on the bottom of the list was one location that all the other photographers had passed up. It said, simply, Flatville, Illinois. I said, really? Flatville, Illinois. I want that one, and my bosses there on that project were shocked. They said are you kidding? All the other photographers, none of them had even asked about that one. They didn't think they'd be able to give that assignment away, the editors said. And I said, "No, no, no that one looks good. That's for me. What is that, farming?" And they said, "Yeah." And I asked if it was flat there, and they said, "I guess." I said, "OK, Count me in."

Hmm, why would I say that? I could've traveled anywhere in the world, had assistants, all this stuff. Why would I want to go to Flatville, Illinois? I knew, I knew, that if this place was flat as a pancake, the light was going to be great there at sunset. There wouldn't be any mountains to block the light. I knew it would have really clean backgrounds, because in Illinois everything's been cleaned up for farming, because it's rural. I knew the people would probably be nice, and I thought, I would probably get to eat homemade pie and sweet corn, it was that time of the year, it was summer. That's a great bonus.

Well, I went there, and it turned out it was all true. It was all true. You know I made frame after frame that my editors liked, and the best part was there was nothing expected of me because it was supposed to be very boring. That's great. And yet, there were tons of pictures to shoot there, and I would say they were probably better pictures than if I'd gone overseas. The farm family I concentrated on was so happy. They never had any attention paid to them. They loved having me there. I had complete freedom and complete access, 24-hour-a-day access to these folks, and they were very happy I was there. It was kind of like I was a part of their family, and that was exactly what I was looking for.

The point of this book is they were really looking for technology, technology in farming. At the time, this type of a cell phone, that was high , and so I would just work until the light got too rough. The light's not great here, but we're using a long lens, leading lines everywhere, right, just trying to show the compression and how big that soybean field is. Or just driving in, I had my little radar detector. You could see the road in the rear view mirror, rule of thirds, rule of thirds, rule of thirds, right? OK? Leading lines, leading lines everywhere, trying to look at technology as far as ultrasounds to see whether cattle are pregnant or not. Get right here up close, rule of thirds again, soft light, getting down low, right into the face of that cow. It's being held to be examined to see if it's pregnant or not. Alright that works.

Maybe that one's a little better. No, probably not, maybe not, but I tried it because I wanted the belt buckle, so I tried that too. Out on the county road, out in front of their farmhouse, the kids listening to music. This is a while ago, obviously. They were using cassette players back then. But the leading line, rule of thirds, having something in the corners of the frame, paying off the viewer. Same place, nice and clean. Do I wish that these wires weren't going into her head? Yes, yes, but, the bubble helps and the early time of day helps, nice light.

Here's the same girl a little later in the day. She loved to chew bubble gum, just a nice, long lens there in her backyard, cleans the grass up to a soft palate of green. That'll work. Maybe we're around a little bit more here, probably the other one's better because the colors were better in it. Now we can actually see her face. I'm just moving around the same girl, playing the same little handheld video game, just moving around her, just moving around her looking at all the different things I can do. And then late in the day when the light gets nice and soft. Look at this, we're out on the porch, dad's working on a computer silhouetted. The young son framed up in the doorway, the light's nice.

We don't have to pay people off. We don't have to have something in every corner, but this picture has stuff going on in it. And there's mom coming to the door, the light's a little bit different. She's about ready to say the pie's ready, hopefully. Dad out on the front porch, the tractor. We see the farm scene. It's clean. Look at how his face stands out right there, pops from

the edge of the house. If we move back or forward the face wouldn't have popped out as well. So I'm thinking about that all the time.

So we went here from what other people thought would be mundane, to extraordinary because of the access I had there. Hmm. And I was able to be there when the light was good, and these folks were happy to have me. And It was a great experience. Now I mentioned pie right? I love pie. Oh yes, they had pie. Do you think any of those photographers going over to the Middle East got homemade pie? I think not. So I was quite happy to be there thank you, quite happy.

You know, people will marvel at your work from the quiet or mundane situations, because nobody bothers to shoot them, and I mean nobody. I would much rather shoot at a place where there's nothing expected of me— and I mean zero—than go into a high-pressure situation where great photos are absolutely demanded, or else. For example, at the Olympics, man, the pressure is on. You have to do great pictures, and there's a bunch of different sports going on at once, usually in different locations. What if you're in Venue A, and a famous athlete breaks their leg at Venue B, and you weren't there and you miss it? It's really pressure packed, and you can't really wander around. You don't have much access. It's tightly controlled. You have a little badge. You have to stand here or stand there, you need a pass for everything.

I've often said this: I would so much rather shoot a six-man football game in some small town in Nebraska, than the Olympics. And I mean that, honest to goodness. So, If you go to a small town and you cover six-man football, you have carte blanche access. You can be with the team as they're doing quiet time in the kindergarten room, just lying around before the game. You can ride the bus with them. You can go downtown. You can be with them when the light's great. You can show downtown, look at this, long lens, compressing distance here, nice, subtle light. Alright, I don't like that pole, but I can't clean up the world, and I'm a fly on the wall. I'm just getting them. I'm just getting them hanging out.

Look at this on the field, last light of day, just caressing the front of that player right there, caressing right here. I'm using the sky as a big negative space to try to make it a compositional element. Not much there, but I'm

using that sky too. It's big and wide open. It's Nebraska. That's alright. The kids saying a prayer right before the game, after practice, kneeling down, slow shutter speed here with a tripod. Look at that car moving. See the movement we get with a slow shutter speed, tripod with a cable release. I know they're going to be kneeling in prayer for quite awhile because I've asked about that. I've already asked about that, just a nice quiet scene, nice and quiet. I stayed back, too, respectful distance.

And now out on the field as the game's getting ready to be played. Again, the sky is a character for me. Look at all the pink light, lovely, lovely. And then I can get a ladder, and I can get up, and I can get them singing the *Star Spangled Banner* as they bring the flag out. It's just a nice, quiet place. The pressure is off, nobody expects anything from me—when kids playing out on the field. It's alright, everything about it is nice, everything.

There's not a bad seat in the house, really. If you have the opportunity to go do six-man football, or anything where people aren't expecting something, I would so encourage it. You know, most people would think of that as just mundane, right? It's not the Super Bowl is it, but I just thought of it as lovely. And to be honest with you, if every shoot were like that, I'd be in heaven. Most of my shoots have a lot more pressure on them.

You know, it's no exaggeration for me that I would rather photograph a local farmer, or say, a windmill repairman, than the president of the United States. That's true. When you get to these little-photographed places in the middle of nowhere, the people are glad you're there. They are, they're happy somebody's taking the time to document their lives, instead of getting mad at me for intruding, because they have so many people wanting a piece of them, as in the case of famous people, or big-time sports, these guys are just glad you're there, and that's great. That's what I want. That's what I'm looking for.

Let's talk about a few more quiet places and how you can make great pictures out of them. How about if we choose hog farms in southeastern Nebraska? Let's go to a hog farm or two, how can you make good pictures at a pig farm. Let's see if we can make good pictures. You know, pigs are interesting to me,

but the epitome of a mundane subject to most other people. What can we do with them? Well, let's see. Let's fish around and see. What can we do?

Well, first of all, they're naturally interesting. They're kind of cute. They're personable. If you want to get fancy, you could throw in a little bit of flash on them, a little supplemental light, and you make it more interesting, just like that, balance out the daylight with it. OK, that'll work. What else? Oh getting down in the mud, of course. They're pigs, you want to get right down in the mud. Now of course, you're going to want to take a shower when you get home. It's not pleasant smelling, a little bit of flash here, that helps, just working around. Boy that pink framed by that fence, look leading lines, framing devices, perfectly right in there.

Could it be a better picture? Yes, probably, another person back there or something going on up here, but you know what, it's cute and it's clean. The light's nice and soft, a little bit too much flash thrown on here. This almost works. The flash is just a little too bright, a little too bright, and I wish that the ambient was dialed down. I wish the house lights were darker, faster shutter speed would make my sky a bit darker and reduce exposure on that snout, maybe it would work, maybe it would work.

So what else is there to shoot that's mundane, the stuff of everyday life? Well, how about the people that raised these pigs? Now that gives us another level. That gives us another layer, and that gets us really into a more interesting scene. We go from just pigs to the family that manages the pigs. Let's take a look. Take this little scene. It's way too early in the morning, and this little girl has to help her mom and do chores. I felt kind of sorry for her, right, she has to help mom work the pigs and give them shots, and the pigs don't like it, and it's just way too early, and she's got to go to school yet. She's comforting the piglets as best she can, but, you know, they're a handful, and they're squirmy, and mom thinks it's funny, and mom and dad especially think it's funny that I'm there to hang out. And then there's just a little tender moment. That's the last piglet. It's a quiet moment, a lot of dead space in here. I wish there was something else, a dog or a pig that got loose, or something else, but there's not, and I'm not directing. I'm just hanging out. That works. That's OK. That'll work.

Let's go to another farm, another pig farm, believe it or not. I have friends right down the road, my friends, the Montgomerys. This is a family-run operation, and they work these pigs, mom, dad, the daughters. And the daughters are always arguing or goofing around. There's dad, Don Montgomery, moving pigs. And then we go with Nancy and her girls, and they're just goofing around. See how happy they are? They're kind of posing. They're voguing for me because they don't have many photographers show up to their pig farm.

So, here they are out working; nice, soft light. Love the blue jumpers, they stand right out, right here. That's about the right angle. If I were to get down low that sky would be too bright, wouldn't it? And I'm not using flash here, so I try to stay up high, keep that horizon line up high, so I'm not fighting that bright sky, because the sky, that soft overcast light—that's the light source. I'm up high looking down, it works out, it works out. And then I always stick around late. I get there early, stick around late, and try to just get whatever I can, little unexpected moments—or the girls sticking their tongues out at each other as we head back to the main barn.

So, when we go after this type of stuff I'm just looking for interesting pictures, right? And it doesn't matter. I could be at a pig farm or I could be at a ranch. Ranching is a bit more romantic than pig farming, right? To some people, I guess so. I've shot on a lot on ranches, and I never get tired of it. Man, it is a bit of the old west. Let's check this out.

This is out in the Sandhills, wide-open spaces near Whitman, Nebraska. I love the color and the amazing characters here. Again, staying up high, horseback, trying to keep that sky to a minimum because it's actually quite bright, and I don't want it to compete. I think about shooting the meal, the potluck dinner after branding. I love the hats, the spurs, working hay bales, riding the hay bales making sure they don't fall out as you're lowering them down. Look at this, look at how he pops out from that hay bale right there. A little moon up in the corner, nice, soft light, look at how his hat is right inside that lariat, perfect.

Now, I shot a lot of pictures to get that. I was behind that guy all day long, all day long. Just a little bit out into the snow, it makes that dog's head pop out,

all these things, though. Doesn't it look like something out of an old west movie? Maybe it's mundane, maybe it's not. Maybe it depends on how you look at it, how you see it. Most of the time I think I'm so lucky to be in this place where the people are so friendly, they want me here. They're excited to have me here, and man, it's the real thing. It's the old west. I'm excited to be there. So I never think of anything as mundane anymore. I think of this stuff as a golden opportunity, everywhere I go. It's just a chance to make great, interesting pictures. A rainbow with cowboys? Come on, you can't beat that, can you? Spurs, a little bit of glow there, man, that's why I like living where I do.

Now let's take a look at something that's even quieter, an office setting. Now, I've seen lots of photos of offices, and I've taken lots of photos in offices, and you know what, that doesn't scare me. Let's look at a few situations, situations that you can get into. You know, first off, I'm always on the lookout for something interesting, aren't I? And offices, in general, they can be tough. They can be a little bit boring. What can you shoot in an office? Most offices are quite cluttered. Well let's work that.

Let's talk about file cabinets. I love how the red of the shirt mimics the folders. Let's talk about file rooms. Let's talk about somebody's desk, somebody who has too much paperwork. She's drowning in an ocean of paperwork, just a little window light here. Just something interesting, it could be somebody's messy office, buried in paperwork. How do you make it sing? Literally, I didn't show the face of the woman in the file room or at her desk, right, just her hand on top of the papers or hiding behind things. I just want to show that she's going under fast, that's it. So it's kind of fun, it's kind fun.

Or, in the case of this office, I chose to shoot this on black and white. This is at my accountant's Kyle Sitzman, just black and white to give the portraits a certain look. I want to do portraits of everybody in his office. Notice that I try to say something about each personality there. I want to say something about everybody. What is it about their office? I try to shoot little detail shots as I go along, like Kyle's a hunter. He's a big member of Ducks Unlimited, so I'm not just getting them sitting behind their desk. I know everybody there pretty well, and I try to photograph something that deals with their personality.

Veronica, the lady at the front desk, and her typing on her keyboard, there's Les, he runs the place. This is a little bit of a conflict, but his head still reads there. It still pops out. He's big into golf, alright? Dennis has a football autographed to him by the past coach of the Nebraska football team. The telephone cord could be tangled up because they're too busy to unwind it. It's tax season. That's Suman, one of the guys there, great smile. He's into sailing ships. He's actually from Panama. I blocked his face there a little bit, I have a picture of his face in the previous frames, but I'm trying to work this. I really am trying to craft this and use these pictures to work together as a team.

I want all the clutter. I want everything about these folks. They're nice, they're in an accounting office. What do we do? We show numbers, we show somebody that loves Mountain Dew, we show anything we can, reflections off windows, putting another billing statement in the mail. That's what they like, dialing phones, shoes, stress control ruler, anything really. I'm trying to just capture the dance of life, that's all I'm doing, right? I'm trying to do all these shots to get the people's personalities there, to get a complete rendition of everybody. That's it, that's it.

So, for a final example of how to conquer the mundane, let's take a few shots in an office right here at The Great Courses. I did that here just to show you. So here's our crack team, Tony, Kat, and Marcy, and this is the green room. This is where I hang out when I'm not taping here, and we're just talking about, well, bringing you the finest photography course you've ever seen, of course. We're just talking. Could we get some pictures here? Sure, yes, let's make some pictures here. That's the green room. What can we do with this cluttered space? Oh, it's got a nice window. Let's try to do something here.

Let's work it, let's work it. Let's see what we can do. There's Tony, has kind of that swimmer's physique. He's always eating healthy, so we have him framed perfectly in the window, and he has an apple. Basically I said in 15 minutes I can do all three of you guys and make you look good, so let's look. Kat, the pen is mightier than the sword. She's my content editor. She puts that pen right up in front of her. Look at that smiling away, perfect. I love the way the color in the pen balances out with the light. Very shallow depth of field, I want the pen in focus, she goes slightly soft. Don't need a lot of

depth of field for that. And then there's Marcy, steely-eyed. She looks like a bird of prey in another life, right? Well let's hold up the jacket, that brown really brings out the green in her earrings and her shirt. She's known for her earrings and her jewelry, so, great. That provides a nice, smooth background, doesn't it? Three pictures in 15 minutes. Is it high art? I don't know, but it was fun and you saw how that room looked, not much, right? And they liked these pictures, and they've got them hanging up in their offices, so that's good. It's all good.

I mean, in a situation, really, like that, do you expect to get much? You can make something out of it. There's not much going on, but if you think about it, you can bring out each person's personality. You can do this. What I'm trying to get at here, folks, in case you don't get it, is there's no such thing as mundane. In my opinion, mundane does not exist! Mundane is an opportunity. There is no such thing as boring. It's all how you view your life. In my opinion, it's all great stuff.

Common mistakes, the most common mistake here is not believing that the entire world is your oyster, it is. If you can't find anything to take pictures of, you need to start thinking differently, because you're just not trying, you're not looking. If you go about it the right way, great pictures can be had everywhere, and every day. Also, realize that some situations are better than others. Yes, it's true. Some hotel rooms are, indeed, better to shoot in than others. Some have better color, better windows that allow more light in at really good times of the day. Having other people in the room with you will also add a layer of drama and complexity, though, that you can't get when it's just you. And there's no excuse for not making good pictures, then.

You know, I know I've said it before too, but it's true: most of the time the answer is no to the question, should I take a picture now? Probably not, unless you're really compelled to do so because you've figured out how to solve the problem of seeing quiet things in a really good way, taking the mundane and elevating it. Don't take pictures just to be taking them. Take pictures because you know you're onto something interesting. Think about this, what would Joel do? Would Joel shoot this? Am I going to hammer you if you show me your picture and it's really super boring? Come on don't do it, don't do it.

So, your assignment for this lecture, I want you to go to the most visually uninteresting place, you knew this was coming, go to the most boring place you can think of and make a really interesting picture. Maybe that's a high-end hotel room, it could be a stripped down motel room. Take somebody with you so you have somebody to shoot, or take a picture of yourself in the mirror or something. Take a dog if they allow pets, or even if they don't. You could just photograph the TV if you wanted to and couldn't figure out any other way to come up with something interesting. Be sure and show what's around the TV though, and let's pray that there's something interesting there. Let's pray.

Don't think you can do it? Sure, sure I use my own legs and feet all the time to do something interesting. They're always with me and they can't say no. So, I try to take pictures for a story on Florida's coast. Look, the weatherman, the weather's a big topic in Florida. I couldn't think of what else to shoot, so I thought the weather is important, orange juice is important, so I photographed the glass of orange juice, put my bare legs up on the balcony, and I've got a scene here, right? I made a picture. There's a person in it, but it's the weatherman from the TV channel. I used him to make the picture interesting. You can use TVs you know. Why not, why not?

So, go find that boring place and work it! Remember, think of that boring place as a stage and wait for something to happen. Wait for a character to appear. Maybe it's a family member or two, maybe it's some talking head on the television, talking at you, and maybe it's just out the window, I don't know. But make something out of a very uninteresting place.

I tell you what, if you can pull this off, you're going to be a great photographer. When it's really a jazzy, exciting situation, you're going to be able to make those frames, no problem, guaranteed. It is the mark of a real professional to take an assignment they care nothing about, or even dislike, and make a great frame out it. So, I hope you've mastered your camera now, because next up is the main event: birthdays, weddings and holidays. How do we make the most out of those very special occasions in which the action comes at you fast and furious? I will tell you in great detail, of course, next lecture. See you then.

Let's Go to Work—Special Occasions
Lecture 16

When we think about the importance of photography, of course, we think about special occasions—weddings, birthday parties, holidays, and so on. Special occasions are loaded with the moments we want to capture in photographs. In these situations, you can use the intimate knowledge you have and actually anticipate what's going to happen so that you can get even better pictures. In this lecture, we'll review tips for shooting celebrations and see some wonderful ways to share your photos.

How to Work a Special Occasion

- On special occasions, such as a wedding, almost all of your photos should be candid shots. Try to capture the small moments that seldom get photographed, as well as people enjoying themselves. Stay in the background and let your subjects behave naturally.

- Carrying minimal gear is usually optimal; bring a workhorse lens, such as a 24-70 zoom, and a flash.

- Let any "official" photographers direct the subjects, while you hang back and shoot what you can get by being a fly on the wall. If you're a friend of the participants, such as the bride or groom, try to photograph them as they get ready for the event.

- As always, look for the not-so-great moments, too—a crying child or a frustrated or nervous bride.

- It's fun to take some shots of other people taking pictures at an event—a paparazzi scene.

- Especially if you're photographing a wedding ceremony, do your homework about when and where you can take your shots. If possible, meet with the rabbi or minister ahead of time to find out whether

you can shoot during the ceremony.

- Detail shots are often nice, too. Again, at a wedding, think about shooting the flowers, name cards, rings, the "Just Married" sign, or even the bridesmaids' shoes.

© Joel Sartore.

Family celebrations are great opportunities to practice taking candid photos; be a fly on the wall and try to capture real emotions.

- If you're shooting a reception or other large gathering in the evening, you'll need to pull out all your low-light photography tricks. But if you use flash, keep it subdued. Bounce the flash off a wall or the ceiling, or use a bounce card. You'll often have to use a long shutter speed without a tripod, but that can be perfect for capturing a swirl of activity.

Photo Analysis: Weddings
- Often, a wedding ceremony isn't all that surprising, but the reception that takes place afterward presents multiple opportunities for great shots.
 - o Here, a giant white tent offered a wonderful backdrop for portraits taken inside and out. The light inside the tent was soft and filtered. You could almost point your camera in any direction and get a good shot.

 - o A beam of light on the checkered dance floor highlighted the dancers' feet.

- At any event you shoot, think about the direction of light and the background, as well as the emotions and the moments you plan to capture. Keep in mind, too, that your goal is to build a picture story, with a beginning, a middle, and an end.

Behind the Lens

As we go back to [the groom's] place, the sun comes out again, the storm passes, and we're in his garage. That works—just get a few pictures of the day showing all the people that came to the reception. These will all be valuable to them later on as they get older. [I get] another chance to do a portrait in the garage—just nice, soft light—get them together; do a quick picture. Nice shot showing the cake. Usually the cakes are very extravagant, very expensive; we want to get a good picture of that. And then I notice these logs lying around. I'm thinking, "Logs? Why are there logs?" Well, there are logs because it turns out [the groom] is an arborist and he has a bucket truck, so of course, over the great objections of my wife—why would I make him work on a day like this? He's not working; he's sending me up—still wearing his beautiful wedding suit—he's sending me up in the bucket truck so I can do this. This is unusual for a wedding photographer to get up and over the crowd, but that's his house—he built it with his own hands— and there's the happy couple and all their friends.

They can see who was there. Everybody's out there. They're all waving, and it's kind of fun. It shows where they're living; everybody's happy and young, and they're forever that age in that picture.

© Joel Sartore.

- If you can't clean up the background, get down low and use the sky as your background. To get different effects, keep moving as you shoot. Get closer and farther away; get down on the ground and up high. An unusual shot of a home wedding reception was taken from a bucket truck owned by the groom.

Tips for Shooting Birthdays and Holidays

- Birthday parties are probably the best opportunities to practice taking candid pictures of children.

- Before you begin shooting a birthday party—or a similar event—plan where you want the guest of honor to sit. Look for an uncluttered background. Also before the party, make sure you have a fresh card in your camera.

- Use flash when you're shooting an event that is happening indoors, especially one where a flurry of activity is taking place, such as kids opening presents. Most people think of flash just as a means of illumination, but it also freezes the action in an indoor situation.
 - o You can use direct flash, such as on a point-and-shoot camera, or you can use bounce flash.

 - o Angle the head of the flash up so that it bounces off the ceiling. This technique softens the light, creates a nice cascading effect, and makes the subject look natural.

- After you've gotten the traditional shots—the candles being blown out, the presents being opened, and so on—get some shots of the aftermath— the carnage on the table after the kids have eaten. The best shots often happen before or after a big event.

- Especially at a child's birthday party, you won't be able to stop the action, so be prepared to shoot whatever you can get. Think about what you'll be photographing ahead of time so that you don't hold up the celebration.

- Try to focus on the emotional center of any event, while staying aware of the background and the light. As always, vary your perspective.

- Arrive at any event or celebration early. Shoot people putting up bunting for the Fourth of July, kids putting on costumes on Halloween night, family members arriving for Thanksgiving dinner.

- And keep shooting after the main event. On Thanksgiving, for example, you may have time to work the scene as people linger at the dinner table, or you can shoot the resulting mess in the kitchen. Again, you're building a story in pictures.

- Finally, after you've gotten some shots, put the camera down and enjoy the celebration. Sometimes the camera can act as a barrier. If you want to engage with your family and friends and have fun, don't try to shoot everything. Turn the camera off and have some cake.

Common Mistakes
- Don't miss the small moments by spending all your time looking at the pictures on the back of the camera. Just check the camera once to make sure you're not blowing out the highlights, then concentrate on what's in the viewfinder.

- As we've said, shoot the tense or dramatic scenes if you get a chance, but don't intrude on delicate situations. And pay your subjects back by giving them prints they might like.

Assignment
- Shoot only candids at the next big event you go to—no subjects smiling and stiff for the camera, no people lined up like bowling pins with fixed grimaces on their faces. This also means that you can't tell your subjects what to do.

- Notice the light and determine the best direction and perspective to shoot from; choose the right lens. Aim to shoot a good-quality picture, but don't try to control the subjects.

Suggested Reading

Marshall, *Not Fade Away*.

Sartore (with Healey), *Photographing Your Family*, pp. 72–127.

Homework

Shoot only candid photographs at the next big event you go to. Act as an observer—notice the light, the direction, and the perspective, and choose the right lens, but don't direct your subjects.

Let's Go to Work—Special Occasions
Lecture 16—Transcript

So special occasions, yeah you're getting good at this now, you can do this. When we think about the importance of photography, don't we think about special occasions? Absolutely. I mean, think about it, weddings and birthday parties, holidays. The good thing is, special occasions like this, they usually are loaded with these moments that we want. So now is the time to take that intimate knowledge you have and actually anticipate what's going to happen so that you can get even better pictures. That's great.

For example, you've been to a bunch of weddings and you know the bride and groom are going to kiss at the end of the ceremony. You know they're going to walk down the aisle as a newly married couple, if they get married indoors. You know they're going to feed each other cake and get all messy at the reception. You know they're going to dance around in circles until the wee hours. You know this stuff is going to happen. So, to summarize, you know you're going to be having a good time and the people you are with are as well, so there's no reason why you can't capture all this. Special moments abound at things like weddings and birthday parties and so forth. This is one you'll really be able to hit a home run with and have fun on.

Let's walk through all these things now, using the techniques we've learned in the course so far. We're going to talk about how I work weddings and birthday parties. Our photos from these events, really you guys, above all the rest, should be fun, surprising, and well done. This matters, this matters.

Let's talk about what works well and doesn't work so well using wedding pictures I've taken, for example. Let's look at a wedding, OK? This is one that's nice, it's on a summer day up in Minnesota, the light's overcast. I thought I'd actually shoot this as a wedding gift for the couple. I'd known the groom since he was a little boy. So, when I'm shooting something like a wedding, I'm shooting candidly almost the whole time. I'm not really the official hired wedding photographer. They didn't even know I was going to bring my camera, but I go about this as if I'm just on another *National Geographic* assignment, and I try to appreciate the little moments that seldom get photographed, the little bitty things. I try to get pictures of people

enjoying themselves. If they're having a great time, maybe there's interesting and amazing things there, right in front of the camera, far better than I could ever dream up. So I just let people do what they're going to do. You don't want to interrupt a wedding ceremony, anyway. I just let people go. I don't talk much. I really just hang out, and it pays off.

In this case, I had minimal gear. I had a Nikon D3 and just one lens. One lens, my 24–70 zoom, my workhorse lens. That's it. I wanted to actually enjoy the wedding and the reception, so I wasn't all burdened by gear. We were on vacation after all, and I wasn't the official photographer. I was just kind of hanging out, so everything you're seeing here was shot with that one lens, and the one body, and the flash.

Now that's the official photographer. She's directing people, but I'm just kind of playing off what she's getting. If she's having the couples and their kids stand around, that's fine. I'm just going to shoot whatever it is I can get by being a fly on the wall and photograph the events of the day. I love working candids. These are a little bit staged for me, but you know what? They're what was going on. The wedding photographer had this going on. I don't know what this one was about using, the lawnmower, but I just keep shooting and shooting and shooting, eventually shoot the parents of the groom walking down a trail together. And then I do get the couple by myself, and this is what I do with them, just on the way to the reception, just have them stand there and just shoot whatever happens, just let them do their thing and goof around. Fine, that works. That's just fine, and that's cute. That's cute. It doesn't seem so forced that way.

Let's talk through a few other weddings that I've shot. Now, I've never done a wedding for pay, mind you. I'm just going to talk about the things that I shoot in terms of the highlights from the perspective of a photographer, a guy who likes to shoot candids. I don't want the pressure on me of getting paid, so I just do this for friends, and it works out great.

So, this is just in downtown Lincoln, and I try to work my way in so that if I'm a close friend, and obviously I am if I'm shooting this wedding. I'm a close friend of either the bride or groom, I want to photograph them as they get ready. Brides and bridesmaids go through a very long ritual, don't they,

of putting on the hair and the makeup, and it's full of great images, all that is. So I try to get there early, for sure get the makeup getting put on. With the grooms it's a little tougher because they don't have as much stuff to put on. I get them tying their tie, that'll work too, whatever I can do. Just try to get there a little ahead of time and just photograph little details, a little nervousness before the wedding is fine, whatever I can do. It all works.

So, I know it sounds rather merciless of me, but visually, it's better if you are there early because then you can see the not so great stuff too. I kind of like shooting everything. As you know, I'll shoot my kid's crying. I like to shoot other kids crying too. If I can get to a wedding early and work that, some kid having a meltdown, I'll shoot it. If I can get the bride a little frustrated, or the bride wigging out a little bit, that's good, that's good. You know I've found, if you just hang out and keep your eyes open, you'll see a little bit of everything, and a lot of it will be very interesting.

You know, cameras abound at weddings too, and I also think it's fun to shoot others actually taking pictures of the wedding party. I go through and shoot the paparazzi, I guess, like a paparazzi scene, friends and family all blasting away at the couple. I try to do that every time. There's more and more of these camera phones out there, so, I try to photograph just anything I think is interesting. In other words, I try make pictures of other people making pictures, and, I also try to show what they're showing. What are they working? And I try to do it a little bit better. If the couple's posed there as they get ready to say their vows, I try to zoom in. If the wind is an element, instead of fighting the wind, I'll try to shoot that and show the effect of wind. I try to show the couple kind of going away as they leave the reception. I always try to do this in a respectful way, by the way, always. What do I mean by that? I do my homework. You know, many places of worship, like churches, synagogues, they have rules about where you can and can't go, and what you can and can't do. I try to really learn this and respect this stuff.

I try to do my homework first. I will talk to the minister of the church and find out where I'm allowed to walk and where I can stand. Some places are sacred, I can't stand here, I can't stand there. You really do not want to get in trouble with the church or the synagogue because you were moving around too much, or because you didn't ask them permission. Most places

are really pretty good, by the way, if you ask permission. They'll give you special access off to the sides, or behind the scenes, up in the balcony. You really need to find out who runs the place ahead of time, and get permission. Besides, won't it be hard to find the dressing room at the church if you've never been there and you have no clue where it is. So, do. Go ahead of time, scout it out, do your homework.

And also, the other thing too when I shoot weddings, I think about detail shots all the time, feet, hands flowers, rings, table settings, I love flowers centered on people, name cards, the shoes of the bridesmaids is always fun. A detailed shot of the ring, anything I can just little detail shots add depth to a coverage. They add a little bit more. They're like seasoning, in a way, to the main dish.

You know, the wedding reception also, it's a whole other ball of wax. Generally, when you're shooting a wedding reception it's time to pull out all your low-light photography tricks on that one. Make sure you take a look at the lecture on low light coming up in the course. Low light is what receptions are all about, usually, because they're usually held in the evening.

For me, as a guy who has a daughter, the most touching elements of the wedding reception are the couple's first dance and the father-daughter dance. I try to shoot everything going on up to that point, but the father-daughter dance to me is a very serious thing, and I love the way, with a little bit of flash and a long exposure to soak up the light in this room, we have a nice, hard edge there. That's of my assistant Katy, actually, on her wedding day. But I love the way that she's; It's a serious, solemn moment. It's kind of a bittersweet moment with the father-daughter dance. And I try to work natural light. I don't pop the flash off very much if I can get away from it.

These people are not in total darkness, you know? You just try to capture it without ruining the moment by blasting it with flash. Or if you do use flash, just use a little bit of it. Later on there will be, obviously, a cake cutting, and they'll feed each other cake. That always makes good pictures. That happens kind of fast, so you need to be ready for it. No problem, that's just bouncing a little light off the corner. It's not the best of situations, but , you know what, that little bit of flash will freeze the action and make things look more

natural, right? I'll bounce the flash off the ceiling if it's low enough, I'll bounce it, I'll put a flash card on my camera, just a little bounce card on my flash off to one side. Any way I can light it, I will. It's all a big experiment to me, alright?

Now, you know, as the night gets later, there's going to be more and more colored lights, people are going to be drinking. I just try to capture what I can, and I try to use ambient light. That means I keep my shutter open a long time to avoid that bat-cave look. I'll put flash in there if things still aren't bright enough, but it's kind of a last resort for me. You know, most of the time these wedding receptions, they are at night, they are indoors, and it's tough. Just leave that shutter open awhile. Really soak up that ambient light. That's what a long shutter speed is for. I'm not using a tripod. I'm hand holding, there's too much action for a tripod. I'm trying to get all that colored light and the swirl of the dance of life, that is all very good stuff to me. It really is.

So, I want to go back to that Minnesota wedding for just a bit, and just kind of take you through what happens after the wedding. After all, the wedding ceremony, to me, is just the starting point. There's nothing about it that's really that surprising. You know, the couple goes up, they're married by a minister, they walk out. Now let's see where we're going to go. Wow, over the hill, you mean they had a giant tent, and it was translucent, and it's going to let light in? Wow, folks walked through the woods and into this clearing with this big, white tent, and man, there were lots of opportunities to do some portraits up against the side of it, or inside. There was nice, soft light, which was really great.

So let's go inside the tent and look around a little bit. Look at that, just awash in beautiful light. When we're inside that tent I'm looking to see which way the light looks best, of course, but really, it was hard to take a bad picture isn't it. The light's kind of soft, and it's filtered, and you can just do a lot of things. I wander inside and I wander outside. It's kind of an overcast day. I'm trying to just work anything I can see. I really try to work this and make every background sing, whether it's grass, whether it's looking at the outside of the tent, whether it's up on the hill, people playing croquet. I got lucky here because the light was fairly soft. I got lucky too, because they sent an

ice cream truck, all you can eat ice cream out of this truck because they ran out of the food at the reception. That was alright. I'd never had six ice cream bars before, but I did that day. I think my boy beat me, with eight. Yes, so anyway, what else? Detail shots, details of course, tight shots of anything I can get, working around inside here. The best part, you know, is I went there as a guest, but by shooting this I had this wedding gift for them, something they'll always treasure. You know, they're always going to be young in these pictures. These pictures have stopped time.

Look at this, raising the glass in a toast. You cannot point your camera anyway in here and really have a bad image. And he's listening to his dad toast him, and it's really powerful. I'm just really glad that I can be there and help them out. I show some of the guests and everything that goes on that day, get back outside, the later in the day, the lower the light is—that's great. The lower the light is, the more pretty the light is. Saying a prayer.

Here's where it gets good, we're out on the dance floor, love the black and white checkered dance floor. It just so happens that, look at that, that dance floor is actually lit well. Holy cow, look at this, off we go. The light gets better and better and better, and people are having more and more fun. Just a beam of light, people getting excited, beams of light. I'm always looking for beams of light, and a little kiss at the end, right?

You know, the next day I gave them a little slideshow. I always do this, and I like to take pictures of people that were at the wedding watching the slideshow. That's the happy couple, but I've done this for many friends. I love photographing people as they watch the pictures. It's good, that's good. So, they love it. It's satisfying, very much so for me. These pictures really mean something to these people, and they stick and they're going to be around for the rest of their lives.

So, how about a prairie wedding? Something that's not indoors at all, really. Throughout any wedding reception I shoot, I'm always thinking about the direction of light—the emotions, the moments, certainly, but directions of light and background when you're outdoors it's really up to you to make these things work. All of the things we're talking about. I'm building a picture story with these things, a beginning, middle and an end. I use those

detail shots, surprising shots, emotions, you name it. I'm building all of that into these pictures to try to tell the story of the day here. So let's go through another wedding, a much smaller affair out on the prairie, close to where I live.

My friend Randy Doctor and his new bride Vonni, we're out at Spring Creek Prairie by Lincoln, you know, the light was a little harsh to start out, but the prairie skies are big and building, same thing as when I was with Ellen and Spencer in that parking lot. If I can't clean up the background, I'll get down low. Remember when we were in that parking lot with all the structures behind them and we worked through that? I'm just getting down low to clean up any distractions and show that big sky. I use the sky as my background all the time. And granted, there are some detail shots you need to cover if you want to be thorough, but again, that low perspective with the sky and clouds as your background. That can be very powerful, it really can.

I use my 24–70 mm lens a lot on these pictures, a lot, and I get different effects by moving. I use my feet, and I move closer and farther away. I'm not afraid to get dirty. I get down on the ground. I get up high. There we are, leaving, some simple portraits. Now the sky is getting more and more ominous, no more sun. It's getting dark, it looks like it's going to rain. That's good stuff too, I use that dark background, I shoot into that dark background. I love the fact that her clothing kind of matches the patina in the sky.

Now look at this, just a portrait of the bride and groom. This is their wedding portrait, and I've moved down low, and I really have them sticking out of the hill, a little bit of a bridge there up in that corner, just a nice portrait where they're contained in this prairie, or we can get down low and show the sky, and they really stand out. There's no right or wrong way. It's just a matter of seeing things kind of clearly and thinking about your options. I'm trying different things. I'm always trying different things, and that's on the way out.

So, as we go back to his place, the sun comes out again, the storm passes and we're in his garage. That works. Just get a few pictures of the day showing all the people that came to the reception. These will all be valuable to them later on as they get older, another little chance to do a portrait in the garage, just nice, soft light, get them together, do a quick picture. Nice shot showing

the cake, usually the cakes are very extravagant, very expensive. We want to get a good picture of that. And then I notice these logs lying around, and I'm thinking logs, why are there logs? Well, there are logs because it turns out Randy is an arborist, and he has a bucket truck, so, of course, over the great objections of my wife—why would I make him work on a day like this? Well, he's not working. He's sending me up, still wearing his beautiful wedding suit, he's sending me up in the bucket truck so I can do this. This is unusual for a wedding photographer to get up and over the crowd. But that's his house, he built it with his own hands, and there's the happy couple and all their friends. And they can see who was there. Everybody's out there. They're all waving, and it's kind of fun. It shows where they're living. Everybody's happy and young, and they're forever that age in that picture. Love it, love it!

So, let's talk about birthday parties a bit, too, because those are the other biggies for us, aren't they, weddings and birthday parties. Let's talk about something that happens in everybody's lives, especially if you have kids, it's such a big deal. When you get my age maybe you don't want to think about birthdays, but for kids, boy, they're a big deal. Kids look forward to them all year, and, you know, these are great opportunities to practice taking candid pictures, aren't they? Even if we don't like our own birthdays coming around, they are good opportunities to make good pictures.

With three kids in my house, we have a lot of these celebrations, and I photograph every one, every year. Again, we use all the same techniques that you've been learning in the course so far: composition, low light photography, flash, telling a story with pictures.

My little boy Spencer turned eight while we were in Lincoln shooting the field video footage for this course—so we had a little birthday party to celebrate. It wasn't a big celebration—just my wife, Cole, Ellen, and the birthday boy himself, but there are some important things to think about if you're going to get the best shots you can from an event like this. Let me show you what I mean in this little video.

WSo we are here in my dining room, and i. It is a big day; Spencer is going to turn eight years old. Today is his birthday, so we're going to have a little

party. BNow before we have a birthday party, or before you have a birthday party, you want to think about some basic, basic things, like, where to put the birthday person. Where do you put them? YAnd you say, "What do you mean, where do you put them? I just let them sit where they want!" Not if you're trying to do good pictures. You make sure that they're sitting in a place that doesn't kill you, alright?. You really want to make sure of that. So in this room, I tried putting him at the head of the table down there, but you know, there's this big mirror, and it's going to reflect flash, and it's going to do all sorts of things. So I knew that that would be a bad spot because it's cluttered.

I also know this, and this is very, very important: Wherever I put him counts—the background has got to be good—because he's the emotional center of the whole thing. That's where all the action is, on the birthday boy or birthday girl. That's where all the presents are going to come, that's are where the candles are going to get blown out, so we really want to watch this. You want to take that shining star, (the birthday person), and put them in a really sweet spot so that then your pictures come very easily to you. TSo that's what this is about. (Oh, yYou know, one other thing:? Make sure you have a fresh card in your camera. IfBecause if you're on the last picture and you go to take pictures and he goes to blows out the candles and you're out of pictures, it canyou're going to be very, very sad.)

So let's get started. Look at how pretty that looks. That looks nice. Look at everybody back there. VOK, very nice. OK Spencer, go ahead, go ahead. Nice.! SOK, so, now we have present opening, but me being the bad guy that I am, I am stopping everything so that I can talk a little bit about how to capture this. I like to use flash when I'm doing something that happens indoors, especially, and when it's a flurry of activity, like kids rampaging through presents. I like to use flash because it freezes the action. Most people think about flash just as illuminating, well, . I think about flash as going off so fast that it freezes the action in an indoor situation, so that's how I do it.

There's two ways of doing that, obviously. You can have a direct flash, such as on a little point- and- shoot, like this. I point that at Spencer, and he's looking kind of disgusted because he can't get his presents opened yet. Or I can use this camera which has a flash that I just mount to the top, and . I'm

going to do a technique called "bounce flash." Literally, I've got the head of the flash, instead of blasting him straight ahead like that, I'm going to angle that up at the ceiling and bounce down. It's going to create a nice cascading effect. I, it's going to soften the light, and it's going to make it look very, very natural. It's just going to make it look like room light. You'll never even know the flash hit him. That's the thing about flash: It ruins more pictures than it gets. TSo, that's what we're going to do. Are you ready, Spencer, to open your presents finally? You're such a sweet kid. GOK, go ahead AlanEllen. ; Ppass him some presents. Let's see what kind of pictures we can get, OK?. Well don't guess. Open them up, man! Let's see how it looks. What is it? Oh, let's see. Hold it up, hold it up! Nice. Very nice. OK, what else, what else? That's pretty snazzy wrapping paper. What is it? What is that? Nice.

OK, I'm going to stop you right there and I'm going to say this: I tend to work these kids like rented mules because I'm a photographer. B, but I don't ruin their holidays. Today is a little bit different in that I am stopping Spencer from opening presents, that kind of thing, but, when you're taking pictures, do your homework in advance, study, practice a little bit so that you don't have to hold things up. Just because you have a camera is not a license to ruin every holiday and special even in your house. Be ready to go;. kKnow what you're doing. It'll come naturally, and j. Just let people have fun, and they won't hate you the rest of their lives. OK, go ahead Spencer. How'd you get so lucky? You must have been a good kid, huh? OK, what's left? It's a huge one, what do you think? Do you guys each have blowers? Nice. OK. Give Spencer a little blow action before he… Oh… what is it? What is it? Let me see. Oh no. That's going to keep me up at night. Oh, man! Hey, turn that around towards me. Hold it up. Everybody, give him a little, give him a little, ah, whatever you call those things. Alright. Very nice, very nice. OK. Alright. That's it.

We've done the birthday candles being blown out, and we have done the present opening, and now we are going to cut the cake. TAnd the thing to think about, too, is, you know, after you get the action of the presents being opened, that's when most people put the camera away. But actually, it's really fun to shoot the aftermath—all the carnage on the table after the presents are opened, people eating cake. You know, like on certain holidays like

Thanksgiving, I'll shoot people lying around on the floor because they're too full to move. They look like beached whales. I'll shoot that. I always look for the stuff that happens before and after a big event, because that's actually the best stuff. Nobody thinks to shoot that. So, I think I'm going to shoot a little bit here, starting with a little bit of above—, always thinking about the angles—, high angles, low angles—and just see what else we can get. I'm sure we'll get something.

How is it Spencer? Of course, it's ice cream cake. Hey Spencer, take your finger and point at your cake. Nice. OK, got it. Thank you. I will absolutely have some. Absolutely.

YAnd you know, the other thing too, what I like to do most? ou know the other thing that I like to do most? I like to put the camera down. I'll shoot a few, and then I'll actually have fun. TYou know, the camera is a great barrier. It really separates you from what's going on. So instead of enjoying the birthday party, I have worked the birthday party. They are exclusive, in a way. ISo if you really want to actually engage with your family and have fun, you don't shoot the whole thing. You turn the camera off, and you have some cake. That's really important. So, dig me up a piece.

So, pretty quiet, wasn't it? I hope you know that we did start and stop that celebration for this course. In the real world, your job as a good event photographer is to be a fly on the wall, be prepared, and not stop the action once it has started. That's usually how I shoot these kids' parties. I try to just hang out and get whatever I can. By the way, daughter Ellen used to have parties like this, just nice, little Cinderella cake, she's sweet as can be, but nowadays it looks more like this, which is kind of a mess, you know. She really gets excited, as do all kids. They love it, no matter what. It's rowdy, and I try not to stop the action. I try to just let it go, and they have a great time.

Who wants to stop the action, anyway? And this applies to other birthday parties as well. I like to just hang out, hang out, nice and easy. You know, a lot of the things I talked about in that field shoot are relevant for other special occasions too. I try to find the emotional center of the event. I try to be aware of the backgrounds and the light, be prepared, and vary my perspective. I do

that with everything I shoot to try to do something different, and catch the real emotions—a fly on the wall, get those candid shots. That's how I try to do it.

Any time I'm at any type of a holiday event, I do the same thing, the same way, just like with the weddings. I try to get the preparation and the start. It's getting there early that really pays off. I like to do this, let's say, on July 4th, with buntings going up on people's porches, the kids playing in the yards, multiple families getting together. I try to think about this all the time.

Halloween, no exception, I try to show the kids mummifying each other with toilet paper, the kids in their costumes. This I love. Cole has cut a hole in the table and it's just his head, supposedly his head, when kids come up. There's Ellen dressed as Dorothy. When kids come up he asks them if they want to take candy off the table in front of his head. I like that a lot. I try to shoot anything I can. Spencer in a pancake outfit Kathy made him. Ellen in a witch outfit Kathy made. Spencer is a robot, same costume designer, my wife. Me goofing around as Frankenstein, love this too. Ellen loves to eat candy to the point where she gets sick. OK, so she's sick from eating too much candy, I show that too. Merciless aren't I? Terrible, terrible.

You know, Thanksgiving, though, is one of my favorites, to be honest. It's lots of people, families gathered about. They're having a great time. I show them arriving, piles of food coming out. It's just really, really nice. It's a great time for people to just relax and pay attention to each other. All this in the same room. It's really great.

If you think about it, it's one of the very few times that people ever linger at the dinner table these days. We're all in such a big rush, you know? We've all got to do something, not on this day. We're just there to enjoy each other's company, to sit together, and to talk. People will linger over the dinner table, they'll linger in the living room, they'll have some more wine. It's just a great day, seconds and thirds of turkey, and we're not rushed. This is a great time to actually work photographs. You don't have to rush your pictures because you're going to get ample opportunities.

Now don't shoot everything. Just have your camera there. Pick up your camera, think about your light, think about your perspective, think about what's going on. Think about all of this. Look for the right background, and look for the nice moment. Fire off a few, not a ton, maybe. If you don't see a good opportunity, don't take any pictures at all, just enjoy it. How about that?

Now remember that post holiday stuff makes for frames too. The holiday is good, but it's the before and after that's unexpected. I try to show the prep, and I try to show the after effects too. Afterwards I show people lying around exhausted. The aftermath, the mess, you can show all that. You can't go wrong when you've covered it as if you were covering a picture story. Like a movie, there's a beginning, a middle, and an end.

You know, one thing we do at our house is, we do holiday cards every year. Every year we swear it's going to be the last because there's so much work involved and we can't agree on the subject. But I thought I'd show a few of these to kind of finish out this lecture. I'm a photographer after all. My wife is creative as well. We're both visual people, so I just thought I'd show you that the same thing applies to holiday cards. This was one of our first ones. Warm wishes, my wife made a fake turkey out of papier-mâché. There's the dog eating dog food out of it. We got the dog up on there, our Afghan hound named Joan.

Let's see, what else. When we had our first child, there's Joan. We're at Mt. Rushmore, obviously. The little baby Cole, who would that be, one of the faces on the mountain. This is another favorite. It's been three weeks. Santa's got to go, so that's once the kids got a little older. This one was kind of sad. We're all crying. It says Christmas morning, naughty family, empty stockings, broken hearts. That's OK.

Oh what else. Oh we formed a cult one year, Christmas off the grid, formed a cult. That's kind of nice. Kathy made those dresses. This was last year's. we just can't quit you, old St. Nicotine. Is it wrong to be lighting up an eight year old's cigarette? We didn't actually light it, just so you know Child Social Services. Oh, and this last one, we got our cards out so late, Christmas was over by the time we sent them out. Never give Spencer a shotgun.

So, by the way, my wife and I start arguing, and I mean discussing next year's cards the moment we've done the last one, and it takes about a year. It's never easy. In fact, usually one of us threatens to boycott every year, but somehow we get it done. Sometimes we play off lighter news events. Sometimes we're just trying to visually fill out some caption one of us thought up. It's not easy, but what fun would it be if it was?

Common mistakes. One common mistake I see a lot in holiday pictures, or weddings or birthdays, is when the photographer misses the little moment. A lot of good pictures are missed because the photographers are staring at the back of their camera, looking at what they've just shot. I try to limit that. When you want to start shooting a scene, look at the back of the camera once to make sure you're not blowing out the highlights, and then start shooting. Concentrate on what's in the viewfinder, always.

You know, when I shoot, everybody is usually happy and excited to be there, they're getting along well, I'm a fly on the wall. Even if they aren't happy, I sneak off a picture or two there too, even if there's some tension. But I shoot first. I ask questions later. As a journalist, that's what I'm trained to do.

Now, mind you, I don't work delicate situations to the hilt. I discriminate, I don't abuse it, I have my camera there, people know I'm a photographer. They know me well enough. They know they're going to get their picture taken if they hang around my house, or if I come to theirs. But I try to make sure people always get prints, that they're looking good, that their kids are sweet looking, and they like it. There's a payoff for putting up with me.

So, your assignment for this lecture: Shoot only candids at the next big event you go to. I wonder if you can do it? Sure you can! You've had this course. No subjects smiling and stiff for the camera. No lining people up in a row like bowling pins with a fixed grimace on their face, only candids at the next event you go to. That also means you cannot tell people what to do. You have to just hang out. You have to observe, notice the light, notice the direction, the perspective, choose the right lens. You're going to be shooting a good quality picture, but what the subject is doing is out of your control. No direction, you cannot direct them, OK?

You're going to really need to use what you've learned in these lectures now. Try to pick your moments carefully. Choose the right places, where the light looks the best, where the background looks best. Get something interesting, please. You do not have to worry about making stiff portraits, where everybody is wearing a cheesy grin, this is very freeing, you guys. You're going to enjoy not having to worry about that and just shooting the kind of pictures you want to take, not the kind of pictures you think other people want to see.

So good luck! Have fun with this, and in our next lecture we're going to go on vacation, or at least talk about vacation and travel pictures. We'll see you then.

Let's Go to Work—Family Vacations
Lecture 17

Piling into the car and heading out on the road is a time-honored tradition in American families and full of opportunities for picture taking. But most pictures of Mount Rushmore, or the Statue of Liberty, or the Grand Canyon, or other well-known landmarks look the same: people standing stiffly against different backgrounds that happen to be famous. In this lecture, we'll try to turn our thinking around a little bit about traditional vacation pictures; instead of posed shots or familiar views, we'll learn to shoot candids and look for different perspectives on monuments we've all seen many times.

Case Study: Shooting on Vacation
- A trip to the Nebraska state capitol building serves as a case study for some typical issues you might encounter on vacation.

- The day is cloudy and dark. A couple of sample shots taken outside don't work: When the exposure is set for the sky, the capitol building goes dark; when the exposure is set for the building, the sky blows out white.
 - o But if you're on vacation, what do you do in this situation? You may not be able to return to shoot at another time.

 - o In this case, you might try some architectural shots—close-ups of the building that eliminate the sky.

- The interior of the building is fabulously opulent; perhaps its most exquisite feature is its mosaic tile floors, which almost demand some overhead shots. Having family members lie down on the floor makes the shots even more interesting and fun.

What to Pack
- When you're planning to take pictures on vacation, take extra film or digital storage cards, extra batteries and a charger, your favorite lenses

(wide to telephoto), an external flash and sync cord, and a tripod and cable release.

- Keep a list of all the gear you are taking, along with serial numbers, in case something is lost, broken, or stolen. Bring one copy of the list with you and leave one at home.

Avoiding Traditional Vacation Shots

- Whenever you're visiting famous landmarks, try to find ways to shoot them differently. For example, with such landmarks as the St. Louis Arch or the Delicate Arch, include people in the picture to give the viewers a sense of size. With Mount Rushmore, don't show the whole mountain; use a long lens to get up close and let viewers see the stone.

- As we've said before, you can sleep and eat any time, but the light for photographing is sweet only twice a day. Even on vacation, if you're serious about getting good shots, you have to get up early and stay up late.

© Joel Sartore/National Geographic Stock.

The world is full of famous visual landmarks that we've all seen a million times; your job is to shoot them differently.

Behind the Lens

Even when I'm going on a personal trip, I'll hire a local if I'm going abroad. I'll spend my own money to do it, and that says something. For example, let's take a look at a little trip I made to Italy not long ago with my father and uncle. We went over there because we're Italian, and we got a local guy to help show us around the Sartore home country....

We went to this little, bitty town in Italy, one that doesn't have anybody, really, that speaks English. These photography friends that I'd met through the web basically agreed to take us around to the mountains up north. It was a rainy day, but we had a great time. The thing about it is not only is the language different, [but] the cemeteries look different, the food, the displays in the shops—everything looks totally different to us. Nobody speaks a word of English.

It was really important for us to get out and see the "real" villages with somebody that we knew was going to show us around very well and tell us what things meant. We could concentrate then on learning about our family's heritage— and the best places to go eat, of course. That doesn't mean that my father necessarily liked it. In fact, prosciutto? He won't touch it. We weren't going to any tourist areas, so having that guide, who could speak English as well as Italian, that was

© Joel Sartore.

critical to enjoying our brief time there. Best of all, my guide was actually a friend, one I'd traded photo tips with over the years, so that made it a bonus. I got to spend time with him, too.

- Another good strategy for getting unusual shots is to photograph the back or underside of a monument or shoot tight shots of just one part of it. You can also take pictures of the surrounding area that people don't often see.

- There are often numerous opportunities to surprise viewers, even with pictures of famous landmarks, because such scenes are usually not worked very thoroughly. Show people a different angle; let them get a fresh look at something they've seen all their lives.

- A shot taken of the Colosseum in Rome serves as an example of an unusual picture of one of the most recognizable buildings on earth. As opposed to showing a static ruin, the photo gives a sense of the fast pace of life in the city of Rome.

- Of course, including your family in pictures of famous places also gives energy and life to your photos. Look for opportunities to show family members, especially children, discovering new things. Try shooting the back of a subject to give a photo a sense of mystery.

Vacation Photos as Stories
- Vacations offer the perfect opportunity to tell a story in pictures. You can include some traditional photos to provide context, such as the traveler shown here, smiling in front of a small group of penguins, and then follow up with pictures that are a bit more intriguing or require more craftsmanship, such as the shot in the kayak.

- Think of mini-vacations—trips close to home—as another opportunity for storytelling. You may be familiar with quirky locations near where you live, even a restaurant or lounge, where you can get unusual shots.

- A storytelling image of a place that also contains a family member represents a departure from traditional family pictures.

The Rules Still Apply!

- Even if you're on vacation, try to scope out locations before you shoot. Look for the best angles to shoot from. Don't stop thinking about seeing well or doing good work just because you're on vacation!

 - For example, several landscapes shot in Italy and France benefited from the addition of a boy into the scene. As mentioned in an earlier lecture, think of a landscape as a stage waiting for players.

 - Another shot of a girl looking out a train window is interesting because of the movement of her hair and the scenery outside the train.

 - Again, get up early to capture the good light and revisit locations at sunset, when other tourists are at dinner.

 - In other words, don't waive all the rules just because your family is standing in front of a famous landmark. And don't forget to shoot the moments that no one else does, such as your kids asleep in the back of the car on the way home.

- If you're traveling abroad, try to enlist a local guide to help you navigate the culture and take you to unusual locations or events, such as festivals. If your guide is photo-savvy, he or she may even be able to get you up on a rooftop for aerial shots.

 - To find a guide, ask friends who have recently traveled to the country you plan to visit, call a travel agency, or get in touch with a university in the area and ask for the names of students who might be willing to assist you.

 - You should also visit the websites of *National Geographic* and the Lonely Planet travel guides to get background information on the places you plan to visit.

Protecting Your Gear

- Wherever you travel, keep an eye on your camera gear. Don't leave your equipment unattended, and if you have to leave it in a car, put it

in the trunk, where it can't be seen. You might even ask your guide or translator to stand watch while you're looking through your viewfinder.

- Think about protecting your equipment from water and high humidity. You can use specialized covers or heavy-duty plastic bags. Keep a towel or a chamois handy to dry your gear off quickly if it gets wet. You can also buy desiccants to pack with your gear to dry out any moisture.

- If you're going to be doing anything over water, such as boating, you may want to buy or rent an underwater housing for your camera, or you might buy an inexpensive point-and-shoot underwater camera just for experimenting. You can then take pictures of your kids while they swim or the wildlife you see while scuba diving. The harsh, middle-of-the-day light that you generally try to avoid on land is exactly what you want for shooting underwater.

Assignment
- Shoot a very famous place but in a way that's all your own. Try walking around behind it and looking up or down; try tight shots or pictures of the surrounding area.

- Almost every city has some famous landmark or area that is often photographed. Visit that scene and work it to try to find the surprises.

Suggested Reading

Caputo, *National Geographic Photography Field Guide: Travel*.

Krist, *Spirit of Place*.

Homework

Shoot a very famous place, but in a way that is all your own.

Let's Go to Work—Family Vacations
Lecture 17—Transcript

Hi again, everybody. You know, piling in the car and heading out on the road is a time-honored tradition in American families and full of opportunities for picture taking. It is a grand thing to go on vacation with your family. You know what I want to do is turn your thinking around a little bit as to what a traditional vacation picture is and all that it could be. So, let's look, even if it's Mount Rushmore, or the Statue of Liberty, or some other famous place, most pictures of them look the same. Now in this case I threw the statue over to the left just so it wouldn't be too much the same, but they seem to be photographed from all the same spots over and over again. Why is that?

So many times, we're growing up as kids, we're all taught to stand in a row like a picket fence, and squint into the sun, and smile, so you have the same painful-looking formation over and over again, but with the background changing to the Grand Canyon to the Golden Gate Bridge. It's all the same people standing stiff, but with these different backgrounds that happen to be famous. Now, if that trips your shutter then fine, but what I'm saying is that's probably not the best picture you can make at these very famous vacation destinations. Instead, I say, why not shoot candids? Make it real, or shift something thoughtful or different.

You know, I'm always looking for the best pictures that I can make, no matter where I go. So if I can get my family in the scene too, that's fabulous. Let's take a look at one of the most famous landmarks in my home town and how we handle it photographically. Take a look.

Alright, so lLet's talk about being on vacation, shall we? We work all year to be able to go on vacation. WAnd what do we want to do? We want to take pictures, of course, and usually we go to places that will yield great pictures. I am at one such place. This is the Nebraska state capitol building in Lincoln. LSo let's pretend I'm on vacation. I've traveled a long way to get here, and I want to do great pictures. Oh my goodness. I, it's cloudy as can be, and dark and dingy outside. What do we do, what do we do? This is our time. IYou know, if you're with a group tour, or your family members are putting pressure on you, you can't hang around here until the weather breaks. You

have to do what you can with what you're given. LSo, let's see. Let me take a picture real quick and see how this looks.

It looks just like I thought. If you expose for the sky, the building goes super dark. If you expose for the building, the sky blows out terribly white. So, you know what? Tthe answer is "no" right now to the question, "Should I take a picture?" TSo, this is tough. What do we do, what do we do? We have to make pictures; this is our one time to be here. WWell, we can do a couple of things. We can do architectural shots, close-ups of the building so we cut the sky out because the sky is too big to light with my flash, obviously. The sky is too big, the building is too big; f. Forget it. So we can do architectural details, or we can wait and come back later when the house-light is dim, when it gets a little darker out and the lights on the building come up. T; that might be a good time to take a picture. But really, the easiest thing is to come back on a day when it's sunny and the Sun is very low in the sky (dawn or dusk). SAlright, since we can't do that, why don't we go inside and look around? This is a very ornate and fabulous, fabulous building, and I'm sure there are lots of pictures to get and we won't be fighting this bright -white sky at all. So let's go inside and look around to see what we can get.

SOK, so we've walked all around the outside of the building and shot some architectural details—really neat. It's still kind of a gray day outside, so we've come inside and, wow, what a fabulous place. It's a temple. TAnd this place was built in the Depression for cash. They paid cash as they went. It is a fabulously opulent building inside. I did my homework before I came, as you folks could, too. Do your homework when you go to a place so you don't get unpleasantly surprised when you get home from vacation only to find that you missed a bunch of good stuff. So I've done my homework; I knew that this place was fabulous on the inside, of course, . There are carvings everywhere, buffalo carved in white marble, corncob-shaped brass doorknobs on things. I'm looking around; it's very, very fabulous. But I know that the best thing of all—because I've done my homework—are these mosaic tile floors here. TAnd this is actually the history of life on this floor right here. And I'm thinking, "HWell, how can I show this?" I can't really get it all in. I'm thinking, "Is there a place to go that's up to show an overview?" LAnd look right up there; that's the spot. WSo we're going to go up there and try it from above and see what we get. I think it'll be fabulous.

SOK, so we've moved up here, overlooking the tile floor, and just as I suspected, it is killer; it is excellent. It's great empty, but it's really good with people walking through it, and it's even better if we take our friends and family and put them down there. I've tried photographing my friends and family from all angles down there—not so good. You know what? You come up here, and man,d it's awesome. It's really awesome, especially when you spread them out on the floor and have them hold hands. How can you miss this? It's rReally outstanding. I mean, iIt's awesome. It's like this building was made for good pictures. So, you know, this is something that anybody can do. Instead of just standing people up, stiff as a board, why not have some fun, and why not take advantage of great-looking situations? T and think your way through it and put people where they need to be. NI mean, nobody's going to kill you for lying around on a tile floor in a public building, are they? I don't think so. It makes good pictures. It's worth it; it's totally worth it. Mission accomplished.

Well, as you can see, I'm really serious about the potential of a good floor. It's a great, clean background a lot of times, and you don't want to overlook it—like the floor in the farmhouse kitchen. Do you remember that patterned floor, checkerboard? The floor in the state capitol building offered a really interesting and exciting background. It also gave us a really unique picture of friends and family in the building. You can bet that there aren't any postcards in the gift shop with people you love lying on the floor!

So, let's talk a bit about what to pack for picture taking on vacation. Here's what I take, extra film or digital storage cards, extra batteries, don't forget a charger for those batteries too. Without the charger, you're done. Keep a list of the gear you are taking, along with serial numbers, in case something is lost or broken. Your favorite lenses—wide to telephoto—you want to be able to handle anything you come across. External flash and sync cord to get the flash off the camera, tripod, and a cable release, OK? Now, keep a list of all that gear at home, too, so you have it in two places, in case your list of gear gets stolen out of your car, you want all your serial numbers recorded at home in case you want to file it with insurance. Know what you have; just keep track of it.

Once gear is all together, now you're ready to shoot, right? But be sure to keep an open mind. It's a great big world out there brim full of visual potential, and these famous visual landmarks you all have seen them a million times since you were a kid and you're going to want to shoot them the same way, but I'm telling you, do them differently, please. So take the St. Louis arch, for example. This is a very standard picture, very standard, but I also shot this like this, a little airplane flying over it, or with my son, Cole, at the base of it. This one I like the best, the light's nice, a little bit of ambient light in the sky, a little bit of man-made light, a little color there. Cole gives it perspective.

What next? Delicate Arch in Utah. Delicate Arch, you know about delicate arch. I think we've seen that before in this course. A guy's lining his family up in there, nothing wrong with that. OK, kind of a standard picture, but, once more, it's the people around it that gives it the sense of size. Look at how massive it is when you look at it this way. Holy cow! It is really impressive and massive, and that guy down at the bottom, he has a little beam of light on him, really shows off the place. A lot different picture than the other one, and one that I hadn't seen before, one the *Geographic* hadn't seen, and so that's the type of picture I like. It makes it into the magazine, and it makes it in in a fairly large way, a new spin on an old subject. I always try to do something new with the familiar then, and by the way, I really, really don't just like it, I love to do that. In fact, I make my living doing that. Let's look at a few more.

Mount Rushmore, for example, Mount Rushmore, OK, you know what it looks like. This is what it looks like, nice, subtle light. That's fine, but, let's get up early, let's see the whole mountain. Let's see the clouds with all the pink. You see the difference, right? It's a little bit later in the morning, no clouds at all. It's better to get up early, let me tell you. I hate getting up, by the way, I hate getting up early. If I'm serious about pictures, I have to do it. That red light on the mountain was an amazing sunrise. You can sleep and eat any time, but that light's only really sweet twice a day, if you're lucky. Take advantage of that. Don't miss it. Don't miss a second of great light. What else can you do with Mount Rushmore? Get in a little closer. Look at that, it's carved from that mountain right there. Amazing! Or closer yet, wow, look at that. You really have never seen Jefferson before with all

these veins of marble going through his face, marble and granite. Very cool, very interesting.

You know, one reason that I don't actually enjoy my vacations, if I'm shooting seriously, is because I take gear and I do work it, but I love the results. And I do relax in the middle of the day. I rest up when the light is bad outside. I do take it easy in the middle of the day, but you know what, that light's only good twice a day. You cannot help it. You have to get up early, and you have to stay up late if you're serious, OK?

Let's look at another one, The Statue of Liberty. Did you know the Statue of Liberty looked like that from the back? You didn't, did you? I didn't either until I went there and I thought why is it I've never seen a picture of the Statue from the back. People just don't shoot it. Everybody shoots it from the front. Well what else? I did tight shots of the torch, tight shots from underneath. It really helps to have a nice, long lens with you, it really does. And look at this, seagulls flying all around the base, a little bit slower shutter speed showing some movement in those seagulls. And then late in the day there's all these tourists in helicopters that fly around her and show tourists what the torch looks like from above, what the crown looks like lit. Ad now we have these lights coming up, the twilight is dimming and we really, really, really can do some nice things with light there, even very, very late in the day. So, all these things, right?

You know what else, there's a park right at the base of it where people from all over the world come, and they gather at the base of the Statue of Liberty, and they have little picnics out there with the New York City skyline right in the background. I didn't know that either. That's excellent, one more thing to shoot, one more thing. I bet you didn't know that, I know I didn't.

How about the Eiffel Tower? The Eiffel Tower, you've seen it a million times, right? Well, yes, so have I, so have I. So when I go I shoot the classic shot, and then I shoot something that I haven't seen before. It's a very obvious picture, anybody going there stands there and looks up, that's what you see, but I hadn't seen that intricate lattice work like that before, hadn't seen it. So, these are things that are easy to do. It's not as hard as you think.

You just think about perspective, lens choice, time of day, not that hard, really, if you're thinking about it.

You know, the good news is that we have all sorts of opportunities to surprise people, even with famous landmarks because they're just not worked very thoroughly. People don't think about this. Show people a different angle. Let them get a good look at something they've seen all their lives! As I travel, I find that no matter where I go, no matter how famous something is, I can shoot it in a new and different way, and you can too. It doesn't mean that we're geniuses, it just means that other people haven't put any thought into anything, really. It's just postcard picture after postcard picture from the same place, OK?

Let's look at another one. Rome, the Coliseum. I've seen a million pictures of the Coliseum But I wanted to show the pace of Rome, a little bit more fast paced. This is a very-fast paced city. I didn't just want to show a ruin standing there. I went at night, I used a tripod, a cable release, and a very slow shutter speed. You get all this blur of color and activity. It looks very dramatic. I think it would've been better if I'd gotten there a bit earlier to get more blue in the sky, get a little bit more ambient light in the sky. I got there a little late, there are no excuses, but I was on vacation. But, at least this shows you, you can do something unusual or even weird out of something you've seen for a long time, even one of the most famous buildings on Earth.

You know, the other thing I'll do is I'll include my family in pictures of famous places, or in pictures I think need a little bit more energy. Obviously, on a family vacation, you'll want to do this, too. But, it's not just about making pictures of the iconic, but about getting the whole family out and showing everyone as they're looking around and discovering these places you go to, whether they're famous or not.

For example, when we were in Italy, I had little Spencer, and he was always out running ahead of us. And I was thinking, well, should I control him, should I try to get in front of him. I thought, OK, let's use that. Let's not fight it, let's work it. If he's ahead of me on some street in a little Italian village, fine .If his shirt matches the color of the walls in the alley, we can do that. The street makes him pop out nice and clean, or how about this, even better,

he's in this big column of trees wearing his little kid's clothes. You wonder what he's looking at there. You wonder what's going on in his head, has he heard something off to the side, is the Big Bad Wolf there? I don't know. But it has more of an iconic feel.

And I love pictures like this where you can see only the back of someone, and they're looking off, like they've heard a strange sound or seen something wonderful. It makes me wonder. We're always taking pictures of people's faces, and faces are good, but, you know, it gives it away, in a way, especially if you're photographing somebody who's smiling for the camera. Where's the mystery in that? Sometimes a picture of someone from the back can be very good and very interesting, better in fact, than straightforward smiling at the camera.

To me, photos that ask more questions than they answer are among the most intriguing of all. They really are. Also, I went to Antarctica recently with my wife, Kathy, and this is a very straightforward picture. She's staring at the camera; she's smiling. This is exactly what I told you not to do right? Exactly what I was just griping about. Well, I can do a good shot of penguins. I sure can, but you know this was her first time being with penguins on land in Antarctica, and it's just a nice snapshot, and she's happy, and that's the moment. It's nice. It's great. It gives us context. Is it a great picture? No, but it's the moment when she first saw penguins, so it means something to both of us. And besides, it does show where we are. We have a sense of where we are there. Could it be better? Yes, sure, absolutely, but we see mountains, icebergs, penguins in the background. It's fine, it's fine.

Maybe later on, we're out in the kayak, maybe that gets us a little bit more of an intriguing picture, a little bit more of a craftsmanship thing going on here where it's a little bit better. But, you know, we're on vacation. I'm trying to improve what I have in Antarctica. Neither of these are the greatest, but this was our first time, so it meant a lot to both of us, and we were having fun, and we were on vacation. I'm not trying to beat a dead horse. I'm really, really trying to have fun and make some meaningful pictures at the same time. I don't shoot every second of the day, I shoot when I want to.

So, let's look at another one, a short drive through my home state of Nebraska. We take these little mini vacations, close to home. It's a nice way to get away for the weekend. There's a place, it's one of my favorites, out in western Nebraska along I-80, the interstate, in Paxton. Paxton, Nebraska is home to Ole's big game lounge. Well, that's my kind of place, very interesting, lots of stuffed animals in there. A big polar bear and people sitting in booths all around it. It tells a story of the place. What I really like about this picture is my son Cole is in there in the yellow shirt. He's one of the people in the restaurant, right there in the booth. I love it when I can get a nice, story-telling image of a place that also contains a family member. To me that's just the best, and it's a departure from traditional family pictures, isn't it? It's just a way about recording the moment. We were in this restaurant. It's very moody. It's about getting good pictures but also showing family members in there looking around. So it's a way of combining interesting pictures with family members, very different way of looking at your vacation pictures then.

You know, on vacation I still scope out things before I shoot, too. I prepare. I try to figure out a way to make the best frame in that place, and then I'll include my family members in it once in awhile. And it's really as much about the quality of the picture then, as it is getting a picture of them. I don't quit thinking about seeing well and doing good work just because I'm on vacation! I really try to make the vacation pictures just as good as anything else I do.

For example, on that same trip to Italy where little Spencer was, there were several frames that were lovely, several scenes that were lovely, but I needed a person in them. So, here's Cole, running through a big wheat field, nice. It gives it a little bit more of a splash. I had shot the wheat field without him. Now here's another picture of Cole running by a swimming pool at a little villa we were staying at. Nice scene, fine landscape, kind of boring. It really helps to have Cole in there. We've introduced a family member into it, and look at him go. He's athletic, that kid. That's fun. It really livens it up, helps a ton.

Or, let's see, how about a picture of the Mona Lisa. Of course, this isn't the real Mona Lisa, people would be in trouble. But just fun things that say Italy.

It's just set up for the tourists to take their pictures with, and that's OK. It's a lot of fun. It could be daughter Ellen sitting gazing into the distance. It could be her looking out the window of a train. I like this one better for a landscape because there's movement, alright? There's a little bit. She's looking out at the beautiful Tuscan countryside, and we have a slow shutter speed going, and we're really with her on the train with her hair blowing in the wind. And it's shot, maybe at a 30th of a second or so, 15th of a second. I love that feeling of movement, both in her hair and the countryside going by. The world's in a blur.

This would be a nice frame if it was anybody in there, but it's Ellen, my daughter, so that makes it special. The light's soft, her face stands out well because we have that blurred background. It's just a simple, little picture, nothing grandiose about it. I don't know that it would run in *National Geographic*, in fact it wouldn't, but it's my daughter, and that makes it say something to me.

So, to sum up, you don't want to waive all the rules just because it's your family standing in front of stuff that's famous, right? If you're smart, you're visiting famous places when the light's good. You are up at dawn, you're taking pictures, probably by yourself because your family's not going to want to get up that early, and I can't blame them. They are on vacation. But you have another chance with you family at sunset. When the tourists are all having dinner, you're out shooting. You've had a late lunch when the light is harsh. You know you don't want to fight that harsh light, and now when the light's great, you're out shooting. You can always have a late dinner with your family, but you can't tell the sun to hold off for a while on setting.

So, I know that eating is a big thing on vacation, and I hear about it all the time from my wife and kids. It's one of the joys of being on vacation, great meals, relaxing, but try to remember that you only get good light twice a day. You should not miss that good light, vacation or not. Have a late dinner, make it fun for them, buy the kids extra dessert, whatever it takes to have them with you so you can incorporate them into these good pictures. Be out there when the sun's setting. Have your family with you. You know, they're just going to be enjoying what they're seeing, not hamming it up for the camera, and never in bad light, please, never.

You know, your best picture from vacation might actually just be your kids asleep in the back of the car on the way home, exhausted from all of the fun they've had at the state fair. That could be the best picture. And to me, it is probably the best picture I got that day or that week, totally.

You know, one of the things I do, especially traveling abroad, is I'll enlist the help of a local. That's very important, to have a good person in the field, whether it's a friend, or a family member, or a hired guide, there is no substitute for a local person with first-hand knowledge, first-hand knowledgeable, somebody that lives there. You know, it may be an additional expense to you, but I've found it's really money well spent. A local person that's friendly and knows what they're doing, they can help you navigate any new culture and any new place and really saves you a lot of time and makes for a lot better photos. They can take you, for example, to the places they know will make great photos. They know what festivals are going on. If they are photo savvy, they'll even know the best vantage points. They'll know a rooftop or two you can get on to get an overview. They're going to know everything because they live there. How's this for a bonus? They're going to know the best places to eat, too.

Even when I'm going on a personal trip, I'll hire a local if I'm going abroad. I'll spend my own money to do it, and that says something. For example, let's take a look at a little trip I made to Italy not long ago with my father and uncle. We went over there because we're Italian, and we got a local guy to help show us around the Sartore home country, right. They'd never been; I'd been one time. My father had never been out of the United States, and he was 82 years old at the time, so we had an excellent couple of guys show us around. We went to this little bitty town in Italy, one that doesn't have anybody, really, that speaks English. And, these photography friends that I'd met through the web, basically, agreed to take us around to the mountains up north. It was a rainy day, but we had a great time. You know, the thing about it is, not only is the language different, the cemeteries look different, the food, the displays in the shops, everything looks totally different to us. Nobody speaks a word of English.

So it was really important for us to get out and see the "real" villages with somebody that we knew was going to show us around very well and tell

us what things meant. We could concentrate, then, on learning about our family's heritage, and the best places to go eat, of course, alright? That doesn't mean that my father necessarily liked it. In fact, prosciutto, he won't touch it. We weren't going to any tourist areas, so having that guide, who could speak English as well as Italian, man that was critical to enjoying our brief time there. Best of all, my guide was actually a friend, one I'd traded photo tips with over the years, so that made it a bonus. I got to spend time with him too.

You know, if you're trying to make contact with folks in other countries where you've not visited before, I always start by contacting the people I know who have already been there and find out what they did and who they had helping them. I call people I know. If somebody's been to Egypt recently, I call them and say, who did you have help you in Egypt? I work the networks, what few networks I have, right? I try to figure it out that way. If that doesn't work, I'll widen my search to include travel agencies to see if they book trips to that area, and if so, who do they use as guides or maybe I'll want to hire the agency myself.

I'll also want to do some research via the Web, of course, and see if there's a college or a university in the area and then contact their journalism department to see if I can get lined up with a student, maybe a student assistant who's from that area. The list goes on and on, but you get the idea, right? Not only is the *National Geographic* Web site, by the way, a great place to get general information on the place you're visiting, the Lonely Planet guides are good too, terrific actually, in terms of getting you the background info you need on a particular place, everywhere from where to eat and stay, to areas to be avoided. That's really critical, too.

Now, a couple of general tips. Number one, something I always do, keep your eye on your camera gear. Do not leave it unattended while you shoot, or even when you're not shooting. If you have to leave it in a car, stash it in the trunk where it can't be seen. Don't tempt anybody. If you want to continue shooting during your trip, make sure you do not leave your gear out.

Sometimes you'll need to take even more precautions. If you have somebody who's a helper, translator, or fixer that can kind of stand watch while you're

looking through your viewfinder, that's good. It helps to have somebody on the lookout while you obliviously look through that viewfinder because its blinders on you. It really helps keep gear in your hands longer. It really does.

You know, if your camera is going to be near water, be sure to protect it. This means rain too. Don't forget rain can ruin your camera just as surely as anything. High humidity can even wreck your camera. Use specialized covers, or just plain plastic bags, Ziploc bags, trash bags. I work for *National Geographic*, so I need this specialized type of gear, but you probably won't. A Ziploc bag should take care of things for you, OK? Keep a towel or a chamois handy to dry your gear off quickly if it gets wet. Hopefully it won't get wet. I'll also take an airtight plastic shipping case for my gear and a sock or two full of desiccants to dry the gear out if it gets damp. I'll literally leave the gear in there with the desiccants overnight and dry soak them to get them up and running the next day.

If you're going to be doing anything over water, in canoes, kayaks, or little boats, there are inexpensive underwater housings available for just about all cameras now, including many point and shoots. Consider buying or renting one of those housings, because they're kind of expensive to just buy outright. You can rent them, and photograph your kids while they swim, for example. You know, as a percentage, there are not many underwater pictures taken. That means there's a lot of room for great work in this category. This is the way to really make pictures stand out when you're on vacation.

Let's take a look. When I went to vacation in the Galapagos, for example, I took an underwater camera with me. It was great because there were lots of chances to use it. There were sea lions laying around the beach. It's amazing. The animals are just right there with you, other tourists are there too. It's nice, but you know what, I did my homework, and I knew that we'd have lots of time in the water. I made sure I had an adequate housing to go in there. Why? Well, because most of the tours are during the middle of the day, but because we're shooting underwater, that terrible light in the middle of the day, that's what we want for shooting under water. That harsh light illuminates underneath the sea and makes for some amazing photo possibilities at a time of the day when you would never dream of shooting outside.

Look at this, fantastic. Absolutely, Galapagos sea lions, the middle of the day when the light is the worst, that's when you're going to get the most light on your subject under water. That's the exact time you would want to shoot under the water is when you'd never dream of shooting above the surface, right? If you tried to shoot when the light was really lovely above, out on land, it would be too dark and gray underneath the waves, so the middle of the day that's a great time for shooting underwater. How about that? Amazing.

What a fabulous place by the way. If you ever get a chance to go, quite lovely, and it's as if it's always been like that. My son Cole goofing around. He wanted his senior picture taken wearing a suit and tie underwater. Well, I told you it's about making unusual vacation pictures, right? Mission accomplished. It's a fabulous, fabulous place.

You know, for this last shot, it's actually inside a sea cave in the Galapagos. I experimented with holding the camera half in and half out of the water; it's in an underwater housing OK. I used a very large aperture number, a tiny hole in the lens, to produce a good depth of field, right, probably like F-16 or so. I'm not using some special filter or technique, it's just a small hole in the lens that really gets me a lot of things in focus. I used a wide lens, that helped as well to keep a lot of things in focus. It helps compensate for the fact that the density in water and air are different, so they focus differently.

By having a very small hole in the lens and a high aperture number, I could pull this off. I love this. It's kind of weird, and totally unexpected. It was just during a snorkel in the middle of the day. The back of the cave is backlit, but the swimmers are out of the light, so they're silhouettes. How nice and unexpected, and it's because I had an underwater camera with me. You can get these very, very inexpensively now, and they're really a lot of fun to shoot. You can buy little point and shoot underwater cameras right off the cruise ships at the gift shops. No reason not to try it.

So, your assignment. Shoot a very famous place, but in a way that's all your own. Remember how I talked about the Statue of Liberty? Walking around behind her, taking a look, look up, look down. I want you to go to a famous place and really have a good look at it. And shoot everything you can.

Do really tight pictures, loose pictures, people out on the lawn around the Statue of Liberty, whatever. It's a very famous place, and yet some of these pictures don't even have the statue in them. That's OK. We need to try to start thinking differently. Let's really work things well and find the surprises.

Remember as you go forward, whatever city you live in has some famous aspect to it, something that's been very commonly photographed, again and again, and hence commonly seen, for years and years. Make sure you do your best to find your own way of seeing it. I'm sure you can do it, so go out there and try it. It is a lot of fun.

Advanced Topics—Research and Preparation
Lecture 18

In the last lecture, we noted that doing some research about family vacation destinations would give you a better idea of where to get great photographs. In this lecture, we'll go into a little more depth on the subject of research and learn how a professional photographer prepares for photo assignments. As we'll see, good pictures take work; in many cases, the difference between a good picture and a great picture is the amount of time you put into it.

Case Study: Researching an Animal Shoot

- For a photo shoot about animals, questions to ask beforehand include the following: Where do the animals live? What are their habits? Are they nocturnal? What's their conservation status? Are there specialized care facilities for the animals?

- A photo shoot about koalas attempted to show that they are in trouble because their habitat is shrinking. On-location experts, in this case, staff members at a wildlife hospital and a koala specialist, provided invaluable information about picture possibilities that would help tell the story and generate public support for saving koalas.

- The result of not doing proper research is getting skunked, that is, showing up for a shoot and hearing the words "You should have been here yesterday."

Research Tools

- Of course, these days, one of the greatest research tools is the Internet. web research allows you to gather information that used to require weeks or months of going to the library, mailing off for brochures, and working the phone to ask follow-up questions.

- The Internet also allows you to e-mail on-location experts or video-chat with them through online services, such as Skype. Be sure to ask about

the possibility of gaining special access if you need it. Can you shoot from the top of a building or near a freeway? Can you accompany an expert to restricted locations?

- Don't be surprised if your research involves hundreds of e-mails and phone calls. You should expect to spend approximately one day conducting research for each day you'll be shooting on location.

- After you've done your shoot, make sure to share your pictures with people who helped you in the research phase or on location.

Photo Analysis: Whale Hunting
- Research for an assignment to cover whale hunting in Alaska included finding out which villages had permission to hunt whales, which village would be most receptive to having a visit by a photographer, and which village gets its allotment of whales the fastest and in the most predictable manner.

© Joel Sartore/National Geographic Stock.

Research before a shoot in Africa led to an expert in tracking lions, who also provided information on other conservation and wildlife issues.

- The village of Kaktovik, Alaska, on the edge of the Arctic National Wildlife Refuge, is allowed by law to hunt three bowhead whales for food each year. The villagers usually get their whales in a week around Labor Day.

- Permission to shoot the butchering of a whale was obtained from the whaling captains and the mayor of the city. The shoot involved flying a small camera blimp on a tether over one of the whales to get an overhead shot of the butchering.

- Research conducted for the whale shoot also revealed that it would be possible to get pictures of polar bears feeding on the whale carcass after the butchering.

Case Study: Researching a Shoot at the Albertine Rift
- Research before an assignment in Africa included about a month's worth of e-mail exchanges with other photographers, the Ugandan Wildlife Authority, veterinarians, and others.

- Eventually, a German veterinarian, Dr. Ludwig Siefert, was located who had fitted radio collars on more than a dozen lions. He was interested in publicizing the fact that predators in Queen Elizabeth National Park were being poisoned by cattle ranchers, who were fighting to take over precious grazing land inside the park.

- Dr. Siefert identified locations where lions climb trees to stay cool and sleep all day. The outstanding results of the shoot again highlight the importance of establishing a good relationship with an on-location expert.

Permissions and Paperwork
- Before you travel, find out if you need special permits or permissions to photograph at particular sites. The ghostly lighting in a photo of a military PR officer underscores the secretive nature of a military base that, of course, required special permission to shoot.

Behind the Lens

This [photo] came from a story I was researching on Nebraska for *National Geographic*. … I wanted to photograph small-town festivals, and I hit this one in the research phase and I thought, "Holy cow, the Wayne Chicken Show! I'm going to hit all three days of this thing. This is epic."

…This festival—three days—it's all things chicken and eggs. The folks there have a great time. I knew the [Chickendale] dancers would be there, and you know what? They make for good pictures. … [The parade has] a chicken theme, of course—a guy in a chicken suit is the grand marshal—and when you get there, there's a lot of room for serendipity or things to just happen. There are plenty of chances for happy accidents.

They have a chicken flying contest even. Can you believe that? This is where a guy literally pushes a chicken out a mailbox with a plunger to see how far it will go. [They have a] favorite chicken contest [and a] chicken-mobile. There's a guy who's driving an old yellow Cadillac with a big plastic chicken on the trunk. There's a best-looking chicken contest. There's an egg-dropping contest where you try to catch an egg without breaking it. …

© Joel Sartore/National Geographic Stock.

The whole thing about the chicken festival is that it's visually loaded. I love things that are visually loaded. It happens at nice times of the day … when the sun is low on the horizon. How can you beat that? Are you getting this? If it happens at a nice time of the day and it's visually loaded, your odds go way up of making great pictures.

- Be persistent in requesting permission, and remember: Homework equals access. If you want to do a great job on a difficult or complicated shoot, do your homework and don't give up.

- A photo of a B-2 Stealth bomber flying over Nebraska required a year of correspondence with the National Guard and Langley Air Force Base before permission was obtained to do the shoot.

- Once you've done your research and gotten permission to shoot, arrive early and stay late. The best frames often happen at the end of a shoot, once you've seen how the light works and learned how your subject behaves. Once you have your pictures and you're sure about them, put in another card and shoot that one, too. When you think you're done, push yourself to shoot some more—that's where the great frames come from.

Preparing for Local Conditions
- The Boy Scout motto certainly applies to photography: Be prepared. Make sure you have the correct gear for the expected weather conditions where you plan to shoot, as well as a good pair of hiking boots.

- In cold conditions, wearing a hat will actually help keep your hands warm because otherwise, you lose heat from your head. If the weather is sunny and hot, pack a broad-brimmed hat, sunscreen, and water.

- Be smart about how you dress and how much equipment you carry when you're traveling to shoot; the potential for crime is everywhere. Carry less gear and don't always wear the big photo vest that says, "I'm a walking ATM."

Photo Analysis: National Three Peaks Challenge

- The National Three Peaks Challenge is a mountain-climbing event that occurs every year in the United Kingdom. Research in advance of this shoot included finding out the required physical conditioning to photograph the race—fortunately, not extensive.

- Photos taken before the event show the fire station team's pre-race rituals, including working out at the station, enjoying the kiddie rides at an amusement park, and stopping at a local pub.

- A slow shutter speed, maybe 1/15 or 1/20 of a second, and a low angle captured the movement of the team during the race.

- Photos of the team running back down the mountain at the end of the day were shot using a radio trigger and remote.

- Research before the shoot revealed the reasoning behind the race: the need to track down sheep that may have gotten lost in the mountains. Research also disclosed the availability of a train to ride to the top of the last mountain. Finally, the pre-shoot research helped in forming a friendship with the subjects.

- Staying after the shoot enabled post-race photos of the team members asleep in the van.

A Hard Lesson

- In conducting your research, don't forget to ask one crucial question: Will the subject consent to be photographed?

- You may have permission to be on location and the conditions for photographing may be perfect, but your research efforts will be wasted if you haven't clearly stated the reason for your visit.

Assignment

- Plan a shoot of an event or a site that requires special timing or access, such as a performance or a rooftop view of Main Street.

- Conduct research before the shoot. Find out the expected weather conditions if necessary and talk to the person in charge of granting access.

Suggested Reading

Ludwig, photographer, "The Long Shadow of Chernobyl."

Sartore, photographer, "Top Ten State Fair Joys."

Homework

Take pictures of an event or a site that requires special timing or access, such as behind-the-scenes access at a concert or ballet performance or access to a building's rooftop to shoot overviews.

Advanced Topics—Research and Preparation
Lecture 18—Transcript

Hi again everybody. You know, in the last lecture, I urged you to do some research about your family vacation destination so you'd have some idea of where to get great photographs. In this lecture, I'd like to go into a little more depth on that subject and give you an inside look at how I prepare professionally to do the best photo story I can. It all starts with research.

My photo stories, my coverages for *National Geographic* magazine, are made or broken in the research phase, literally. They are literally only as good as the research is. For every day I spend in the field shooting, I bet I spend at least a full day researching a story at home. Let's take koalas for example. That's a recent thing I had in *National Geographic.* I had three weeks to be with koalas in Australia. I spent three weeks in the research phase. See how it matches up? What does that mean, exactly, spending three weeks shooting, three weeks researching ahead of time? It means that I start finding out everything I can about koalas before I go there. Where do they live? What are their habits? If they're nocturnal, I need to know that. That's huge because it's going to determine how much I'll need to think about lighting things at night, alright? Also, what's the conservation status of these animals? Are they in trouble? Do people care for them at home? Where do they go when they are in trouble? Well, as it turns out, they really are in trouble. The entire northern population is now threatened with extinction.

So, as I went through, you know what? I looked and looked, and I just tried to find funny things, a guy that's with his dog wearing a koala costume, a lady that's taking care of a koala at home as if it were a baby. The trouble koalas get in is right here, the only place for koalas in this part of Australia are in the trees on the fairway of a golf course. That's how tough it is for them in some places, and they end up stranded in trees in neighborhoods.

So these are all the things that I wanted to try to work and really try to tell the story of koalas well. I went to a koala hospital where they worked on healing koalas to release them back into the wild, very moving and touching. They're so cute, you know? They're so cute. I went to the world's largest koala of course, down by Melbourne, which was really interesting. Notice

the spotlight up there. It looks familiar. Anyway, I had a really interesting time shooting koalas, but it all came from the research. That was key. Also, this lady, Megan Aitken . I found an expert on the ground and I learned from her when to be there, where to go. I just hung out with her. I lived with her.

I emailed both the Australia Wildlife Hospital and Megan, and I found that between the two, my story was covered. Both were intimately involved with trying to save injured koalas and try to save the species. They're there in the trenches on a day-to-day basis. They were both extremely helpful in keeping me filled in on what was going on, what the picture possibilities were, the best time to come to Australia to get good images to tell the story to save the koala. But you know, I bet you I had 500 emails between the two of them, 500 or so. That's a lot of work, but that's what it takes to get pictures like that, a lot of work, a lot of preparation. If I don't do my homework like that, I just won't get onto the plane and go. I have to feel good about it before I ever leave.

You know my biggest fear? Getting skunked. Showing up at a place to hear somebody say, "Oh, you should have been here yesterday." Or last week, or last month, or last year. In all my time with the *Geographic*, I've tried to really do my homework and not get skunked, but I have gotten skunked a time or two. Both times it was because I wasn't researching heavily enough, or because I didn't make follow-up calls when it became closer to the time of the trip.

One time, for example, I was covering a story on brown bears. The only place where you can drive and watch brown bears in North America is this place called Hyder, Alaska. The trip was all lined up, but, I didn't call the locals up there the week before I left, and it turns out the week before I got there, a bear had killed somebody. And authorities had closed down all the bear viewing. In fact, they pepper sprayed the remaining bears to get them out of there, to make the place safe.

There were no bears when I got there, which was a huge problem. You can't shoot what isn't there. You cannot publish excuses if you're the editors of *National Geographic*. And there is no way to tell the bears I work for *National Geographic* wants them to have their picture taken. They just don't

care. The bears don't subscribe, so, they're not going to come back to have their picture taken if they've been hazed away. So, I was out of luck. There's no happy ending to the story, by the way. I have no pictures to show you from that; I had to turn around, get on the plane with my tail between my legs, and go home, skunked.

So, we really try not to let that happen. We can't and be successful professionally as photographers for *National Geographic*. So, how do we go about researching, really? Well, the Internet is a great tool these days. It used to take me weeks or months of going to the library, and mailing off for brochures about various places, and then working the phone to ask follow-up questions. These days, a lot of times, to tell you the truth, I take the shortcut. I just go online. I can research things pretty well in a very short amount of time, email is a real miracle. It really is quite amazing.

When I want to correspond with people, I find out what it is that I can do. Now, email is the worst way to actually communicate and find that stuff out. Email is the worst. A phone call is second, and face-to-face is the best. I actually like Skype, things like Skype, because I can actually see who I'm talking to. I talk lot to a lot of people, and Skype, or other programs like that, allow me to really read them. You know, most communication is nonverbal. I want to see their faces as I'm talking and making requests of going in and getting special access, for example. Can I get access to the top of the building to make pictures near a freeway? Or, can I hang out with you as you go into a restricted part of the woods to study nesting rare birds? I really like Skype better than the phone or email, because I can see people, read their body language, see whether they're receptive, maybe they're not so happy that I'm coming to visit. Sometimes, you know, they say, yeah Joel, that's great. Come on by, that's great, that's great. But if they're shaking their head no, that's really important to know, and you can't tell that over the phone or email, really.

When I'm researching something, I want to be with people who want me to be there. That's the great thing about working for *National Geographic*. I don't want to be with people that are belligerent or irritated or bothered. Life is too short. And it's not really my job to irritate people, although my wife would tell you differently. Believe it or not, I want to go somewhere where

I'm wanted, and there are tons of places where people are excited to have a photographer paying attention to them, whether it's *National Geographic* or somebody else.

So, I say this, as long as you promise to share your pictures with people, or at least offer them to have a good experience if they've allowed you into their lives, you'll be golden. That's a big thing. I've said it before, but when you're conversing with somebody and you're able to see them face-to-face during your research phase, just smile. A smile shows that you're happy and you're not going to be a problem. People like that.

Let's talk about one thing that took a lot of research and prep. Whale hunting in Alaska. I was doing a story on Alaska's North Slope, and first of all, I had to spend weeks, on the phone, mostly, because the Internet was just budding out then. I was trying to talk to native people. I talked to people with the International Whaling Commission, trying to find a village that was very successful in their whale hunting each year. I knew that I wanted to get a picture of a whale from above as it was being cut up. But I couldn't live in those villages for a year. We didn't have the budget for it, and my wife wouldn't tolerate that, obviously, or my kids either. So I had to find out which village has permission to hunt whales, which village would be the most receptive to me being there, and which village gets their allotment of whales the fastest and in the most predictable manner. Those are weird questions to ask on the phone, but that's what you do. That way I wanted to target my visit so that I would be there at the right time.

So I learned of this place, it's called Kaktovik, Alaska. It's a little village on the edge of the Arctic National Wildlife Refuge. By law, they are allowed to hunt three bowhead whales for food each year. They usually get them in the week right around Labor Day. This village had everything I needed, basically. There was a little window of time, a small window of time, and a place where the folks would allow me to be there, so it all came together there.

Next, I needed to get permission to be there, right? Butchering whales is a delicate subject to people, so I met with the whaling captains, the captains of the whaling crews there, and with the mayor of the town. As I recall, I told

them all I was doing a piece for *National Geographic*, which is true. What I wanted to do was fly a small camera blimp, about 18 feet long, on a tether over one of the whales when they beached in order to take a photo looking straight down as it was being butchered.

I paid a fee to the Alaska Whaling Commission, and I think I might have paid an honorarium to some of the people of the town. I promised prints, and I delivered those prints to the whaling captains who participated in the hunt, and I was given permission. And we could have done the same picture with a lift truck, or a bucket truck, but I wasn't allowed to use the town's bucket truck.

So, in comes the blimp and along with it Kenji Yamaguchi, who's one of the people that works at photo engineering at *The Geographic.* I had to arrange for helium tanks to be flown in, too. I had to get the camera blimp up there and up in the air. So Kenji shows up. He knows how to inflate the blimp, he knows how to run it, he helps run the cameras. He knows about all this stuff. I don't. I'm not using it very often. And when the hunters brought their first whale in, we lifted this blimp up. There's the camera. It lifts about 6.5 or 7 pounds and eventually got our pictures. There it goes. I hired another young man. I said do not let go of the tether. If you let go of the tether, this is the only one of these in North America, and we are done. And we had a lot of money invested. Anyway, there's your picture.

It's a little bit different perspective, bird's eye view looking straight down. This ran as a two-page picture in the magazine, and I liked how it looked, it was pretty much exactly how I had envisioned. I wish the whale had been even more giant, for size comparison, but you can really see what it's like there. You know it's a whale, you know it's a very unique picture. And notice that I'm not commenting on what I think about whale hunting. My job as a journalist for *National Geographic* is to show the readers of the magazine and let them decide. I'm showing them the world, and they can decide what they think about whale hunting, but that was a lot of work, but it did run big in the magazine, so, mission accomplished.

I want to show you another couple of pictures because from that same place I knew through my research that if I went up there at that time, I would not

only get a picture of a whale, but I could get pictures of polar bears feeding on what was left of the whales. I knew that if I hung around long enough, the bears show up just like clockwork around Labor Day, alright? I'd never even seen a polar bear before. I was very excited. I knew, through research, I was going to get a twofer, you know, a whale picture and polar bears. Both of which fit right into our coverage of the north slope of Alaska. And so, one polar bear even made the cover, believe it or not. But this took a long time. There he is, the jaws of a bowhead whale, tremendously big, and there he made the cover. How about that? That doesn't happen very often.

And of course, one beat on the door trying to get in and eat us when our van wouldn't start, but that's another story. It goes with the job. But that was pretty exciting, and it all came from doing my homework.

I knew from my research that I'd be welcome there, that I could fly my camera blimp. I had a place to stay. I could get meals. They would provide transportation for a fee. I knew that we could get polar bears if we could stick around for a bit after the hunt, about a week afterwards. It worked out perfectly, but the only reason it did work out perfectly was because I'd done my homework, at least 100 phone calls, maybe more. I mean, a lot of time goes into these stories, obviously a lot of time. And then there's weeks on the road, so you really have to want it. You really want to be type A if you work for *National Geographic*.

Let's look at another one closer to home. A little festival, probably my favorite festival of all time. Of course, it's from Nebraska. This came from a story I was researching on Nebraska for *National Geographic*. They were kind enough to let me work in my home state. I wanted to photograph small town festivals, and I hit this one in the research phase and I thought, "Holy cow, the Wayne Chicken Show. I'm going to hit all three days of this thing. This is epic."

So these are the Chickendale dancers. They're not quite as fit as the Chippendale's, but they drink more, and that probably explains it. So, this festival, three days, it's all things chicken and eggs. The folks there have a great time. I knew the dancers would be there, and you know what, they make for good pictures. So, here we are in the big parade. It's a chicken

theme, of course, a guy in a chicken suit is the grand marshal, and then when you get there, there's a lot of room for serendipity or things to just happen. There are plenty of chances for happy accidents.

They have a chicken flying contest, even. Can you believe that? This is where a guy literally pushes a chicken out a mailbox with a plunger to see how far it will go. Favorite chicken contest, or this, this is chicken mobile. There's a guy who's driving an old yellow Cadillac with a big plastic chicken on the trunk. There's a best looking chicken contest. There's an egg dropping contest where you try to catch an egg without breaking it. They drop it out of a bucket truck. Of course, everybody gets sprayed with egg when it breaks. It's hilarious.

There's a best beak contest, one of my favorite, best chicken beak on a person. Everybody sticks his or her nose through a hole in a piece of cardboard, and on the other side there are judges to judge the best beak, right? There is a best drumstick contest, as I remember too, where people were sticking their legs out of a painting of a chicken or something. They feed you eggs in the morning, chicken for lunch and chicken for dinner. That's fine me, I like chicken. You know, that's me with the Chippendales, the Chickendales sorry, I'm not quite as big as them, but I'm working on it. I'm working on it all the time.

The whole thing about the Chicken Festival, it's visually loaded. I love things that are visually loaded. It happens at nice times of the day, and it's visually loaded. When the sun is low on the horizon, how can you beat that? Are you getting this? If it happens at a nice time of the day and it's visually loaded, your odds go way up of making great pictures. Don't shoot the Chicken Festival in the middle of the day, shoot the Chicken Festival when the light's nice. It's all good stuff, OK?

Now, here's a big research job for you. Let's go even bigger than Alaska's North Slope. Let's go to Africa, The Albertine Rift, which is a big, volcanic valley in Uganda, in east Africa. This all started one day, I was riding my bike home from the grocery store with a gallon of milk, my editor, long-time editor, 20 years, Kathy Moran, called and said, "How would you like to go to Africa?" And I immediately said no because they expect too much. They

expect results, and there've been lots of great *Geographic* photographers worked at Africa over the years, and I said no. She said, "Come on Joel. You know, there are lions that sleep in the trees there. That would make a really good picture, wouldn't it?" I was like, OK.

So, now, until this phone call from my editor, about all I knew in Africa is that there are a lot of machine guns everywhere. This is my friend, Charles Rash, a videographer, with such a guy—a guard with a machine gun. I mean, that's about all I knew. Before I decided to take the , anyway. I started to write e-mails, and anybody, anywhere that I'd ever talked to that had worked in that part of the world, I called them. I contacted anybody who might know something about how to work over there. I exchanged e-mails with people that were with the Ugandan Wildlife Authority and with veterinarians, anybody that knew about this stuff, anybody, constantly, constantly looking. And eventually, you know what, one day about a month into my morning emails, I met this guy through email, a doctor, a veterinarian, German-born named Lu Siefert, Dr. Ludwig Siefert. He proved to be a godsend. He'd been working out of one town called Mweya, in the middle of Queen Elizabeth National Park, for 30 years. This guy was just absolutely fabulous.

I wrote to him, and the next thing I knew, he's the guy to hang out with. He had more than a dozen lions radio collared. He was doing a tracking study, more than anybody else. He had vehicles, and he was really desperate to tell the story of how the predators in Queen Elizabeth National Park were being poisoned by the cattlemen who were fighting to take over precious grazing land inside the park.

Lu knew everybody there, and he was well-respected. He was the guy with the dart gun for tranquilizing lions. He was the center of the action. He was it. Two vehicles, and he said he'd help me rig my camera traps for other species, too. Lu was what I like to call one-stop shopping. Man, I knew I could get just a ton of visuals if I went out with them and these visuals would be representational of the Rift's wildlife and conservation issues, just by hanging out with this one guy because we could be led into so many other things. Always, always a good thing if you can find one-stop shopping.

So, no matter what I do, I'm looking a person like Lu. Truly, if you can find one really talkative person, a friendly person that you hit it off with in each location you hope to shoot, your life will be a dream photographically, or at least visually loaded. I mean true, we eventually found lions that were sleeping the day away in the trees. It was great. And it was ideal for us because they weren't going anywhere. They were just lying around and yawning and sleeping and they'd stand up and stretch. Dr. Lu said they'd climb these trees to stay cool. So that's great, that made for a lot of great pictures, right?

I'd worked with Dr. Lu quite a bit via emails and phone calls, and we had a really good rapport before I even got there, and right off the bat We had a great shoot the whole time. I made sure that I shared pictures with him, obviously, before I came out. And just think of this, all of these pictures came from research I'd done from my kitchen table back home in Lincoln, Nebraska. Can you believe that? I wrote 700 emails, by the way, in the course of researching this story, but man, it was worth it. It was totally worth it.

You know, another thing to keep in mind, find out if you need special permission, permits, or paperwork to photograph a particular situation. You know, the world's gotten a lot more uptight since 9-11. There's a lot more permitting being done in this part of the world. Now, for example, I had to photograph a couple of military things for my story on Nebraska. This was before 9-11, and even then, it was tough. I wanted to go to their top-secret, war-planning room at Offutt Air Force Base. It's now called Stratcom, this place. This is a big room on springs so that they can take the shock of a nuclear blast, if one hits them. They would bounce up and down. It wouldn't destroy the room or the gear in the room. I wanted to see what this looked like. I wanted to see where World War III was going to be waged electronically. So, I got permission to go down there as part of this Nebraska story, but it was quite amazing. Lots and lots of screens, believe it or not. Some of them tuned to CNN before I got there.

I ended up photographing the PR guy that took me around. I wanted to make a picture beyond just the room, but I wanted the human element. I wanted something that spoke to the secretive nature of the place so we kind of have this little bit of ghost lighting coming up from behind him. I ended up with

this picture as the keeper. I didn't want to show his whole face, I wanted him to look more like, I don't know, he was top secret. If you look at the screens in the background, you can see all of the non-classified pictures of nuclear delivery vehicles that we have in our country, bombers, submarines, land based, that kind of thing, but this ran in the magazine. Mainly, we're talking about something that filled the screen. It was kind of intriguing. It was a look that had not been seen before. Look at that, rule of thirds, we're trying to fill out the frame as much as we can.

So when you're doing your research and prep, you have to be persistent. Sometimes you don't get permission. Sometimes it takes a long time. Homework equals access, though, I cannot stress that enough. If you want to do a really great job on something that's complicated, especially, do your homework and never give up.

Let me tell you about a picture that I really like, but it took a long time to get. For a year, I tried to get permission to get on a refueling aircraft based out of Lincoln so I could photograph a B-2 Stealth bomber over Nebraska. I knew that they refueled over the western end of the state. It would be a great way to show a landscape of Nebraska, an aerial, and throw this great-looking aircraft in the center of it. So do this, I went back and forth, back and forth between the National Guard wing that ran those planes and our local National Guard base in Lincoln, the one that provided the refueling tankers to fuel this thing right up in flight. I needed it to be late in the day, or very early when the light was nice. I got the run around and I never gave up, month after month.

I finally got permission and I got this frame. What happened, somebody felt sorry for me after a year of getting told no. They found that out, and they finally said I needed to call Langley Air Force base on the East Coast because that's where they cut the orders. So I talked to their public affairs person out there, and you know what? Within a week, they called back and said, "We need your social security number, we can get you on the next plane and you can get your pictures."

So it worked out, but I did not give up. I mean I worked it, and worked it, and worked it. I bet you I had 50–60 phone calls easy and emails, over and

over and over again trying to figure out what is it, what is it I have to do to get this picture because it happened all the time. I just needed permission to be there, but that's typical. If you want really good pictures, sometimes you have to be type A and driven. By the way, after this ran in the magazine, I got calls from the farmers who recognized their land down below, and they bought prints for Christmas. How about that?

Another thing I like to say, prepare for the weather. Above it all, in every way, I try to be prepared. I'm proud to say that I'm an Eagle Scout, and that's where I learned this. The Boy Scout motto certainly applies to photography. Be Prepared. If you're shooting something outside, be ready for bad weather. There is no excuse, whether it's rainy or sunny, you're going to need specialized gear. That's sun hats, that's raincoats, that's good hiking boots, whatever it takes, rubber boots, I don't know.

You need to know how to work in cold conditions. Wearing a hat actually keeps your hands warm, believe it or not, because you lose so much heat out of the crown of your head, so you wear a good hat and your gloves will work. Simple, simple, but you have to experience it or be told that to know it, right? If it's sunny and hot, pack a broad-brimmed hat and sunscreen.

Just be smart about how you go about it. Keep hydrated. That is huge. Be smart about how you carry yourself out in this big wide world of ours, too. Before you go anywhere, learn about the crime potential there. Talk to people who have been there. Are there pickpockets? If so, then maybe you don't want to walk around so conspicuously, right, with all these valuable things hanging off of you? Dress appropriately so you'll fit in. Carry much less gear and forget about the big photo vest that says, I'm a walking ATM. Be smart about how you dress, smart about how you behave, and it will greatly improve your odds of having a very pleasant trip. Most of all, though, bring backups of your most critical gear in case something bad happens to it. Believe me, you're going to need it.

Good pictures take work, from the research and prep time you spend in the field. I often say that the difference between a good picture and a great picture is the amount of time you put into it. That's it. It's a function of time. You can get a good picture with 90% of the effort, maybe. But to get a great

picture, it usually doesn't take another 10%. It's usually another 90% more work to get a great picture. It really is key, and that's what separates your pictures that are great from everybody else's. You've put the time in on it. You've really hammered it.

Persistence is really a key ingredient in getting great pictures. So, once you've researched and gotten to a place, don't leave early. Get there early and stay late. The best frames usually happen at the end of the shoot, really, once I've learned how my subject behaves, whether I'm in or not, whether there's a good vibe there, once I've seen how the light works. Once I anticipate the dance that's going on. Once I have my picture and I'm sure about it, I'll put in another card, and shoot that one too, just to make sure, because it's often on that very last card that's the best stuff, the best stuff of the whole shoot, right, because you're problem solving the whole time. You're working through solutions. Your brain is helping you figure that out the whole time, shoot again and again. When you think you're done, shoot some more. Push yourself. That's where the really great frames come in. Go beyond the obvious.

I'll show you another illustration here of the time that I had to work in the United Kingdom. I worked the Three Peaks Challenge. This is a mountain climbing event that happens every year in the United Kingdom. It's a race for charity, where various people run up and down the mountains. And, again, when the *Geographic* called me to do this, I said no. I didn't want to go because I'm no mountain climber. I don't run anywhere but the fridge, really, so I mean, run up and down mountains? I think not.

But, I did my research. My editor Kathy Moran calmed me down. I did my research, and I knew before I went that the guys I'd be partnered with, some guys from a fire station in England, they were very, very good guys. They were going to be very kind to me. They would slow up for me a little bit. I knew from talking to my editor and to the story writer, that I would not have to race up and down the mountains, but I would be able to make good pictures. These guys were nice. They were excited to have me come in. They're all trained athletes. I'm a butterball. So are we kidding? But the research phase literally saved me and certainly eased my mind and convinced me that I should go and I should try to make the most out of it.

So, let's see what we do. Well, the first thing I did was get there early, get there early and see these guys working out and trying to make funny pictures of them working out. They have these pre-race rituals. They work out at the fire station on the day that they get ready to go, and they stop at an amusement park on the west coast of England, and they ride the kiddie rides, just for fun, and then try to loosen them up. So that's great, that's great. That's a good thing. Then they stop at the pub. I know I can make pictures in there of these guys drinking beer, and I had one or two as well, and then I wasn't quite as concerned about whether my pictures were going to get me fired or not. So, I shot as best I could, and then we start getting into the mountains. And they get there a couple of days early. I'm there with them, and we're working out. They're practicing, so it's a chance to try different things. Slow shutter speed of these guys moving around, maybe a 15th or 20th of a second here, but it's a chance to try low angle, worm's eye view. Put the camera on the trails. These guys are running back down at the end of the day, and shoot with a motor drive with a little radio trigger, a little remote, and fire it bang, bang, bang, as they're jumping over. And even got a boot getting ready to come down right in front.

So I'm learning in all these cases I can get a little bit ahead of them and get pictures of them coming up the mountain, and then when I'm extremely fatigued, I'll go back down and get them right when they're running back down the mountain. So I really didn't get to the top very much, but I was able to make pictures. There are other people in this race, too, that would absolutely conk out on top of the road, they just couldn't handle So, that's good pictures too. I'm looking for pictures anywhere I can get it.

If it's a sheep that's lost and running alongside the road, you have to drive to three mountains and climb three mountains in 24 hours, so it is really a race, and it takes its toll. That's a picture too. And I knew about all this stuff in general just from my research phase. I knew that these guys would be pretty beat up because they're going 24 hours straight and they were really rough, really rough in the van. I wasn't feeling to good either, but you know what? It's alright, it all makes pictures.

The last mountain they finish up. The ultimate ace in the hole I had was they went to the top of Mount Snowdon in Wales. Now, obviously, this is a

place anybody can get to. Here are some tourists that were there when we got there. Why? Because there's a train that goes to the top of the mountain so I rode that train up there. This is my face before realizing what I was in for. The train goes to the top; that's great. I can ride the train and beat the guys up there; I can ride with the retirees, and that's fine. I was able to get up there way ahead of them before they turned around and came back down, and here we go on the way down. So I was able to hang out with them even on the last mountain.

So I'd researched this well enough to know that I was really going to be able to make a story, all because of the research totally, totally. There they run down the mountain with the little train. That's my kind of mountain climbing where you take the train to the top of the mountain. And that's the end of the day, sleeping. Well, almost the end of the day. Of course, we had to hit the pub on the way out, right? If I had just gone there, by the way, and had not done all this research, do you think I would've gotten any pictures? I would've gotten a few, but you know what, that research phase helped bond me to them. It really helped make the story complete because I was friends with them before I got there, plus I would have been freaking out. I wanted to know that I'd make a nice set of pictures before I ever put myself on the airplane to go. Hmm, makes sense, right?

One last story here. This is how you do something the wrong way, the hard way. I want to tell you about a time back when I worked at the *Wichita Eagle* in Kansas. I needed to go photograph a windmill repairman out on the Colorado plains. There's not much going on out there on the east side of the Rockies. It's windy and desolate, not a whole lot of people live out there. It's very pretty to me, though. I called the postmistress out there to learn what goes on. I asked what people do. She said, "You know, rural mail carriers come around out here, and there're people that grade the roads, and cowboys moving cattle once in a while, and there's a windmill repairman that works out in this county? I said, hmm windmill repairman; that sounds good. Alright so I'll try that.

So I got the repairman's name and phone number. I called him up, and I asked, you know, when's he doing his work. He says I work from dawn to dusk This is a busy time of the year, summertime, so I knew I could get

pictures in the right light. I asked if he had a boom truck, one that gets him up to the windmill head and takes those heads off those windmills. He said sure. I said can I climb the boom? He says sure, but you're going to get greasy and oily, wear old clothes. So that's great.

So I go all the way out there and I climb up to the top, right across from him. That's fantastic, old windmill out on the Colorado plains. I'm all set, he's getting ready to go, the sun's just getting ready to come up, and he says, "Whoa, whoa, what are you doing, what are you doing?" He's up on the windmill, getting ready to go, getting ready to work on it. I can see the picture coming together right in front of me! And I'm saying well, I'm getting ready to take pictures. He says, "No, no, no, no. You never asked me that! I'm wanted! You can't take any pictures of me. Sorry."

Well, I'd driven six or seven hours out there, but he was right. I never did in my research phase go all the way through and ask if I could take his picture. I just asked if I could take pictures of the windmill. So you know what I do now? I ask if I can take a picture of the person that I'm talking to. It's a basic thing, but all it takes is a six- or seven-hour drive, one way, and getting skunked, that teaches you that lesson. It's a basic, stupid question, but it's not stupid question if somebody's wanted and you can't take their picture. So always ask, ask permission, be nice about it. Smile, be specific about it. Be very specific, or you'll find yourself moping all the way back home without a picture. I did go out there again, I found a different guy, one that was not wanted. We got a nice picture, but what a lesson. I eventually did get him, and it worked out great, but you know, did it the hard way, totally.

So our next assignment. I want you to take pictures that require special timing or special access to get to, something you have to work a little bit for. This could be for behind the scenes access at a concert, or a ballet performance, or a play, or getting to a building's rooftop to shoot overviews of a downtown Main Street. This is the fun stuff, you guys. You'll be really glad you did. So next up, in our next lecture, a little change of gears in that we turn our attention to the least among us, the small things, and how we can photograph them, I mean physically small using macro equipment. It is a lot of fun so we will see you then.

Advanced Topics—Macro Photography
Lecture 19

There is a whole world that exists under your feet—insects, tiny plants, invertebrates, and more. In this lecture, we'll get very close to this tiny world and look at what often seem to be the alien life forms that live there. Macro photography is what lets us see into this normally unseen place. To get good macro shots, we'll discuss depth of field and supplemental light sources in detail.

Gear for Macro Work
- There are hundreds of macro photography rigs available, often customized, but keep in mind that technology changes constantly, and some of the things you'll use aren't necessarily part of the newest, most advanced systems.

- A ring light that fits over the end of the lens illuminates small subjects well. Small extension tubes help get the lens away from the body of the camera, enabling you to zoom in a bit more, even if you're using a macro lens.

- Probably the best set-up is a tripod with a macro lens and a cable release and light introduced with a flash and a softbox. You can also try a small light dome that mounts on the flash.

- If your subject is likely to move, it helps to have an autofocus macro lens, but you won't need one for photographing flowers.

Shallow Depth of Field
- Of course, close-up photos have shallow depth of field. The closer you get, the less that will be in focus in your shots.

- You can think of a macro lens as a telephoto lens in miniature for two reasons: (1) You have a shallow depth of field when you're in very close, and (2) the image is prone to camera shake and movement because

you're magnifying the subject so much. These are both factors to be careful of.

- The shallow depth of field makes it harder to choose a spot to focus on, but it also blurs out the backgrounds, allowing you to bring your subject forward and soften it. In a close shot of a bouquet of flowers, there's just a hint of color and the suggestion of other flowers in the background.

- To correct for the shallow depth of field that's inherent in macro photography, use a lot of light and set the aperture very small (f/22, f/36, or even f/45). Gather the available light with long exposures using a tripod and a cable release.
 - o Steadying the camera with a tripod when you're using a macro lens is just as important as it is when you're using a larger, heavier lens, such as a 600mm telephoto.

 - o You also need to use a cable release because, with a macro lens, even the slightest movement will throw your subject wildly out of focus.

 - o You may even need to steady the subject itself by surrounding it with a box or a portable shooting tent.

Light Sources for Macro Photography
- The biggest challenge in macro photography is to get all the depth of field you can. If you're not working with a tripod, you need to add some light to the situation and increase the aperture.

- Among the light sources you can use are flashlights, reflected sunlight, and store-bought reflectors, especially a gold reflector. On a sunny day, find a flower, shade it, and then use the gold reflector to add soft, warm light—it almost looks like firelight in the middle of the day.

- Of course, a flash is the fastest and most reliable way to add lots of light to macro shots, and it freezes action. Flash can be a must when photographing small creatures that are moving.

- A handheld softbox with a flash will enable you to use a smaller hole in the lens and greatly increase the depth of field. It also gives off a fabulous quality of light. You can even try putting a tissue over the end of your lens to diffuse the light.

- As we've said, the closer the light is to your subject, the softer it will be. Macro photography offers an excellent opportunity to see how elegant electronic flash can be when used well.

- An alternative to a softbox is an index card or even your shirt—anything that you can bounce light off of and onto your subject.

- A ring light that fits around the lens is useful in situations where the lens itself is shading the subject.

- Consider having light come at your subject from an angle, just as you would if you were shooting a big scene. This allows you to get more shadows and gives depth and dimension to your pictures.

- Relatively inexpensive studio lighting kits are available that include a power pack, several flash heads with softboxes, and light stands. Such a kit packs easily into a suitcase and can be used for both large-scale and macro photography.

Use clean black or white backgrounds to bring out the essence of tiny subjects.

- The specific delivery vehicle for light isn't important; what matters is having enough light to give you plenty of depth of field. Put small creatures or plants against a black or white background, put the light off to the side, and shoot them with a macro lens; your viewers will see the beauty in these tiny living things.

Additional Tips for Macro Shooting
- Everyone thinks about flowers and insects when they think about macro, but you can go beyond that by shooting close-ups of parts of larger subjects, such as eyes, teeth, jewelry, or money. This technique allows you to show common things in a new and intimate way.

- In macro work, holding relatively still, both on your end and your subject's, is fairly important because there's so little focus depth if you're using only ambient light.

- A series of photos of a box of chocolates shows the effects you can get by experimenting with flash, a softbox, and a gold reflector—really

Behind the Lens

Even if it's an abstraction, think about composition always—I do. It's more than okay to experiment with abstract composition in macro work; just try different things. To me, I love getting in really close on flowers—to where you can't even tell what they are—because that's different and new and surprising. I do that all the time.... I am constantly looking for what I can do to make the world look very, very interesting right in my own backyard....

© Joel Sartore/National Geographic Stock.

quite a simple lighting system. Especially when you need depth of field, use flash and a softbox.

- Never try macro photography in harsh light or really bright direct sun because the shadows will be too prominent. It's easy enough to shade the small subjects you're working with.

- A pair of photographs of a toad again shows the difference in depth of field and detail you can achieve by using flash and a softbox.

- Always remember that even in the world of macro, the regular rules of composition still apply. Even with little depth of field, keep your backgrounds clean. And don't be afraid to experiment with abstract composition in macro work.

- Common mistakes in macro photography include not lighting the subject well, not getting enough depth of field, and not getting low enough to be where the action is in the macro world. Whether you're shooting a turtle, a gecko, or a grasshopper, you want to be eye to eye with your subject.

Assignment
- Shoot one great macro photo at home—in your driveway, on your sidewalk, or in your yard. Try to show something ordinary or common in a remarkable way.

- For extra credit, shoot the same subject both with and without supplemental light.

Suggested Reading

Naskrecki, *The Smaller Majority*.

Latimer, ed., *Ultimate Field Guide to Photography*, pp. 166–169.

Homework

Shoot one great macro shot in your yard or on your street. The subject can be anything, but it has to be out of the ordinary for you. Push yourself: Photograph a common, everyday thing in a remarkable way.

Advanced Topics—Macro Photography
Lecture 19—Transcript

Hi there. You know there is, literally, a whole world that exists under your feet. Did you know that, a whole world right under your feet? Well you wouldn't want this under your feet, or that, since it's venomous. But, close-ups, macro photography, that's what we're talking about today. This is the little things in life, right, little invertebrates, insects, tiny plants. When you get really close to them, and look at them, they are as alien as if from outer space, especially the insects, very amazing.

In this lecture, we're going to discuss macro photography, and this is a subject that's very otherworldly indeed. You know, it may be that the eye is the window to the soul, even if that eye is wearing contact lenses, but it's good macro photography that gets us there in the first place, isn't it? It's a window, or a portal, to this normally unseen place. If that sounds exciting, it's because it is, really.

I want to show you some of the gear that I use for macro work. Now let me say first off, first and foremost, there are literally a thousand macro photography rigs out there, often customized, and what you see here won't be around forever. Technology changes constantly. It's a good thing this isn't really a technical course or an equipment course. I don't want you to be too consumed with the gear. This is about seeing well and thinking things through. So what you see here is just what I use, and I don't use all this stuff consistently. It's whatever I feel like. This just gives you an idea of the things that I use before you go out and form your own style of trying this.

So, let's take a look at what I have. There's a wide variety here and most people would say, oh gee, I want to be a really good macro photographer. I'm going to get the best thing I can find. I'm going to get this wireless flash system and an auto-focus TTL lens on a new body. I'm going to do this. Well that's fine. You could do that, I guess. But, you know, a lot of times, I don't use something like that. I'll use a little ring light that goes over the end of my lens, illuminates subjects, small subjects, very well. I will use little extension tubes, look at that, there's no glass in this. It is simply a hollow ring that gets the lens away from the body so I can zoom in a little bit more, even though

I'm using macro lenses. Or you know what, if I'm lazy, or even if I'm not, I'm on vacation, I'll use this. It's a little point and shoot. It has a macro setting on it that's very, very nice. Love it. It's just fine.

So what do I use a lot? Well, to tell you the truth, I use this. I'll use a tripod with a macro lens in a soft light. I will introduce light also to get lots of depth of field. I will introduce light by using something like this, a little softbox, or, if I want to travel extra light, I'll use a little light dome on my flash, just like this. It's kind of nice. It's just translucent like a milk carton. Take it, put it on there, mount it up, turn it on. That's it. A tripod and a cable release, I use these all the time, all the time. I hold the flash up here, fire away, it looks good. If I want the light even softer, the softer, softer light comes from a closer light. The closer the light is, the softer it is, so I'm just going to work like this. That's it, a tripod and the cable release.

A lot of times, I won't even use a flash. It just depends on my mood and what I want to do. It's that simple, it really is. It's not too complicated. I like to keep things simple, soft light, tripod cable release, subject's not moving, no reason not to, lots of depth of field, away we go.

So, one last point, flowers are easy. It helps to have an autofocus macro lens if your subjects are likely to move, like insects, for example, or little frogs or something. This is because, even for somebody like me who does this stuff for a living, when you're working really close up, it's nearly impossible to follow focus with a macro on something that's moving about quickly. Insects that are moving really, really are tough to get in focus without an autofocus lens.

So now that we've talked about the physical equipment, and you notice how light we are on that talk, well, it's because I want you to think and see well, that's why.

What else are we going to talk about? Guess what, guys? We're going to talk about the same rules we've been talking about all through this course. They apply to macro photography as well—lighting, composition, and something, interesting please. I expect the same high standards. It's just that close ups

in nature, well, it's a little more challenging—but it's more interesting in a way, too.

Let's look at a couple of pictures that really start us off with what macro photography is about, a very shallow depth of field. As you get closer, you get less and less in focus. Look at that, that's just a macro lens out of the box on another venomous snake, but it's very, very, it's very, very shallow depth of field. Why is that?

Well, I think of a macro lens as a telephoto lens in miniature, for two reasons: You have a shallow depth of field when you're in very close, and also, the image is very prone to camera shake and movement because you're magnifying things so much, you're really zooming in. It's a telephoto in miniature. These are both things to be careful of. Now, we know that we can eliminate camera shake with a tripod if the subject is sitting still, just like I showed you back there. So let's try that first on something very easy, flowers. Why? Because they're pretty, and they're not running away from us.

I use flowers all the time. I enjoy flower photography, nothing wrong with that. So, flowers are three dimensional, aren't they? They don't occur on a single plane. Most of them are rounded. Not everything is going to be sharp therefore, if you have a very shallow depth of field. Some may curse that a bit, because it makes it harder to pick a spot to focus on. I think this can offer some advantage. It blurs out the backgrounds, even when I'm a little farther back, right? When you're blurring out the background, you really help bring your subject forward and soften everything up. OK.

So let's look at a couple of these. Look! I'm getting in closer, less depth of field, a lot less depth of field here. How is this done? Just like I'm showing you in here. That's it. Flowers on a tabletop with a macro lens on a tripod with a cable release with window light. That's it.

Alright, let's look at three more here. Here we go, now, if you're starting away from the subject a little bit, like I did, I'm pulled back here, you don't really need a lot of depth of field, again, because you have a good idea that this is a bouquet, don't you? But as you get closer, look what happens. As you get closer and you're still focused on your prime subject there, your

target, the other flowers get softer and softer. Pretty soon we just have a hint of color back there, a suggestion that other flowers are back there, but they're not at all sharp and that's fine. That's OK to do it that way.

Now remember, the closer you get to the subject, the less depth of field you're going to have. I'm going to say that over and over again, but it's very true. The farther away you get from your subject in macro, the more depth of field you get, OK? That's just how it is, but getting closer is the point. We want to be close. That's what macro is. So, that means you're going to need to learn to maximize your depth of field if you want to go beyond the easy stuff, the shallow stuff.

So, how do we correct for this very shallow depth of field that's inherent in macro photography? We get a lot of light in there and crank down that aperture to a very small hole, that's how. We gather light how? With long exposures on something that's not moving using a tripod and a cable release, OK that's easy, or we add artificial light. We throw light in there with a flash, something like a flash, to really make it sing. We'll talk more about adding flash in a minute.

But let's really talk about using natural light well. If the subject's not moving, I get that tripod down and dirty. I get that in there and I move that lens around and I really look at the subject and study it. My goal is to get as many good pictures of, say, a gerbera daisy, as I can get. That's how it works, right? With a tripod, really you can do some amazing things on subject's that aren't going anywhere. You can get incredibly high apertures, moving beyond even say f/22 to 36. One of my macro lenses goes to f/45, and that's incredible. Does that mean everything's tack sharp? Sometimes yes, depending on how close you are and how far back you want to throw that focus, sometimes not, but it'll get you most of the way, f/22, f/36, f/45, that's good stuff. It's very, very three-dimensional that way.

Now, if I'm trying to work outside, that's tough if it's a little windy out and you're trying to do flowers that would normally be stock still indoors. I work outside all the time. I try to bring something with me to keep things from moving in the wind. It could be anything from a cardboard box to one of my

portable shooting tents that allows light to filter in from all sides, so we get closer. This was a very windy day, actually, the flowers are tack sharp.

So, again, let me stress that, when you need to get close to a subject that's not running away from you, you really need to have that camera on a tripod if you want a tiny hole in the lens because you're going to call for a longer exposure than you can hold still. Steadying the camera is really, really important with macro, critically important, just as it is with a larger, heavier lens like a 600 mm telephoto, you need help. You'd want a tripod or a monopod, OK?

Don't forget that in that soft, weak light, with the smallest hole in the lens, you're going to have to use that cable release, you are. It's a little bit of a pain, but you have to use it so that you don't jiggle the camera when you press the shutter. With a macro, even the slightest movement will throw your subject wildly out of focus. The whole world will be a blurry mess. That's just how it is. Steady the camera, steady the subject when you're working on a tripod with slow shutter speeds, it's very important, OK?

So, I often like to increase the aperture and work the light. So to sum up, as a very general rule in macro, and there's a million ways to do this, this is my way of doing it, the biggest challenge is to get all the depth of field I can. If I'm not working on a tripod, it means I'm going to want to pump some light on the situation and increase the aperture, which will give us more of the frame in focus.

Besides using a tripod, how else to get that aperture constricted? I've done it a number of ways, I'll show you a couple here. I've used a flashlight on amphibians, for example, to really pump light in and get things sharp. Because the animal's breathing, moving a little bit, we get a fast enough shutter speed that way. Then there's reflected sunlight. That's a lovely light source for macro photos. One very simple way to do this, is just, and the way that I started out, is to shade the subject, on a sunny, day shade the subject, just my own shadow or friends, and then use a reflector to kick supplemental light onto the subject. You can use anything. You could use a store-bought reflector. You could use a piece of colored paper, you could us a t-shirt that's

bright or maybe a t-shirt that's got some orange or some yellow to it. It's pretty easy, and pretty nice.

Personally, I'm partial to a gold reflector. If the sun's out, I'll find a flower, shade it, and then kick in this soft, warm, beautiful, glowy, reflected light. It is gold, it looks like firelight in the middle of the day. You've shaded your subject, and now you're kicking in this wonderful, reflected light straight off the sun, let's say off of a gold reflector or gold t-shirt, or anything like that. Oh, man. I love that. It's one of the very best looks. Very subtle, and yet effective, very nice.

A couple of pictures here with the camera stopped down as much as I can, with the lens stopped down as much as I can, tiniest hole in the lens I can get. These are actually tiny ground-hugging flowers, about this tall, maybe not even a half inch tall, out in the middle of the desert in Nevada. It's in the middle of the summer at high noon. The light outdoors couldn't have been any worse, but you would never know it to look. That's just shaded and now with the gold reflector kicking in. Wow, tiny hole in the lens, camera's on a tripod, I am using a cable release, it is not a windy day, and voilà! There we go. Just a lovely, lovely light source there, reflected light.

Of course, what would a macro lecture be without talking about flash? We must talk about flash. Yes flash is our friend, and we can use it, and it's nothing to be scared of. I use flash all the time in macro. It just depends on my mood and whether the subject's moving. Truly, a flash is the fastest and most reliable way to add lots of light to our macro shots. Plus, it freezes action, doesn't it? A must when photographing small critters or things that are moving around on you.

My favorite flash technique, by far, is to use a little handheld soft box like I had on the table there. Don't let how that thing looks fool you, by the way. It's small but mighty. It allows me to use a smaller hole in the lens and greatly increase the depth of field, and that's what we're all about if we're trying to get a lot of information about little critters that I photograph. It also gives off a quality of light that is really fabulous, if you look at this. This is with that little handheld softbox, but you can do this with a Kleenex over the end of your lens, too, just anything to diffuse the light a little bit.

As is always the case with flash, the closer the light is to your subject, the softer it will be. It's a bit counterintuitive, but that's how it is. So I try to get that flash, or the diffuser covering it, right up close and basically drool as I watch that flash wrap around my subject. Macro flash is a fantastic place to really see how elegant electronic flash is when really used well. Can you believe it? That's just a lady bug in my backyard. Can you believe that? It's just using flash well, nice and close, that's the beauty of macro photography. You could spend a lifetime in your backyard, you totally could.

Now, if you don't want to use a soft box, you could do it on the cheap and use a little bounce card, simply like an index card, or anything, really. Bounce it off your shirt, anything light that the light will bounce off of and on to your subject, that's fine. The other way you can use flash, for example, in insects anyway, is with a ring light, as I mentioned. A ring light just puts a light right around the tip of the lens there and it's a nice feature, because sometimes your lens is so close to a subject, it literally shades the subject from any light. So, that's trouble. You need to use a ring light or light right at the tip of the lens. That's just how it goes. It's mounted right on the front. It's a handy invention, very handy. I'd recommend it if you're doing something where you're really, really, really close, such as this.

This is a water boatman, a little insect. He has this iridescent sheen on him, and you do get a little bit of a reflection because he has a hard shell that makes him shiny. But, that's OK, it makes great pictures in an otherwise kind of impossible situation where your lens is right on top of the subject, so close that your softbox wouldn't be able to really light him fully. A ring light's very helpful there.

One thing I really like to do is have the light come at the subject at more of an angle, just like if I was shooting a big scene, macro is no different, right? You get more shadows that way, which gives you more dimension and depth to your pictures. So let's look at some of the animals I've photographed using macro lenses and using flash with the camera. As with flowers, I'm hoping for a lot of depth of field here, but because the subject is moving some, I really like to use flash to freeze the action a bit, otherwise it would be pretty tough.

So, here I'm using an inexpensive studio lighting kit, one I got at a garage sale actually, my first one, anyway, and I'm still using pieces of it. This is a crocodilian down in Florida. It's a slender-snouted crocodile. The kit that I have consists of a power pack, right there, and several of these flash heads that have bigger softboxes on them, right? And you mount those to little light stands. It's a little kit that packs in a suitcase very easily. Again, the closer to your subject, the softer the light is. I can use this studio lighting set for bigger things and macro work. So it's just a matter of having enough light. It doesn't matter what the delivery vehicle for the light is, it's just a matter of having enough light to get you plenty of depth of field to really work it. And again, getting the flash off the camera and having those flashes come at different directions really models, really scopes the light, very, very nice.

You know, I've been photographing a lot of plants and animals using that studio softbox set. The results are wonderful and surprising. I mean if you think about how this stuff would normally look in the wild. They'd be hidden down in the brush; you can't really see them. They're in the mud or the sticks, there are all sorts of debris and distractions around. They'd be in heavy shade. I like to use these backgrounds to really clean them up, black and white backgrounds really brings out their essence. I don't know if that turtle's happy or not, but he's sure got a smile on his face, right? But it works great for plants as well.

Again, it's not really how you deliver the light, it's how you capture it in this case. Little snails the size of a pencil eraser, even. They look great on white backgrounds, they really do. So, by adding this type of light source and making things beautiful, you take something that's normally overlooked, these tiny, little things, and you make them extraordinary really, like a ladybug. How can you make a ladybug look good? Macro and getting the light off to the side. That's it. You're lighting this stuff in such a beautiful way that your viewers won't be able to help but to see how great these things are. They'll fall in love with these creatures. They absolutely will not be able to help themselves. They'll oooh and aaah every time, I guarantee it.

For example let's take toads. What can you do with a toad? I don't know. Toads are often maligned. I think they're kind of beautiful, and they're very cool when you put light on them and you shoot them with a macro lens.

Wow, they're interesting. They really are! There's a lot of texture, a worm's eye view shooting through glass from underneath, get them hopping away or just facing away, right? Look at what you can do with a macro and just some additional light. You almost don't even need to worry about anything else and just zoom in. You don't even need a background, in a way, when you're that close to his eye. It's wonderful, and it's not anything that's that complicated. It's just adding a lot of light, and being in focus, and hoping they hold still long enough.

Another tip: do the unexpected. Everybody thinks about flowers and insects when they think about macro, but you can and should go beyond that. I do that all the time. How about the human eye, you know somebody that's got a great eye, I'm sure you do, somebody in your own home, maybe one of your kids, your spouse, whatever. I shoot eyes all the time. I don't shoot the whole face, just part of an eye. It's fascinating. It's amazing.

Have you ever gotten close to it and seen how a pupil constricts, and the eyelashes, and the color, and the veins? The eye is an amazing thing, just amazing. If you get in close with a macro, you'd be fascinated at how it looks from that point of view, that perspective. And this is something that you're looking at all your life, many times a day in the mirror. How about that? The human eye, it's nice. Don't forget to photograph non-human eyes as well, which are even more amazing! Have you ever looked at a cat eye up close, or how about an alligator eye up close. Well, you can do this stuff. It's just a baby alligator, but he doesn't look it. He looks enormous, right?

The same with good teeth believe it or not. Teeth pictures, my assistant Grace, she's obviously taken good care of her teeth over the years, get very, very close once in awhile, just very, very close on her mouth. It's very interesting, it's fun, at least for me, I don't know if Grace likes it or not, but she puts up with it. The things people have to put up with at my house, it's not good, but they all get paid, so it's alright.

So, let's look at things you can do with macro just around the office, for example. It's not just living things you can do inanimate objects, can't you? Jewelry is a classic place to do things like this. Have you ever done close-ups of jewelry? Have you ever looked a diamond this way? Have you ever

looked at one in a mount? Have you ever seen up-close of how a diamond is kept in place, so that you don't lose it? I bet that would be a nice shot to try sometime. Or you could do other rings, maybe just a tight shot of somebody's hands with a macro lens. You can actually back up, you don't have to be super close all the time.

So what else? Well it's often fun to use a macro lens on money. Detailed shots reveal that our currency is actually beautiful, works of art, totally. Closer, closer, closer, wow. You never stop and look at these things. The bottom line is that anything like this, if you go in tiny and close, common things, you cannot believe how you can reveal these things in a very intimate way, in a new and surprising way that's worth thinking about going after with a macro lens. It's totally worth your time.

Now, again, it's not like this is genius or anything, it's just that we're talking about taking the time to craft the light well, and to think, and to use a macro lens effectively. And this just comes with practice. That's it. Now one other thing with macro; this is where we get the little racehorse effect. We really, really want to zoom in close, really close. We use the extension tube I mentioned over at the table. It's just a simple ring of metal that extends your macro lens away from your camera body a little bit and zooms in a little bit more. Look at the eye on this gecko. Holy cow. Or even just his feet. Amazing, just amazing!

Now these are just little reptiles you'd buy at a pet shop, alright? The amazing detail you can see there, it's like you're on another planet. The best part is geckos don't move very much or, chameleons; they hold fairly still. They like to sit still all the time. So you could do this with anything, in theory, if you could find something that would sit still long enough.

In macro work, holding relatively still, both on your end and your subject's, is fairly important because there's so little focus depth if you're only using ambient light. Now let's look at something that I shot handheld, using shade, flash, and reflector. We got a box of chocolates at our house and before I ate all of them, well, maybe I shared a little bit, I decided, well I'm going to work a wide range of things here because I really want to see what I can do. Now look the top of these chocolates, the top, they're all on the same focal

plane, so great, we can use a shallow depth of field for one. They're all on the same focal plane for this initial shot. This is just basically standard light, nothing to it. That's what the light looked like. There we go.

Mid-morning sunlight, the sun comes out a little bit more harsh. Look at how we lost the shadow detail there, no shadow detail at all, very harsh. We're exposing for the highlights so we're not blowing out or losing data there, but very harsh shadows, not that pleasing. Now let's see what else we can do. OK, there's little Spencer, he's shading it. He's shading the box with my softbox. That's all we're doing is shading it right now. OK, mid-morning sunlight and shaded, now we're starting to get some shadow detail in there. Much better, we're not blowing out the highlights, we've exposed for the bright parts and we do have shadow detail, so just shading. That's a lot better than just harsh sun. It's probably 9:30, 10:00 in the morning.

Now we're actually going to light with that softbox. Check this out. Mid-morning sunlight, shaded with the softbox, and throwing a little flash in there and we've got a little bit more detail. That works too, but you know my favorite is the easiest. My favorite is actually the easiest. There's Grace holding that big gold reflector and Spencer is shading those chocolates, so we've got shade and reflected sun, look at that beautiful, warm, glowy, love that. That's my favorite look of all and I didn't need any expensive setup to do this, handheld, not very much depth of field because all the chocolates, we're focusing on the tops of the chocolates. The simplest lighting system of all, and that's the best? Yes, you don't need expensive gear, you can do this just by thinking your way through this. Honest!

So, one reason I really like using a flash and a soft box is that it gives me a certain look, lots more depth of field. When I need depth of field I'll throw flash in there all the time if something's moving, right, because it freezes action. I can move freely if my subject's hopping around. In the case of the candy, we wouldn't want to eat them if they were moving, of course. But, no matter the technique, in macro I'm looking for the same thing as always, something interesting, always something interesting, composed well, nicely lit. And sometimes I will purposely use f/2.8, just to see how that very shallow depth of field looks. I like that.

Like for example, this tiger's eye shot at a zoo. I use a very shallow depth sometimes, and it's a nice effect, nothing wrong with that. In fact, I like it better than if I had a lot of depth of field. I do that all the time.

You want to know something I try to never do, though, in macro photography? Harsh light, really bright direct sun. Man, the shadows just kill you. This may look like an OK picture to you, but I don't care for it. I mean, I've got a lot of shadow in there, and that really, really hurts, I think. I really try to think about that. It's easy to shade a subject when you're talking about macro, because the area you're concentrating on is very small, just have somebody stand next to you they can shade the subject. So, see the difference here, we have soft light now. That's where it's at for me most of the time, soft light. All we did is move those flowers out of the sun and we can move around on them. That's all, that's it.

So, speaking of soft light, it is very hard to beat ambient light, are you picking that up? Are you with me now? And so I'm often tempted to shoot only available light because it works so well some of the time. And it has a certain look to it, depending on my mood, that's just fine. I want you to look at a couple of pairs of pictures here, the first I shot using just available light and the second using flash. There are subtle differences, but see now, you have a discerning taste and you're going to know what you're looking at.

So let's look at a pair here. This is a little bit noisy. It's in a dark room, again one of my favorite subjects, toads. Very little depth of field, the skin on the eye is sharp, but the skin on his body is soft. That's how little the depth of field is. I'll bet we don't have an eighth of an inch depth of field, maybe a quarter of an inch. Certainly the leg and the hand holding him aren't sharp. Now we'll look at this same species with light, OK, with flash. Look at this, every detail is sharp and you know sometimes I prefer this look whenever I can get it, if I take the time to get the softbox out, really nice and sharp, very professionally lit. The light is off to the side, you can see the highlight in the eye there. We're holding the light off to the side, and we're really lighting him well, and that's nice, OK?

Another pair, same thing here. This was , actually, just last week. This is a little sparrow. This is using a wide-open aperture, just ambient light, that's

it. It's a little dull, a little flat, it's inside my shooting tent. Not a whole lot of depth of field, but it's a nice, soft, kind of a down mood, but it's OK. Now look at the second one, using flash, much more vibrant, much more lively and lots and lots of detail there. The second one using flash is much more stopped down, a tinier hole in the lens, so we have much more in focus here. Which one do you prefer? Some days, I can't decide. I just wing it every time.

Another thing, always remember that even in the wonderful world of macro, the regular rules of composition still apply. Even with little depth of field, you want to watch those backgrounds, you want to keep them clean. Be aware of visual clutter. A couple here, just illustrating visual clutter. Two shots of a mantis, a praying mantis, at my house in the backyard. We've got some clutter here. We've got a leaf in the way, a stick, not quite working well, not quite working well.

Now look at this. I move a little bit lower, maybe the mantis climbs a little higher, and look, we get a nice, clean shot. Now, mantises move quite slowly, so you really need to have some patience, but this totally changes the background. It's very clean. There's no depth of field here, we're still shooting with a wide-open aperture, but it still works because you're back far enough and the head is sharp. It would be nice if we had a little bit more depth of field, but you still go right to the eyes, and this is a fairly successful frame for that, although it's a very straight picture, not too complicated.

By the way, you know the last place I saw a praying mantis, it was at a gas station. Took forever, I think he was waiting for his receipt, I don't know he wouldn't move, giant thing, that big, but I digress. Watch that background and use it to your advantage. Always. Watch the clutter back there. You can get cluttered backgrounds even in a really shallow depth of field macro world, you can. Be patient, and get the composition right. It counts in the macro too. Just because you're close on something does not give you a pass or an excuse to shoot junk, OK?

Even if it's an abstraction, think about composition, always, I do. It's more than OK to experiment with abstract composition in macro work, just try different things. To me, I love getting in really close on flowers to where you

can't even tell what they are because that's different and new and surprising. I do that all the time. I try to anyway. I am constantly looking for what I can do to make the world look very, very interesting right in my own backyard, all the time.

So what are the most common mistakes in macro photography? Well, they are not lighting it, and not getting enough depth of field, and not getting low enough to really be where the action is. Remember, I want to get there eye to eye with the turtle, or the gecko, or the grasshopper, whatever it is. I want to be eye to eye with these things, right on top of them, always. Even a fly, if I can do it, even a fly, eye to eye. Now, for a lot of things that are moving, an off-camera flash, along with a softbox, combined with being nimble, really works wonders. It really does. It's just a matter of patience and really working and shooting a lot of pictures.

So, your assignment. I want you to shoot one great macro shot at home. It could be in your driveway or on your sidewalk. I just want you to make one really nice macro shot right where you live. This is an easy one. For extra credit, shoot it both with supplemental light and without. Shoot it with reflector, flash, flashlight, whatever. You decide. I just want you to shoot it with straight ambient and adding light.

You know, it could be anything. It could be your dog sleeping, a tight shot of his nose. I don't care. Just do something that's out of the ordinary for you. Push yourself. Do something that is really remarkably seen of a common everyday thing, right in your own yard. It's a lot of fun.

Our next lecture covers something that used to be the bane of my photographic existence, low light. However, with modern technology, it's become one of my favorite situations to shoot in. So, make sure you join me, low light, it's excellent. I'll see you then.

Advanced Topics—Low Light
Lecture 20

Many photographers think of low light as the bane of their existence, but as we've seen throughout these lectures, it's often the best light in which to shoot. These days, photographers can shoot at 4000, 5000, or even 6400 ISO—gaining more than 10 times the sensitivity to light over the old 100 or 400 ISO film. That means that you can shoot in just about any light; if you can see it, you can photograph it. In this lecture, we'll learn about the technical aspects of shooting in low light and take another look at using the histogram to get proper exposures in low-light conditions.

Photo Analysis: Low-Light Conditions

- Firelight would have been almost impossible to shoot in the days of film, but here, with an ISO setting of about 2000, the people around a campfire are still and sharp.

- The aerial photos of bison were actually shot in very weak sunlight, with a wide-open aperture and a fast shutter speed.

- The photo of sandhill cranes was taken when it was nearly dark outside, and the exposure took several minutes. In the old days of 50 ISO film, none of the birds would have been sharp, and the photo would have been worthless.

- High ISOs have opened up a whole new world for photographers, enabling you to get great shots in low, lyrical light.

Technical Considerations and Equipment

- In low light, the dynamic range between the darkest and lightest items in the frame is evened out; the contrast has dropped so much that the camera can expose the whole scene properly. The camera sees things closer to the way your eyes do, allowing you to capture details even in shadows.

- Generally, your camera will warn you if you've got low light levels in your viewfinder, but you should learn how to disable any automatic flash that pops up and use only the light that's available to you.

- To shoot in low light, you need a lens that opens up wide, f/2.8 or even a smaller, f/2 or f/1.4. Prime lenses that have apertures that open up wider than f/2.8 are great. When you use that type of lens, you want the camera set on 5000 or 6400 ISO. If you know you're going to be shooting in low-light conditions, you may also want to bring a flash.

- During most of the day, the sun will overpower whatever manmade light source you happen to find in a scene. However, there is a small window of time at the beginning and end of each day when the ambient light from the rising or setting sun balances with subtle manmade light sources, such as table lamps, firelight, or light from the windows of buildings and houses.
 o Photos taken around a campfire illustrate this point. Here, the light in the sky and the manmade light of the fire balance out.

 o These shots were taken looking toward the east first, where the light would play out earlier. Then, the shoot was extended by turning around and looking toward the west.

 o In the small window of time available to you, think about the direction from which the light looks best and how long the light will last.

- In low light, remember that you're going to have a wide-open aperture and a very shallow depth of field if you want to keep that shutter speed high enough so that your subjects don't become blurry. If you have lots of depth, then you're going to need either a stock-still subject, such as a building, and a very long exposure, or you're going to need to introduce a bit of flash.

- On some cameras, the ISO will go all the way to 24,000, but the results are generally too "noisy," that is, grainy. However, camera technology is constantly improving, allowing for sharper images shot at high ISOs.

o When you dial up the ISO to 20,000+ on a high-end camera, you're telling your sensor to be very, very sensitive to the light that's reaching it, and that means it's going to be very, very sensitive to the electrical activity within the camera itself. That's what creates the background noise.

o Some post-processing programs can clean up this noise, but it's probably better to find the highest ISO you can work with that yields non-grainy results.

o Using a wide-open aperture, high ISO, and a good lens, you should be able to shoot without a tripod, even with hardly any light from the sky.

• What do you do if you're shooting in a low-light situation with a single bright spot? In some cases, the camera will read the entire field of view and average it out to give a correct light-meter reading, but in other cases, it may expose for the brightest part of the frame, no matter the overall light level. This can make the rest of the frame go dark.

o You may like the effect of a single bright spot in an otherwise dark frame. If you don't, put your camera on a manual setting and think about what you can do to craft the shot.

o You might shoot so that the bright spot isn't in the picture, or you might try for a tighter shot, where you have, for example, just the subject's face and some candles filling the frame. You might also try to block the bright spot with a person or an object.

o Experiment with the situation. Open the aperture and try different shutter speeds.

• Remember, when the light is low, the shutter speed is slow. Even the action of your finger pressing the shutter button can generate enough camera shake to blur an image. To solve this problem, use a tripod and a cable release, or increase the ISO to get a faster shutter speed. If your subject is slow enough, you may be able to set up your camera on

something stable and use the self-timer to get a shot. That way, you can get in the picture, too!

Using the Histogram

- If you're shooting digitally in low light, check the screen on the back of the camera to make sure the image is sharp.

Behind the Lens

Now, this [photo] actually ran in *National Geographic*…. Some branches—some treetops actually—are blocking [the sun] a bit, plus you can tell that my aperture is greatly restricted in the lens by the way the sun is throwing around this kind of star pattern, or these rays. That's an indication that a lens is stopped down fully, meaning the lens has the smallest aperture hole possible—tiny, tiny—resulting in this nice constricted spot of sun. I did shoot a lot of frames with the sun not in it because I found the hotspot to be distracting, [but] I realized that I could also use it as another compositional element. I left it in, and this is the one that ended up in the *Geographic*… but it was a matter of taming the sun there. It was a matter of really controlling it and getting the sun so it didn't overpower everything.

- If your camera is on an automatic setting and you don't have the exposure compensation dialed down enough, the camera will try to open up everything and make the scene look like broad daylight. The camera meter wants to make the picture super-bright and vibrant.

- To avoid this, switch the camera to manual and check the histogram to make sure some information remains on the left of the graph (the dark side).

- The histograms for a series of portrait shots taken in low light show how the screen looks for under-, over-, and properly exposed images.
 - With an underexposed image, the histogram is skewed to the left, and there are very few details to the right of the centerline.

 - With an overexposed image, the right side has no highlight detail—it's blown out.

 - With the properly exposed image, we see plenty of detail to the right of the centerline, but nothing touching the right. The graph touches the left side a little, but that's acceptable for this frame.

Painting with Light
- Nighttime shooting offers numerous opportunities to be creative. Use long exposures to paint with the light, or experiment with shorter shutters.

- Try different light sources, such as a flashlight or headlights from a car.

- Don't give up too early if you're shooting at night; great light happens well after sunset.

Assignment
- Go outside, face east, and shoot a picture so long after sunset that the light is almost completely gone.

- Feel free to add light sources to get different effects.

Suggested Reading

Cook and Jenshel, photographers, "New York's High Line."

Richardson, photographer, "Our Vanishing Night."

Homework

Go outside at sunset, point your camera anywhere but west, and shoot a picture so long after sunset that the light is almost completely gone. Feel free to add additional light sources—firelight, taillights, spotlights, and so on.

Advanced Topics—Low Light
Lecture 20—Transcript

So welcome on into the low light lecture everybody. Low light, what does that mean? Well, I know it used to be the bane of my existence. Can you believe it? Now it's all I want to shoot in. Let's look at a few pictures shot in low light.

You know, for many years working for the *Geographic* here, at home, elsewhere, I didn't have the option to shoot real high ISOs, I just didn't. They weren't available. We were using color slide film then. We had 50 and 100 ISO film. In black and white, we could go to about 400, and that was it. Now I am routinely shooting more than that. I'm shooting 4000 ISO on my camera or 5000, or 6400, ten times more sensitivity to light than the most extreme films we had back then. That's amazing. That means I can shoot in just about any light. If I can see it, I can get it. That is so nice. I can't begin to describe it to you, but in this lecture I'll try.

You know, I want to show you a few pictures that would not have been possible in the film days, just absolutely impossible, mainly, firelight. Firelight was very tough to get anybody still and sharp. Some people sitting around a campfire after the sunset, nice and sharp. About 2000 ISO here, 2000 ISO. Wow, you can really make it work, absolutely. No matter what, if I can see it, I can get it. You know what, it may not even look like low light, but it certainly is. It absolutely is. The camera can capture things that are just absolutely amazing.

You know, it tells you when the sun is up, you can get it, even if the sun's set you can get it. Bison pictures out over South Dakota, you know, these may not look like it to you, but they're actually low-light photos because the sun's very weak here, and we need a fast shutter speed in order to not have the world blurry when flying fast in a fixed-wing aircraft. Your aperture might be fairly wide open, but you still need a lot of shutter speed so the whole world doesn't blur by.

Or here, this was so dark that I could barely see anything. In fact, I don't think I could really see a thing, I just guessed at where the focus should be,

sandhill cranes on the Platte River. That exposure took several minutes. The camera, though, it opens it right up doesn't it. It sees things that we can't. Look at the water flowing past all their legs, kind of blurry, again this whip cream look. You can tell it's a really long exposure because some of the birds are moving, right? It's so long that some of the birds are blurry, some of them are staying still. In the old days, this would be at 50 ISO, shot at night, it would've taken many, many minutes. None of the birds would've been sharp because they're all moving a bit. It would've been worthless. Today, we can get pictures like this, and that's remarkable.

Same thing with this. This is well after the sun has set, out fishing. Yet we've got amazing detail and color. Everything is sharp. It's excellent. Nothing wrong with it at all. This is a very exciting time to get into photography. It's actually the best time to get into photography, because we're able to shoot so late in the day, it's really wonderful. You know, high ISOs have opened up a whole new world for pictures, haven't they? We go from having to shoot in bright sunlight like this to low light, and it's lyrical and very nice. Again, bright sunlight, you've seen these pictures before, but low light, family portraits in low light well after the sun has set. It's a whole new world for pictures and very, very exciting.

Technically, in low light the dynamic range between the darkest and lightest items in the frame is evened out, if you get that. The camera can finally expose the whole scene properly because the contrast has dropped so much. In soft light, we don't have that raging contrast between the brights and the shadows, so we can see things just as your eyes and brain interpret it once the light has quieted down and the sun has set. There are really no exposure problems when you have low light, really, with these new cameras.

Let's revisit this again. This time the same demolition derby pictures so you can see these in harsh versus sharp light, soft light, excuse me. Harsh light here, very harsh. Wow, that's rough. Hot light, middle of the day, people are banging away. Now look at this. Same scene, back a little bit, reframed. What a difference, what a difference. It's the same event, old cars banging into each other, but you look at the colors now because the lights are so subdued. Nice and even, no vast contrast, it's just rich, and clean and nice. I get relaxed just looking at this thing, right, even though it's cars running into

each other. That's so critical, shooting after the sun has set, when the light evens out, oh it's relaxing just thinking about it.

In low light. then, we get shadow detail. We get details in the dark stuff, even. It is perfect as far as shooting goes, just perfect. I also think that various types of low light have a lot to offer, like a flickering fireplace or birthday candles. Let's take a look at a few of these, just things that you could never dream of getting in film. We think of candle light, firelight, and even some electric lighting that are so warm, they seem very romantic. Everything is bathed in this warm, golden light. People look great, buildings look great. I love firelight as a light source. I shoot in it all the time, every summer when I go up to Minnesota, constantly. Look at that. It looks like a painting, and it's just the warm light of a fire kicked up into their faces. It's absolutely lovely, cannot go wrong.

Buildings look fabulous, too. I try to shoot when there's a little ambient light left in sky, a little blue there to kind of balance out. There's time at the beginning and end of each day to do this type of picture, very nice. Again, after the sunset, beautiful time to work, absolutely. The later it is, the better for me. Now, not many people work in this kind of light do they, and if they do, they turn the flash on in their camera, or the flash automatically pops up and they blast away. The camera will warn you that you've got low light levels in your viewfinder and insist that you use flash sometimes on lower end cameras. I'm telling you learn how to disable that and use the great light that's in front of you and all around you every day. Crank that ISO up if your camera can handle it. Open that hole up in the lens and get that aperture as wide open as you can get, 2.8 or bigger, if you can. Go shoot in that low light, and it will be lovely, trust me. You do not need to blast everything away with flash. In fact, flash ruins more pictures than it yields. It ruins pictures. Use lovely, low light, please.

Low light, to me, is freeing. It actually is. It means virtually everywhere I look, I'm safe to shoot knowing that the photos will not be ruined by harsh light. No matter which direction I turn, I'm going to make a great frame. Look, another low-light picture, and it's delightful, just Ellen looking at fireflies. It would be better if one of them was glowing, but you know what

this light is, that's just a streetlight. That's just a streetlight edging her face, 5000 ISO, 4000, a picture that would have been impossible not too long ago.

However, you will need the right techniques and the right gear in order to be in good shape for low-light shooting. So what is the right gear? A lens that opens up, wide-open, f/2.8 or even a smaller aperture f/2, f/1.4. Prime lenses that have apertures that open up wider than f/2.8 are great. They can get a little expensive, though. And, when you use that type of lens, you want the camera on a high ISO too, if you're shooting in that kind of low light, maybe it goes to 5000 or 6400 ISO, technology improves. It gets better every year, and then you can shoot in low light, really, but you'll need to get maybe $1/30^{th}$ of a second for a birthday cake, or even $1/60^{th}$ of a second because people are moving around, but with the right gear, you can handle it. It's no problem.

You know, during most of the day, the sun will just overpower whatever man-made light source you happen to find in a scene, won't it? However, there is this little ten-minute window that's kind of magic, beginning and end of each day it occurs, and during this window the ambient light from the rising or setting sun can balance with the subtle man-made light sources that we see all the time, like table lamps or the light of a fire, or the light that comes up on a building or house. If you're paying attention and waiting for that little window, it's your chance to get some really good professional looking pictures.

Let's look at a couple. Every year at Leech Lake, where my family and I vacation, almost every night, they have a campfire. There is this little, small window of time where people are standing around, sitting around, everything balances out, light-wise—the light in the sky and the man-made light around the fire balance out. So, I'm always looking towards the east at first, that's the place where the light's going to play out first. Then, once that plays out totally, I'll turn around and I'll look towards the west. Now I've extended my shooting process, haven't I? When I have people by the fire and I turn west, look at this, it balances out with the sky, and I've extended my shoot just by turning around 180°, different compass directions.

As the light gets lower and lower outside during sunset, as the light diminishes, look at this, we can do longer shutter speeds. We can back up. I'll often close my eyes and kind of squint to figure out the intensity of light, how it compares to the background or the foreground, I'll squint to see how silhouetted people are against the sky. Is the sky blowing out super brightly? I don't know. After a while, you won't be able to shoot hardly at all because there won't be any ambient light anymore, and it will just go black. That's all you're going to have.

Then, if you include the fire, you know, it'll be blowing out. So, you really get this little window. You have to really think about it. And just think which way does the light look best? And for how long? Once the ambient light's out of the sky, you know what, my day is done. By the way, in low light, remember that you're going to have a wide open aperture and a very shallow depth of field if you want to keep that shutter speed high enough so that your living, breathing subjects don't become a blurry mess, OK? If you have lots of depth, you're going to need either a stock-still subject, like a building, for a very long exposure, or you're going to need to introduce a bit of flash.

Oftentimes in very low light, buildings are perfect, or trees or whatever. So if you know you're going to be working in low light, pack fast lenses and pack a flash. Crank up that ISO and take on the darkness. This is really low light in a cloud forest of Ecuador. That is a giant earthworm, can you believe it? They are about six-feet long when they stretch out. Holy cow, that's amazing, isn't it.? Even here on this, this is really late in the day, I'm shooting with as much ambient light as I can, it's probably dragging the shutter down 1/15th or a 1/20th of a second, I throw in a little flash, just to light up that tree trunk and get some color.

Now, when I'm not using flash, I'll routinely crank my ISO all the way up to 4000, if I need it. My camera will go all the way to 24,000, by the way, but that's really too noisy for my taste. What does noisy mean? It means it's too grainy, as in there're little dots everywhere. It doesn't look good, like grainy film in the old days. Here are couple just to illustrate to you. This is a very grainy picture of my little dog Baxter shot with a super high ISO— 24,000. You can really see the noise and the grain here, can't you?

And now, this one is shot at a normal ISO. Let's say at about 1000 or so. You can really tell the difference. Camera technology is constantly improving, and images are looking better and better at high ISOs, which is great. For the foreseeable future, though, there will always be a point at which your ISO is too noisy. That's just how it is. Know the limitations of your gear. If it's something extraordinary and you have to have that kind of ISO, that real high stuff, to get the graven image, maybe I'd say yes. If it's a picture of Big Foot walking through the forest, OK, fine. Crank it up to 24,000 ISO, crank up the grain, but otherwise don't push it that far. Why do that? Usually you have choices here.

When you crank up your ISO to 20,000+ on a high end camera, that's the only time you're going to get that high, you really know you're telling your sensor to be very, very sensitive to the light that's reaching it, and that means it's going to be very, very sensitive to the electrical activity within the camera itself, and that creates a background noise. That's why we get this. You know, we could run these pictures through post-processing programs, and maybe make them work, but why not shoot it right in the first place? Find the highest ISO you can work in that really yields a non-grainy result, and use that. You've heard me say this before. The fun part is shooting photos, not working them. I like my pictures to be shot right in the first place so I don't have to spend any more time in front of my computer than I already do.

The take away from all of this is high ISOs have their uses, but you should try to always shoot the lowest ISO you can in order to avoid noise, unnecessary noise. When using a wide-open aperture, high ISO and a good lens, I'm able to shoot handheld now, without a tripod, with barely any light from the sky. This includes aerials, sometimes, but again I'm really watching that ISO. I don't want it to be grainy. Now what's amazing, I can now shoot ISOs around sunset, before and after the sun's gone down, and that's remarkable. That didn't used to happen. That's a wonderful benefit to being able to shoot super-fast ISOs, wide open apertures.

You know, sometimes you're going to have a situation where the light is generally low, but there's a single, bright spot. Have you ever had that happen where there's something very bright in the photo and it kind of messes up your meter? Many times the in-camera light meters are getting

more and more sophisticated than the old hand held versions, and your camera is actually a computer that can read the entire field of view, and it averages out what it sees to give you a correct meter reading. Sometimes this works perfect, sometimes not so perfect. It's less of an issue than it used to be, but you still need to be aware of this, that a bright spot in the picture can mess up the meter.

Let's look at a picture here. Your camera meter will often expose for the brightest part in the frame, no matter what time of day or the light level. This can make the rest of the frame go dark. In this case I like the effect, I do. I kind of like how that looks. If you're using the camera's automatic-exposure feature, and it's a high end camera, you should be fine, as I was in the case here, right? If it's a lower end camera, it's going to want to expose for just the highlights, and that's going to darken down everything else, so you need to be thinking about how to overcome that. Maybe you put your camera on a manual setting and you look at the back and you really craft it. This can be a nice effect, but you really need to think about it, you really do.

So, either shoot so that you don't have the light source in the picture, or so the camera exposes the rest of the scene well. Or just work it as a tighter shot, where you have the subject's face and, let's say, candles filling the frame. What I would do is experiment. I would try different shutter speeds. Put that exposure, dare I say, on manual, and you control the shutter. Have the aperture as wide open as you can get to soak up that light, shoot in manual, and see which pictures look best. Just kind of experiment. I do that all the time, every birthday party it seems I'm experimenting.

For example, I don't want this scene of Ellen blowing out the candles to look like broad daylight, right? That wouldn't be right. Just nice to open it up just a little bit. This shot of my dad has more of a cave effect, he has a lot more candles on his cake, he's a lot older. This is shot at 3200 , so what do I do. I'm exposing, basically, for the candles here. I don't want them all blowing out, meaning no data processed by the camera. It's too, too bright. So in this case, you know, as much as I warn against staying away from post-digital processing, I actually opened it up a little bit and made it a little brighter after the fact using Photoshop. You know, I could've shot it with a higher

ISO in the first place, but I chose to just do it afterwards so I wouldn't get any more noise and grain than I had to.

Alternately, you can block a bright spot often in a picture with a person or an object. You can get the glow without the burning pinpoint of light in there if you have somebody's head or a hand in the way. You could do just the glow of the candles, or just the glow of the sky, by blocking the brightest part of the frame, that's the flame on top of the candles. You can do that and just get the glow, and I do that all the time. It's a very nice effect. Again it's all about experimentation and seeing what looks best to you.

Here's another good example, let's look at this. Talking about a bright part of the frame, this is with monarch butterflies, super bright, looking directly into the sun here. You see it blasting in the corner. I experimented with these monarchs a little bit. They weren't going anywhere, and at times, I moved to the side to block the sun. I used the lens to block the sun, so I didn't have that bright sparkle of sun blasting away. And, at other times, I tried different things. I'd actually move to get the sun out.

Now this one that actually ran in *National Geographic*, which I showed you before, has the same beam of sunlight, just a couple of minutes later, but it's much more refined. Some branches, some treetops, actually, are blocking it a bit, plus you can tell that my aperture is greatly restricted in the lens by the way the sun is throwing around this kind of star pattern, or these rays. That's an indication that a lens is stopped down fully, meaning the lens has the smallest aperture hole possible, tiny, tiny, resulting in this nice, constricted spot of sun. I did shoot a lot of frames with the sun not in it because I found the hotspot to be distracting, and I realized that I could also use it as another compositional element, so, I left it in. And this is the one that ended up in the *Geographic*, so they liked it too. But it was a matter of taming the sun there. It was a matter of really controlling it and getting the sun so it didn't overpower everything. That was very important.

You know, I experiment all the time, in case you couldn't guess. I'm not always sure about what I'm doing, even. Every situation I get to is new, and I just do the best I can. It keeps things from becoming too pedestrian, anyway. I don't want to get into some routine, but I'm not too hard on myself either,

by the way. It's all kind of a grand experiment, every day and in every way. That's why I like this. That's why I like it so much.

Remember this, when the light is low, the shutter speed is slow. That's a pretty good rhyme and a pretty good rule of thumb. When the light is low the shutter speed is slow. Even the action of your finger pressing the shutter button can generate enough camera shake to blur an image. Let's look at a couple of pictures where this has happened. Of course, I did this intentionally just to show you.

This is a camera with a little shake. We call this camera shake, a picture of my daughter's cockatiel. I'm shooting a slow enough shutter, and I move the camera a little bit. The cockatiel's name is Jimy, for some reason, with one m. I'll never understand. Now look at this. A little tighter, look at this, still shaky. Now, we're going to use a tripod. We'll try to make it a little sharper, there we go. It's a little bit better. You can really see that sharpness increase. I fixed this camera-shake problem simply. The shutter speed was too slow for me to hand hold. It looks bright, but it's actually a fairly dark room, well after the sunset, and I fixed it just with the tripod and a cable release.

You can fix your pictures the same way. No problem. You can increase your ISO, also, to get a faster shutter speed. You can use a tripod, make the hole in your lens bigger, right? There are lots of ways to reduce your chances of getting camera shake and blurriness. Lots of tools in your toolbox here, which is excellent.

You know, if you're caught without a cable release and your subject is still enough, you can trigger your camera's self-timer so that you don't have to touch the camera. You literally can put your camera on a wadded-up coat, or on a car hood, or wherever. I often shoot this way if I'm stuck without a tripod. I just put my camera on the ground or on a rock or on the roof of a truck and I set my self-timer, and I run around and get in the picture. I do this all the time, and it works great for very low-light situations. This is very low light, there's nobody around to help my dad, my son, and I out fishing. Roll up a shirt or a jacket, anything, set the camera there on the hood of the car, and run around and stand with my family members. We're standing on the bank of a favorite fishing pond here.

Same here, it's just little Spencer and I out fishing at a pond. We wanted to show off where we were. That's how I do it. There's nobody around to help; it's just me. So, and you know what? I treasure this picture out of all of them. Remember if there was somebody there, if they touch the camera it vibrated, so that's no good. There's a very slow shutter speed, probably a $1/15^{th}$ or a $1/10^{th}$ of a second or so, there would be a lot of camera movement in there, so a little self-timer trick on the hood of a truck works as good as a tripod, better than if somebody was there because the light was so low, works great.

If you're shooting digitally, then, check the screen on the back of your camera when you're working in low light, and chimp it to make sure you're getting a graven image—a picture of record that's at least sharp—and that it's good. This is critical. Do you know how convenient this is? You can just look at the back of a camera and see if you're doing it right. Holy cow, I wish I had this 20, 30 years ago.

Be aware that a lot of times, if you have a camera on an automatic setting, and you don't have your exposure-compensation dial dialed down enough, the camera will want to open up everything and make it look like broad daylight. It doesn't matter what time of the day it is, that camera meter is going to want to make that picture super bright and vibrant. You don't want that if you're shooting dark and you want the picture to look like it's the appropriate time of day. To avoid that, and to avoid super long shutter speeds, I will often switch to manual. I'll manually expose when I'm working in a dark place. And to make that work, I just look at the back of the camera, I check the histogram to make sure some information remains on the left of the graph, that's the dark side, and then I'll start working.

I look all the time at what the exposure is going to be, what it looks like if I underexpose it, overexpose it, and properly expose it. I do that all the time. If I have time in a situation, that is, if I have time, I'll play around with that until I think it looks good. I certainly don't want to blow out the highlights. That's my biggest concern. I also want things sharp, of course. The histogram on your camera makes this a lot easier. It's very easy to do this. To see how your histogram will look in under, over, and on properly exposed images, we've taken this portrait shot in low light.

There we go. This is actually fairly low light. So we've underexposed this one by a stop and a half. Look at how the histogram is really skewed to the left. That's the dark side, and it means we have a lot of dark pixels in the frame. There are very few details to the right of the centerline are there. All on the left, the dark side. Now look at this one. Wow, very overexposed. The right side actually has no highlight detail. It's blown out. Look at this. All the details on the right are clipped. The histogram tells us that. We've totally clipped the right side, and that means we've blown out the highlights.

Now let's look at this frame, which is properly exposed. Plenty of detail if we look at the histogram to the right of the centerline. But, it's not clipped, it's not touching the right. That means it's not blown out on the right side. It clips a little or touches the left, the dark side, but that's OK because that's how it looks. There were true blacks in the shadows, so this is a properly exposed frame. Your histogram is going to look different on every picture, by the way. These are general rules of thumb, remember that.

Shorter shutters can play a role in low light too, of course. You want shorter shutters sometimes. You have to have them. This picture, for example, was taken in the Sunken Gardens of Lincoln a few years ago. It's with a shorter exposure, not a super long one like you often see in fireworks .It got the fireworks just like I wanted it. I didn't want them to look any streakier or long than they already were. I didn't want to slow the shutter down too much. I just wanted it to be a nice burst of a frame, maybe a $1/60^{th}$ of a second or $1/30^{th}$ here. No problem.

You know, nighttime shooting offers a lot of opportunities to be creative. I use really long exposures sometimes to actually paint with light. Have you ever heard about this, painting with light? Flash can work well with this, so you should experiment. I do this all the time. I paint with light constantly. It's a lot of fun, especially at twilight, of course, when there's still some glow in the sky. In this case I'm using my camera on a tripod, and I'm using a man-made light source to light up what I want. Case in point, this old barn I just hit it with a flashlight. That's probably a one minute exposure or so, just painted it with light. That's all there was to it.

So it is in the Everglades, as well. Look at this, just car headlights that's all. Just enough light in there to spice up the bottom half of the frame, and then we have the clouds above. That's a really handy technique. You can paint with any number of light sources. The sky's the limit, just use your imagination. You don't have to paint with light just a flashlight, it could be car taillights, headlights, anything you can think of, anything, all sorts of different things. I'd encourage you to experiment.

So common mistakes and solutions to them. Giving up too early to get the great light that happens well after sunset; that's the number one common mistake. People get hungry for dinner and they quit, not if you're a good photographer you don't, you stick with it. That's the sweet stuff. You don't want to miss that. Same story before sunrise, though that's a little early. Shoot until the light is completely gone in the sky late in the day, by the way. It will make your pictures great. I'm telling you.

Now for your assignment, I want you to go outside, and looking away from the west, shoot a picture so long after sunset, so late, that the light is almost completely gone. That means face east. Face east at sunset and shoot until the light is almost completely gone. You'll be amazed at the colors you get. Feel free to add any light sources, such as firelight, if you want. For example, I shot my friend Erik out in Wyoming years ago in a wilderness area. He has a little campfire going. The sun is down a long time, yet look at him, he stands out from the campfire. It's a lovely effect, something that you guys can do too, no problem.

These are all things that you should not be afraid to try. Don't look into the sun to get your sunset picture. Look the other way. That's when you start taking pictures, after the sun has set, after the world is all bathed in that pink glow. It's absolutely beautiful. So, in our next lecture, we're going to combine much of what we've learned in the last few lectures to discuss visual problem solving, one of the hardest things to do, but it is so satisfying when you nail it. So, come right back.

Advanced Topics—Problem Solving
Lecture 21

As photographers, our task is to go out into the real world and make order from chaos, shooting beautiful pictures in the process. This can seem like a difficult assignment at times, especially when you're forced to shoot in harsh light or against a cluttered background. But in fact, all the elements we've been discussing in these lectures—composition, light, and interesting subjects—are tools you can use to solve visual problems. In this lecture, we'll look at some typical problem situations and see how we can apply what we've learned to cleaning up these situations and getting great shots.

Case Studies: Harsh Midday Light
- The goal of a series of photographs taken in Mozambique was to highlight the dignity of the local people and show the mountains where they live. The shoot took place at midday, when the light was harsh.
 - The first step in getting a good shot was to move the group of people into the trees. Then, a softbox and flash were used, and the background was purposely underexposed.

 - Underexposing the shots made the light more subtle and brought out the colors in the scene.

- On another shoot, this one of a "bio-blitz" (a rapid assessment of an area's plant and animal species), the sun was again shining brightly. To compensate, one photo was shot through a plastic bag and underexposed dramatically. Another was shot with the subjects in deep shade.

- The problem of midday light in a shot of a black-headed oriole was solved by using a 70mm lens very close and an aperture setting of 2.8. In this situation, you might also use a macro lens to get the same blurring effect behind the bird.

- As we've said, it's also possible to put the subject in shade and use your flash. This approach gives you a wide depth of field.

- Remember, a great picture needs three things: good light, good composition, and an interesting subject. Sometimes, just one or two of the three are present, and your job is to figure out how you can get the missing elements.

Easy to Complex Situations

- Antarctica might be one of the easiest places on earth to make good pictures; it offers clean backgrounds (no telephone poles or vans driving by); soft, overcast light; and gregarious animal subjects. You can point your camera in almost any direction in such a location and get a good shot.

© Joel Sartore/National Geographic Stock.

Urban environments represent the most difficult task in problem solving; look for interesting subjects and think about how you can clean up the background.

 - Even in a dream location like Antarctica, however, you need to think about horizon lines and framing.

 - You also want to go beyond the obvious and show big, deep scenes, with plenty of depth of field.

 - If you find yourself in Antarctica or a similar environment, look for layering opportunities, as well—interesting animals in the foreground and middle ground and beautiful scenery in the background.

- Rural America represents the next level of complexity in problem solving. There aren't too many distractions, but you start to see elements that can muddle your images, such as roads, fences, train tracks, or buildings.

Behind the Lens

This snowy road is in Yellowstone National Park.... I was out there looking for gray wolves, only there were no wolves to be found that morning—or any other—[during] my first two or three weeks out there. Talk about nerve-wracking! I was actually on assignment, [and] I couldn't find wolves. I'm doing a story on gray wolves, [so] that's a problem. I took pictures of whatever else I could find, out of nervousness, I guess, in this case, bison.

I really like the way the road takes you to him, literally leading, and the fact that the bison fits perfectly right there on the road, his horn fits in there. I like the way the road frames him a bit. I like that this is a nice stage with one player on it—a player has appeared and the road takes you to it. The bison is a little bit of a payoff, visually.

I remember it was 30° below zero that morning, and my assistant, Nathan Varley, had made excellent sandwiches that day, and that was the high point. We did get our wolves, but it was three weeks of waiting it out. We did eventually get the wolves, and that was lovely. Out of eight weeks of being in the park, by the way, we got about 20 minutes of being with wild wolves, but it was enough to do the story. I guess that's one of the reasons I love still photography so much. A

picture, like a good song, can immediately take you back to a time and place when something excellent or exciting was going on, maybe just the bone-chilling cold. It got to 49° degrees below zero one time out there, and I had to go to the bathroom. That was really bad. But these pictures remind me of a place and a time when I was very happy and much younger, so that's all right. Pictures do that for us.

- The primary problem with most images is compositional, but in this course, we've learned how to look at water towers, phone lines, and the occasional pickup truck as potential compositional elements that can be used to our advantage.

- Instead of letting a fence ruin your picture, use it as a framing element. Or change the background by walking around your subject and shooting from different angles. You might even try using panned action to eliminate a cluttered background.

- Again, the beauty of a digital camera is that you can see immediately whether or not you're getting the effect you like. If not, keep experimenting.

- The ultimate task in problem solving—and one that many of us have to deal with—is producing great pictures in a city. In an urban environment, a photographer has to fight to find a clean window in which to shoot.
 - Think first about what you want to show. A street festival, for example, offers lots of possibilities for capturing light and color. In a city like New York, you might try shooting an urban icon, such as a taxi.

 - It's important to note that cities have tall buildings that shape the light and shadow at all times of the day. Skyscrapers can provide dramatic darkness and reflection in your images.

 - When you're shooting in a city, the number of choices you have can be overwhelming. It's important to be discerning and

selective in what you shoot. Try putting the city itself in the background of the scene, as in the shot of the cocktail party on the boat. But with a shot like this, choose the camera height carefully. You don't want a cluttered background interfering with the heads of your subjects in the foreground.

o Whenever you pick up a camera, for any reason, think about composition, background, the placement of the horizon line, the shadows and highlights, and so on. Even in a city and even with all those elements in place, you still have to come up with an interesting subject. Here, for example, we see a woman wearing an imitation Dalmatian-fur coat and walking a Dalmatian, a street prayer meeting, and a view from the stands at a baseball game.

o Think about what people do for fun in your city or something your city is known for; then go to that location and try to capture the energy. A basic truth in photography is that if you want your pictures to be more interesting, you have to stand in front of interesting stuff.

o A city often seems like an electrified beehive. An aerial shot showing the Customs House in Boston tries to capture that feeling. The exposure here was perhaps 10 seconds or so, resulting in an image in which the lights from cars seem to flow like a river through the city.

Assignment
- Look back over some of the first pictures you took during this course and try to identify some visual problems you encountered.

- Now, return to one of the locations, rethink the situation, and shoot some more pictures. Work out the visual problems until you're satisfied with the picture.

Suggested Reading

Communication Arts magazine.

Vesilind, *National Geographic: On Assignment USA*.

Homework

Look back over some of the first pictures you took during this course. Chances are, you'll notice visual problems you were not able to overcome. Go back, rethink, and reshoot one of those situations until you are satisfied with the picture.

Advanced Topics—Problem Solving
Lecture 21—Transcript

Hi again everybody. We've had plenty of lectures under our belts now. Now it's time for visual problem solving. Your task is to go into the real world now and make, not only, order from chaos, but beautiful pictures. This is tough, but we're going to figure some things out in this lecture. Let's take a typical thing for me, a typical problem.

I'm in Mozambique, in Africa, for *National Geographic*. We have a mountain range, shown in the background here. I'm trying to photograph the local people that live in those mountains in such a way that it gives them dignity, and yet, the ambient light is rough. This is a midday gathering, and the only time I'm going to be able to photograph many of these folks in their best clothing. I must show the mountains in the background because that's where they live. I have to light it all beautifully, if I can. And all I have is the gear on my back. The event is going to be over before the light gets good again, so what do I do? This is tough. The light's harsh.

We move over into the trees, that's the first step, to shade things a little bit. So, here we go. In this little portrait, we have a group of women here and their kids, and I used my little softbox, and I underexposed the background, purposely. It's the middle of the day. I have to turn down the houselights somehow. That's how I handled this, underexposing the background. That solved the problem in that we're not overpowered by the light of the sun and we're able to light everybody's skin very subtly, with nice, soft light from a handheld softbox. Look at this nice sense of place here, a little bit more flash, now we have color. Everybody looks lovely. People away from the flash a little bit more darkly lit, but it works. It works out. It's a way of salvaging the situation in very tough light.

Another example, here's famed biologist E. O. Wilson with Greg Carr, both great guys, and they're looking through the plans of what they're going to do on a BioBlitz. Basically a BioBlitz is Dr. Wilson's rapid assessment of an area's plant and animal species, usually with the help of local folks to round things up. These guys are planning the next day's events. You can see

animals just walk right up to you to say hello. They have no fear of people. It is amazing.

In Antarctica, really, I think about the horizon a lot. There are different horizon lines in all these pictures, aren't there, constantly. I'm moving the horizon up and down, choosing where the horizon should go. I'm thinking high and low. What do I think about? I think about horizon lines as being one of the only problems to solve, even in Antarctica. I think about that, constantly.

I look at framing all the time, too. Ice drift, icebergs drifting by so slowly in the water, there is no excuse for not taking your time and really framing them properly. I use the rule of thirds a lot. Sometimes, I'll center an iceberg, but most of the time I put it off to one side or another, it just depends. I kind of let one side breathe if the iceberg is on the other side. I really let the viewer study the background. You can't go wrong. It's just abstract art all day long. It's really great.

So, of course, the star of the show down there, for me, are the penguins, and I'm always thinking about well, how do I really go beyond the obvious and find a very interesting thing like fish in a barrel with penguins, it is. But, I want a big, big, deep scene. I want to see a lot of where we are. I want to see deep blue icebergs carved into weird shapes by melting or erosion. I want to see penguins up close and these beautiful epic scenes, plenty of depth of field. If you can notice it, usually, you can get it. Of all the pictures I shot down there, by the way, this is probably my favorite.

In terms of layering, there's no better place to make a layered picture, in my opinion. You have interesting animals in the foreground, the rest of their groups in the middle ground, some of the most beautiful scenery on Earth in the background, and this all right at sunrise. I knew when I shot this, this is probably the best thing I was ever going to see in my entire life. And that's OK. I don't see how it could ever get any better than that, and it never has gotten any better, actually. It's a great place to go if you can. So, it's impossible to go wrong, unless you don't know how to expose things, if you go to Antarctica. That's a nice place. It's a nice place for problem solving. It's very easy there.

Advanced Topics—Problem Solving
Lecture 21—Transcript

Hi again everybody. We've had plenty of lectures under our belts now. Now it's time for visual problem solving. Your task is to go into the real world now and make, not only, order from chaos, but beautiful pictures. This is tough, but we're going to figure some things out in this lecture. Let's take a typical thing for me, a typical problem.

I'm in Mozambique, in Africa, for *National Geographic*. We have a mountain range, shown in the background here. I'm trying to photograph the local people that live in those mountains in such a way that it gives them dignity, and yet, the ambient light is rough. This is a midday gathering, and the only time I'm going to be able to photograph many of these folks in their best clothing. I must show the mountains in the background because that's where they live. I have to light it all beautifully, if I can. And all I have is the gear on my back. The event is going to be over before the light gets good again, so what do I do? This is tough. The light's harsh.

We move over into the trees, that's the first step, to shade things a little bit. So, here we go. In this little portrait, we have a group of women here and their kids, and I used my little softbox, and I underexposed the background, purposely. It's the middle of the day. I have to turn down the houselights somehow. That's how I handled this, underexposing the background. That solved the problem in that we're not overpowered by the light of the sun and we're able to light everybody's skin very subtly, with nice, soft light from a handheld softbox. Look at this nice sense of place here, a little bit more flash, now we have color. Everybody looks lovely. People away from the flash a little bit more darkly lit, but it works. It works out. It's a way of salvaging the situation in very tough light.

Another example, here's famed biologist E. O. Wilson with Greg Carr, both great guys, and they're looking through the plans of what they're going to do on a BioBlitz. Basically a BioBlitz is Dr. Wilson's rapid assessment of an area's plant and animal species, usually with the help of local folks to round things up. These guys are planning the next day's events. You can see

a little twilight in the sky. And it looks like we're at a lodge, out in the bush, and we are.

So, on the day of the Blitz, the sun is shining very brightly, and the local kids are scrambling, but the light is harsh again. So what to do? I capture what I can by shooting through a bag of the insects they've collected, and I underexpose the scene, drastically. That's one thing I do, or, I shoot the kids in the deep shade of a waterfall where the waterfall and the trees block the sun. Nice shade, middle of a sunny day, but you know what, anything to stay out of that harsh light like this, anything I can do to stay out of the harsh light.

What else? Let's take a look at another situation. Look at the color palette in this, very lovely. This is a black-headed oriole getting removed from a mist net that a biologist had set up to do leg banding of birds. Look at the color. Now how do we show this bird? How do we get that sort of an intimate shot? Again, middle of the day, harsh light. I'm using a 70-mm lens, but I'm very close and I'm at 2.8, to solve the problem, wide open aperture. You could also use a macro lens on this to get the same blurring effect behind the bird. I love the fact, by the way, that we've got this soft, green-fleece jacket in the background. The black and the yellow of this bird just pop right out against it. It's very nice and subtle. It's a good way of handling something. Again, very cluttered, and in the middle of the day, we're in open shade. That's really a nice way to do it.

Another few portraits here using my flash equipment, as we've discussed before. Biologists at the park are capturing the animals, pretty much around the clock, whenever there's some sun, and even at night when there are bats to be caught. We're able to do close-up pictures of all these different critters, no matter what the light is outside. I'm controlling the light, see? There're no clouds in the sky at that time of the year, so the light's pretty harsh in the middle of the day, always, really. We have to figure out a good way of making great pictures of little bitty critters in harsh light.

So, first, we just shoot in soft light, and then we create our own with flashes. We shade the subject, and we throw our own flash in to really up the ambient light level combining with flash. Get lots of depth of field that way. It looks

subtle, but it's actually lit with flash and a combination of ambient light, so they're working together, lots of depth of field.

Remember a great picture needs three things: good light, good composition, and something interesting. Always, I think about that. And sometimes two out of the three are there, and sometimes just one, maybe. But, that's when you need to work on these other two. Fix them if you can. That's the goal. You don't always get there, but if you're a real visual problem solver you're working towards this. You're always thinking about, can I get the three elements? Can I get two, maybe just one, but at least you're thinking about it.

So let's put this into practice by starting in a really easy place to make pictures and talking about why they're easy, and then moving into something more complex. So I thought, what's the simplest place that you can go to make good pictures? Antarctica. OK. We talked about Antarctica a little bit before. It's a long way away, but you know what? In our lecture on backgrounds we weren't thinking about visual problem solving as much. We were talking about clean backgrounds, mainly, and it is true, lots of clean backgrounds, beautiful soft light, a kind of an overcast light usually graces everything, and gregarious animals that are all around you come right up to you, in fact, like penguins and seals. There are seals laying on the ice. There are seals laying up close. There are no telephone poles. There are no billboards, no fence lines, no power lines, no white moving vans in the background; just ice and snow, and it's all in epic proportions. It's a fabulous place to do simple, clean, and dramatic landscapes. But you want to know the biggest problem there? There is a big problem. When do you want to break away to eat? It's hard to leave when you see such good pictures everywhere and the light's good every direction you look. If you can't make a good picture in Antarctica, really, it's because you're not trying. You can point your camera in almost direction, and the animals are literally lying around in front of you. They have no fear of you, quite remarkable.

If you ever get a chance to go to Antarctica, boy, would I suggest it. It is epic. Visit South Georgia Island, too, while you're there. I mean you're down there anyway. That's where a lot of these pictures were taken, either on the Antarctica thumb, or on South Georgia Island, quite amazing. The

animals just walk right up to you to say hello. They have no fear of people. It is amazing.

In Antarctica, really, I think about the horizon a lot. There are different horizon lines in all these pictures, aren't there, constantly. I'm moving the horizon up and down, choosing where the horizon should go. I'm thinking high and low. What do I think about? I think about horizon lines as being one of the only problems to solve, even in Antarctica. I think about that, constantly.

I look at framing all the time, too. Ice drift, icebergs drifting by so slowly in the water, there is no excuse for not taking your time and really framing them properly. I use the rule of thirds a lot. Sometimes, I'll center an iceberg, but most of the time I put it off to one side or another, it just depends. I kind of let one side breathe if the iceberg is on the other side. I really let the viewer study the background. You can't go wrong. It's just abstract art all day long. It's really great.

So, of course, the star of the show down there, for me, are the penguins, and I'm always thinking about well, how do I really go beyond the obvious and find a very interesting thing like fish in a barrel with penguins, it is. But, I want a big, big, deep scene. I want to see a lot of where we are. I want to see deep blue icebergs carved into weird shapes by melting or erosion. I want to see penguins up close and these beautiful epic scenes, plenty of depth of field. If you can notice it, usually, you can get it. Of all the pictures I shot down there, by the way, this is probably my favorite.

In terms of layering, there's no better place to make a layered picture, in my opinion. You have interesting animals in the foreground, the rest of their groups in the middle ground, some of the most beautiful scenery on Earth in the background, and this all right at sunrise. I knew when I shot this, this is probably the best thing I was ever going to see in my entire life. And that's OK. I don't see how it could ever get any better than that, and it never has gotten any better, actually. It's a great place to go if you can. So, it's impossible to go wrong, unless you don't know how to expose things, if you go to Antarctica. That's a nice place. It's a nice place for problem solving. It's very easy there.

Now let's talk about the next level of complexity in problem solving, what I call the minor leagues. Rural America, the countryside, not too many distractions there. It's a nice place, but in the countryside, we are starting to see elements that can junk up pictures if you let them. Things like roads, and fences, and railroad tracks, and buildings, and windmills, and trees. There aren't even any trees in Antarctica to get in your way. So in this case, rural America. You know how to handle these things now, though. You've had this course. You know how to look at water towers, and phone lines, and the occasional pickup truck as elements that can actually add to your image, right? There are important compositional elements here to be taken advantage of. So instead of letting this get in your way, make that fence rail a framing element. Instead of letting it ruin your pictures, you can enhance your pictures by showing viewers where you were when you pressed the shutter button, right?

In most everyday situations, the number one problem is compositional, and one you are already equipped to deal with because of this course, cluttered backgrounds. Change that perspective. Walk around your subject all 360°, high angle, low angle, bird's eye view, worm's eye view, all the things you know. Figure out which direction the light looks best. Try these different vantage points, get down low, don't be afraid to get your clothes dirty. It's fine, get down low, get up high, whatever it takes. That's what it takes.

Don't care for the background? You can use panned action as well. Did you know that? Of course you did. You've been listening, you've been paying attention. If you don't like, say, the background that a tiger has in an enclosure, fine. Use panned action. Clean the background up. Make it look lovely. All you see is the tiger now and a wash of green. Panned action is an excellent way of cleaning up a background, but you've got to practice to get good at it. You don't want it to be too slow. You don't want it to be too fast. You have to practice. Practice makes perfect.

You know what, the beauty of a digital camera is you can see immediately on the back, if you're getting the effect you like, so why not play around with it. Something as simple as, let's say, a snowy road can be worth a picture if you spend some time framing it well. This may not be a prize winner, but it definitely communicates the bone-chilling cold and stillness in the air when

this was taken. This picture could use one more element, by the way. I like the leading lines going into it, but boy, if it had a little figure out there, a deer, a person, a horse-drawn sleigh, anything, something very small in the background? Those tracks in the road would be leading right to it, and it would be really wonderful. It's kind of a nice scene, or stage, here, but we could have used a player to really take it up a level.

Maybe next time it snows hard, I'll get out there and do that. Oh wait, here's what I'm talking about, right here. I have done that. This snowy road is in Yellowstone National Park, leading lines going into it, and now we do have a player there, a bison. I was out there looking for gray wolves, only there were no wolves to be found that morning, or any other my first two or three weeks out there. Talk about nerve-wracking, I was actually on assignment. I couldn't find wolves. I'm doing a story on gray wolves, that's a problem. So I took pictures of whatever else I could find, out of nervousness I guess, in this case, bison.

I really like the way the road takes you to him, literally leading lines and the fact that the bison fits perfectly right there on the road, his horn fits in there. I like the way the road frames him a bit. And I like that this is a nice stage with one player on it. A player has appeared, and the road takes you to it. The bison is a little bit of a payoff, visually.

I remember it was 30 below zero that morning, and my assistant, Nathan Varley, had made excellent sandwiches that day, and that was the high point. We did get our wolves, but it was three weeks of waiting it out. We did eventually get wolves, and then, that was lovely. Out of eight weeks of being in the park, by the way, we got about 20 minutes of being with wild wolves, but it was enough to do the story. I guess that's one of the reasons I love still photography so much. You know, a picture, like a good song, can immediately take you back to a time and place when something excellent or exciting was going on, maybe just the bone-chilling cold. It got to 49 degrees below zero one time out there, and I had to go to the bathroom. That was really bad. But, these pictures remind me of a place and a time when I was very happy, and much younger, so that's alright. Pictures do that for us.

By looking around and simply thinking about how to compose pictures, working in good light, watching our backgrounds, shooting an interesting subject, we are, in fact, problem solving with every push of our shutter button. That's what we're doing.

Now let's talk about the ultimate task in problem solving, one that many of us have to deal with all the time, working in a city, producing great pictures in a city, very cluttered. We call this the big game, urban landscapes. How in the world do you work in a place like this? That's a tough one. The urban environment is complex, fast paced, chock full of distractions. I dare say it's more distracting than a casino when you first walk in. As a photographer, you're really going to have to fight to have a clean window to shoot in aren't you. You're going to have to concentrate. What is it that you want to show about this city? Point your camera, look, and think about it, really think. What do you want to show? There are all sorts of things to show.

For my money, an Italian festival is excellent. This is in Boston where they carry a seine around the streets. I enjoyed it. I'm Italian. The food was good, the people are happy, a lot of light and color, a lot of fun. So, that, for me, is something that says something about the city. I thought about it. I hung out. I wished there was some ambient light in the sky, but there's not, but I still enjoyed myself.

What else do you want to try to show? How about a signature thing from New York, something like taxis. How can you show those in a new and different way? Maybe it's like this, maybe it's out the window, maybe it's looking straight down. Not that this is a great shot, but at least the perspective is different.

Maybe once you get into a big city, you just want to just stay in your hotel room and mope because there are too many choices. I can hear you. I understand. I've shot quite a bit both in Boston and New York. Let's talk a little bit about how I handle a lot of the confusion, and a lot of noise, and the hassle of shooting in cities. Remember—light, composition, and something interesting—it all applies in big cities, too. So, the first thing I think of when I get into cities is they have big buildings that really shape the light and shadow at all times of the day, don't they? They truly do. Even in the middle

of the day in a big city you've got buildings throwing huge shadows across the streets. It doesn't matter what time of day it is, almost. It's not like you're out in the open, out in a pasture somewhere, where there's nothing to block the sun. So, you really need to think about light and time of day differently here. You have good light sources all day long in a city, but you have to look for them, don't you? You do have to look for them.

You have big skyscrapers throwing darkness and reflection. And people are walking between these giant, monster buildings. They're so small, comparatively. It's very dramatic and very powerful. There's a lot of visual potential here, but you really have to think about narrowing it down. There are too many choices. It is overwhelming, so many choices. You have to be strategic and surgical almost. You must be discerning and selective. That's really tough.

So, if I need to tell the story of a place, what do I want to say? Truly, we know the technical side of photography now, how do you want to say it? What do you want to say? Do I want to, say, get away from the downtown core and show the city in the background? How do you do that? Well, like here, at a cocktail party on a boat. That's one way. This is out in New York Harbor. You see the background is the city and the background is also water. And this is a nice, novel way of doing it, plus you have people having a good time on a boat. Look at this couple, They're obviously in love, or some such thing. And there are other couples in the background. You can see they're all talking, but they're smaller in the frame. Our main couple, right up close.

I just sit there and wait for the expression, wait for the moment, wait for them to forget I was there. A good 15 minutes of my time spent on this couple. I liked her shimmery gold top, and I thought they had good chemistry. Their body positions were very good. Loved the beam of light coming in on her face. It was all really great, but you have to wait for a little moment to happen, a little connection. It's not enough, sometimes, just to get the composition right. We need some action, and a little magic.

Now look also where I've positioned the heads of everybody, by height. By moving the camera to a certain height, I've kept their heads against the water as the background. That way we see them clearly, don't we? They stand out.

Even though they're slightly out of focus, and they're much smaller in the frame, they still stand out. Imagine if I'd gotten a little lower, you wouldn't have been able to see the water nearly as much, and their heads would've all been up in the skyline. It would've been a big mess. Cluttered backgrounds sticking out of people's heads? No thanks. By being in the exact right height position here, and thinking about the height of the camera, I put those people exactly where they need to be. The picture reads clearly that way.

Now I haven't told them what to do or anything. I'm just hanging out, but I'm choosing the height. I'm putting those heads where I want them just by moving the camera, that's all. These are all very subtle things, aren't they? Most people would just take a picture, but now, now that you're learning all this stuff, you're learning how professional photographers do it. Each and every time I pick up a camera, for any reason, I think about that composition. I think about that background, the placement of the horizon line, the subjects, the people. That's all really critical if you want to solve visual problems.

I worry about shadows and highlights in cities, and backgrounds, sure, but mostly, I worry about getting something that sings, something that's interesting. And even in a big city that's full of action, that's a problem to solve, too.

Years ago, I was doing a story on Boston. I had to show the physical properties of the city, sure, but I also had to shoot as many surprising and interesting things as I could—a very tall order for a kid from Nebraska who had never been there before. I tried to do my homework, but I also tried to keep an open mind for anything else that came up, like this lady. This lady's name was Hedda Rev Kury, and she was just a lovely person. She owned a restaurant. I went in there, it was very popular, just bathed in this red light. She loved the red light of this restaurant.

She's actually a doctor and just a lovely person. And she would sit with me and talk to me when I went in there for dinner. She owned the place. It was a lot of fun, and she said, "You know, you need to photograph me walking my dog, Joel." And I went, "Uh-huh, uh-huh." And she said, "I have a pet Dalmatian; he's a really lovely dog." And I was like: "uh-huh, sure, sure." And she says, "I wear my fake Dalmatian coat when I walk him. We really

turn heads. Some people yell Cruella de Vil at me." I was like, well, my ears really picked up then. I mean, for sure, seriously? "When do you walk your Dalmatian wearing your full-length, fake Dalmatian skin coat?" I asked. And she said, "Well, each fall and winter." So, I remembered that.

Now, unfortunately, it was July when she had that conversation with me, but I am nothing, if not patient. I made sure I called her in the fall when I went back to Boston, and it was really worth the wait. When I went back there, we spent late afternoon together one day, and we just went for a walk. It was lovely. One of my favorite pictures of my whole career came out of this little walk. It's just unusual and different. And it isn't this. I worked it. I waited. I was patient, and I thought about what would make the frame read. It's this one, just the last beams of light. The background's clean enough here to make things pop out. It doesn't have that much information. They're not even facing my way, but what is there doesn't get in the way. I think this one is still used on a greeting card now and then. It's just clean, it works, and it's a little bit of a mystery. One of my favorite pictures of this very, very elegant lady.

Right after that in Boston, I learned about a prayer meeting in a burnt-out neighborhood by talking with some folks. You can actually see the burned-out shell of a building across the street and the graffiti. This is a religious organization praying for their neighborhood to be restored, to restore some order there. That to me was interesting, and the editors at the *Geographic* thought it was too, and they published it. So what else?

Well, Boston is known for the Boston Pops right, the big festival on the river downtown and the big band shell in the summer is really interesting. Look at the color in the sky. This is their big 4th of July celebration, and later, of course, they set off fireworks. Now, the problem here is getting the best vantage point for shooting—the whole city's down there, everybody's jockeying for position. I'd done my research though, and I knew that I could get access to a rooftop, and I could make good pictures up there. Not only a loose shot, but a little bit tighter too, to show some of the boats and the people listening to the music.

What else do you think about when you think about Boston? This is exactly how I problem solve, believe me. I think Fenway Park. What do you do? I

had permission to go down by the players, down low on the field, to shoot the sports action, but I didn't really want that. I wanted a feel for the place. This is a signature ballpark. In America it is even. Do you know what I ended up doing? I just went up in the stands. I bought a general admission ticket, went up there, see the whole place, and then you've got a nice scene. This is what you would see if you were at a Red Sox game on a Friday night. This is it. That works. That worked for the magazine.

So, anytime I work in a city, I'm always thinking about what the people do there for fun. What is it culturally about this city that makes it tick? These all give me something interesting to shoot, or at least think about, trying to figure things out. Is the city really proud of its sports team? Proud of its urban parks? Are they proud that they have giant skyscrapers, or that they have great ethnic neighborhoods, that they're physically located in a great place. It just depends.

Cities are really amazing if you think about the amount of energy that's being consumed in them. Cities are like electrified beehives to me. And that was one of my problems to solve in Boston, how to show that for my overview picture for this story for *National Geographic*. So, this is what I ended up with. How did this come about?

To do this shot, I first looked from the base of the Customs House, which is what you're seeing here. It's kind of a clock tower building. From the Customs House, I could see a skyscraper across the freeway, and I thought, that would be a good place to show the Customs House. It turned out to be a residential building, apartments. So I went to that building, I found somebody who lived there, talked to people, smiled a little bit, got myself invited in. Found somebody who would allow me up to shoot out of their apartment window.

So, this shot, actually, a very long exposure, probably 10 seconds or so, a little bit more. I wanted to get all the traffic lights moving like a river, coming and going. You can see the white lights and the red taillights going. The sun is setting. For just a few minutes, the end of the day, you get this glow in the sky that balances out with the red of the taillights and the white of the headlights, it all balances out. And you can really define the landscape

only when there's still that touch of light in the sky. You can see the tops of the buildings outlined very well. You get the color in the streets, and it all matches up. The light balances out. That window of time that is really something important to work. I think about that all the time.

To be able to show a city, and have it be colorful, lyrical and beautiful like that, that to me is a problem solved, and it satisfied my bosses at the *National Geographic*, and here I am still working for them, so that's good. There's a technical aspect of photography to think about, thought, what lens to use, what lights, what time of day, where to be, composition, subject—these are all problems, but you can run into other hurdles as well.

My talented assistant of 13 years, Katie, has asked me to tell you the snail story as part of this lecture on problem solving. The snail story goes something like this. Once upon a time, there was a young photographer, let's call him, "Joel." He was assigned to do a story on the Endangered Species Act. One of the smallest critters on the Endangered Species List was called the Bruno Idaho Hot Springs Snail. It was a little creature that was confined to one little hot springs in rural Idaho. It lives in hot water, which makes it actually kind of a remarkable creature.

Well, I went out to this hot springs with the rancher that owns the place, nice guy. I thought, this snail is the size of a pencil eraser, how do I show this? How do I give it a size perspective? How do I make this interesting? Well, I thought and thought, and thought. I got it, I got it. OK. Let's put this snail on the rancher's fingernail, OK? So we get the snail and put it on the rancher's finger and it has this kind of mottled brown shell and it is what it is and we do some pictures. I say thanks, and I drive off to the next shoot location, about 200 miles away.

A couple of days later, I talk to a biologist who is the expert in this country on that snail. And I describe the snail to him, because he'd led me to the place in the first place, and I described it to him on the phone. He says, "Huh, how big was it?" I said, "The size of a pencil eraser, it was tiny." He says, "Well you know there's two species of snail in that spring, and you photographed the wrong one, the common species. The Bruno Idaho Hot Springs Snail, the

want you want, is much smaller than that." And I said, "Smaller?" He said, "Yeah, it's like the size of a grain of pepper, maybe."

So, how do I solve the problem? Only one way. I had to head back. I had to go back. There's two of them right there. They're tiny. I had to go all the way back, grab the couple again. We go all the way down to the hot springs, find the right snail, which took forever. This time we used the wife, of course, because she had nicer-looking nails. So, the lesson here? Know what you're doing, or end up with the wrong snail, simple as that.

And finally, I wanted to leave you with one more pearl of wisdom, from a friend of mine, and this is a basic truth in photography. I say this almost every day, or I think it. If you want your pictures to be more interesting, stand in front of more interesting stuff. Pretty clear, isn't it? Interesting stuff, good light, good composition. That's it, really. Visual problems solved.

So your assignment, look back over some of the first pictures you took during this course. Chances are, there are some visual problems you were not able to overcome, weren't there? Go back, rethink, and reshoot one of those situations until you're satisfied with the picture. Can you do that for me?

Pretend that I'm going to be looking at that new picture you've just taken. Imagine what I'm going to say to you. If the horizon's crooked, I'm going to nail you. If you have a phone pole or a tree sticking out of somebody's head, I'm really going to nail you. That is not acceptable, not now, not now. You're better than that. If you're shooting something in lousy light, please don't, unless you want to, I guess. You know better now. Never shoot a picture in lousy light unless, of course, you've figured out a way to make it beautiful. Don't compose things poorly either unless there's a really great reason. That is a must, OK, a must.

So in our next lecture, one of the biggest problems that happen in photography is after the snap, as in workflow and organization, especially in this digital era. If you're shooting thousands and thousands of pictures and they're all digital, how in the world are you ever going to find them? That's what we're going to talk about in our next lecture. It is critically important so stay tuned.

After the Snap—Workflow and Organization
Lecture 22

Just like all the other elements in photography, organization and workflow after the images are shot require careful thought from the photographer. Whether you're shooting film or digital, you'll need a system to organize your pictures. In this lecture, we'll go step by step through a system for downloading and storing your images and briefly discuss the process of "toning," that is, touching up your images on the computer so they look just like they did when you took them.

The Hidden Costs of Digital Photography

- In the days of film, most photographers stored their negatives in plastic sleeves in three-ring binders, perhaps with a date on the spine of the binder. Slides were often stored in boxes or in file cabinets, preferably in a cool, dry room. If the atmosphere wasn't damp, such negatives and slides would be readable even after 25 years.

- Today, with digital photography, we shoot flash cards instead of film, and we can tell immediately whether or not our pictures are exposed properly. This instant feedback is great, but it doesn't come without a cost.

- Instead of cardboard boxes, our pictures are now likely to be stored on a server, on an external drive, or on DVDs. All these advances in storage technology are far more expensive than three-ring binders or cardboard boxes, and we don't yet know how long into the future they will last.

Organization

- Whether you're shooting film or digital, organization is critical to being able to find your pictures months or even years later.

- When you have a full flash card, write your name, e-mail address, and phone number on the underside of it and insert it with that side up in the card wallet. That means the card has been exposed but not yet downloaded. You might also store cards in color-coded wallets.

- Develop a consistent, logical system for filing your images and stick with it. Create folders on your computer for images and make sure the name of each folder includes a date and a subject name. It may also include a coding system to indicate whether the images were shot for personal use, as part of an assignment, or for a client. In the file name for each image, include the same date and subject name, along with a sequential number.

- If you shoot lots of pictures, a system such as this will help you know where to look if you need to go back to the original shoot or find a near frame. It's not difficult to organize and find pictures using this system, but it's nearly impossible to find images if you don't develop some organizational system and use it consistently.

- Most image organizational software, such as Photo Mechanic, will name, ingest, and caption images automatically.

- Make sure your system is easy for you to use. If you have to manually drag the digital files from one shoot into 50 different folders to categorize them, you're likely to get bored of that process in a hurry. Instead of using folders, think about tagging your images with categories and then searching them using an image organization program.

What Makes a Good Caption?
- If you've ever taken a journalism class, you know about the five W's: who, what, when, where, and why. Good captions list all of these for a given situation.

- Always include a date in your captions. If you can't pin down an exact date, at least include the year.

- An uninformative caption for a photo of cowboys might read simply: "Cowboys in Brazil's Pantanal Region." The caption is accurate, but it tells us very little about the image.

- A good caption for the same image might read this way: "November 15, 2005. Cowboys, known locally as *pantaneiros*, ride horses to round up

livestock in Brazil's Pantanal region, about 100 kilometers south of the town of Campo Grande. The Pantanal is a seasonally flooded marsh, often compared to the Everglades, but in South America."

- Type your caption into the computer at the end of a shoot and ingest it into each of the pictures. You should also try to include contact information in your caption, such as the name, phone number, and e-mail address of the person who owns the land where you shot or helped you arrange the shoot.

- If someone wants to publish one of your pictures at a later date, the caption gives context that may not be apparent in the photo. Don't be afraid to include lots of information in your caption; you type it in once and it automatically goes onto all your pictures upon ingest.

Backups
- Digital files can be duplicated with just a couple of mouse clicks, so there's no excuse not to have at least one backup of your best images.

© Joel Sartore/National Geographic Stock.

Although you should always strive to get the shot right the first time, it's expected that professional photographers will make minor adjustments to the color, contrast, and exposure of digital images.

- If you're shooting film, get your best images scanned and keep the scans in a safe place. If you're shooting digital, have a drive of the files you work from and a backup drive that is updated regularly.

- If possible, keep two backups, one on-site and one in a safety deposit box or at the home of a friend or relative in another town.

The Download Process
- Get in the habit of downloading full cards at the end of every day of shooting. Once a card is full, store it underside up in the card wallet, so you know at a glance whether it is full and needs to be downloaded.

- Whenever you get a break from shooting, ingest the photos you've taken. The ingest process involves copying the photos from the compact flash card to your computer's hard drive and backup drives, adding captions and other pertinent information, and renaming the files. Most image management software allows you to do this all in one step. A typical ingest process includes these steps:
 o Plug the camera into an external hard drive and put the compact flash card into the card reader. Using an external drive allows you to make two copies of the images at once.

 o Open the image management software and select the ingest option. If you're on a field shoot, use the batch-caption option to type in one long caption for all the images you've shot that day. Later, you can use the information in the long caption to create more specific captions.

 o Double-check to make sure the folder and file names match and are correctly formatted. Then, click the ingest button. In just a few minutes, the images on the card can be downloaded, copied, captioned, and renamed, all at once.

Toning and Image Manipulation
- Every time an amazing photo appears on the Internet, someone insists that it has been manipulated, and many have. Digital technology makes

manipulation easier, but fakes have been around since the days of the darkroom.

- As we've said several times in this course, it's better to think about shooting a good image in the first place, rather than spending hours tinkering with images on the computer.
 - If something needs cropped in, you should walk closer to it in the field or use a longer lens. Move around the scene as you shoot to find the best light, or wait until the light improves.

 - An extra hour or two spent in the field practicing techniques you've learned in this course will improve your photography far more than the same hours spent in front of a computer pushing pixels around.

- That said, most professional photographers do make minor adjustments to the color, contrast, and exposure of their digital images before shipping them off to their editors or printing them. Professionals set their cameras to capture the maximum amount of information, and that results in an image file that can be used in a variety of ways. It also usually means that the images may need a little adjustment to look their best in any given medium.

Behind the Lens

If you want to ensure that you'll be able to view and enjoy your photos years from now, this backup routine [is] critical. I cannot stress this [enough]. Do not learn the hard way, like I did when I was starting out. Hard drives fail; basements flood; disks, optical disks, CDs, DVDs—they get scratched and they are not readable. It's not a question, really, of if but when. Just as you wouldn't go on a shoot without an extra camera battery, do not trust your files ever to a single hard drive or a single type of storage medium. We save things in triplicate back in my office, maybe more, depending on how rare those pictures are.

- If you're trying to achieve a specific look in your pictures, you can automate the adjustments with a custom profile in your camera or with batch actions in your software.

- A series of photos of an iceberg shows the difference a few touch-ups can make.
 - The first image looks a little washed out—definitely not what it looked like when the image was taken. In a scene like this, the eyes and brain expect to see true black—clipping, in other words, on the left side of the histogram. When that black is not present, the image looks washed out and bland.

 - Image software can correct this problem by clipping the blacks. The software can also eliminate dust spots that show up in an image from a dirty sensor.

 - This process is called "toning." It is generally accepted—and even expected—that images taken by professionals will be toned to make the scene look the way it did in real life. The colors will be punched up, the contrast will be adjusted, and so on.

Archiving
- Digital photography is a wonderful development; it allows you to experiment in ways that might never have been possible with film. But as we've seen, it's more expensive and complicated to store digital files.

- It's also true that digital images may not be archival; that is, they may not last for 75 or 100 years. In fact, the only way to make sure an image will be seen by future generations is to put it in a format that doesn't require a machine to read.

- The easy solution to this problem is to make prints for photo albums, just as you've probably been doing all your life. Print your photos on archival paper and keep them out of the sun. There are even services now that will print and bind a photo book for you (see bibliography).

- If you have prints made, ask your printer to use archival materials and methods. Display your images under UV glass and don't hang them where they'll be exposed to direct sunlight.

Common Workflow Errors
- The most common mistake people make when it comes to workflow and organization is not being organized in the first place. Develop a system that works for you, including a naming structure, and stick to it.

- Also make sure you know which cards are full, and don't delay in downloading them.

Assignment
- If you're shooting film, organize your negatives at least by year.

- If you're shooting digital, label your images with the date and subject, and make a backup drive of all your work.

Suggested Reading

Bendavid-Val, Delaney, and Mulvihill, *National Geographic Image Collection.*

Krogh, *The DAM Book: Digital Asset Management for Photographers.*

Sartore (with Healey), *Photographing Your Family*, pp. 128–171.

Homework

If you're shooting with film, organize your negatives at least by year. If you're shooting digital, make a backup drive of all your work. Label your images by year/month/day and subject.

After the Snap—Workflow and Organization
Lecture 22—Transcript

Hi again everybody. Today we're going to talk about organization and what to do after you take those pictures. How do you find them again? This is tough, but well worth listening to and well worth thinking through, just like everything else in photography. Whether you're shooting film or digital, you're going to need a system to organize your pictures, aren't you? This lecture's going to take you step by step through that process, at least the process I use, which is really pretty efficient.

I started taking photographs back in the early '80s, a long time ago, about when I was graduating high school. By the way, the word workflow didn't exist back then in photographic circles. Here are a few typical pictures from that day. I kind of hate to admit it, but these were all taken on film from a much more simple time, and, I have to say, I was just shooting pictures of my college roommates, mainly for fun. We'd just do goofy things, whatever I thought was interesting. These are not pictures that I am showing you hoping that you emulate them. There's no redeeming value in these pictures at all, quite frankly. Mainly I was just shooting cheerleaders to try to impress them, and they just found it creepy.

So I took my camera with me everywhere. I found that I liked it, I really must have liked that cheerleader. She's in a lot of the pictures. I went on spring break trips to North Dakota, drank beer, held tumbleweeds in front of my head with my friend Chris Burback, there he is, or maybe that's me. Bad idea going out and standing in the middle of a herd of buffalo. They don't like it sometimes. That's really a dumb idea.

I thought that standing on your head was fascinating because photographs freeze time, actually, so I did a lot of that with my friends. Anyway, don't try that at home, and don't emulate it. It's not worth it.

Back then, though, I stored my negatives in very simple form in plastic pages in three-ring binders. I'd label them on the top to see what they were. Maybe there would be a date on the spine of the binder, and that would be about it. To this day, they're all stored that way in my house in boxes down

in the basement, and they're safe and sound actually, easy to find, easy to go through, even though it's very, very simple.

So next, when I started working for *National Geographic*, I switched to slide film, slide film. So how do you store those? How do you find those? My slides, the best of them anyway, are stored in file cabinets, the best or the selects, are hanging in these cabinets with my seconds, or not-so-good images down in the basement. I have a special slide room. It's just cool and dry down there. I estimate I have a half million slides down there now from all the time I shot slide film for the *Geographic*. Each of these boxes holds 100 rolls, and the ends of each box are marked with a Sharpie marker to indicate how many rolls are inside. I put them in this cool, dry room, and everything's good. I can still go back to those slides—even though there are some of them that are 25 years old now—and look at those pictures, and the colors are fine, and I can see what's on there in each slide without the aid of a machine. That's very critical. You know, to be truly archival, you must be able to read your pictures without the aid of a machine. Think about that, think about that.

Today with digital, I don't do as much agonizing over exposure anymore, and none at all over the processing. It's really a dream to shoot pictures now. But the rest of this has gotten vastly more complicated. It is so complicated and expensive. Now I shoot flash cards now instead of film. Who knows how long this will last. We'll probably just shoot direct to hard drives eventually. But, I can tell you immediately when I'm shooting this way, on flash cards, I can tell whether the picture was exposed properly. I just check the histogram. I check the viewing screen on the back of the camera. That instant feedback is a miracle to me. It is so much better than shooting film, and it does make my pictures better, it sure does. But it comes at great cost, one that nobody wants to talk about. This is one of the dirty little secrets of photography. It comes with several costs.

What kind of costs, you're asking? Well, this. This is a server that costs a lot of money. You see, instead of cardboard boxes now, my pictures live as ones and zeros on a server, backup drives, and even some DVDs. They're scattered about, and this is far more expensive than anything I've had to deal with in terms of file cabinets and cardboard boxes. DVDs? I don't even

know that we're going to use DVDs anymore, and I just took this picture last year. I don't even think we use them anymore for storage. Huh!

You know, since I'm not a technical guy, and I shoot all the time, I've had to hire three full-time employees now to help me keep my archives straight, and to get these pictures out to the world, three people, yeah, three people. We market these pictures as stock, in exhibitions. We prep them for various speaking engagements I do, for books, and certainly for magazine stories. That's a lot of people working. They're working, working, working in there. That's a lot of money.

So what's the lesson in this for you? Whether you're shooting film or digital, organization is critical to you being able to find your pictures again, months or even years later. It is so critical. Let's start with some basic principles that apply to both film and digital photography. Here's a system for what you've shot, OK. And this is a good system, I think. It applies to everything from shooting to filing or downloading, keywording. When I shot film, I always knew which rolls were fully exposed because the tails of the film were wound fully back into my little canister. We don't have that with digital.

But, with digital, I know which cards are full because I place them "belly-up" in the card wallet, belly up. One side of the card usually has the brand name and the number of gigs on it, that kind of thing. On the underside of the card, what I call the belly, there's usually a space to write information. I don't write anything on there but my name and my email and my phone number. For me, belly-up means this card has been exposed, yet not downloaded.

Now other photographers will use a system like they'll have a green card wallet for, '*good to go ahead and shoot this*,' or red card wallet for '*stop and download these before you erase these cards, you idiot*.' You know, we've all done this. If we shoot enough, we get confused and erase a card we've just shot. Oh, my goodness, the horror there, but, we all have our systems. For me, I put my cards belly up, that way I know it has to be downloaded yet.

If you do accidently erase a card, there are rescue programs. You can go in and rescue pictures on that card if you had to, but it's time consuming, and time is money, isn't it? Time is something none of us have a ton of. So, a

system to track your images is crucial in digital. When I shot slide film, all the rolls from a story were numbered and kept in the same box, pretty easy, or a series of boxes.

With digital, all the images from each story have a date, a subject name, and sequential number in the filename. When going back to a past shoot, I can tell at a glance the client I shot it for, when I shot it, other things that were shot at the same time. With digital, you need a consistent, logical system to file your images and then stick with it. It's very important.

With slides, I filed my selects (the really good stuff, anyway) in plastic sleeves hanging from racks inside file cabinets with a drawer or two dedicated to each story, alphabetical. It's like books in a library, OK? We still haven't quite found the silver bullet for organizing digital images, but here's what we've come up with so far, for World Headquarters of Joel Sartore Photography.

You know, all the images from a day of shooting on the same subject go into a folder named this way, with the date, year first, then month, then day—so January 31, 2012 would be 12 for the year, 01, for the month, and 31 for the day, so it would be 12-01-31. A single letter, S or A, indicates, for me, whether I shot it as stock, just for myself, or assignment, for a client. And then finally, a title at the end of this little naming string, a very short description of the subject.

First, let's say I shot pictures of my dog, Muldoon, on a given day, here's our naming string right there. Let's say I shot pictures of Muldoon on a given day. That's not a good picture to really point out to you. That's worse. If these were shot on the same day, that is much worse. OK, that's a good one. We'll use that one, OK? Let's say I shot that on a given day and I go to download that. So, photographs of my dog, Muldoon, from January 31, 2012, would go in a folder named 120131_S_Muldoon. It's as simple as that. That's a stock picture, right? This date and subject system has worked really well for us, and I shoot a ton of pictures; wow 2 to 3 terabytes a year. A terabyte is over a 1,000 gigabytes, by the way.

Now, each image in the folder uses the folder name as the base of its filename, followed by a sequential number. So now, if there are 150 pictures, the files would be numbered 120131_S_Muldoon-00001-120131_S_Muldoon_00150, like that, OK? So you've gone from frame one to 150 pictures of Muldoon, and they're all organized. The beauty of this, why name them this way, by the way? It's the same reason I numbered rolls of film years ago. If we need to find a near frame, or we need to get back into that original shoot, I know right where to look.

You know, it's not hard to find the pictures this way, it really isn't, but it's impossible to find pictures if you *don't* keep track of them. Keep in mind that this re-naming is not done manually. Most amateur and professional image organizational software these days, I use Photo Mechanic a little inexpensive program. It can handle image renaming for you in one way or another, and that's really nice. I use an inexpensive little program called Photo Mechanic to name, ingest, caption, and take care of my images that way. There are dozens of good programs out there that do the same thing.

Whichever system you choose has to work for you—or you won't use it. Remember that. An unused or sloppily used system of shooting and organizing images means that it'll take you a lot of work to find them later on—if you can even find them at all. That's the thing in digital, good luck finding them at all, ever, if they are not organized.

What else? Keep captions with your images. In my film days, I took notes as I shot and then I wrote formal captions at the end of the day in a little notebook with two carbon sheets in it, so I'd have copies. With digital, I embed the captions right into the files themselves, upon ingest, at the time I bring the pictures into my system.

Let's talk for a minute about what makes a good caption. If you've ever taken a journalism class, you know about the five Ws: who, what, when, where, and why. Good captions list all of those for a given situation. Who, what, when, where, and why. A good caption captures all of that, right? Good captions also include a date. If you can't pin down an exact date, at least include the year. You'd be amazed how quickly time goes by and you won't even be able to remember the year that you shot. You might think that

you'll never forget the event you're photographing, or the year it took place, but you'll be surprised, it vanishes from your memory. The years get shorter as you get older, and they do fly by. So always get the year on there, at a minimum.

Let's take a look at an example of a bad caption and a good caption for the same image. Let's say I have a picture of cowboys in the Pantanal of Brazil. I bet you I have a picture like that, I do. A bad caption for this would be: Cowboys in Brazil's Pantanal region. It's adequate. it's accurate. But why is it bad? Well, it tells us so little about the image, that it doesn't really give me much at all—or anybody else that reads it—much beyond the very basics that they already see in the photo.

A good caption might read this way: November 15, 2005. Cowboys, known locally as pantaneiros, ride horses to round up livestock in Brazil's Pantanal region about 100 km south of the town of Campo Grande. The Pantanal is a seasonally flooded marsh, often compared to the Everglades, but of South America.

I'm typing all this in on my computer, by the way, alright? At the end of each day, I'm going to type a long caption and ingest that, and brand that, into each of the pictures. The caption could go on to say something like: Because of the wet ground found throughout the marsh, horses are still the best way to get around. With proper management, the land can be used for both cattle and the region's abundant and highly-varied wildlife, go on and on. I usually try to put contact information at the end, too. Contact for this ranch is Daniel DeGranville, and then I'd list his phone number, e-mail, whatever.

So I really try to work that, I really do. I think about captions quite a bit because they really are lifesavers later when you want to find out more information, you want to go back to a place, or somebody wants to publish your picture, you need that caption information. Not only does the caption tell me what's going on in the picture, though, it gives me context that isn't apparent and details if I want to follow up. So, we understand that now, right? Really over-the-top captions, you can't go wrong. You really can't have too much caption information, and you type it in once and it goes onto

all your pictures upon ingest, or you can do it after the fact, too, a day or two later. I like to do mine right at the time.

So, what else about digital? Keep at least one backup of your work. You've heard it a million times. Somebody's hard drive dies; they lose everything. It's a sad story, but true. Digital files can be duplicated with a couple of clicks, and there is no excuse not to have at least one backup of your best images. If you're shooting film, you get your best images scanned and you keep the scans somewhere else, right? If you're shooting digital, have a drive of files you work from and a backup drive that's updated regularly. If you can, man, I like to keep two backups, one on-site, and then one off-site, safety deposit box, for example, or at a friend's house, or at a relative's in another town, just something to get the stuff out of there and make sure I have multiple copies.

If you want to be able to ensure that you'll be able to view and enjoy your photos years from now, this backup routine, boy it's critical. I cannot stress this. Do not learn the hard way like I did when I was starting out. Hard drives fail, basements flood, disks, optical disks, CDs, DVDs, they get scratched, and they are not readable. It's not a question, really, of if but when. Just as you wouldn't go on a shoot without an extra camera battery, do not trust your files ever to a single hard drive or a single type of storage medium. We save things in triplicate back in my office, maybe more, depending on how rare those pictures are. I get nervous and we make multiple, multiple copies of things.

So how to file your images; there are two key considerations that can help you develop your own system, one that works for you. Who will be using the system? If it's just you, then using a method and terms that make sense for you may be OK, if it's just you. What are we going to do when you're gone, though, if nobody else understands it? If it's you and others trying to figure out where your work is and how it is filed, you might want to be more general.

For example, I took this picture of a horned lizard in Los Angeles years ago. I photographed this thing at the foot of the runway at LAX airport, by the way. This is when I did all of my own filing. I didn't have an assistant back then,

and so I filed it in my story drawer, in my file cabinet, under Los Angeles, Right? Because I knew to look for it there if ever I needed it. Then, I got an assistant one day, and she had to come and look for that slide, and she's like, good grief. If I hadn't been around to let her know that the horned lizard was filed under Los Angeles instead of horned lizard, or genus and species, she never would have found it, ever.

So, ask yourself, is it a relatively easy to use filing system that you have? Ask yourself. If you have to manually drag your digital files from one shoot into 50 different folders to categorize them, you will get lazy in a hurry, or stop doing it altogether, or never start doing it. Instead of using folders, what about tagging your images with categories, and then searching them using an image organization program? That makes so much more sense. It's so good to save time, especially as we get busier and busier during our daily lives.

So from shutter to shutdown, since most of you are shooting digitally, let's go step-by-step through my typical after-the-shoot download process. I do my best to never to let full cards lie around for more than a day without downloading them, I just get too nervous. Do not leave those precious pictures on your camera, please! Get them somewhere else. I download every night, at the end of every shoot day, just religiously. Sometimes I download during the day if I have some quiet time. I would never leave a full card overnight, I am just asking for problems, asking to lose images if that happens.

1. Once a card's full, I store it belly-up in my card wallet, as I've said. That allows me to tell at a glance what's full and in need of downloading and what's not.

2. When I get a break from shooting, I ingest those photos. The ingest process means copying the photos from the compact flash card to my hard drive and backup drives, adding captions, other pertinent information, and renaming the files—all in one step. Most image management software offers similar features, so you should be able to find the one that works best for you.

3. The first step in ingesting is to plug in my external hard drive. I put that compact flash card in the card reader, and away we go. Why plug in an

external hard drive into my laptop? Because I'm making two copies at once. One goes on my hard drive, safe and sound, that's on my laptop, and one's on my laptop. So one on the hard drive that's external, one's on the laptop. If I spill coffee on something, or if I drop one of those things, I have a backup there. I have to make two copies on ingest, OK?

4. I open up my software program and I select the ingest option.

5. I have the option to batch-caption images, what a blessing this is, so I do that. When I'm in the field, I often download once a day, so I use one really long caption for everything I've shot to make things quicker. I can use the information from the long caption to, therefore, make more specific captions later on if I have some time, alright?

Now, before I hit the Ingest button to start the process, I double-check things to make sure the folder and the filenames match and are correctly formatted. Once that's all done, I click it, off we go. After a few minutes, the images on the card can be downloaded, copied, captioned, and renamed all in one step.

Now it is so much faster to edit from digital, than slides. I can't begin to tell you, and when they're all captioned well, boy, it really is a breeze, and it's a joy. It really is. I know why everybody loves digital. It's so good all the way through. There were a lot of things about film I really didn't care for. The environmental problems with developing it, and the fact that it's slow to edit, it can get x-rayed at airports, the fact that you can't see your pictures until days or weeks later, if you're out in the field. Digital really has it all. It's just really difficult to store well, long term. That's the main problem—the long term. This is the other dirty, little secret. You can store it, but I don't know how archival it is. And we'll talk about that a little bit more in a minute.

Toning and image manipulation. It seems like every time an amazing photo appears on the Internet, someone will insist it's been manipulated, and many have, really. Digital technology makes manipulation easier, but fakes have been around since the days of the darkroom. There are entire books written about the ethics of photo manipulation, some you can look at on my reading list, if you're interested. But, I want to repeat a point that I've made several times now in the course that often goes unspoken. Rather than spending

hours and hours fiddling with an image on your computer, why not just shoot it better in the first place? Truly, don't you spend enough time on the computer? I spend way too much time on the computer, personally, and I don't even fiddle with things.

If something needs cropped in, why didn't you walk closer to the thing in the first place, or just use a longer lens? Don't talk about cropping. Shoot it right. Use your feet as your zoom. Does the light look lousy? Move around to find the best light, or wait until it improves. Did you miss the moment? Wait until another moment comes along and do it right the second time.

An extra hour or two spent in the field practicing techniques you've learned in this course will improve your photography far more than the same hours spent in front of a computer pushing pixels around, really. That said, most professional photographers do make minor adjustments to the color and the contrast, and the exposure of their digital images before shipping them off to their editors or to print them. Why? Well, most of us know that we set our cameras to capture the maximum amount of information, and that results in an image file that can be used in a variety of ways. But it usually means the images themselves need a little adjustment here and there to look their best in any given medium. I just want to think of it as straightening a necktie— no major adjustments, just a little here and a little there to make the best impression. That's what we need to do most of the time.

I just want the pictures to look how they looked when I was there, really. If you have a specific look you want, you can automate this with a custom profile in your camera, or with batch actions, again, to do lots of them. Again, there are dozens of programs you can use and entire books written on how to do this, and things change all the time, constantly. So do check out the course bibliography.

Now, let's take a look at the difference a little touch-up can make. I'm not advocating that you do this to each and every one of your images, why would you? Just your keepers, I guess, if they need anything. But, if you're showing them to others, it's worth a little extra time to make sure they look their best. So, this is a picture that just comes straight out of the camera,

straight out. It's a graven image of an iceberg in Antarctica. I captured tons of detail. There's no clipping on the histogram, I know that, the light's soft.

But it looks a little blah and washed out, a little bit doesn't it? So, is it as good as what I saw in person when I was there? No, absolutely not. Why? Well, in a scene like this, our eyes and our brain expect to see true black—clipping, in other words, on the left side of that histogram. When it's not there, the image looks a little washed out and kind of bland, doesn't it? Absolutely it does. Now, look at this.

We have a little bit of an adjustment on this. Same image with three adjustments applied: we've told the software to clip the blacks, but just barely, as you can see from the histogram, just barely. Watch this. The histogram is right there. I've told it to clip the blacks a little bit by less than a stop. There was also some dust on the sensor when I shot it. And you can see in the upper-left corner of the first frame that I showed, Go back to that, You can see dust up there. My sensor was dirty. I'm often shooting outside in really filthy conditions. I get sensor dust all the time. It's a problem. It's like in the darkroom days, you'd get dust on a negative that would show up in the print. I handle it the same way—a little bit of digital spotting, except this time it's done with software instead of a tiny paintbrush and ink.

So, three little adjustments to this picture take it from OK to something more worth looking at. It now looks to my eyes like it did when I was there. The process just took a few seconds and didn't require complicated masking or special techniques beyond what was making it look like what I saw originally.

So this is what toning is. It's generally accepted, toning—and even expected—in professional circles, that your pictures will be toned a little bit back to the way the scene looked in real life. It's expected that the colors you show people will be punched up a little bit and the contrast will be where it needs to be. Again, not a ton, very little, just enough to make it look real, to make it look like you saw it originally.

The archiving issue, boy, this is one that could take awhile, but, in the interest of time, this is my biggest problem when I think of the long-term storage of

digital images. This is the biggest problem I have with digital. Nobody wants to talk about this. I'm going to give it to you straight. Digital photography is a wonderful development. I mean, you go to digital, it's hard to go back to film, if not impossible. Once I switched, and I hesitated, I was one of the last *Geographic* photographers to give up film, once I switched, I've never looked back. I mean, digital allows me to experiment and try things I might never have been able to try shooting film, especially with flash. Wow, you can really craft the light.

Now we've already talked about the downside and expense of shooting digital files. It's more expensive and complicated. I've had to hire people, but there's an additional issue we need to address, and nobody wants to talk about this. I don't think digital is archival. I don't. And I'm a guy that takes a lot of pride in wanting to believe that my pictures will last for a long time. I put a lot of time and money into these pictures, travel all over the world.

I tell you, I've talked to archivists, they say the only way to make sure an image will be seen by future generations is to put it in a format that doesn't require a machine to read it. That's it. Don't believe it? How many of you still have a functioning 5 ¼ inch floppy drive? How about ZIP disks; they also used to be an industry standard, and they went out the window with CD burners and USB thumb drives and all of these things some of you may not even have heard of. It's only a matter of time before what we are using now is absolutely replaced with something else. This is a problem, isn't it? It's a problem.

What do we do? I'll tell you what we do. There's an easy solution. We make prints, we make prints for photo albums, believe it or not, that's how we do it. My mother has prints from 60 years ago when she was a , and they look fine. Even a so-so print in a hastily put-together album is better than nothing at all, and that may be as archival as we're going to get right now. You print something on archival paper and you keep it out of the sun. That's it.

There are even services now that will print and bind a photo book for you, and we list a few of those in our supplemental materials in this course as well. It's a good way of getting archival duration out of your photographs. What do I mean by archival? I mean 50, 75, 100 years, that's what we're

thinking, 100 years. If you want to ensure that your prints are around for years to come, ask your printer whether they use archival materials and methods. It costs more, but if it's truly a special image to you, it's worth it, isn't it?

So, where you display your images makes a difference in archivability, too. Like I said, no direct sunlight; don't hang it in direct sunlight. Even with UV glass, it's going to fade. Without UV glass, it's going to fade within weeks or months. Sun really takes its toll. Ask your framer to use archival materials and techniques when you get your photos framed if you feel those photos are worth the extra expense. Again, it may cost more, but it's really worth it to me.

Now, the number one mistake I see when it comes to workflow and organization, not being organized before you take your first picture. Don't start shooting and not have this system in place. Have that workflow in place. Remember, year, month, date, subject. You can never go wrong that way because the date changes every day. You can never overlap that way.

Make sure your system for telling which cards are full and which aren't makes sense to you. I have my little method, belly-up, but if that doesn't make sense to you, come up with a system, and be consistent. What will work for you in the field? I've not found a better way than belly-up with my cards, and ingesting the cards when I can, right away, I don't put it off. Do it properly. Don't delay, because you can get all confused and not know what you've downloaded and what you have. Develop an ingest procedure that works for you, and use it every single time. Once you have one, it's like a warm-up swing in a golf game or a free-throw routine in basketball— just something that's just part of how you play the game. If something's not working right, you'll be able to fix it then. You'll know when it's not working right.

Again, have that caption in place, and have your naming structure in place. When you hit ingest, that all gets recorded into the pictures at that moment. Get it all done at once. Get it over with. Life is short. Make the most of it.

Your assignment: If you're shooting with film, organize your negatives, at least by year, please, at least put the year on there. If you're shooting digital, make a backup drive of all your work. Label all by year/month/day and subject. You'll be really glad you did, I promise. This is worth a weekend of your time, or whatever it's going to take.

Now in our next lecture, we're going to talk about something that's also quite important. Now that you've got your photos downloaded, filed and very well organized, of course, the next step is choosing the best basic ones, which ones are the best. And we will cover editing next. Don't go away.

Editing—Choosing the Right Image
Lecture 23

In this lecture, we'll go through several groups of images to see if we can choose the best photos from a shoot. Just like good shooting, the editing process takes time and practice. You first eliminate the bad images—those that aren't sharp or well lit—then look for subtle distinctions that make one photo stand out from the rest. As you're sorting your images, you'll develop an eye for good lighting and composition and, of course, an interesting subject. In the end, this process will make you a better photographer, highlighting where you can improve on your next shoot.

Sorting Images

- Earlier, we saw a photo of a lion in a tree at sunset, but of course, not all of the images taken on that shoot were as stunning as this one.

 o First of all, getting the shot required waiting many hours for the sky to darken, as well as experimenting with the composition— going in tighter or framing from different angles.

 o In the final shot, the spotlight is a little bright, but the lion is quite visible in the tree, not blocked by shadows or branches.

- Another set of images—aerial shots of crater lakes in the Albertine Rift of Uganda—also illustrates the process of sorting images. In the last image, the color is good, the horizon is straight, and we have a wide field of view. Getting closer to the lake allowed an additional shot of Cape buffalo crossing its surface, their trails forming a graphic pattern in the water.

- Both of these shoots offered a healthy number of frames to choose from and covered the elements we've talked about—interesting subjects in nice light.

- Keep in mind that it's hard to find a truly beautiful image if the frame was never taken in the first place. If you find yourself in a visually loaded situation, shoot heavily.

Case Study: Picking the Best Image
- A shoot documenting mountain goats in Glacier National Park started with some research to learn the habits of the animals and where they might be seen. In the summer, these mountain goats migrate to lower altitudes to lick salt off rocks.

- As the mountain goats appeared, a variety of shots was taken—panned action, tight, loose, vertical, horizontal, and so on. Soft light, interesting subjects, steep surfaces, and craggy rocks combined to make this a visually loaded situation.

- One frame with a mother and baby and another with three goats look promising; the texture of the coats of the animals matches the rocks, and the overall scene is very graphic.

- Additional shots show a mountain goat in an incredibly precarious position. Again, multiple shots were taken, with the goat centered, with more space above and more space below, wider, with different framing, and so on. A shot with more space underneath the goat dramatically conveys the danger of its location.

- Comparing two similar shots of the goat also helps to identify which shot is better. The "keeper" image shows the goat's face a little better, and the positioning of its hoof implies the grace of the animal. The framing of the shot includes a good deal of vertical space underneath.

A Mental Editing Checklist
- When you're editing, you'll probably want to make at least two passes through all your images. On the first pass, eliminate any images that aren't sharp, especially if the eyes of the subjects aren't sharp.

- Also check the exposure on the first pass. In general, eliminate any shots that are too dark or too light. But if you have a frame of something really

special that's dark, don't discard it right away. You can often digitally render a nice image out of a dark picture.

- o Keep in mind, though, that it's usually worth correcting an image digitally only if it's very valuable, for example, a photo of a grand old building that has since been demolished.

- o In most cases, it's better to shoot the image correctly in the first place or go back and redo the shoot.

- o You'll probably keep most images from a shoot, even if you don't select them as "winners." Simply save them to your storage media and hold on to them.

- Once you've made a first pass through your pictures and eliminated the soft or poorly exposed ones, then you can concentrate on finding the best images.

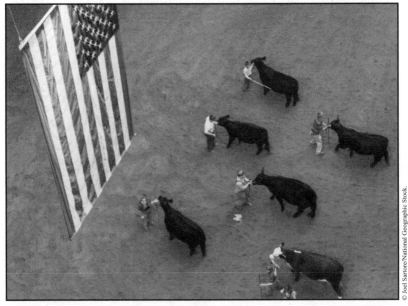

An aerial view begins to show possibilities for capturing patterns on the floor of a state fair.

o With digital technology, many pictures these days are technically fine but lack a truly interesting subject.

o When you're looking for keepers, ask yourself if your photo passes the "Hey, look at that" test. In other words, would you call someone over to view the scene if it happened outside your window?

- If you're still stuck trying to find the better of two seemingly equal photos, trust your initial reaction to the pictures.

Photo Analysis: State Fairs
- A series of shots taken at state fairs illustrates the photographer's thinking in the editing process.

- The series begins with photos of livestock owners who must sleep at the fair overnight to tend their animals. Some of these images could be improved by using a longer lens.

- At another state fair, getting a higher view improves the shots, but some of the early images still show a lot of dead space. The aerial view, however, presents possibilities for capturing patterns in the scene. Patience pays off as more and more cows come in to view and parade in circles past the judge.

Photo Analysis: A Portrait
- Again, we follow the thinking process in a series of portrait shots of a man in front of his historic home.

- The first shot is underexposed but can be brightened up on the computer. Still, the chimney seems to be coming out of the subject's head, and there's too much sky in the picture.

- With a longer lens, some of the house remains in the image, but there's too much depth of field, and the gutter line seems to split the subject's head in half. With an even longer lens and a tighter shot, the house is lost.

Behind the Lens

I was on assignment for [*National Geographic*] in Uganda, and I was there for months. I had an assistant there running camera traps, as well. We would set these cameras along water holes, game trails, and carcasses, and we got lots of really intimate shots: leopards coming down off Cape buffalo at dusk…, hippos at waterholes glowering at the camera…, hyenas lounging around a den at night. We really, I thought, did well.

In the end, *National Geographic* used about 6 pictures out of that entire coverage of 30,000 frames! Six pictures from the two of us working there for months and months. That's tough, isn't it? I mean, they were good pictures that were used—don't get me wrong—but 6 out of 30,000! You better have a tough skin if you work for *National Geographic*. [On the other hand,] *National Geographic* was delighted. They were very happy with the coverage. They'll employ me again. It looks like I'll live to shoot another day.

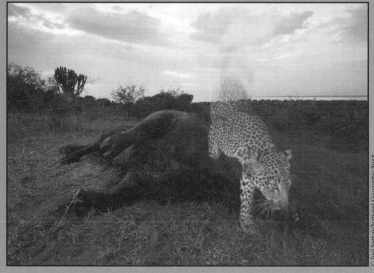

My point is in all this: At *National Geographic*, we are not afraid to really hone our edit down to only the very best. You shouldn't hesitate to do the same. Maybe not that drastically, of course, but you need to be fairly brutal in your edits nonetheless. Bad photos and a lack of editing are [among] the reasons that slide shows have gotten such a bad rap as a snooze-fest over the years. [But] you can avoid falling into the same trap.

- With a 70-200mm lens and a change of perspective, the subject stands out against his home, and the columns tell us that the home is an older one. Moving around to find the right frame for the subject makes the photo even better.

Common Editing Mistakes

- Perhaps the biggest editing mistake you can make is not being critical enough of your own work. Be brutal on yourself, and if you can't be, find a friend with a good eye whose judgment you trust.

- With digital technology, we shoot a lot more pictures than we ever did with film, so it's important to be discriminating when you edit. A good photographer can probably find problems or room for improvement in almost any shot. The editing process will make you a better photographer because it shows you what you missed in the field and what to address on your next shoot.

- When you're narrowing down your pictures to find the best shot, put yourself in the editor's shoes. An editor doesn't care how hard you worked or how far you traveled to get a picture. What matters is a well-crafted image.

Assignment

- Do a complete edit from one day of shooting. Start by making a rough selection, eliminating bad shots, and noting possibilities for keepers.

- Narrow your images down to one picture per situation, view, or direction. From a full day of shooting, choose 20 pictures or even fewer. Finally, see if you can find your favorite picture from that day. This exercise will make you a better photographer.

Suggested Reading

Abell, *The Life of a Photograph.*

Lubben, ed., *Magnum Contact Sheets.*

Homework

Do a complete edit from a full day of shooting. Start by marking rough selects, then selects, then primes—the real keepers. Narrow your choices down to one picture per situation or one picture per view or direction. If you've had a really big day of shooting, narrow the selection down to 20 pictures, 10, or even your favorite single image.

Editing—Choosing the Right Image
Lecture 23—Transcript

Hi again everybody. Choosing the best photos from a shoot is a process known as editing, of course. Good editing elevates the work. The editors I work with at *National Geographic* magazine, and here at *The Teaching Company* as well, are among the best in the world. Between working with them and editing my own work over the years, you could say I've picked up a few things. So let's talk a little bit about this so you can apply the methods I've learned to your own work.

In this lecture, we're going to go through several groups of images and then pick the one that really stands out. We're going to work towards that payoff, I guess. We'll have to pay a bit of attention, though, because some of these images are going to look similar to you, but not to worry. Good editing takes a little time and some practice, just like good shooting, and sometimes, you know what, I can't really be sure which one is the best.

I thought we'd start out big, though, by editing a couple of takes or shoots, I did in Africa and then end up closer to home. So, first, a little story about editing for *National Geographic*. I was on assignment for them in Uganda, and I was there for months. I had an assistant there running camera traps as well. And we would set these cameras along water holes, game trails, and carcasses, and we got lots of really intimate shots. Leopards coming down off Cape Buffalo at dusk with these camera traps. Hippos at water holes glowering at the camera, you know, anything we could get. Hyenas lounging around a den at night. We really, I thought, did well.

Now in the end, *National Geographic* used about six pictures out of that entire coverage of 30,000 frames! Six pictures from the two of us working there for months and months. Man that's tough, isn't it? I mean they were good pictures that they used, don't get me wrong, but six out of 30,000. You better have a tough skin if you work for *National Geographic*. So, *National Geographic*, six pictures, 30,000, they were delighted. They were very happy with the coverage. They'll employ me again, it looks like. I live to shoot another day.

My point is in all this, at *National Geographic*, we are not afraid to really hone our edit down to only the very best. And you shouldn't hesitate to do the same. Maybe not that drastically, of course, but you need to be fairly brutal in your edits, nonetheless. Bad photos, and a lack of editing, are one of the reasons that slide shows have gotten such a bad rap as a snooze fest over the years. Let's look at how you can avoid falling into the same trap, OK?

Let's talk about how we sort out our general take, I call a shoot a take, down to just that one keeper. Let me show you how I got to a nice picture. This picture, you've seen it before, of a lion in a tree at sunset. Now, this is a good illustration of the editing process, in my mind. Believe it or not, when we got there, that tree looked like this. Wow, pretty rough, right? Now, there are two male sleeping lions in that tree. You can't see them. There's one, he's on the left side. These are brother male lions. One has a radio collar on, so we know he's in there somewhere, OK? Here's the other one, out on that branch. Tough to see huh? They're so hidden by branches and shade, you'd never know they were there.

So how did we go from these to that one that I showed you in really nice light? Let me show you. Basically, we start by sitting still and waiting and being patient. We know these lions are nocturnal. They're going to hang out and they're going to stay right there. They're not going to go anywhere. They're just going to sleep because they've been up all night trying to feed, or maybe they killed something. They're going to lay around during the heat of the day, that's why they get up into the trees.

Here we have the lion on the left, one of the brothers, you can hardly see him at all. You really can't. The lion on the right, the light's starting to drop. I'm putting these up for you kind of in chronological order the way that I shot them. The light is dropping a little bit. Alright, we can barely make him out now. A little bit more, we're starting to put a little bit of light on him, just a little bit. Now we look. It's really darkening down. The sky's getting a nice, nice blue color. We're putting a little bit of light on him in the form of a little spotlight that runs off the cigarette lighter in the vehicle we're in. We're always in the vehicle. I'm just actually sticking my head up out the roof of the vehicle, and we're on a slope across from that tree.

So, is that good? It's getting there, I guess, getting there. Notice, I'm playing around with the composition. I'm not really sure as I'm shooting, not really sure. Is that one better? I don't know. Let's keep going, let's keep going. Maybe a clear winner will stand out. Well, you know what the winner of this is. The light is a little overexposed there, a little bit too bright, but now we can really see him. That light really helps. Now is when we're getting down, OK. I think we got something there, I think we got something. The blue in the sky is really nice, nice royal blue, and the lion's there. Now, the brother, he goes down the tree. We shine our light on him. He's gone into the deep grass. He's going out hunting. This guy's still there, so, let's see, which frame is the best, maybe not so much loose. I don't think so. I think we need to be tighter.

I tried a couple of more loose, I don't know. Oh, he's standing up. OK, alright. Now I'm framing off to the left, he stood there, he looked about. That's it, that's the one, and as soon as I shot that, he walked down the tree limb. Do you know how long he was up on that tree limb? Five seconds, I looked on my counter in my digital files, five seconds. He stood up, looked, looked my way. That was it, so that's our keeper. Now, that's a pretty obvious one, isn't it? That's pretty obvious. We can see where we're going with that because there's one that really stands out.

Let's look at another situation that's not quite so obvious here. This is the Albertine Rift of Uganda, here we've got crater lakes caused by ancient volcanic activity, OK? I wanted to do an aerial, it's *National Geographic*, after all, but, watch how this turns into something more, and we even get a twofer here, and our edit helps to get us there. So, we start out very wide. These are crater lakes, and I notice, man, these have this kind of unusual stuff in the water. What is it? It's algae brought on by the sun, is what I'd heard. So, we fly around it. We're in our little fixed-wing aircraft. That might be the frame. That's a nice, wide shot, good color right here. It's a nice landscape.

I'm looking at that and I'm thinking OK, it's better than this, yes. It's better than that, yes. It's better than that. Why? Well, I'm going to go with this last one because the color is there. That little strip of yellow really helps bring it out. The horizon's straight, and it's not so distorted. It's not hugging the edge of the field of view. It's a little bit away from our field of view, and

that wide angle lens, that 14-mm lens, really stretches things if you were to put it too close. So that's our keeper there, but, you get on in closer, what do we see? Some patterns there, maybe we can make another picture. Let's see if we can edit through this and get another picture. I like the yellow, and I like the green, but what are these? Notice those little brown dots. Let's get closer. They're cape buffalo that come there to graze on the flats around the lake. Nice pattern shot, maybe, maybe. Let's see. Let's keep going. Maybe it's better with the yellow up there. I don't know, this is a little less obvious. Which frame do you go with? Probably not that, not enough color there, I don't think. Maybe it's this. Look at this. As they wander in the surface stuff, the minerals from this volcanic lake, as they wander in the surface stuff, they leave little trails, so maybe we're on to something. But I want that color again so we have to get the plane around. We fly around, now we have some color, but I don't quite like the composition as well. Let's see, there we go, maybe that's better, maybe that's better. Now, it's not perfect. I would've loved it if there'd be a couple out here, but there weren't, but we have them on both sides, and we have this nice graphic pattern going on, and the color's very rich. So, OK, I like that one. We can keep that one. So we've edited our way to this. There were lots of others in between, though, that I didn't bother to show you. I didn't really want to bore you too much.

But, in both of these cases, we had a healthy number of frames to choose from, didn't we? And the bases we've covered pretty well. Interesting subjects, nice light.

Now, remember, it's hard to edit down to that true keeper if the frame was never taken in the first place. I really want you to think about shooting heavily on something that's visually interesting and paying off. Do shoot heavily. But sometimes, especially when you're in a visually-loaded situation, even, it's really tough to see the forest for the trees, isn't it? It can be really tough to pick out the winner when you're so close to it. My photos are really like my kids; I really can't bear to lose any of them if they're any good, and yet I have to, and that's what editing is about, and so do you. You have to be really tough on yourself.

So, now, let's look at a situation in this country. We're going to try to pick the best image we can. Here's a hint, like the lion in the tree. I've already

shown you the best frame earlier in this course, but now we're going to see what it was like to get up into the situation, how I worked it, and then what that frame was up against in the competition to be picked. So, where're we going? We're going to Glacier National Park, lots of mountain goats there, dozens of them. They migrate down to lower altitudes to get salt off the rocks in the summer. My challenge was to come up with a photo of a mountain goat unlike anything the *Geographic* readers had seen before, and that's kind of a tall order. So, what do we do? We start in. I know that they lick salt off the rocks there, but there just weren't that many, so I wandered around. I looked. I watched. A biologist friend told me where he thought they might be. Yes, they're along the highway on the west side of Glacier Park.

So, fine, I'm shooting a little bit and they're very habituated. They're very used to people being there, obviously. The goats are coming down from the higher elevations to get salt. I try to shoot a variety. I'm always trying to shoot a variety. In this case, a little bit of panned action of the goat moving, and here's our scene. This is our scene. This is what we start with. This big area right here, there's a slot canyon right underneath the bridge, and I'm just sitting underneath that bridge, so I was hanging from a rope to get this picture. There's a couple of mountain goats right there, a mama and her baby.

So, here we go. They lay down, they look around, I'm shooting tight, I'm shooting loose. I'm really trying to feel my way through it. I'm shooting a lot of pictures. This is what I consider a visually loaded situation. We have soft light, mountain goats, real steep surfaces, really interesting colored rocks, very craggy. Let's see what we can get. I start out vertically, of course, see what we can get. Try to get mom, the baby, keep working it, OK. Horizontal because we have three goats here, and I love the way their coats match the color of the rock. That's not a bad frame. That would work. That'd be a keeper, soft light, kind of an interesting subject, very, very graphic. That would work. That would work.

Let's see what else. Now, maybe this is better. Now again, I'm showing these to you kind of in chronological order, the way that I shot them, so you can kind of see I'm editing in my head as I'm shooting, too. Now I'm thinking, what is it about this? I like that because it implies danger, but it's horizontal. Is horizontal really the way to go? I tried vertical, but that doesn't

really imply any danger does it. Now this, this implies danger. This might be a keeper. We see that drop, we see that that mountain goat is in such a remarkable position. How did it get there? I don't know.

So now I'm backing up, and I'm trying centering the goat. Is it better centered? Is that a better body language? Do I want more space above or below? This is just actually how I'm shooting these pictures pretty much in chronological order. Now I'm horizontal; I'm trying to do the rocks. I had quite a bit of time to work this, obviously. She was probably there for 15 minutes licking at the same spot on the rocks. Now I'm back wider. Is that any good? I don't know; It's pretty dramatic.

Let's go back vertical. As I'm shooting this I'm trying all these different things. So which picture's the best? Is it that one? I don't know. Is it that one? I think I'm framing it up wrong. I think the photographer should've been smarter and shot it with space underneath. Now we're talking. Why? Because this implies that if that goat slips, it dies. Is it this frame? Is this the winner? I think so. I think so, but, let's look a little bit more. Let's be a better editor than that. Maybe this is better. Why? Let's look at the two.

I go back and forth all the time. Why? Why is that frame better? I think it's better because that foot's up and it implies this is a very graceful animal that's totally comfortable on really steep slopes that would kill anything that tried to chase after it and eat it. They've evolved to live up there. That hoof up totally makes it. Better than that, you can see the face a little bit better and the hoof is out, and the hoof pops out against that black background, and we're framing it so that there's a lot of vertical space underneath. That's the picture to choose out of this.

By the way, people ask me a lot about how did that goat get in that situation? Well, that goat crawled down right here, right along this edge, and hopped down to that ledge with all four feet where it's back feet are standing, leapt across, wedged itself in that little fissure there, licked the rocks all it wanted to get salt, and then got out the same way, sprang back, all four feet on that ledge, and literally backed up, backed up the hill, quite amazing. They have gripper pads on their hooves so they don't slip. Quite amazing.

So, it wasn't a hard shot to shoot, but getting there visually, even though that looks pretty obvious, for me, it took awhile. I don't think about verticals as much as I should, and I should do that better. I should.

So, I've shown you three situations, enough to look through. We found the best frames in each right, right? And though you wouldn't know it, I have a mental checklist in my head that I constantly refer to as I'm editing. If a picture doesn't meet my standards on that first cut, it's out of here. That's it. Among my most basic requirements, first, I edit for exposure and focus, right off the bat, so does *Geographic*, so does any good editor. I usually make at least two passes through images in a shoot when I'm editing. The first is a very quick pass to sort out the sheep from the goats, so to speak. I think of sheep as nicer looking, I guess. So I'm always looking to see if it's sharp. If it's not sharp, it's gone. That's it. I look at the eyes of the animals or the people that I'm shooting and see if they're sharp. That's very critical. The whole world can be blurry, but I want sharp eyes.

Also, on that first pass, I'm checking exposure. Is the frame way too dark, or way too light? All frames being equal, if it's way too dark or way too light, then it's out, too. Notice that I didn't show you anything in the way of really out of focus or really underexposed or overexposed frames in that. I'm trying to avoid the obvious here, as we all know that the blurry and dark and too bright work won't cut it, so I didn't bother you with that. And with auto exposure on my camera, I really didn't have too much in the way of exposure or focus problems because the animal's there, it's good contrast, it's good light, fairly easy to do.

I want you to remember, though, that if a frame is too dark and it's of something very special, I wouldn't pitch it, not just yet. You can usually save a frame that's too dark digitally. You can render a nice image out of a dark picture, but if it's really blown out white, there's no information there, it's really tough to save. So I will quickly discard those because I know my *Geographic* editors when they get to those pictures, they'll discard them as fast as they can.

Also, remember that you can fix some things digitally, but it's really only worth it if the photo is very, very valuable, right? If it's a grand old building

right before they push the plunger down to demolish it, and all you have are some really under or really overexposed images, well, yeah, I guess, you could try to save those, I guess so, because it won't happen again. It was a once-in-a-lifetime thing. Otherwise, you're much better shooting it correctly in the first place, or going back to re-shoot, if you can, rather than try to salvage something that's really a terrible exposure. Do you know what I mean? If it's out of focus, then that's even harder to justify saving, and I toss them. I get rid of them.

Now I do save every original file from my shoot, but I just don't select those. And if I file them, I put them on a storage medium and I forget them. I don't really throw away a ton unless it's really obviously bad, but I don't go back to those again. My edit's about winnowing down from thousands, to dozens, to just a few.

You know, once I've swept through the pictures and gotten rid of the soft ones and the poorly exposed, then I can really concentrate on finding the best images. When I was starting out, this initial run through of mine used to eliminate nearly half of the photos I shot, but since technology and I have both improved with time, I shoot fewer frames now that are really, really, really awful in terms of exposure and sharpness. Hallelujah for that.

Now, besides yearning to discover something that's lit and composed well, I have a final test for you. Is it interesting? You've heard me say this a lot. That's so true. A good analysis of this is what I call my "Hey, hon" test. If I was driving down the road with my wife next to me, would I tap her on the shoulder if she was reading a book and say, "Hey, hon, look at that." Would I? Would I distract her from her reading to do that, knowing that she doesn't get much of a chance to read with three kids hanging out around her all the time. So, it better be worth it. That's kind of the test that I use. So many pictures these days are technically perfect but lack a truly interesting subject. Man, just think about the junk that you see all the time. Pictures just aren't interesting.

So after you've done all that, and you're sure about it, and you're still stuck trying to find the best between seemingly equal photos, does that happen to you? It happens to the best of us. Sometimes it's just really hard to tell which

one is best, isn't it? What I do then is I trust my gut. I trust my initial instinct or reaction to the pictures. Humans are very visual creatures, and we react to images the instant we see them. If you flip to an image and you instantly like, or dislike it, that's a feeling worth noting in your edit, OK?

Alright, let's take another run at this, something that's even closer to my home, state fairs. Let's look at this for a little bit. Alright, so state fairs, I was assigned to do that for *National Geographic*, and I thought what about state fairs would be kind of fun to shoot. OK, what can I shoot? I like the fact that people sleep with their cows at state fairs, so I wondered around, and I shot a bunch of people sleeping with their cows. It's very easy to do; they stay there all night to tend their livestock. Somebody has to be there, a family member usually has to be there to spend the night. They can't just leave the animals in these fair barns.

So, I go on in and I wonder around. I'm going to kind of give you a running commentary of whether these pictures are in our out as we go. So, I'd say that's out because he's a little stretchy. I like the way his head pops out. I can't see the cows as much. There are a lot of distractions. I think that's out. This one, a little bit better, but again, I've used this wide lens, and I've really made his arms bigger than his head. When am I going to learn? I need to use less of a wide lens right there. I've used too wide a lens, really have stretched that out.

Alright next, this isn't bad. I like the colors here. I like the fact that she looks like she's sleeping. I love the little pink phone right there. I like the cows. This doesn't hold up as well for me, so I moved. I think I moved when I shot this, yes. I came in. Now I see another girl here, but again, using that real stretchy, wide lens. I don't know; it's just a whole lot of blanket there. Is that what I want to show? I need to learn to use a little bit longer lens and less of a wide lens. I like the shallow depth of field. We have cows here. This is an almost, but man, there's so much color, and the rest of that scene is very earth tone. I don't think so.

Now this, now we have a scene. I like this, I like this scene. I'm standing back here a little ways with a longer lens, by longer I mean maybe it's a 50 mm instead of a 24 or a 20. I like the way that this is working. I like the fact

that they stand out from the background on that couch. I like the other action going on in the background. OK, so I'm going to work this a little bit. She seems to be waking up a little bit, probably because there's a camera clicking near. I'm kind of working around here. Is that as good? I have a lot of dead space right here. I don't think that's our frame.

Now we're talking. A little bit of a longer lens, maybe this is a 70 or 80 mm on a zoom lens, and we've stacked it up. And she's more the center of attention, lots of stuff going on. That fan blocks that real bright spot very well. These guys are grooming a cow. We have a big cow there. It's cluttered, but I like that frame. I think that's our frame. That's our keeper out of that group. OK, fine.

Now, let's look at one more set of pictures from the same thing. I don't know about you, but that last set of pictures just kind of whet my appetite for some more good cow-picture editing. So let's do some more here. Alright, this time at the Minnesota State Fair now. What are we going to do? Well, they have a huge dairy sale. Minnesota is big into dairy, a big dairy sale and a big arena, lots of cows, hundreds of cows are shown. Let's look.

I thought I'll get up, I'll get a little height here. Let's see, a little bit of height. Now, I have a lot of height. I think I like that better than either of these. I don't see it here, a lot of dead space. I don't really see it here either, a lot of dead space. I'm going to throw those out. But I do like the fact that we might be able to get some patterns up here, especially if I get over, because look, if you shoot with a long lens on these, you're going to get crowds in the background, but if you get up, now we're talking. There's an American flag there. We're going to start to make pattern pictures by being way up and looking down on that American flag.

Now, that's nice and clean, nice flag, shimmery, love it. Wish there were a couple more cows over there, but I worked this for awhile, and I think one of these pictures will work. Maybe that one's a little bit better because it's more full, more complete. Now I'm working the judge, and he's lining up all these cows to really point them out. He's pointing out his favorites. They've got them in different organizations, so I'm thinking, OK, yeah, we've got a pattern here. I think I like one of those flag pictures. I'll keep that, and

maybe we'll get something here of these kids moving their cows around for the judge.

I'm thinking, let me try one more time. Let's go back a ways. So I go back to this end and I see this pattern forming up, right here, and I think, I'm going to be patient. I think this could be a good shot if we get enough cows in here. Let me work this. And so I edit, and there were dozens and dozens of frames of these cows parading around. I picked the best one for you guys. There we go, a little tighter, nice, circles taking everything up, plenty of people. This is the grand championship, so there's lots and lots of people in the stands, and that same judge is pointing out his favorite cow right there, so that's the moment. I worked that situation, I edit it in my head, get to the spot, off we go. That's it.

So, now let's get really close to home, one more situation here, something that could've been shot right on your own block. From a stack of photos, let's try to find a good portrait of somebody in front of their house. How about that? OK, so my friend Clark, he's built this old house himself with his own two hands. It's a lovely house, built to fit his historic neighborhood, but I didn't do a very good job there, did I? It's important that I do a really good job, because he built this house with his own two hands, and we really want to do this man justice.

He has a lovely old house built to fit his historic neighborhood. I can brighten it up in Photoshop. Look, I did a bad job exposing, I can brighten that up, but what good is this? This picture is a goner. A chimney coming out of his head, and trees, and he doesn't look that good here, and a lot of white sky, what am I, a huge fan of that sky? What's the deal? Well, let's try something else. OK, a little bit better. We're back, our angle is different. Now we just have house coming out of his head. It's a little distracting, but a little bit better, it's OK. It's alright.

Now, a little bit longer lens, kind of cleaning things up. We still get a good feel for his house. We have a little bit too much depth of field, though, don't we, because we've got this gutter line going right through his head, splitting his head in half. I don't think that's the frame either. I think this could be better. Let's keep looking. Let's edit this a little bit. A longer lens, yet, to

really clean that up, because we don't think we can really use the house without cleaning it up by a real shallow depth of field, OK. Well we have a little drain pipe going in. It's not bad. It's cleaner, but I'm not seeing enough of the house again. I think I'm too tight.

OK, we'll do an intermediate, 70- to 200-mm lens, on 200 here. Again, the same line, what to do, what to do? I'm going to change my perspective a little bit. I'm going to get back and get a little higher, and now he stands out, and we know it's an old home with those columns. That looks like it could work. That looks alright. Let's try one more thing because I really want to see more of this house. Again, this trim is just killing me, that white trim going through there. There's no way I'm going to keep that in the edit, no way. What else did I shoot?

OK, now we're talking. It's a matter of moving around and finding the blank spots in the house in which I can put his head. He fits perfectly right there. That's the best one of the whole shoot so far to me. I get a real good sense of the house. Every part of the frame has something going on. He's comfortable there. There's no white sky blowing out. That's a keeper, that's a keeper. That would be my keeper unless I had this one. I like this one a little bit better. It might not be as good technically, a little bit of window coming out there, but he fits right in there in that eave, and most importantly, it's a little moment. He's happy. He's probably happy because the shoot is over with.

So, out of all those frames, that's my keeper. Nice sense of the man and house he built. His jacket's not cut off. We have good color; every part of the frame's working. So that's alright.

So, what could possibly go wrong when you're editing? I'll tell you the biggest problem of all, one I see all the time. I have mentioned it, not being critical enough of your own work in the editing process. You have to be brutal. You're the one that cares the most about it; they're your pictures. You're the one who's invested all the time and the money and the travel. You must be really critical of your own work. If you can't decide, if you're one of those people who can't choose what you want when you're sitting down in a restaurant off the menu, if you can't pick something, have someone help you. Get other people's opinions. This is a huge deal.

It makes the work better if you have other people's opinions, actually. I never try to edit myself fully. I have people helping me, and I'm a pretty good editor, and I want other people to look at my work. So be critical of your own work, push yourself, but let others do it too. It really helps to have a friend edit with you, somebody who has a very good eye, someone you trust. Don't argue with them. Don't bristle at what they say or they won't come back, especially if they're good. Just take it as the gracious gesture that it is, that someone has taken their time to look over your work and give you their honest opinion. Then, after you have their opinion, it's in hand, you can make the call about what you think is the right thing, which is the right picture.

Remember, once you start shooting, you're quickly going to find yourself building up to a library of images—a very large library if you're shooting digital, and it's so easy to shoot multiple pictures of something and those pictures are going to be very close together, right? Remember, with film, you used to have 36 pictures on a roll, and then you stopped and you thought, do I really want to spend more money on this next roll to develop, or do I think I have it? Not so with digital. So we shoot a lot more pictures digitally, at least I know I do, and we must be much more discriminating when we go to edit. Learning to choose the best ones is almost as important as learning where to point your camera.

We want to be able to edit our own work, don't we? We want to shoot it well in the first place and then have the guts, and the nerves, and a thick enough skin to edit ourselves down to one or two pictures from each situation. That is a tall order sometimes and is really, really uncomfortable. But if you want to improve your photography, you must become your own worst critic. If you can't really put the editing pressure on yourself to know when your pictures stink and when to get rid of them; or when your pictures are just so-so, and get rid of them; or when your pictures are kind of good, and get rid of them, then the great images for you will be few and far between because you will not be uncomfortable enough to get any better. Editing makes you better because it shows you what you missed in the field.

When I have people come to me who want to work for *National Geographic*, and there are plenty, they send me a portfolio, you know what, I'm not

looking for their best pictures. I'm looking for their worst ones, every time. That tells me where their mind is. That tells me whether or not they know how to edit themselves. If they don't, they don't have any business working there. In fact, I have never thought, wow, that picture's just perfect. I can see problems with every picture I've ever done.

Take our keepers from today, our keeper pictures, for example. Sure, I'm attached to the ones that we ended up with, but I don't have any up in my house. I don't have any of my own work up in my house, other than some snapshots of my kids. Why? Because I see the problems in them. That, I would argue, that one thing, is the key to getting better, being really uncomfortable with your own work.

By the way, a good editor won't care how hard you worked or how far you traveled to get a picture. As an editor, that's not their job. What matters is the image they're seeing. Is it well crafted? Is it edited well? Could it be better? Could you go back and do it again? These are the things I'm thinking. Really, you should be thinking about the same things in the same way. It's only about the image. That's it. that's it.

So, I wanted you to know that even a *National Geographic* photographer constantly seeks out the opinions of other people. I don't trust myself, and I have been at this a long time, folks. I'm always seeking out the advice of other people. I can't decide. is this any good? I have a feeling whether it's good or not, but you know, really, picking the actual frame is tough. That takes multiple people sometimes, multiple. Sometimes I'll go for a consensus and show a picture to five or six people, or show a group of pictures. What do they think? I go with the majority opinion sometimes. I really do. It's not an exact science. This is art, and that's very subjective.

So, your assignment. From a day of shooting, I want you to do a complete edit. Start by marking those rough selects, marking them, get rid of the junks, and then note your primes, and your real keepers, the ones you're going to get down to. Narrow it down to one picture per situation, one picture per view or direction would work, too, for this. Really narrow it down, though. If you've had a big day of shooting, narrow it down to 20 pictures from that day, that's plenty. I've done entire stories over months where I don't have

20 pictures run. Narrow it down. If you can narrow it down to ten or five pictures, that's even better, or, dare I say, pick your favorite picture from that single day. It's hard, but you can do it. You have to do it in order to become a better photographer.

So, in our next lecture, whether you're presenting a slideshow or putting an album together, learning to tell stories with images is an extremely valuable skill. We're going to discuss that and why shooting great picture stories, or photo essays, is truly the highest form of photography.

By the way, it's hard to believe, but our next lecture is our last, and that means the most to me, this next lecture. I saved the best for last, in my opinion. We're going to talk about storytelling, which is about all I do, and why it's so important. This is the reason that I'm on the road so much each year, the thing that I think can change the world for the better. So it's a great way to close out the course. Please come right back.

Telling a Story with Pictures—The Photo Essay
Lecture 24

The ultimate use of photography is to tell a great story—one that moves people, perhaps simply to smile or to do something significant, such as save the planet. Photo stories are the highest calling in still photography. Thus, it's fitting that our last lecture is devoted to telling stories with pictures. We've learned how to shoot and select good frames; now, we'll find out how to put them together to build a photo essay.

Elements of a Photo Essay

- A wide variety of light, situations, lens choices, and above all, storytelling moments are at the heart of any good photo story. Whether you're putting together a photo essay, a web gallery, or a vacation slide show, getting your images in the right sequence and edited well can elevate your work and grab the attention of your audience.

- Of course, putting all these elements together takes time. Great moments happen in front of your camera only so often, so you have to be patient. The perseverance of the photographer plays a significant role in determining the end results.

- Photo stories, no matter what their final format, should have a great deal of variety; be well executed; and should have a beginning, a middle, and an end. In other words, you'll be shooting and editing a lot of pictures to pull this off well, but the result will be well worth your time.

Alaska's North Slope

- A good photo story starts with a wide or an establishing shot of some kind, something that feels like an opening. It should grab the viewers' attention and let them know right away what the story is about. Give your viewers a sense of the place where the drama of your story will unfold. For a story on Alaska's North Slope, an aerial view establishes the setting as rough and rugged.

481

- Next come the detail and intermediate shots: caribou crossing a road in traffic, a worm's eye view of cotton grass, and some shots of scientists putting leg bands on geese. These images work together to give a sense of place.

- All these photos prop up the "money shot": a polar bear feeding on the carcass of a bowhead whale.

- A good ending for this photo essay was a shot of a rainbow over a caribou antler.

For a photo essay, choose a subject that you care about deeply; you may be working with it for months or even years.

Leech Lake, Minnesota

- A photo story of a yearly family vacation taken at Leech Lake in Minnesota begins with a couple of scene-setting shots: a lyrical shot of the woods and some ducks on the lake.

- Next, a few people are introduced: a boy in a kayak at the last light of day and a woman on a boat dock. A particular tree by the lake with a tremendous bend makes for an interesting subject in different kinds of light and with and without people climbing it or swinging from it.

- Notice that the photos are presented in a sequence that is similar to cars on a train. We started with a few photos of the lake—that's the lake car; then we switched to land with a few photos of the tree—the land car. The cars might be linked by a similar quality of light, such as the light of sunset, followed by soft indoor light in the evening or firelight.

- A photo of a mayfly on a screen door shows us that we're back outside the next morning, ready to go fishing. The light is now bright and colorful.

- It's interesting to include portraits in a photo essay to add visual variety to the story.

- The return of sunset signals that the story is coming to a close. The shot of two girls waving serves as the final picture in the story. A closing picture should give a sense of completion and provide a strong ending to the story.

- Your family members may be the best subjects for beginning photo essays because you have almost constant access to them and can take many photos to document your lives together. Think, too, about the richness and variety of situations you can find to shoot around your hometown.

Photo Stories v. Photo Essays
- A photo story has a fairly obvious beginning, middle, and end. It could be shot over the course of a weekend. A photo essay is a collection of images centered on a theme. Its storyline may be less obvious, and it may combine fine art with storytelling.

- Whether it's your family or something else, choose the subject for a photo essay carefully. You want something that's physically close to you, so that you can work it repeatedly over the course of months or even years. Choose a subject that you care deeply about, because you will be spending a great deal of time with it.

- The point of a photo story on an endangered bird species is to increase awareness of the animals that could be lost if humans continue to take over their habitats.
 - The story begins with a shot of a stuffed ivory-billed woodpecker, a species thought to have gone extinct in the 1940s.

 - Next comes an establishing shot of the spot on the Cache River in eastern Arkansas where a sighting of the woodpecker had been reported.

 - An intermediate shot shows biologists out in the cypress swamps looking for the bird. The dappled light gives the viewer a real sense of being in the woods.

- Detail shots include a prothonotary warbler coming out of its hole and a water snake trying to swallow a catfish in the mud.

- Given that the bird may no longer exist, the essay includes shots of other woodpeckers, as well as photos of the local diner and woodpecker decoys.

The Biodiversity Project

- The Biodiversity Project is an extended series of animal portraits meant to highlight the value of these creatures to our world.

- Some of the species photographed now exist only in zoos, so it's important to document them for posterity. The goal of the project is to pique the interest of viewers and entice them to learn more about these animals.

- Not only are the animals photographed inherently beautiful and valuable, but they may hold the keys to important scientific or medical discoveries for humans.

- All of these photos take into account the elements of good photography we've discussed throughout this course: leading lines, clean backgrounds, the rule of thirds, interesting subjects, and beautiful light.

- Some of the amphibian portraits are of the very last representatives of the species, but the good news for many of these animals is that they can be saved. The goal of this photo essay is to make people care enough to visit a local zoo or aquarium and perhaps contribute to a captive breeding program for endangered species or a habitat protection program.

- So far, this essay includes photos of more than 2,000 animals, and it's likely that it will never end. Having said that, make sure your essays include images that won't go stale. The mark of a great essay is its ability to make us want to return to it again and again.

Behind the Lens

And so, my friends, that is it. It is up to you now, really. The training wheels are ready to come off, [and] you're ready to ride off into the sunset. That would be a good closing picture, wouldn't it? When you do, I will be standing right behind you, encouraging, smiling, cheering, and rooting you on.

A final thought: I've said it before, but photography freezes time, something nothing else can do. How lovely is that? That's a great thing. So think of the things you've learned throughout this course and judge each photo carefully. Is the light good? What about the background? Above all, is it interesting? It sounded so simple when we started, didn't it? But right now you know there's a world of subtlety in all of it. That's why I'm still in love with photography some 30 years after I picked up my first real camera.

...Now, go out there and make great pictures, pictures we all can be proud of, and thank you.

© Joel Sartore.

Assignment

- Shoot a favorite subject as a picture story. Be sure to think about scene-setting shots, detail shots and close-ups, a money shot or a nice moment, and a strong closing image.

- Try to get the most variety you can in terms of times of day, weather conditions, varying lens choices, and even the emotions of your subjects.

- Practice your editing by choosing only the very best frames and, if necessary, return to the scene to reshoot to get the perfect images for your story.

Suggested Reading

Allard, *Vanishing Breed.*

Forsberg, *Great Plains.*

LIFE 75 Years.

Homework

Shoot a favorite subject as a picture story—not an essay, just a picture story. You could shoot this in an afternoon if you wanted to, but be sure to think about a scene-setter, a detail shot, a close-up, a nice moment, and an ending frame or a closer. Work to get the most variety in terms of times of day, weather conditions, lens choices, even emotions if you can find them.

Telling a Story with Pictures—The Photo Essay
Lecture 24—Transcript

Well hi again, everybody, our last lecture. This one's a good one. We're going to talk about picture stories and photo essays, my favorite subject. The ultimate use of photography is to tell a great story, isn't it? One that moves people. Or it could be to simply smile, or to motivate them to save the planet, even. Photo stories are, pure and simple, the highest calling in still photography.

So it's fitting that our last lecture is about telling a story with pictures. Now that you're feeling good about what makes individual frames sing, let's jump right in and see if we can't build a real photo essay or two. A wide variety of light, situations, lens choices and, above all, story-telling moments, are the heart of any good photo story. Whether you're putting together a photo essay, a web gallery, or a vacation slide show, getting your images in the right sequence and edited down well can really elevate your work and make it so attention grabbing. It's very important. But this all takes time. Great moments are going to happen in front of your camera only so often, so you have to be patient. The perseverance of the photographer plays a huge role in determining the end results. Photo stories, no matter what their final format, or final presentation form, should have a great deal of variety, be well-executed, and should have a beginning, middle, and an end. Translation: you'll be shooting and editing a lot of pictures to pull this off well, but it is so worth it.

So in this lecture, we're going to look, first, at a story about Alaska's North Slope, then at a story about people at Leech Lake, Minnesota, and finally at a little work in progress or two, and my personal work on the loss of biodiversity to extinction. I'm in the middle of working on that one, and it may very well be my life's work. I plan on doing it for the next ten years, at least.

So let's get started. Whenever I'm doing a photo story, I start with a wide or an establishing shot of some kind, something that feels like an opener. Good beginnings of photo stories grab viewers' attention and let them know right away what the story is about. Your establishing pictures should be well done

technically, and also give your viewer a real sense of place and establishing where the drama coming up will be played out.

So let's look at this. For my story on Alaska's North Slope, how do you get any more dramatic? Aerials are my establishing shots, basically. Here we go. We know we're in some big, rough, rugged country, don't we? And here we go onto the Arctic National Wildlife Refuge onto the coastal plain with thousands of caribou down below us, to just a few pictures here that take us, a beginning, middle, and an end, a little picture story, that's all we're trying to do. We know there's industrial action up there. They produce a lot of oil, there's a lot of roads, caribou try to cross in front of the traffic. We want to do detail shots in picture stories, don't we, detail shots. Those are very important.

This is a typical picture of cotton grass, but maybe it's a little less typical because we're down low. We have a worm's eye view going. How else can we do a detail shot? Well, we can make detail shots from a medium shot believe it or not. Look at the bugs in that. Reminds me of how buggy it was, mosquitoes everywhere, holy cow.

So we have a team of people catching geese for scientific research, white-fronted geese. They're flightless at that time of the year so they can round them up in nets, put leg bands on them, and let them go. While they had them in their hands, I went ahead and got ready and set up my camera for a pan, and when they let them go, I do a little panned action. So there's a little detail shot, a little bit different. Now for a real close up, one's in the hand of one of those scientists, we do a real close-up, detail shot.

Now, all of these pictures go to really prop up what I call the money shot, or the really good one in this story, this one. Now you've seen this before, but it's a polar bear on the carcass of a bowhead whale with the big jawbone sticking up. This one actually made it to the cover of *National Geographic*, which was nice, to say the least. And this is kind of the picture that you really want to envelope with all your other pictures, these detail shots, your openers, your closers. They all kind of support this picture and elevate this and get this into the magazine. But you really need all these pictures working as a team to really come together and work as a story and tell the story of the

place well, and then an ender. A good story has to have an ender, just like going to the movies or listening to a good song. What's your ender? Well, how about a rainbow over a caribou antler? That feels like an ender to me.

So, a little bitty photo story there, beginning, middle, and end. That's it. That's all there is to it. But you have to be thinking about these elements when you're shooting. They don't just happen in the edit. You have to get them first. You can't edit them if they don't exist, right? So, the nice thing about a picture story is it tells you where you are, and so you just naturally assume that any shots within it are a part of the same situation. The mind works that way. All these pictures are working together as a team and they're really pulling their weight and they're building on one another.

So now let's look at a more extensive photo story, beginning, middle, and end, again. These are pictures I shot up at Leech Lake, Minnesota, which is where our family goes to vacation every summer, every summer. Even though I'm there every year, in my pictures I try to capture daily life well and make it really sing. I'm trying to do a photo story here, always, always trying that. So what is this? It's just kind of a lyrical shot of the woods, our cabin along Leech Lake is deep in the woods, that's just a scene from the road driving in, probably a ½-second exposure. It's a little bit different. I like different; different is good.

OK, so, here we are on the lake, a little bit of a scene setter. We have some ducks on the lake, that's fine. That works. And now we're introducing people. There's Cole out there in a kayak, last light of day. And Ellen out on the boat dock where we stay at this Trader's Bay Lodge. So, that's fine. We're getting a few pictures here. I want to mention something else. As we go through these, notice that they're not in random order. I have sequenced these for you. We start driving through the woods, and we come upon the lake. And now we're out swimming in the lake. I'm trying to do these things so that they're sequenced. Think of them like cars on a train; you put together all the lake pictures, that's a car. And then you put those together, and now you switch to this. We've switched to land. We're going to have a few pictures of this tree, I bet. I bet we are.

This tree, by the way, is one of my favorite things up there. It's just got this tremendous bend in it, and I love it. And I study this thing, and I shoot it in light that's not so good, I shoot in light that's good, a lot of activity goes around this thing, so that's kind of my touchstone up there. And I work this a lot, all the time. There's a rope swing off of it, and I go out there when the light's good, mainly, and kids swing on that all hours of the day and night. And I use that tree, and I try to photograph that thing in as many different ways as possible every time I go up there.

Little Spencer likes to climb it, likes to watch what the other kids are doing, kids from other towns that he doesn't know. He uses that as a lookout. So I think about that tree a lot when I'm up there shooting. See how I've grouped all these trees together? This is my car on the train of this tree. This is where we're going to see that and Spencer leaving it when the light's good. Now the other thing is, watch how I join this car up to the next one. We had great light come in on the back end of a storm one evening at sunset. Oh, look, there's my sister-in-law Jeannie, there's our cabin in the background. She's taking a picture of me, great light to great light. There's our linkage to hook those two train cars together. They were telling a story, not enough to have a beginning, middle, and an end. You have to have links. You have to be able to have easy transitions from one subject to the next. So let's go inside and we'll look at what that light's doing inside from the same storm. It's really casting a lot of great light indoors, even all the way to dinnertime.

Here's Ellen. Cole is watching the storm, seeing if it's going to get worse, and there she is bathed in the last light of day, at age 14. She'll never be any older than that. It's so cool the way pictures can freeze time, even though she's not really enjoying having her picture taken once more. And then we go all the way to the end of day. Again, golden light, but this time, and it fits on that train car, but this golden light is caused by firelight, isn't it? We've learned about firelight and what a nice light source that's, a little bit of ambient light in the sky.

Now, how am I going to transition to my next picture? How am I going to do it? Well, I'm going to make a clean break. Kathy's reading. Here's this. Next morning, off we go. We've started a new day, and Spencer's got his *Star Wars* helmet on that he bought at a garage sale. So he walks up to Kathy, and

he presses a button on the side, and it says, "Halt in the name of the Empire," and she thinks that's funny. I love the fact that I saw this coming. I was over here. I shot one from there, it wasn't very clean, but then I moved around and that helmet pops out of that window perfect. It's framed by the window, and her hand in there pointing at him really stands out. And it's just cute, and the light's nice and subtle.

So we made this transition from nighttime all the way into the next morning. So now here we are in daytime inside the cabin. That picture in the kitchen links to this kitchen picture, and now we're going to something in the bathroom with a bed sheet that's being hung up for privacy. So we go from this screen to this screen, transitions, transitions, transitions, to really help elevate the work. Editing well, that's what it's about.

So we go to a mayfly on a screen. We know we're back outside. We know we're in nature, and we're back in nature. Now we're talking about fishing. OK. To my brother Paul holding up a northern pike that he's caught. Somebody holding something up to somebody holding something up, but now the light's bright and it's colorful, and now the light's bright and it's colorful. So we're trying to link these pictures together some way, either in terms of context or visually. They all have to link together, or you make a clean break like we did at breakfast time with Spencer in the helmet, and you go on to the next thing.

So there we are, a couple of pictures like this, beautiful, beautiful light up there when the sun's out, I just can't help it. I wanted to mention this, too. Portraiture is a lovely, lovely thing to throw into a photo essay or a picture story. Oftentimes portraiture is overlooked, but I think it adds visual variety. I want you to know something. I'm very proud of this picture, not because Ellen's finally happy in a picture, but because of the way that I've got those marshmallows standing out right against the back of Cole's shirt. Perfect, a little bit off to one side, a little lower, you would not be able to see that she'd burned her marshmallows at the marshmallow cookout. So I love that about this. I like her attitude, of course, but I love that; that those marshmallows stand out. That was kind of the whole point of the picture.

So we go from that to just goofing around with the kids, Spencer with some other crazy thing he's got. Minnesota's wolf country; the carpet's appropriate. Some other portraits of Spencer, basically, as he's looking around. He's getting older. And, of course, Ellen again, portraiture. I love doing portraiture as parts of photo stories. It breaks up the monotony, visual variety, we need to keep it interesting, especially if we're showing a lot of pictures.

We goof around a little bit, more depth of field. It gets us back there to that cloud. Cole and I goofing around. Cole has a bright idea. So he's got a think bubble coming out of his head there, I guess. and then we're starting to drop in exposure. We're bringing on the night again. We're going to taper this thing off. We're going to wind it down. The light's going to drop, sunset's coming, lower light, lower light. Lower even to the point where you can see the pre-focus beam on that girl's face, on Ellen's cousin's face there, as her friend takes a picture. That pre-focus beam, just a little hint of red and Shannon's happy; she's smiling, nice. And our last picture, feels like a closer, kind of relaxing, our last picture, Shannon reviewing the pictures on her camera. It's OK, fantastic. That works, nice.

You know, a lot of the great photographs you see in *National Geographic* are shot in that twilight time, especially, you know, long after the sun set. Now cameras have this high ISO and can really handle that low light. What a great time to be shooting. What a great time to have these cameras and to get these really special, quiet moments. Love it, love it. So, I've talked a little bit about endings, but what should an ending be like? That's pretty obvious, sunset, day's over with, the end, OK? Well, the final frame doesn't have to be shot in low light, but it does need to show a sense of completion a little bit.

This is also shot up at Leech Lake. That looks like an ender to me. That looks like an ender. It could be something as simple as girls waving at a cute boy out on the lake, or it could be kids asleep in the back of a car coming home, or it could just be sundown on a pasture, a little less obvious, but closing pictures give us a real sense of finality and completion, and we know we are done. It's like a good, strong finish akin to a movie, OK.

So, you shoot lots and lots of things, and you build these picture stories, or photo essays, praying that you get a couple good shots that are just so killer and so good they make the whole effort worthwhile, right? You have all these other pictures that are good around them, but it's those few marvelous, pictures that really give a story what I call high octane or energy, the real keepers, the money shots.

Another key thing about telling a story with pictures is the amount of time you need to put in to it. I can't stress this enough. This is why using your family is a good place to start when it comes to taking lots of pictures. You don't want to abuse it, but truly, you have so much time with your family. This is the subject that I would start on, if I were you, and you haven't tried this before. In fact, a lifetime project for me is documenting my family. It's very critical that we think about the richness, and the variety, and the diversity of our lives, all around us, at home and in our hometowns. Don't abuse it, don't abuse it. Just be careful. Don't shoot everything. Be discriminating. Keep that camera ready, and shoot when interesting things are happening. Simple as that, your loved ones will thank you for it.

The keys to any good photo essay are time and access. It's very hard to build a photo story on something that you don't have much access to. I've seen lots of photo stories, by the way, that are brilliant, but if you were to take any one picture out of it and look at it standing alone, it really wouldn't have the same impact. In a photo essay, or a picture story, the whole is so much stronger than just the parts if you look at them individually. That's really the true nature of this.

By the way, I keep talking about a picture story and a photo essay. To me there's a simple difference. A photo story is something that has a beginning, middle, and an end, pretty obvious. It could be shot quickly in, let's say, a weekend event. A photo essay, to me, is a collection of images along a theme. A photographic essay is often less obvious, for example, in its story line. It might combine fine art with storytelling, so it doesn't have to be quite so literal, maybe a collection of images, that's it. As such, I really consider the photographic essay the best experience you can have in photography. If you can pull off a great photo essay, it's a bit like climbing Mount Everest. It's very hard to do.

Now, whether it's your family, or something else entirely, choose your subject for your photo essay carefully. You want something that's physically close to you, so that you can work it over and over again throughout the months, and even the years. Remember, choose something that's going to be around for a while and something you care deeply about. You two are going to be stuck together for a long time, you and this photo essay. There are very few photo essays in each of us, by the way. We just don't live that long. We don't have that much time. Be really careful about what you choose.

For me personally, since you've endured the course with me all this time, I'll just tell you personally, since I was young my passion has been endangered species. Ever since I learned that that we'd doomed this bird the passenger pigeon to extinction from market hunting. The last one, named Martha, died in a cage at the Cincinnati Zoo in 1914. Even as a kid, of eight or nine years old, I could not understand how we could purposely drive something to extinction, and I still can't. So, this essay section, this is my attempt to get folks to stop and look at some of the species we could lose if we don't start easing up on them. More than half of all species are projected to go extinct by the turn of the next century if we continue to take habitat like we have been.

So, I've done a few photo stories on rare species for *National Geographic* over the years. And one of my favorites kind of played off the passenger pigeon. It was the ivory-billed woodpecker. Have you ever heard of that bird? It's quite rare. They thought it went extinct back in the 1940s. And some folks, though, thought they'd spotted them again in Arkansas, in the big woods of Arkansas, not too long ago, so I volunteered to go down and cover the search. Talk about a challenge. How do you cover something that might not even exist? This is a tall order. What do you do?

Well, I started out by finding stuffed ones. First of all, I wanted to see what it looked like up close. There's one at the University of Nebraska State Museum. There he is. This is the spot where they think they discovered the bird again. A little bitty place on the Cache River in eastern Arkansas, not very much land there, not far from that overpass. Important to do an aerial an establishing shot beyond that picture of the bird. OK, here are biologists from Cornell, out in the cypress swamps, the hardwood forest, out looking

for the bird. Nice, soft light, it's a good, kind of an intermediate shot. It shows us a sense of place.

Now a little detail, a little prothonotary warbler coming out of his hole. That's shot with a little radio-triggered camera like I showed you earlier in the course. I use that all the time. That's just set up on a cypress knee next to that one, and I fire it with a radio trigger watching through binoculars, no problem, a little nest cavity. So a nice little detail shot. This is a very wild, primitive place, though. Look at this. The snakiest place I've ever been, and I wanted to show that as part of this picture story.

So here we have a water snake that's trying to swallow a catfish down in the mud. Alright, that works, that works. And the group of Cornell biologists towards the end of my time there, all going out in the morning watching other woodpeckers. There's lots of other woodpeckers in the woods, very nicely lit, and some people are in the shadows, and some are in the sun. I love that dappled-light look, and plenty of depth of field to get us into the woods. It kind of feels like we're there. We're not seeing a person's face, the backs of them, oftentimes that's fine. What does the ivory billed woodpecker do? Well he leaves a calling card. If he's there he'd leave big holes in the trees. You know, that's what they're looking for, trees like that. Maybe he's there, but then again, it might've just been pileated woodpeckers, very closely related, but quite small.

I sat up on a nest cavity in a blind and waited for three days to get a picture of a pileated woodpecker. They move like rocket ships through the forest. So there we go. What else do you do for a bird you're never going to see? I knew before I went down there, I had two weeks for this assignment, I knew I wouldn't see one. What else do you shoot? Well, maybe you shoot the local diner where they're serving Ivory billed woodpecker burgers, just hamburgers, but they give them a funny name, and they have ivory-billed art on the walls. Maybe you photograph a man's decoys for ivory bills that are out there. He's trying to put remote cameras, movement triggered on these decoys to see if any come in.

That's him, Bobby Harrison, out in the woods looking around. Good guy. And there are a couple of other Cornell guys just going out every morning

at dawn, closing their eyes having a sandwich at dawn and listening for the bird. Does it exist? I don't know, but it was fun to do the story. It really was.

For me it's very satisfying to do something like this. The photographic essay, though, that's more of a picture story, beginning, middle, and end. The thing that's been most personal to me, that I've been working on, well, it's a thing I call The Biodiversity Project, and I've been doing it for seven years, seven years. It started as a way to do something close to home photographically while my wife was going through chemo for breast cancer. On days when she was feeling OK I'd just go down to my local zoo, about six blocks away, in Lincoln, Nebraska, and I'd do a few portraits of small animals on black and white backgrounds in order to show off how interesting-looking they were, really. I started off with these two species on my first day, just put a couple of blue and black poison dart frogs on a piece of glass and a naked mole rat. That's how this started.

So, what else, what else? Well, I learned that it was pretty interesting, so I went to the zoo in Omaha, and I shot a little bit more. I learned that if I put big enough backgrounds behind these animals, if the zoo gives me permission, well, we can make all sorts of things stand out. What's the point of this, by the way? The point is, I thought it was visually interesting at first, and I love animals, I have since I was a kid. And who doesn't like animals? Most of us love them, and I thought, wow, these animals, they're living works of art. That's amazing to me, and they're so ferocious. Damaraland mole rats, they actually form a eusocial colony, one of only two mammal species to do it. These are soldiers sticking their teeth up trying to bite at me.

Elephants and cheetahs, anything I could do, I just thought is it interesting enough? I've done a lot of species this way. Is it interesting? I think so. Even though it's on black and white backgrounds, a two-headed turtle, how could you not look at it for a little while. Or a Uakari monkey, one of the few that are in captivity. I think there's only three in the entire North American continent. Arabian Oryx, meerkat, vipers, snow leopards, wow. So the list goes on and on and on. These species, all of them, to me, have value, and that's the key.

As I've gone forward with my *Geographic* work, I've learned a couple of things; one is that zoos are arks. They're modern day arks. Some of these species only exist in zoos now, so it's important, I think, to document them for posterity. Zoos have a pretty good inventory of things right now, but will they in another 10 years, 20 years, as things in the wild continue to diminish? I don't know. What is it about these pictures that I hope people will cling to? Well I hope they will look at them and think, wow, that's interesting. I want to learn more about that. What's going on with this? That's my goal, anyway.

In any event, how did I really get going on this. After I shot these for awhile I realized, you know what, I've shot things out in the wild, tons of things, but it's better when they're in an aquarium up close. I've shot these turtles on the beach, just like that. The aquarium is probably better, probably more interesting, eye to eye. How about this drill in the Bushmeat Market? Well, better if you put a piece of velvet behind him. You really engage in there, you really do. And so, I started taking these backgrounds with me, and my little portable lights, wherever I go in the world, and I photograph little things that we can manipulate easy, put them back into the wild unharmed. I have a little containment vessel for birds. I go out with biologists that are trapping birds for banding. I always worth with biologists, and I try to show the world what biodiversity looks like.

Why would I do something like that? Well, I just think it's important. I don't know why, exactly, but I think it's really important. I have something like this. People will say to me, well what good are these animals? Well, these are hibernating Arctic ground squirrels. It's a male and female. They take so long to wake up, they're world champion hibernators, it takes them about four hours to wake up. So, they're at a study center at the University of Alaska, Fairbanks, there's a male and female there, it was about Valentine's Day when I shot this, just put them literally in a snow bank. They hibernate through the coldest of winters. They're laying there, I put them in a heart shape, it was around Valentine's Day. Why would we care whether or not a ground squirrel sticks around into the next century? Well they are world champion hibernators; they can sleep eight months a year without hurting their kidneys. They can super-cool their blood to below freezing, and they can actually heal traumatic brain injury in their sleep, unlike any other mammal we've ever seen.

So a lot of medical secrets can be locked up in this animal. So that's what good this Arctic rodent is. Huh? What secrets lie in this? I don't know, but I think about these things all the time as I'm shooting. I think hmm, what good is it? Well to me they're wonderful, they're absolutely beautiful, and they're worth saving. Besides, the colors, that keeps it interesting. In all these pictures, by the way, I'm thinking about what I've been teaching you through this whole course: leading lines, rule of thirds, something interesting, beautiful light, clean background. Everyone of them, I'm thinking that, every time I shoot. I also happen to be thinking, well, this is one of nine of these left, the Sumatran rhino, one of nine captive, one of three captive Florida panthers left.

Amphibians are really getting hit hard, actually, really hard. We're liable to lose half of all amphibians in the next 10 to 20 years due to climate change and a fungus that's asleep in the world. How bad is it? Well I went to an amphibian lab in Ecuador, and the guy said, take a picture of that one, last one. Then he brought out another, take a picture of that one, last one. Take a picture of that one, last one. Hard to believe. I'm seeing the passenger pigeon all over again. This rabbit actually went extinct when I was creating the last book I did on this subject called *Rare Portraits of America's Endangered Species*. So, gee, time might be running out.

You know, the good news, though, the really good news is that for all these critters, all of them, they can all be saved. All it takes is somebody to pay attention to them. It's not too late for these guys, it is absolutely not. Given attention and funding, literally, any of you out there could save a species, or two, or more, if you tried. Visiting a local zoo or aquarium is a great place to start, you know why, because these are the places that fund captive breeding programs for endangered species, they fund habitat protection in the wild, they also educate the public. Most of us live in cities now, zoos are the only places where we actually see wildlife, so that's amazing. That's huge, and that's my hope in doing these pictures, anyway, to get people to care.

Look these animals in the eye and say, yes, that's awesome, that's worth saving, it totally is, wow.

OK, so, today I've photographed some 2,000 animals this way, can you believe that, 2,000 out of the 6,000 captive in the U.S., and I realize that this is an essay without end, really. I'll keep doing it for another ten years, as long as I can. If I can save a few species because the photos moved people to action, mission accomplished. If it entertains them a little bit along the way, fantastic.

So, I've shown you a lot of pictures of these animals, haven't I? I'll tell you what. Some of them are easy to work with and some are tough. So a lot of work that goes into getting these shots, let me tell you. I want to show you what goes on behind the scenes in this little video I made.

Well, as you can tell, the photographer doesn't always win. So, don't forget, when you're doing a photo essay, the need for evergreen, or non-perishable photographs, is very important. You need to make sure that you have images that will last and that won't go stale. You need to really think about what do you want to cover in a long-term project and whether it will last through time, whether it's worth your time. The mark of a great essay is if it lasts, if you want to go back and look at it over and over again.

You know, I love looking at the essays of different photographers over the years. Among *National Geographic*'s very best, the photo essays by Bill Allard and Sam Abell, taken in the American West, are among my favorites, as is the wildlife work of folks like Chris Johns and Nick Nichols. Each time I look at them, I see something different, especially with the conservation photography. Those are pictures that actually go to work. Those pictures can make the world a better place.

You know, there's no better thing in still photography than a great essay. There are also no shortcuts for spending a lot of time on it, there just aren't. The more time you put in on it, the better the work will be. That's why it's so important to choose wisely, especially in the case of something long term. The photo essay is something that's not just over the weekend, but could last years. You are going to be married to this subject for a long time.

Your assignment, last one for the course, hard to believe. Your assignment for this lecture is to shoot a favorite subject as a picture story, not an essay,

just a short, little picture story. You should shoot this in an afternoon if you want to, you sure could, but be sure to think about a scene setter, a detail, a close up, a nice moment, and an ending frame, or a closer. Remember what I told you about working to get the most variety you can in terms of times of day, weather conditions, varying your lens choices, even emotions if you can find them. Remember that?

Start your story with an opener, then get into the meat of things with some really grabby moments, sprinkle in your detail shots, and finish out with a strong closing image. Remember what we learned in editing. Put together only the very, very best frames. Return to reshoot something, if necessary so that you've chosen a subject that you have a lot of access to, that's very critical.

And so, my friends, that is it. It is up to you now, really. The training wheels are ready to come off, you're ready to ride off into the sunset? That would be a good closing picture, wouldn't it? When you do, I will be standing right behind you, encouraging, smiling, cheering, and rooting you on.

A final thought: I've said it before, but photography freezes time, something nothing else can do. How lovely is that? That's a great thing. So think of the things you've learned throughout this course and judge each photo carefully. Is the light good? What about the background? And above all, is it interesting? It sounded so simple when we started, didn't it? But right now you know there's a world of subtlety in all of it. That's why I'm still in love with photography some 30 years after I picked up my first real camera.

Now I know you'll do great, but if you're still unsure of a thing or two, you can always contact me, believe it or not, you can contact me, at my website, www.joelsartore.com. We'll put it up on the screen for you. If the answer isn't there already on our FAQ, or frequently-asked-questions page, just write me. I'll be happy to help. You've actually sat with me through the whole course; I appreciate that; it's the least I can do. Now, go out there, and make great pictures, pictures we all can be proud of and thank you.

Bibliography

All *National Geographic* magazine articles cited here are viewable online.

Titles with an asterisk are no longer in print but can be found through used book vendors. They're worth the hunt.

Abell, Sam. *The Life of a Photograph*. Washington, DC: Focal Point/ National Geographic, 2008.

*————, and Robert E. Gilka. *Stay This Moment: The Photographs of Sam Abell*. New York: Legacy Words, 1990.

Adams, Ansel, and Mary Street Alinder. *Ansel Adams: An Autobiography*. Boston: Little Brown, 1985.

*Allard, William Albert. *Vanishing Breed: Photographs of the Cowboy and the West*. New York: Bulfinch Press, 1984.

————. *Portraits of America*. Washington, DC: National Geographic Insight, 2001.

American Society of Media Photographers. *ASMP Professional Business Practices in Photography*. 7th ed. New York: Allworth Press, 2008.

Arbus, Diane. *Revelations*. New York: Random House, 2003.

Audubon, John James. *The Birds of America*. New York: Sterling Publishing, 2011. (Multiple editions and sizes of this source are available; this is the most recent.)

Balog, James. *Survivors: A New Vision of Endangered Wildlife*. New York: Harry N. Abrams, 1990.

Bendavid-Val, Leah, ed. *National Geographic: The Photographs*. Washington, DC: National Geographic, 2008.

———, ed. *Through the Lens: National Geographic Greatest Photographs*. Washington, DC: National Geographic, 2009.

———, Michelle Anne Delaney, and Maura Mulvihill. *National Geographic Image Collection*. Washington, DC: Focal Point, 2009.

Black, Dave. *The Way I See It: 50 One Page Photography Workshops*. http://www.blurb.com/bookstore/detail/2025581: Blurb.com, 2011.

*Bown, Jane. *Faces: The Creative Process Behind Great Portraits*. London: Collins & Brown, 2000.

*Brandenburg, Jim. *Chased by the Light*. Chanhassen, MN: Northword Press, 1998.

Brandt, Nick. *A Shadow Falls*. New York: Abrams, 2009.

Burtynsky, Edward. *Manufactured Landscapes: The Photographs of Edward Burtynsky*. New Haven, CT: Yale University Press, 2003.

Caputo, Bob. *National Geographic Photography Field Guide: Travel*. Washington, DC: National Geographic, 2005.

Communication Arts. Any of the photo or design annuals show excellent examples of visual communication and problem solving.

Cook, Diane, and Len Jenshel, photographers. "New York's High Line." *National Geographic*, April 2011.

Crewdson, Gregory. *Twilight*. New York: Harry N. Abrams, 2002.

Forsberg, Michael. *Great Plains: America's Lingering Wild*. Chicago: University of Chicago Press, 2009.

Greenfield, Lauren. *Girl Culture.* San Francisco: Chronicle Books, 2002.

Iooss, Walter. *Athlete.* New York: Sports Illustrated, 2008.

Krist, Bob. *Travel Photography: Documenting the World's People and Places.* New York: Lark Books, 2008.

*———. *Spirit of Place: The Art of the Traveling Photographer.* New York: Amphoto Books, 2000.

Krogh, Peter. *The DAM Book: Digital Asset Management for Photographers.* 2nd ed. Sebastopol, CA: O'Reilly, 2009.

Lanker, Brian. *I Dream a World: Portraits of Black Women Who Changed America.* New York: Stewart, Tabori & Chang, 1989.

Latimer, Bronwen, ed. *Ultimate Field Guide to Photography.* Washington, DC: National Geographic, 2009.

*Leibovitz, Annie. *Photographs, 1970–1990.* New York: Harper Collins, 1991.

LIFE 75 Years: The Very Best of LIFE. New York: Life, 2011.

Lubben, Kristen, ed. *Magnum Contact Sheets.* London: Thames & Hudson, 2011.

Ludwig, Gerd, photographer. "The Long Shadow of Chernobyl." *National Geographic*, April 2006.

Maisel, Jay. *Jay Maisel's New York.* Buffalo, NY: Firefly Books, 2000 (or anything else of Maisel's you can lay your eyes on).

*Marshall, Jim. *Not Fade Away: The Rock and Roll Photography of Jim Marshall.* New York: Bulfinch, 1997.

McNally, Joe. *The Hot Shoe Diaries: Big Light from Small Flashes*. Berkeley, CA: New Riders Press, 2009.

Meyerowitz, Joel. *Cape Light: Color Photographs by Joel Meyerowitz*. New York: Bulfinch, 1979.

*Mitchell, John G., ed. *National Geographic: The Wildlife Photographs*. Washington, DC: National Geographic, 2001.

Morrell, Abelardo. *Camera Obscura*. New York: Bulfinch, 2004.

Morris, Erroll. *Believing Is Seeing: Observations on the Mysteries of Photography*. New York: Penguin, 2011.

Musi, Vincent, photographer. "Taming the Wild." *National Geographic*, March 2011.

Naskrecki, Piotr. *The Smaller Majority*. Cambridge: Belknap Press of Harvard University Press, 2007.

National Geographic Ultimate Field Guide to Photography. Washington, DC: National Geographic, 2009.

Peterson, Bryan. *Beyond Portraiture: Creative People Photography*. New York: Amphoto Books, 2006.

———. *Understanding Close-Up Photography: Creative Close Encounters with or without a Macro Lens*. New York: Amphoto Books, 2009.

———. *Understanding Exposure: How to Shoot Great Photographs with a Film or Digital Camera*. 3rd ed. New York: Amphoto Books, 2010.

Richardson, Jim, photographer. "Our Vanishing Night." *National Geographic*, November 2008.

Rowell, Galen. *Galen Rowell's Inner Game of Outdoor Photography*. New York: W. W. Norton & Company, 2010.

Salgado, Sebastião. *Workers: An Archaeology of the Industrial Age.* New York: Aperture, 2005.

Sartore, Joel. *At Close Range with National Geographic.* Directed by Olive Bucklin. DVD. Walton, KY: PBS Home Video, 2006.

————. *Nebraska: Under a Big Red Sky.* Lincoln, NE: University of Nebraska Press, 2006.

————. *Rare: Portraits of America's Endangered Species.* Washington, DC: Focal Point (National Geographic), 2010.

————, photographer. "Top Ten State Fair Joys." *National Geographic*, July 2009.

————, with John Healey. *Photographing Your Family: And All the Kids and Friends and Animals Who Wander through Too.* Washington, DC: National Geographic, 2008.

*Seliger, Mark. *Physiognomy: The Mark Seliger Photographs.* New York: Bulfinch, 1999.

Shaw, John. *John Shaw's Business of Nature Photography.* New York: Amphoto Books, 1996.

Sontag, Susan. *On Photography.* New York: Picador, 2001.

*Stout, Dr. Bob, and Nancy McMillen, eds. *The Pictures of Texas Monthly: 25 Years.* New York: Stewart, Tabori & Chang, 1998.

Tharp, Brenda. *Creative Nature and Outdoor Photography.* New York: Amphoto Books, 2003.

*Vesilind, Priit. *National Geographic: On Assignment USA.* Washington, DC: National Geographic, 1997.

Wilson, Laura. *Avedon at Work: In the American West.* Austin, TX: University of Texas Press, 2003.

Online Photo Books and Photo Printing Services

AdoramaPix (www.adoramapix.com)

Blurb (www.blurb.com)

MyPublisher (www.mypublisher.com)

Notes

Notes

Notes

Notes

Notes

Notes